TREASURES OF IMPERIAL RUSSIA

CATHERINE *the* GREAT

from the State Hermitage Museum, Leningrad

TREASURES OF IMPERIAL RUSSIA
CATHERINE *the* GREAT
from the State Hermitage Museum, Leningrad

PRESENTED BY THE CITY OF MEMPHIS, TENNESSEE
and the State Hermitage Museum, Leningrad

front cover:

PORTRAIT OF CATHERINE II, 1780s
After originals by Alexander Roslin (1718-93)
and Feodor Rokotov (1735-1808)
Oil on canvas, 263 X 188 cm
The picture is one of many copies of a portrait by the Swedish
artist, Roslin, painted in 1777-78. Catherine complained that
he had given her 'a face as common as a Swedish pastry cook's'.
At her request, in later copies - as here - her face was taken
from her favorite portrait by Rokotov, which made her look
younger and more attractive.

Designed by Trickett & Webb Limited, London
Edited by Isabella Forbes and William Underhill
Editorial Co-ordinator and Translator: Mark Sutcliffe
Consultant: Peter Collingridge
Produced by Booth-Clibborn Editions Inc for
The State Hermitage Marketing Company
ISBN 0 904866 89 0

Printed by Lithograph Printing Company, Memphis

CONTENTS

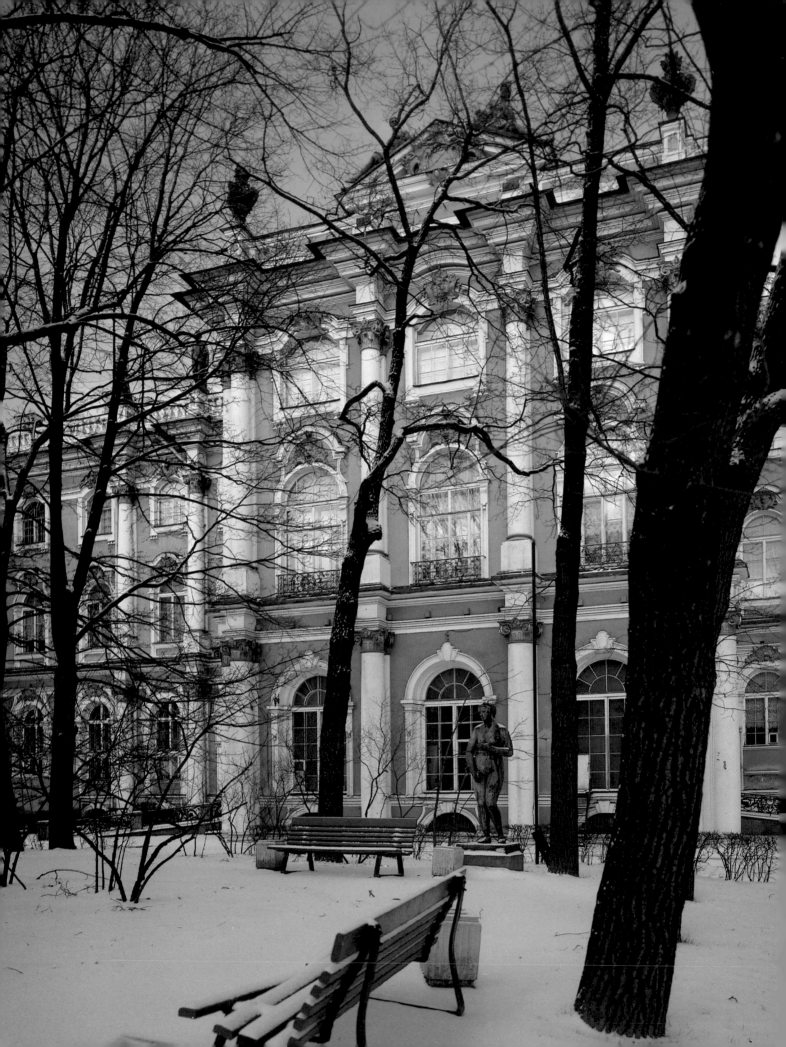

RICHARD C HACKETT

The world is rapidly changing. A new international order is being structured. The possibility of a bright future for all peoples of the globe is on the horizon. It remains for us, all of us, to summon the courage and the wisdom to mold this new world into one of peace and cooperation.

It is for this purpose that WONDERS: The Memphis International Cultural Series has been created. I am most gratified that one of the first beneficiaries of WONDERS is the new, emerging relationship between the United States and the Soviet Union.

The Catherine the Great Exhibition is a magnificent display of art from one of the world's great museums, the State Hermitage Museum in Leningrad. But, it is more than that. It is a splendid example to the world of cooperation and dialogue between two peoples who are searching for a new, peaceful and meaningful relationship.

Memphis is proud to host this grand exhibition. And we are proud to play a part in building the world of tomorrow.

RICHARD C HACKETT
Mayor of Memphis

SPECIAL
ACKNOWLEDGEMENT
by
RICHARD C HACKETT
Mayor of Memphis

In appreciation to
JAMES E BROUGHTON
for his dedication and commitment to
the citizens of Memphis by serving as
the Executive Director and guiding force
behind WONDERS: The Memphis
International Cultural Series.
and
EDWARD W 'NED' COOK
for his foresighted vision and confidence
in the possibilities of this international
cultural program as evidenced by his
beneficent financial contributions and
consisitent encouragement and support.

DEAR EXHIBITION VISITOR,

This letter, like the exhibition you are about to see, has travelled from the banks of the Neva River to you on the banks of the Mississippi. We are very proud to participate in such an event, with the hope that it will lead to a greater understanding between the peoples of our two cities.

The idea for the Catherine the Great exhibition was born in discussion which took place in Leningrad between the National Geographical Society and the Hermitage Museum in 1989, when the Hermitage Museum was celebrating its 250th anniversary. Consequently, we would like to acknowledge our debt to the National Geographical Society for providing the inspiration for this exhibition.

The exhibition has only become a reality after the concerted and devoted efforts of the hard-working staff of the Wonders Series in Memphis and of our museum in Leningrad. I would like to take this opportunity to thank personally everyone who helped bring about this exhibition; without them the dream could not have been realised.

We thank Mayor Hackett and his staff for their initiative in creating this cultural event. Special mention must be made of their generous support of the Hermitage Foundation which enabled us to restore Catherine's Coronation Carriage and include it in the exhibition. Finally, on a personal note, I would like to thank them for the warm hospitality shown me and my staff during our trips to Memphis.

DR VITALY A SUSLOV
Director General
State Hermitage Museum

ORGANIZING COMMITTEE OF THE STATE HERMITAGE MUSEUM

DR VITALY A SUSLOV
Director General, State Hermitage Museum

DR VLADIMIR MATVEYEV
Deputy Director, State Hermitage Museum

MR DMITRI VARIGIN
Deputy Director for International Affairs,
State Hermitage Museum

DR GALINA KOMELOVA
Director of the Department of Russian Culture,
State Hermitage Museum

DR TAMARA V KUDRIAVTSEVA
Curator of the Collection of Russian Porcelain,
State Hermitage Museum

DR IRINA N UCHANOVA
Curator of the Russian Decorative and folk Arts,
State Hermitage Museum

MS AUGUSTA POBEDINSKAYA
Curator of Russian Painting,
State Hermitage Museum

DR VLADIMIR CHERNISCHOV
Curator of Carriages, State Hermitage Museum

MR VLADIMIR KASCHEEV
Chief Carriage Restorer, State Hermitage Museum

DR OLGA KOSTIUK
Curator of Jewelry, State Hermitage Museum

DR ANATOLY A IVANOV
Director of the Oriental Department,
State Hermitage Museum

DR IRINA NOVOSELSKAYA
Director of the Department of Western-European
Art, State Hermitage Museum

DR YURI MILLER
Director of the Armory, State Hermitage Museum

DR VSEVOLOD POTIN
Director of the Numismatic Department,
State Hermitage Museum

MS YEVGENIYA MAKAROVA
Director of the Library Department,
State Hermitage Museum

MR OLEG PLATONOV
Director of the Department of Restoration and
Conservation, State Hermitage Museum

MS MARIA FEODOROVA
Department of Protocol, State Hermitage Museum

MS LARISSA BULKINA
Department of Protocol, State Hermitage Museum

MR ANDREI SAMOILOV
Manager, Art Handling Department,
State Hermitage Museum

MR GEORGE GARKUSHA
State Hermitage Museum Foundation

MR HOWARD CERNY
State Hermitage Museum Foundation

MR SERGEI M FROLOV
State Hermitage Museum Foundation

EXHIBITION CURATED BY

GALINA KOMELOVA
Head Curator of the Department of Russian Culture

TAMARA KUDRIAVTSEVA
Curator of the Department of Russian Culture

AUGUSTA POBEDINSKAYA
Curator of the Department of Russian Culture

IRINA UCHANOVA
Curator of the Department of Russian Culture

AUTHORS

Vladimir Chernischov
Magdelina Dobrovolskaya
Natalya Guseva
Natalya Kazakevich
Galina Komelova
Tamara Korshunova
Olga Kostiuk
Irina Kotelnikova
Tamara Kudriavtseva
Marina Lopato
Maria Malchenko
Vladimir Matveyev
Yelena Moiseenko
Karina Orlova
Augusta Pobedinskaya
Galina Printseva
Yevgeniya Schukina
Galina Serkina
Lina Tarasova
Irina Uchanova
Georgy Vilinbachov
Yekaterina Zagorskaya
Olga Zimina
Larissa Zavadskaya

PHOTOGRAPHERS

Leonid Heifits
Vladimir Terebenin

CARRIAGE RESTORERS

Valentin Andreev
Alexander Gerasimov
Galina Gorbacheva
Vladimir Gradov
Vladimir Kascheev *Head Restorer*
Olga Kolosovskaya
Ivan Kudoayrov
Anastasia Lyakina
Tatyana Pivinskaya
and others

WONDERS: THE MEMPHIS INTERNATIONAL CULTURAL SERIES

EXECUTIVE STAFF

JAMES E BROUGHTON
Executive Director

SHERYL O BOWEN
Manager of Special Projects

GLEN A CAMPBELL
Manager of General Administration

JOHN CONROY
Manager of Design and Construction

TWYLA DIXON
Manager of Sales and Marketing

JOE HOLT
Manager of Security

JACK KYLE
Manager of Communications and Public Relations

STEVE MASLER
Manager of Artistic and Educational Planning

KIPP WILIAMS
Executive Secretary

SPECIAL PROJECTS

SHERYL O BOWEN
Manager

GIFT SHOP
Lotus and Papyrus International, Inc
Rifaat Hassan, Manager

Goldsmith's Department Stores
Bob Wilson

RESTAURANT
Public Eye Catering Company
Herb Goldstein, Manager

RECORDED TOURS
Antenna Corporation
Chris Tellis, Director

VOLUNTEER ADMINISTRATION
Trish Langlois, *Coordinator*

Junior League of Memphis
Nita Lux
Carter Coleman

National Council of Jewish Women
Lauren Lerner

FACILITY SERVICES
Memphis Cook Convention Center
David Greer, Executive Manager

SPECIAL EVENTS
Hicks Convention Services
Memphis Scenic
Judy Boshwit
Wells & Associates

ARTISTS
Memphis State University
Jeff Atnip

Memphis College of Art
Philip Paul
Mathias Work

GENERAL ADMINISTRATION

GLEN A CAMPBELL
Manager

TONI CRUTCHFIELD
Receptionist

GENERAL CONSTRUCTION SERVICES
City of Memphis Division of General Services
Danny Lemmons, Director
Darrell Eldred, Technical Systems Coordinator
Richard Aitken, Manager of Property Maintenance
Buddy Smith, General Foreman
John Stewart, General Foreman
Brenda Vick, Manager of Printing Services

EXTERIOR GRAPHIC SERVICES
City of Memphis Division of Public Works
Benny Lendermon, Director
Rodney 'Butch' Eder, Deputy Director

HORTICULTURAL DISPLAYS
City of Memphis Park Commission
Bob Frame, Director

Memphis Botanic Gardens
Richard Beckwith, Supervisor

BUDGET AND FINANCIAL SERVICES
Marie Owens, *Manager*
Rochelle Gold, *Assistant Manager*
City of Memphis Division of Finance &
Administration
John Pontius, Director
Danny Wray, City Comptroller
David Crum, Deputy Comptroller
Kathryn Woodward, Senior Accountant

PURCHASING SERVICES
Carol Barnett, *Secretary*
Gwen Donaldson, *Contract Specialist*
Lisa Yarbrough, *Buyer*

INSURANCE SERVICES
Jean Markowitz
Sedgewick James of Tennessee Inc, Insurer
Wil Sammons

AUDITING SERVICES
City of Memphis, Division of Auditing
Roland McElrath, Administrator

LEGAL SERVICES
City of Memphis, Division of Legal Services
Monice Hagler, City Attorney

DATA SERVICES
City of Memphis, Division of Information
Systems
John Hourican, Director
Claudis Shumpert, Administrator
Dalia Bland, Systems Information
Celeste Bursi, Telecommunications
Jerry Foster, Micro Computers
Tim Gunthorp, Micro Computers

PERSONNEL SERVICES
City of Memphis, Division of Personnel
Gene Busby, Director
Jane Hardaway, Deputy Director
Bob Bishop, Manager of Compensation

DESIGN AND CONSTRUCTION

JOHN CONROY
Manager

City of Memphis Division of Engineering
Lewis S Fort, Project Manager

EXHIBITION DESIGN
Nathan, Evans, Pounders & Taylor,
Architectural Design
Louis Pounders, Architect
Phillip Perkins
Jim Murray
Donovan Smith
Tom Wade
Tom Nathan

Quenroe Associates Inc, Exhibition Consultants
Elroy Quenroe
Charles Mack
Allyson Smith

Ellers, Oakley, Chester & Rike Inc,
Engineering

EXHIBIT CONSTRUCTION
Gardner General Consruction Inc, General
Contractors
L W Milby, Inc, Display Case Construction,
Graphics
Pacific Southern Buildings Inc
John E Green, President

SALES AND MARKETING

TWYLA DIXON
Manager

Jodi Hall, *Sales Coordinator*
Tracey Ballard, *Box Office Coordinator*

TICKET SERVICES
Select Ticketing System
Globe Ticketing and Label Company

ADVERTISING SERVICES
Sossaman, Bateman, McCuddy Advertising
Ken Sossaman, President
Donna Gordy, Vice Pesident
Eric Melkent, Art Director
Robin McCuddy, Creative Director
Rikki Boyce, Copy Writer

TRAVEL SERVICES
Unique Planning Network
Linda Moore, President
Maudie Knox, Vice President

VISITOR SERVICES
Memphis Convention & Visitors Bureau
Paul Decker, President
Regena Bearden, Director of Tourism
Dorothy Davis, Director of Visitor Information
Center

Tennessee Department of Tourism
Development
The Honorable Sandra Ford Fulton,
Commissioner

SECURITY

JOE HOLT
Manager

N E Bibbs, *Assistant Manager*
David Booker, *Assistant Manager*
Frank Lawrence, *Communications*
D/A Mid-South
Howard Hazelwood

COMMUNICATIONS AND PUBLIC RELATIONS

JACK KYLE
Manager

Dollie Hardy, *Secretary*

GRAND INAUGURAL CEREMONIES
Memphis Symphony Orchestra
Alan Balter, Music Director and Conductor
Michael Maxwell, Executive Director

Memphis Concert Ballet
Dorothy Gunter Pugh, Artistic Director
Evelyn Craft, General Manager

Kallen Esperian
The United States Army Herald Trumpets

LENINGRAD MEDIA TOUR
Delta Airlines, Inc
Nikki Giampapa
Kenneth Nemcovich
Mark Pilkinton

Aeroflot Soviet Airlines
Hotel Olympia, Leningrad
Pia Johnson
Peter Agren
Mats Astrand
Carin Martell

Grand Hotel Europe, Leningrad
Leningrad Television
Victor T Senin

SMENA
Victor T Strugetskij

ORIENTATION THEATRE
WMC-TV, RONALD KLAYMAN
Vice President and General Manager

ARTISTIC AND EDUCATIONAL PLANNING

STEVE MASLER
Manager

CURATORIAL CONSULTANT
Dr Alison Hilton, Georgetown University

EDUCATION
Arts for the Blind and Visually Impaired
Dr John Hughes, President

Annunciation Greek Orthodox Church
Father Nicholas Vieron

Memphis Arts Council
Amelia Barton, Program Director

Memphis College of Art
Lynn Gipson

Memphis State University
Dr David Wilson
Linnea Burwood
Maryanne Hickey

Memphis State University, Department of Art
Dr Carol Crown, Chairperson

Memphis State University, University Gallery
Leslie Luebbers, Director

Barry Burns, *Illustrator*

TRANSLATORS
Ira Abolnik
Helena Parfanova
Maya Yassleman

SPEAKERS BUREAU
Marjorie Gerald, Volunteer Coordinator

SPONSORS

PATRON
Mr Edward W Cook

PRINCIPAL SPONSORS
City of Memphis
Federal Express Corporation

MAJOR SPONSOR
State of Tennessee

OFFICIAL AIRLINE
Delta Air Lines, Inc

The Memphis International Cultural Series wishes to express appreciation to the following individuals and organizations for their generous support of the Catherine the Great Exhibition:

Adron Graphics

Argenbright, Inc

Boehm Porcelain Studios

Carnation Graphics

Cellular One: Memphis Cellular Telephone Company

Daniel N Copp

The Commercial Appeal

Crown Plaza Hotel

Csaba Tibor Chikes, USIA

Rosemary de Carlo, USIA

Embassy of the USSR

Federal Express Corporation

Carolyn Gates

Glory (USA) Inc

Goldsmith's Department Stores

Russ Gordon

Graham's Lighting Fixtures, Inc

Junior League

Lithograph Printing

Ely Maurer, State Department

Memphis Area Transit Authority

Memphis Arts Council

Memphis City Schools

Memphis Concert Ballet

Memphis Convention & Visitors Bureau

Memphis International Airport

Memphis State University Marching Band

Memphis Symphony Orchestra

Naegale Outdoor Advertising Company of Memphis

Wayne Nathan

Nathan, Evans, Pounders & Taylor, Architects

National Bank of Commerce

National Council of Jewish Women

Naval Air Station, Millington

Loris J Nierenberg, State Department

Olympia Hotel, Leningrad

Peabody Hotel

Alexander Potemkin

Booth-Clibborn Editions Inc, London

Quality Foods, Inc

Savin Copiers

Shelby County Schools

State of Tennessee Department of Tourism Development

R Wallace Stuart, State Department

Superior Coffee and Food

Tennessee Air National Guard

Trickett & Webb, London

Jay Wells and Associates

Union Planters Bank

United States Information Agency

United States Naval Technical Center

The history of Russia is one of splendor, passion and intrigue. It is a history carved by a creative, resilient and enduring people. It is a history written by a litany of giants on the world scene. It is a history of monumental accomplishments by larger-than-life personalities. No era of this great country's past, however, was more magnificent, more imposing, or more influential than that of the German Princess become Russian Empress, Catherine the Great.

The life of Catherine and the Russia which she nurtured is a most remarkable period in world history. On the one hand, it was a period of political excess, extravagant lifestyles, and abusive repression. On the other, it was a time of unprecedented advancement in Russian scientific, educational and cultural endeavors. It is this story, told through the magnificent art of the period, that the State Hermitage Museum and the Memphis International Cultural Series present to a world audience for the first time. The City of Memphis is proud to host the international premiere of the Catherine the Great Exhibition.

The exhibition, itself, is a masterpiece of international dialogue and a tribute to diplomatic resolve. It is a monument to a true people to people exchange, a testimonial to the strength of enduring relationships even as a new world order was unfolding. I am forever indebted to all those who ignored the many reasons why this project should not have succeeded and who worked tirelessly to unlock the precious few doors through which it ultimately emerged.

The Memphis International Cultural Series, under whose auspices the Catherine the Great Exhibition is organized, is indebted to one man of extraordinary vision for its very existence. To Mayor Richard C Hackett, I extend my very sincere and personal appreciation for his courageous commitment to this program and for his unwavering trust in me for its development. His vision has truly enriched Memphis and the Mid-South. I also wish to thank Mr Edward W Cook on behalf of all Memphians for his generous gift to the City of Memphis which allowed the development of our widely acclaimed WONDERS program.

My thanks go to Cultural Minister Nikolai Gubenko, Ambassador Yuri Dubinin, Minister of Foreign Affairs Alexander Bessmertnykh and Ambassador Jack Matlock for their approval, encouragement and assistance. I also want to acknowledge the efforts of the Embassy of the Soviet Union and the United States Information Agency.

Of course, very special thanks go to Dr Vitaly Suslov, Director of the magnificent State Hermitage Museum and Madame Galina Komelova, Curator of the Catherine the Great Exhibition, and their colleagues for their gracious cooperation and assistance. Our mutual journey through the pages of Catherine's diary gave birth to this grand exhibition and established new friendships that will forever be treasured.

I am grateful to the Memphis City Council for its support, to our corporate sponsors for their resources and to the citizens of Memphis for their continuing interest in our WONDERS program of cultural enrichment. I am also most appreciative of the local and regional media whose continuing interest in WONDERS has awakened the heartland of America to a new hallmark of cultural endeavor.

Of course, the exhibition simply would not have been possible without the dedication of a fabulous group of volunteers, the commitment of a talented complement of city employees and the cooperation of the management and staff of the Memphis Cook Convention Center. Thank you, ladies and gentlemen, for making it happen.

Finally, I thank my staff for sharing with me the years of tears and laughter, of anxiety and peace, of worry and contentment, of frustration and friendship, of hard work and satisfaction that became the Catherine the Great Exhibition.

JAMES E BROUGHTON
Executive Director
Catherine the Great Exhibition

It gives me great pleasure to introduce to the American public this exhibition: 'Catherine the Great - Treasures of Imperial Russia from the State Hermitage Museum'. Its range and scope make it the largest exhibition of its kind ever to have been staged in the United States. The items are so varied, ranging from the state carriage to the most exquisite miniatures and jewelry, that the visitor will gain a real sense of the astounding originality of Russian culture in the second half of the 18th century - one of the most fascinating periods in the country's history. Here can be seen the effects of the great interweaving of Russian cultural traditions with the influences and ideas of western European. It was at this time too that the ideas of the French 'Age of Enlightenment' took hold among the Russian people.

Meanwhile, St Petersburg, the new capital of the Russian Empire was becoming one of the most magnificent cities of Europe. The banks of the River Neva were adorned with the sumptuous palaces of the Russian nobility and the buildings of the Academy of Sciences and the Academy of Arts. The best French and Italian companies performed at the Winter Palace Theater and, later, at the Hermitage Theater.

Some of the most famous art collections of the day were purchased at auctions in western Europe, to be displayed in the Hermitage Gallery, founded by Catherine in the Winter Palace. The Hermitage was later also to acquire Voltaire's own library.

This complex and turbulent period finds its fullest expression in the personality of Catherine herself, as can be seen from this exhibition. The all-powerful Empress of the Russian Empire possessed such personality, cultivation and intelligence that she could not but stamp her mark on the arts and culture of her day. Many of the exhibits shed light on her habits, tastes and interests. Our main objective, however, in assembling these exhibits was to give the American public some feeling for the period itself: its art and the aspirations and life of its people. I hope that we have, to some extent, succeeded and, if so, it only remains for me to wish all of our visitors a most enjoyable and rewarding time

DR VITALY A SUSLOV
Director General
State Hermitage Museum

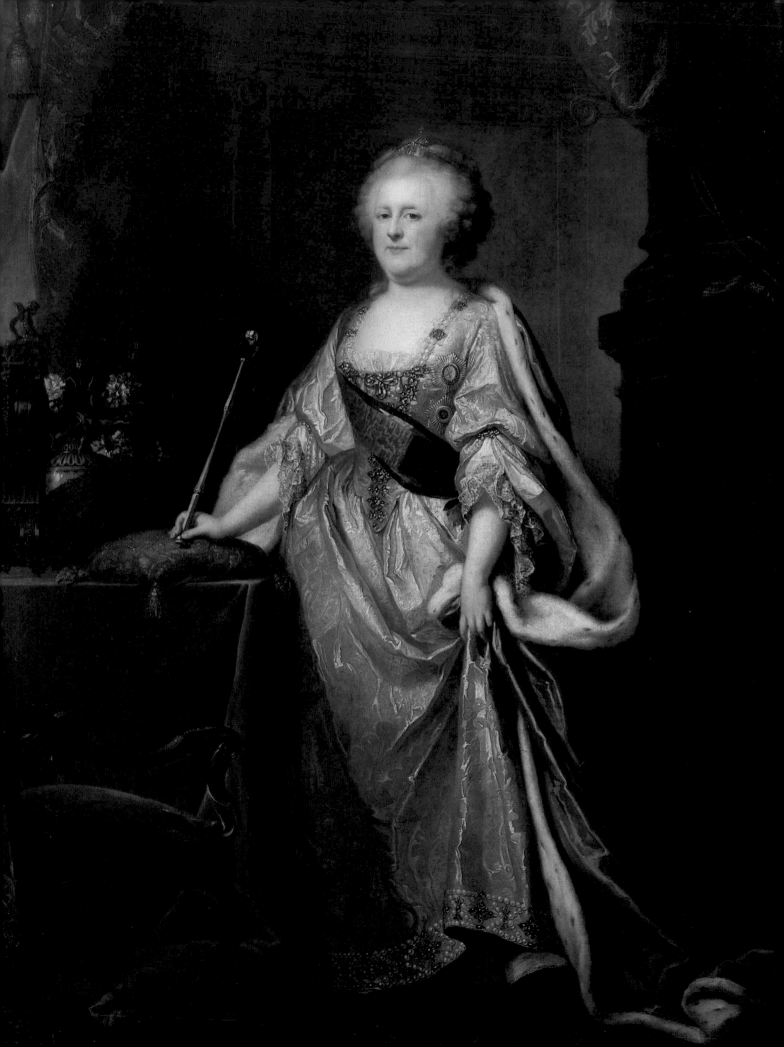

CATHERINE THE GREAT AND HER AGE

-<<< *Dr G N Komelova* >>>-

Few figures in European history have attracted such contradictory judgements as Catherine the Great, the Empress who towered over more than three decades of 18th-century Russia. Even in her lifetime her reputation was a rich mix of fact and often outlandish fiction.

'Among all the eminences of this world one may safely say that Catherine II best deserves to be ranked first and for exceptional deeds to be hailed as Catherine the Great.' So concluded one of Catherine's first biographers, writing in Moscow in 1801, five years after her death.

Such sentiments were commonplace among her contemporaries. The French philosopher Voltaire, enchanted by his correspondence with the Empress, wrote: 'You are not the Northern Lights. You are the brightest star of the North.'

A fuller picture, but barely less enthusiastic, was given by the Comte de Ségur, the French envoy at the Russian court towards the end of her reign. In his memoirs he wrote: 'Catherine was endowed with immense gifts and a subtle intellect, qualities rarely encountered in one individual were wonderfully combined in her. Her ambition was limitless but she knew how to use it to pursue prudent goals...she was a majestic monarch and a gracious lady.'

Other observers, however, offer a more mixed appraisal. Another French diplomat, the Chevalier de Corberon, wrote: 'Our Catherine is a superlative actress. She is gentle, proud, majestic and gracious but inwardly remains true to herself and pursues only her own interests, being prepared to resort to any means to achieve them.'

The great Russian poet, Pushkin, who made a serious study of the age of Catherine the Great

while working on a series of historical novels, provides an authoritative assessment of her character. While aware of her intellect and charm he also appreciated her true nature. 'If one is to rule one has to know the weakness of the human soul and how to make use of it.' he wrote. 'In this respect Catherine deserves posterity's awe. Her splendor was dazzling, her cordiality engaging, her munificence captivating...It was the very voluptuousness of this devious woman that kept her in power. Foreign writers of the day showered Catherine with inordinate praise: quite naturally as they knew of her only through her correspondence with Voltaire and from the stories told by people who she allowed to travel...it was pardonable for the philosopher of Ferney (Voltaire) to extol the virtues of this Tartuffe in skirts for he could not know the truth.' So who really was she, this empress who has been judged so differently by her contemporaries and posterity?

She was born Sophia Augusta Frederica Dorotea, daughter of an obscure German princeling, Christian Augustus of Anhalt-Zerbst, who was serving in the Prussian army of Frederick I.

After her betrothal to the heir to the Russian throne, the Grand Duke Peter, a grandson of Peter the Great, she was received into the Orthodox Church and given the name Catherine.

In 1744 the fourteen-year-old girl was taken by her mother first to Moscow and then to St Petersburg where she was presented to the Empress Elizabeth and to her future husband. The two were married a year later.

-<<<->>>-
PORTRAIT OF CATHERINE II
GIOVANNI BATTISTA LAMPI, 1794
OIL ON CANVAS, 230 X 162 CM
-<<<->>>-

'It was an unhappy marriage' wrote the Comte de Ségur. 'Nature, while giving few of its gifts to the young Grand Duke showered them lavishly on Catherine. Destiny, it seemed, had whimsically decided to give the man the faintheartedness, inconsistency and lack of talent of a subordinate, and his wife the intellect, courage and tenacity of a man born for the throne.'

But seventeen years were to pass between her arrival in Russia and her accession to the throne. Throughout these years she put her natural intelligence and guile to good use as she prepared for her future role. The Soviet historian Yevgeny Anisimov observed: 'Despite the passion for all things French which pervaded fashion and tastes at court, she succeeded in discerning the most important elements; the emphatically national character of the political beliefs and corporate psychology of the Russian nobility and army, the forces which decided the fate of Russia's rulers.'

The young German princess therefore strove for rapid acceptance in her adopted country. It was a long but successful struggle. In the end she was to become 'the little mother Tsarina' of the Russian nobility and the faithful defender of their interests, thus ensuring the stability of her power.

Much of her spare time was devoted to studying the works of the great writers and philosophers of her day, notably Montesquieu and Voltaire, although her reading also covered the classics of previous generations and the ancient world, including Racine, Corneille and Cicero.

Amid·the endless intrigues between the different factions at the Empress Elizabeth's court she tried to remain neutral. 'I did not wish to belong to any party,' she wrote in her memoirs 'I did not interfere in anything and always kept a cheerful countenance and was always courteous, attentive and polite with one and all...I strove harder than ever before to win the favor of all and sundry, great and small alike. Nobody was overlooked by me and I made it a rule to think that I had need of each and every one of them and to win universal love which I succeeded in doing.'

She was helped to her success by the character and behavior of her husband, the Grand Duke Peter, whose failings have been described by

Anisimov: 'Intransigent and narrow minded, he tried in all matters to set himself and his own court against the court of the Empress Elizabeth and its people. By refusing to accept the policies of Elizabeth's rule, the heir to the Russian throne was to all intents and purposes playing into the hands of his enemies. Knowing the character of the heir, it is no wonder that Elizabeth's courtiers contemplated the future with trepidation.'

Peter antagonized many by his admiration for Frederick the Great of Prussia, then at war with Russia and by rejoicing openly at Prussian victories. He devoted much of his time to staging military inspections and parades, spending hours drilling his footmen and coachmen, dressed in Prussian uniforms.

'A boundless passion for military service stayed with him all his life' remarked Claude Carloman de Rulhière, the French envoy's secretary in 1762. 'His favorite pastime was conducting military exercises...His appearance, which was comic by nature, became even more so in a corrupted Prussian uniform.'

Meanwhile, Catherine's tactics soon had the intended effect as she herself described: 'The warmest praise of my heart and intelligence was sung in all quarters and reverberated through all Russia. In this simple and innocuous manner I earned myself immense glory and when the question of the succession to the Russian throne was raised a considerable majority was on my side.'

An impression of Catherine's appearance is given by Grooth's fine portrait from the mid-1740s but there is also a written description by Carloman de Rulhière of the Empress when she was already in her mid-thirties: 'A pleasant and noble bearing, a proud carriage, delectable features and stature, an imperious air, all these proclaim the great character within. Her arched neck is exceedingly beautiful, especially from the side, as she carefully revealed by a movement of the head. She had a large brow and a Roman nose, pink lips, a splendid set of teeth, a fine large and slightly cleft chin, exceedingly beautiful auburn hair, black eyebrows, delightful blue-tinted eyes and dazzlingly white skin. Pride is a distinctive feature of her physionomy. To a discerning eye her wonderful cordiality and

kindness were essentially nothing but the effect of a particular desire to please and her captivating words clearly revealed her dangerous intentions.' .

As the 1750s drew to a close and the Empress Elizabeth's health declined there were secret and anxious discussions at court over the future of the country and of the Russian throne. It was persistently rumored that although her will decreed that the throne should pass to Peter, Elizabeth actually wanted to change the order of succession in favor of his son, the five year-old Grand Duke Paul. Many also believed that Catherine should act as regent until her young son came of age.

Thus, as the year 1761 came to an end, the preparations for Christmas and the New Year went ahead at the Winter Palace in silence and in an atmosphere of impending change. At last, on December 26, the Empress Elizabeth died. Her will was still in force and the Grand Duke Peter succeeded as Peter III.

Catherine had secretly longed for this day. Despite her show of humility and mildness; she had conducted a subtle political game establishing close links with those leading aristocrats who dominated the court and the guards regiments. Her correspondence with the British Ambassador, Sir Charles Hanbury-Williams, which later became known, reveals her secret plans, the blatant cynicism of her conduct towards the Empress Elizabeth and her determination to stop at nothing to reach the throne. In August, 1761 she wrote to him: 'I am presently engaged in collecting, organizing and preparing everything that is essential for the events which you desire and my head is filled with the chaos of intrigues and negotiations.'

Far from ceasing when Peter III came to the throne the 'intrigues and negotiations' intensified. The discord between Catherine and her husband was common knowledge. The Emperor's foul temper and his admiration for Prussia - he had already made peace with Frederick and planned to send troops to his support - as well as his known aversion to all things Russian aroused first dissatisfaction and then open indignation.

The discontent came to a head on June 28, 1762. Aided by the Guards and her chief

conspirators, the Orlov brothers, Catherine staged a palace coup. It passed off quickly and almost without casualties. Peter, who was staying at his country residence forty kilometers from St Petersburg, hastily moved to his estate at Ropsha where he officially abdicated.

A few days later his sudden death was announced. It is now known that he was killed at Ropsha by a group of officers including Count Alexei Orlov, brother of Catherine's favorite, Grigorii.

'I was an eye-witness to the revolution which deposed the grandson of Peter the Great from the Russian throne', wrote de Rulhière in his memoirs, 'in order to put a foreigner on it. I saw this lady, who had secretly escaped from the palace on the same day take possession of her husband's life and throne.'

So began the 34-year reign of Catherine the Great, a period often described as the 'Golden Age' of Russian history. The Russian historian V.O.Kliuchevskii has called the era of Catherine II one of 'individual-constitutional absolutism'. Absolutism had begun to take root in Russia at the beginning of the 18th century during the reign of Peter the Great and had flourished into the latter half of the century. Under Catherine the trend continued. All her legislation and policies were directed towards establishing a powerful absolutist state. Catherine proved an outstanding politician and helped to raise her country's authority abroad.

The Austrian diplomat, the Prince de Ligne, graphically described how she operated: 'How much talk there is of the St Petersburg cabinet! I know none smaller. It is only a few inches wide. It stretches from temple to temple and from nose to nose.'

'Her court', wrote the Comte de Ségur in the 1780s, 'was a meeting place for the leaders of all nations and luminaries of her age. Before her St Petersburg, which had been built in the regions of ice and snow, went practically unnoticed as if it were in Asia. During her reign Russia became a European power. St Petersburg occupied a prominent position among the capitals of the civilized world and the imperial throne ranked among the most powerful and important.'

The court was indeed one of the most brilliant in Europe. An English traveller who visited St Petersburg in 1778 and was invited to celebrations at the Winter Palace, gave this description: 'The wealth and sumptuousness of the Russian court exceeds the most fanciful descriptions. Vestiges of ancient Asiatic splendor were blended with European sophistication. The lavishness and grandeur of the court robes and the abundance of jewelry far exceed the splendor of other European courts.'

Catherine's first decade in power was marked by the most important reforms of her reign. It is generally held that she was guided by immense ambition and that her main aim was to hold onto power at all costs. Yet the sincerity of her actions is undeniable, especially in the years immediately following her accession. She considered herself a disciple of the French philosophers of the 'Enlightenment', Voltaire, Diderot, Montesquieu and others, and corresponded with them regularly. It is clear too that she genuinely wanted to implement their ideas, at least partly. One example was her decision to convene a legislative commission drawn from all levels of society which was to devise a new legal code to satisfy the interests of all her subjects. Catherine agreed with the Enlightenment thinkers that the law played a crucial part in determining a state's well-being.

Her views found their clearest expression in the *Nakaz* or *Great Instruction*, composed as guidelines for the commission which met for the first time in 1767. The work is her own compilation of contemporary thinking, drawing particularly on the writings of Montesquieu. As she wrote in her memoirs: 'Montesquieu's *On the Spirit of the Law* should be the prayerbook of all monarchs with any common sense.'

It was not Catherine's fault that her actions met with strong resistance from the deeply conservative nobility who refused to allow her to change the oppressive laws on serfdom.

But she has been criticized for renouncing her progressive ideas once she encountered opposition and sensed a threat to her rule. At the end of 1768, using the outbreak of the First Russo-Turkish War as an excuse, she

disbanded the commission. It was never to reconvene. Her adherence to liberal ideas was finally abandoned after Pugachev's peasant uprising of 1773-74 which was ruthlessly suppressed. The French Revolution of 1789 served to confirm her distaste for radicalism.

The commission taught Catherine that she could depend only on the nobles and to ensure their support she confirmed their privileges in the special 'Charter to the Nobility' of 1785. Similarly her 'Decree for Managing the Provinces' of 1775 guaranteed them a leading role in the provincial governments.

In general, her domestic policy was directed towards strengthening the absolutist state, while all her plans for implementing the ideas of the Enlightenment came to nothing.

Catherine took sole charge of a vigorous and expansionist foreign policy. In particular, her reign saw the dismemberment of Poland and Russia's acquisition of vast tracts of Polish territory and of the eastern Slav lands. In the South, Russian victories in the two Turkish wars pushed Russia's rule as far as the Black Sea. The Crimea was annexed as well as other areas of the Black Sea coast and the northern Caucusus.

As a follower of the Enlightenment Catherine devoted considerable attention to the development of the arts, sciences and culture in general. Many architects, artists, sculptors poets, writers and scientists enjoyed her patronage. Her absolute power allowed her to use the arts and architecture as a weapon of state policy, for self-glorification and self-assertion. Indeed her patronage of the arts was crucial to fostering her image as an enlightened monarch.

During Catherine the Great's reign the austere beauty of St Petersburg was enhanced by the construction of palaces, mansions, churches and public buildings. Artists and sculptors, both Russian and foreign, gathered to carry out the court's commissions, painting portraits of the Empress, creating allegorical compositions to glorify her virtues and achievements and capturing the beauty of Peter the Great's capital. A regular source of work was portraits of the leading personalities of the time, courtiers, the Empress' favorites and

prominent figures from the arts and sciences. In fact, the figurative material from the second half of the 18th century provides a marvellous insight into the Russian society of the day.

Catherine took credit for founding the Academy of Arts even though it had really opened in 1757 under the Empress Elizabeth, largely through the efforts of Ivan Shuvalov and Mikhail Lomonosov. Declaring this first period of the Academy's life to be 'unofficial', Catherine staged an inauguration ceremony in 1765 attended by the whole court and diplomatic corps. Commemorative medals were struck and Lomonosov, a poet and a scientist, wrote an ode to mark the occasion.

The Academy of Sciences also flourished, benefiting from Catherine's help. Several major expeditions were organized to survey the country and the Russian Academy was founded for the study of the human sciences.

The Empress helped to promote education, the study of history, poetry and printing. Catherine herself was a talented author. She was a gifted letter writer, wrote plays for the Hermitage Theater and a short history of the Russian state for her grandsons.

The manufacture of luxury goods, such as china, glass and tapestries reached new heights under Catherine's reign. The Empress was a discerning collector and among her achievements was the foundation of the Hermitage, now one of the world's largest museums.

Catherine was a good judge of men, surrounding herself with able subordinates. Perhaps the most remarkable was Prince Grigorii Potemkin, a close confidant and adviser whose intelligence she held in high regard. He played a leading part in the affairs of state and after a successful military career was appointed Field-Marshal. Potemkin played an important role in the conquest of the northern shores of the Black Sea and in the creation of the Black Sea Fleet.

The Comte de Ségur described Potemkin's character: 'Never at the court or in civilian life or in the military has there ever been a courtier more wild and wonderful, a minister more enterprizing or less industrious, a general more courageous and, at the same time irresolute...Potemkin had a happy

disposition and a naturally lively, quick and agile mind but at the same time he was carefree and lazy...he had a kind heart and a caustic wit.' Catherine's entourage also included the intelligent and devious Prince Alexander Bezborodko who was responsible for Russia's foreign policy as well as two of Russia's greatest generals, Count Peter Rumiantsev and Count Alexander Suvorov who led the Russian armies to victory over the Turks and the Polish rebels of 1794.

Two further figures to play key roles were the Orlov brothers, Alexei and Grigorii, who were among Catherine's conspirators in the overthrow of Peter III. Grigorii, a byword for bravery in battle and good looks, established himself as a favorite of Catherine even before the coup and was to retain his position for the next ten years although he chose to play little part in affairs of state. Catherine wrote of him: 'Nature was unusually generous when it came to his physique, intellect, heart and soul.' Alexei, by contrast, went on to win fame as commander of the Russian fleet which inflicted a devastating defeat on the Turks at Chesme in 1770.

Women remained a rarity in public life. A striking exception was Princess Dashkova, an energetic patron of science and the arts, who masterminded the writing of the first Russian dictionary. The Princess was an early admirer of Catherine who had helped plot the coup of 1762. It was an uneasy relationship however and the Princess spent the next twenty years away from court. In 1782, however, she was appointed director of the Academy of Sciences and the next year president of the new Russian Academy, responsible for the dictionary.

The same range of interests distinguished another scion of one of Russia's great houses, Count Alexander Stroganov, a connoisseur who became first director of the Public Library and later president of the Academy of Arts. The Abbé Jourgelle, who visited St Petersburg at the end of the 18th century wrote: 'Very intelligent, gracious and endowed with lavish taste, this grandee travelled extensively and benefited greatly from it. He possessed an immense estate and collected rare and interesting paintings, etchings, statues, books and a natural history

collection which made his fine gallery into one of St Petersburg's main attractions.'

Catherine did much to develop the theater, founding the Bolshoi and Hermitage Theaters. They profited from the enlightened support of Catherine's secretary, Ivan Elagin, the Director of Spectacles and Music at the imperial court. Elagin did much to encourage young playwrights as well as writing and translating himself.

Most contemporary accounts speak of Catherine's imposing presence and evident intelligence. The Comte de Ségur described the impact made by his first encounter with the Empress in 1786: 'Sumptuously attired, she stood with one elbow against a column. I was so astounded by her majestic air, the grandeur and nobility of her bearing, her proud gaze and her somewhat artificial pose that I became totally oblivious to everything else around me.'

Equally struck was Jean Bernoulli, nephew of the astronomer. He wrote: 'Stateliness, intelligence and graciousness were perfectly combined in her. She spoke at length and her frequent enchanting smile would reveal a row of exquisite teeth. I was told that she made it a rule to be never less than gracious and never to show anger. Whenever she felt she might lose her temper she would instruct everyone else to wait while she retired to her study. Then, when she was ready, she would reappear, outwardly calm and without giving vent to her rage.'

Her appearance as well as her manner made a strong impression. Her full bust, large blue eyes and high forehead were often noted.

Elizabeth Dimsdale, wife of a British doctor who inoculated Catherine and her son against smallpox, wrote of being presented to the Empress at Tsarkoe Selo in 1781: 'I curtsied low to kiss her hand and she curtsied too and kissed me on the cheek. She was a fine looking woman, not as tall as me with fine expressive blue eyes and a sweet, sensible look. All this makes her a very elegant woman in her 54th year.' Her charms were slow to fade.

The Austrian Prince de Ligne also wrote of the Empress in late-middle age: 'One could see that she had been pretty rather than

beautiful. Her eyes, and her agreeable smile made her large forehead seem smaller. But this forehead still told all...it betokened genius, justice, precision, boldness, depth, equanimity, tenderness, serenity, tenacity, and its width testified to her well-developed memory and imagination. It was clear that there was room for everything in this forehead.

'Her chin, slightly pointed but neither projecting nor receding, was noble in shape. As a result, the oval of her face did not stand out unduly and was most agreeable on account of the direct and cheerful expression on her lips...entering a room she always followed the Russian tradition and bowed three times like a man: first to the right, then to the left, and finally straight ahead. Everything about her was measured and orderly...her greatest hidden feature was that she never said all that she thought. Nor did a suspicious or devious word ever issue from her lips.'

The running of an empire that stretched from the Siberian wastes to the plains of northern Poland demanded unceasing attention but Catherine clearly enjoyed the business of government.

Her secretary, Adrian Gribovskii, left a full description of her day-to-day life in her latter years: 'On normal days in the Winter Palace the Empress would rise at seven and work in her mirrored study until nine, mostly composing statutes for the Senate. At ten she would go to her room...for an audience until twelve. The Empress would then go to her small study to dress her hair. This lasted no longer than a quarter of an hour. At this time her grandchildren came to wish her good day.

'After dressing she spent the time until lunch reading books or making molds of cameos which she sometimes presented as gifts. At two o'clock she would sit down at table. After lunch she read her foreign correspondence, worked on legislation or copied her cameos.

'The evening assembly began at six o clock in her apartments or the Hermitage Theater. By ten everyone had left and by eleven the Empress had retired for the night.'

The summer was normally spent at Tsarkoe Selo, the sumptuous palace some fifteen miles south of St Petersburg. Her daily routine differed little except for a morning walk in the park with her favorite dogs.

Catherine dressed simply. Gribovskii described her usual outfit in her last ten years as a 'predominantly lilac dress with stiff white skirt underneath and a white bonnet with white ribbons'. On special occasions she wore 'Russian silk...and a small crown.' In general she is said to have favored the so called 'Russian style': loose hanging, high cut, waistless dresses which suited her figure.

Catherine might also wear the uniform of one of the guards regiments. An English traveller recalled: 'On the feast day of the Semenovskii Guards the Empress, the regiment's colonel-in-chief, held a special dinner for its officers. She was dressed in the regiment's uniform, edged in gold lace and cut as a riding habit.' (A similar uniform is displayed in the exhibition.)

In the 1790s, when Catherine was already in her early sixties her health deteriorated markedly. She was vastly overweight and often short of breath. The French artist, Madame Vigée Lebrun, who saw Catherine a year before her death, wrote: 'I was first struck by how small she was. I imagined her to be as tall as her glory was immense. She had a fine face which was charmingly framed by her raised white hair. The hallmark of genius was stamped on her wide and very high brow. She had a gentle but penetrating gaze, a Grecian nose, an exceptionally lively complexion and animated expression.' The evidence of the Empress' decline was noted by the French chargé d'affaires Edmond Genet, who wrote in 1792 to his wife: 'Catherine is getting noticeably worse. She can see this and is consumed by melancholy. The Empress' physical condition gives cause for alarm. The Grand Duke's reign will be weak and stormy. In all probability the most brilliant period of Russian history will end with Catherine.'

His comments were prophetic. Catherine died in 1796 when her son, the Grand Duke Paul, was already forty-two. For Russia the change of ruler was disastrous.

'Paul's reign,' wrote François de Ribaupierre, 'was like a storm sweeping everything up and destroying everything without creating anything in its place.' Paul had loathed his mother, and set out to undo much of her work and to introduce his own order.

His attempt was short lived. In 1801 Paul was killed in a palace coup. The throne passed to Catherine's favorite grandson, Alexander I.

This exhibition, with more than three hundred items, offers a broad view of the development of Russian culture in Catherine's day and an introduction to a crucial period in Russian history. It also gives an insight into the personality of a remarkable woman, the last and greatest Empress of All the Russias.

THE RUSSIAN MONARCHY 1645-1825
(Dates refer to duration of reign)

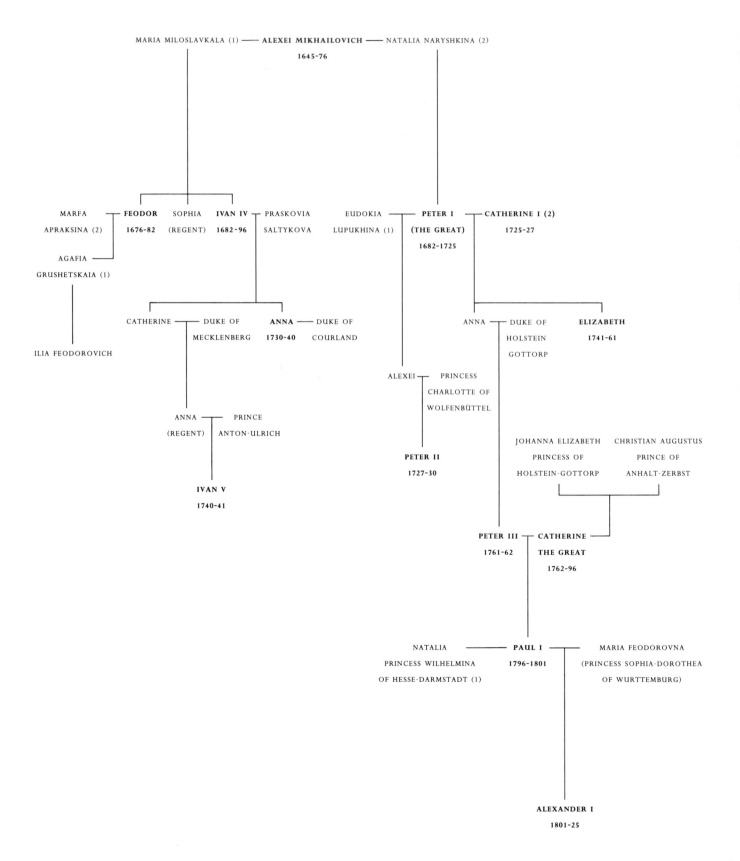

RUSSIA'S ASIAN EMPIRE 1796

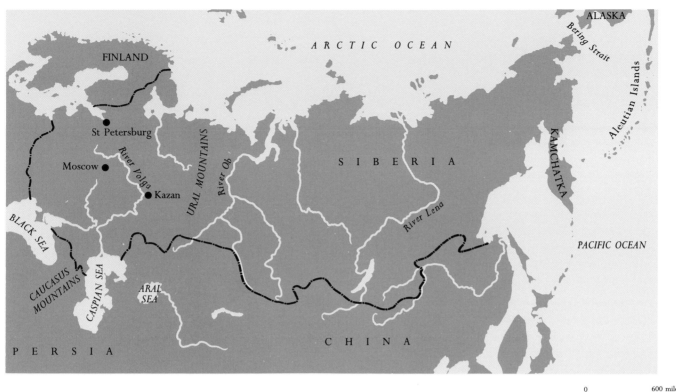

ALASKA

Bering Strait

ARCTIC OCEAN

FINLAND

St Petersburg

Moscow

Kazan

River Volga

URAL MOUNTAINS

River Ob

SIBERIA

River Lena

KAMCHATKA

Aleutian Islands

PACIFIC OCEAN

BLACK SEA

CAUCASUS MOUNTAINS

CASPIAN SEA

ARAL SEA

PERSIA

CHINA

| 0 | | 600 miles |
| 0 | | 600 kms |

RUSSIA'S EUROPEAN EMPIRE 1800

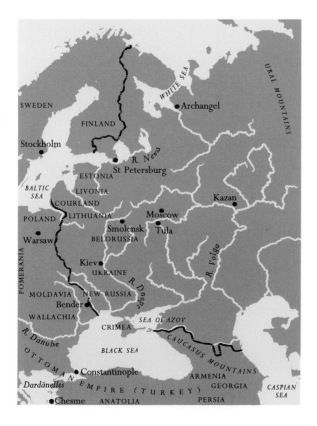

SWEDEN

WHITE SEA

Archangel

URAL MOUNTAINS

FINLAND

Stockholm

R. Neva

St Petersburg

ESTONIA

Kazan

BALTIC SEA

LIVONIA

COURLAND

POLAND

LITHUANIA

Moscow

Tula

Warsaw

Smolensk

BELORUSSIA

POMERANIA

Kiev

UKRAINE

R. Dnepr

R. Volga

MOLDAVIA

NEW RUSSIA

Bender

WALLACHIA

SEA OF AZOV

R. Danube

CRIMEA

BLACK SEA

CAUCASUS MOUNTAINS

OTTOMAN

Constantinople

ARMENIA

GEORGIA

CASPIAN SEA

Dardanelles

EMPIRE (TURKEY)

Chesme

ANATOLIA

PERSIA

| 0 | | 200 miles |
| 0 | | 200 kms |

CHRONOLOGY

1703 Peter the Great founds St Petersburg on the Baltic. The new capital is a showpiece of 18th century architecture, illustrating Peter's determination to break with Russia's past and improve its links with the rest of Europe.

1725 Peter dies without establishing a clear line of succession. Before Catherine the Great's accession in 1762 the throne has six occupants.

1729 Princess Sophia Augusta Frederica Dorotea of Anhalt-Zerbst is born in the Baltic seaport of Stettin where her father serves in the Prussian army. She was re-christened Catherine on her admission to the Orthodox faith before her marriage.

1744 The princess arrives in Russia to meet her prospective husband, Grand Duke Peter, nephew of the reigning Empress Elizabeth and heir to the imperial throne.

1745 Catherine and Peter are married in Moscow. After initial enthusiasm there was little love between the couple. Peter proved neurotic, a heavy drinker and a military fanatic.

1754 Catherine gives birth to a son, the future Emperor Paul 1.

1761 The Empress Elizabeth dies and is succeeded by Peter III, an ineffective and unpopular ruler. He alienates the army by his support for Prussia, then at war with Russia.

1762 Backed by the Guards regiments and a small group of aristocratic conspirators, Catherine seizes power. Peter III is murdered, possibly with his wife's connivance. Catherine is crowned empress.

1762 Catherine gives birth to a son Alexei (father Grigorii Orlov) who is given the name and title of Count Bobrinskii.

1763 The new empress begins her long correspondence with the French philosopher, Voltaire. She was a keen student of the contemporary Enlightenment philosophers but was slowly to abandon her progressive approach in the face of domestic unrest and aristocratic opposition to reform.

1764 Catherine acquires from a Berlin dealer a first collection of 225 pictures by West European masters, the nucleus of the present Hermitage collection. She was to continue amassing treasures throughout her reign.

1764 Official opening (Inauguration) of the Academy of Arts, St Petersburg.

1767 Drawing on her knowledge of political thought outside Russia, Catherine issues her *Nakaz* or *Great Instruction*, setting out her political philosophy. She would govern as a benign autocrat at the head of a highly centralized administration.

1767 A legislative commission is convened to overhaul Russia's entire legal system. Its work is never completed but Catherine's other reforms touch many other areas of Russian life, including education, the army, the church and local government.

1768-1774 The First Russo-Turkish War: After a series of naval victories Russia wins control of large areas around the Black Sea and the Sea of Azov. Catherine's reign saw a vast expansion of Russian territory by conquest or annexation. The country's population rose from around 23 million to 37 million.

1770 Russia, together with Austria and Prussia, takes over large areas of Polish territory in the first of three such partitions. By 1795 Poland had disappeared as an independent state.

1773-1774 A cossack leader, Pugachev, leads an uprising against Catherine. The revolt was one of many during her reign as discontent simmered among Russia's serfs - the majority of the population - who were often treated as mere slaves.

1774 Grigorii Potemkin, an able politician and soldier, emerges as Catherine's favorite. He remained a close confidant and a powerful figure until his death in 1791.

1776 Marriage of the heir to the throne, Paul, to a princess of Wurttemburg who receives the Russian name Maria Feodorovna.

1777 The birth of Catherine's favorite grandson, Alexander, the future Emperor Alexander I.

1783 Foundation of the Russian Academy, St Petersburg.

1785 The privileged status of Russia's nobles is confirmed in the Charter to the Nobility. Catherine's power was dependent on the goodwill of the conservative nobility.

1787 Catherine travels south to visit her newly acquired territories in the Crimea and the surrounding region. The elaborate tour was lavishly staged by Potemkin as a display of Russian power.

1787-1792 The Second Russo-Turkish War secures Russian domination over further territory around the Black Sea. Catherine had contemplated a 'Greek Project' to dismember the Turkish empire and take Constantinople.

1796 Catherine dies and is succeeded by her son Paul I who sets out to undo much of her work.

1801 Paul I is deposed and murdered in a palace coup. He is succeeded by his son, Alexander I.

ST PETERSBURG IN THE MID-18TH CENTURY

———≪≪← →≫≫———

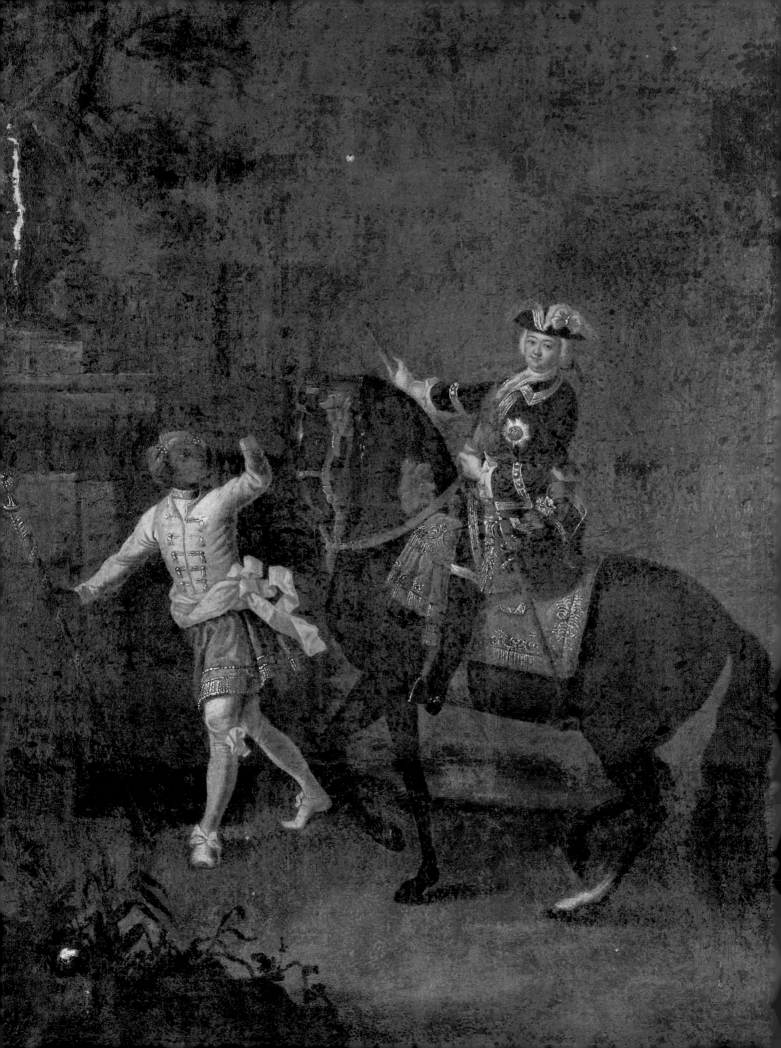

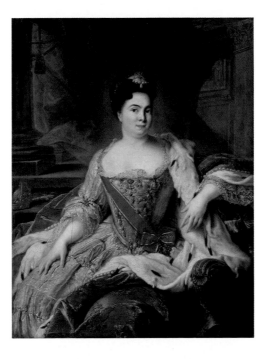

-<<< 2 >>>-

PORTRAIT OF CATHERINE I
JEAN-MARC NATTIER (1685-1766)
OIL ON CANVAS. 142.5 X 110 CM
CATHERINE I (1683-1727), BORN INTO A
LITHUANIAN PEASANT FAMILY, ROSE TO
BECOME MISTRESS AND LATER SECOND
WIFE OF PETER THE GREAT. SHE
SUCCEEDED TO THE THRONE ON HIS
DEATH IN 1725 BUT DIED TWO YEARS
LATER AT THE AGE OF 43. CATHERINE
WAS THE MOTHER OF THE EMPRESS
ELIZABETH. THE WORK IS A PAIR TO
NATTIER'S 1717 PORTRAIT OF PETER.

-<<<->>>-

-<<<->>>-
1 INCH = 2.54 CM
-<<<->>>-

-<<< 1 >>>-
PORTRAIT OF ELIZABETH I ON
HORSEBACK ACCOMPANIED BY A
NEGRO SERVANT, 1743
AFTER THE ORIGINAL BY
GEORG CHRISTOPH GROOTH (1716-49)
OIL ON CANVAS. 75.5 X 57.5 CM
A DAUGHTER OF PETER THE GREAT, THE
EMPRESS ELIZABETH (1709-61) RULED
RUSSIA FROM 1742 UNTIL HER DEATH.
ALTHOUGH DEVOTED TO THE PURSUIT
OF PLEASURE SHE DID MUCH TO
STABILIZE THE MONARCHY. IT WAS
ELIZABETH WHO ARRANGED THE MATCH
BETWEEN CATHERINE AND HER NEPHEW,
THE GRAND DUKE PETER, HEIR TO THE
RUSSIAN THRONE. GROOTH WAS
ELIZABETH'S COURT PAINTER AND
CURATOR OF THE IMPERIAL ART
COLLECTION.
-<<<->>>-

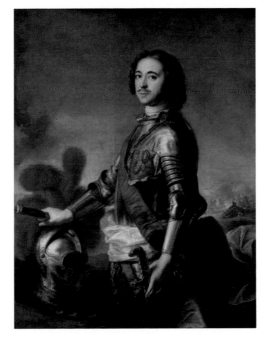

-<<< 3 >>>-
PORTRAIT OF PETER THE GREAT, 1717
JEAN-MARC NATTIER
OIL ON CANVAS. 142. 5 X 110 CM
PETER THE GREAT (1672-1725), SON OF
TSAR ALEXEI MIKHAILOVICH, IS OFTEN
REGARDED AS THE FOUNDER OF
MODERN RUSSIA. HE SOUGHT TO
TRANSFORM HIS BACKWARD EMPIRE
INTO A MODERN EUROPEAN STATE,
CHIEFLY THROUGH HIS OWN EXERTIONS.
HE WAS THE FIRST EMPEROR OF RUSSIA,
A TITLE THAT HE TOOK IN 1721. IN 1702
HE FOUNDED ST PETERSBURG AS
RUSSIA'S NEW CAPITAL AND A WINDOW
ON EUROPE.
-<<<->>>-

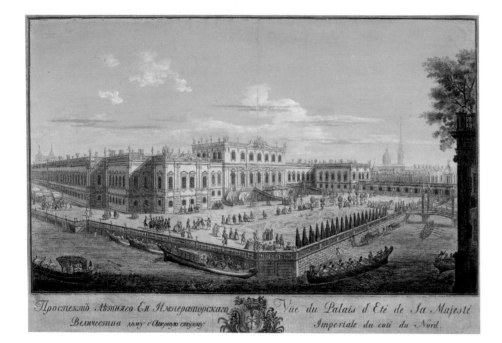

Проспектъ Лѣтняго Ея Императорскаго Vûe du Palais d'Eté de Sa Majesté
Величества дому с Северую сторону. Imperiale du coté du Nord.

-<<< 4 >>>-

THE SUMMER PALACE OF THE EMPRESS
ELIZABETH, ST PETERSBURG, 1753
ENGRAVED BY ALEXEI
GREKOV (C.1726-AFTER 1769)
AFTER THE ORIGINAL BY MIKHAIL
MAKHAEV (C.1718-70). ENGRAVING AND
WATERCOLOR. 48.5 X 71 CM
THE NORTH FRONT OF THE PALACE
FACED ONTO THE SUMMER GARDENS,
DESIGNED BY RASTRELLI (1675-1744)
BETWEEN 1741 AND 1744 .
ST PETERSBURG WAS FOUNDED ON
INHOSPITABLE SWAMPS AND MUCH OF
THE CITY WAS LAID OUT ALONG A
NETWORK OF CANALS OR BESIDE THE
RIVER NEVA. THE SUMMER PALACE WAS
DEMOLISHED IN 1796 TO MAKE WAY FOR
THE MIKHAIL CASTLE.

-<<<->>>-

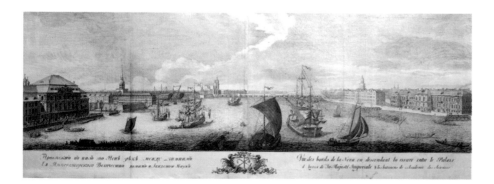

Проспектъ по нѣ по Невѣ рѣкѣ между _линіемъ Vûe des bords de la Neva en descendant la rivière entre le Palais
Ея Императорскаго Величества домомъ и Академіею Наукъ d hyver de Sa Majesté Imperiale & le batiment de l'Academie des Sciences

-<<< 5 >>>-

A VIEW OF ST PETERSBURG FROM THE
NEVA BY THE WINTER PALACE, 1753
ENGRAVED BY G A KACHALOV AFTER
MIKHAIL MAKHAEV. 55.5 X 137 CM

-<<<->>>-

-<<< 6 >>>-
PORTRAIT OF
COUNT IVAN IVANOVICH SHUVALOV
AFTER THE ORIGINAL BY
LOUIS TOCQUE (1696-1772)
OIL ON CANVAS. 68.6 X 54.2 CM
A FAVORITE OF THE EMPRESS ELIZABETH,
SHUVALOV (1727-97) WAS AN
ENLIGHTENED PATRON OF MANY ARTISTS,
WRITERS AND SCIENTISTS. HE HELPED TO
FOUND BOTH THE RUSSIAN ACADEMY OF
ARTS AND MOSCOW UNIVERSITY.
-<<<->>>-

-<<< 7 >>>-
PORTRAIT OF MIKHAIL VASIL'EVICH
LOMONOSOV
AFTER THE ORIGINAL BY G.PRENNER,
LATE-18TH CENTURY
OIL ON CANVAS. 87 X 70 CM
AN INTELLECTUAL PRODIGY,
LOMONOSOV (1711-65) TOWERED
ABOVE HIS CONTEMPORARIES AS A
POET, HISTORIAN, SCIENTIST, ENGINEER
AND ARTIST. HE IS SOMETIMES
CONSIDERED THE FIRST EXPONENT OF
RUSSIAN AS A LITERARY LANGUAGE.
-<<<->>>-

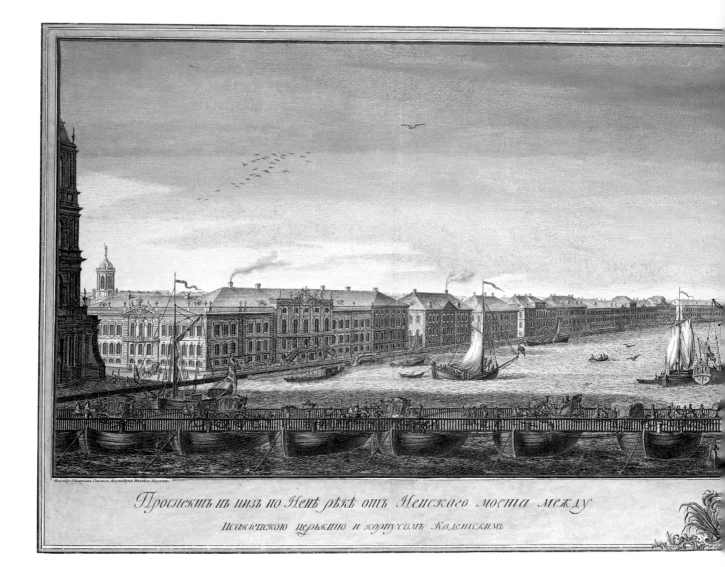

Проспектъ в низъ по Нев рек отъ Невскаго моста между
Исакiевскою церьквiю и корпусомъ Кадетскимъ

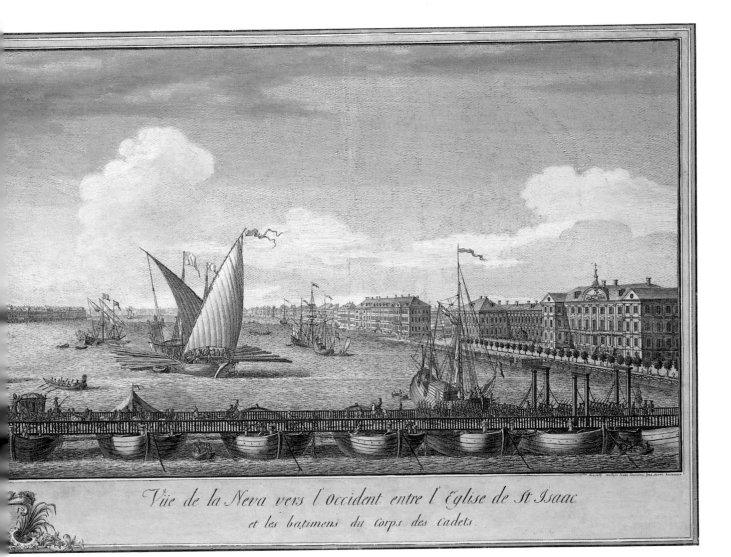

Vüe de la Neva vers l'Occident entre l'Eglise de St Isaac et les batimens du Corps des Cadets.

-<<< 8 >>>-

A VIEW OF ST PETERSBURG FROM THE NEVA, 1753

ENGRAVED BY IAKOV VASIL'EVICH VASIL'EV FROM THE ORIGINAL BY MIKHAIL MAKHAEV

ENGRAVING AND WATERCOLOR. 52 X 189.5 CM

THE PICTURE, FROM A 1753 ALBUM, SHOWS A WIDE STRETCH OF THE WATERFRONT

INCLUDING A CORNER OF THE OLD ST ISAAC'S CATHEDRAL (DEMOLISHED IN THE MID-18TH

CENTURY), THE SENATE AND, ON THE LEFT, THE CADET CORPS HEADQUARTERS AND THE

ACADEMY OF ARTS. THE PONTOON BRIDGE IN THE FOREGROUND WAS BUILT IN 1727.

-<<<->>>-

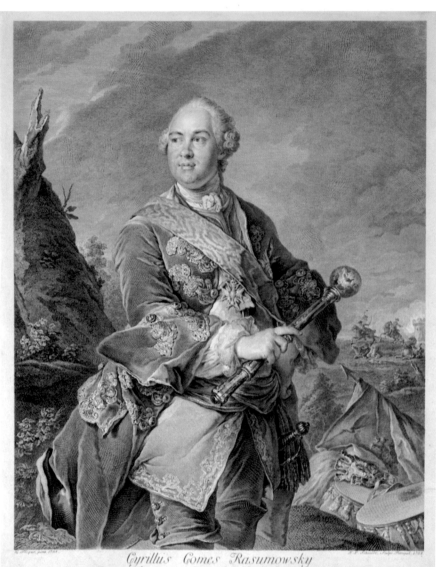

Cyrillus Comes Rasumowsky

S.I. Maj. Sturvae Russiae ad utramque Ripam Borysthenis Copiarumque trans Cataractas Dux, Camerarius, Milit. Praetorianor. Ismailoviensium Praefectus, Imp. Acad. Scient. Petropolit. Praeses, Ordinum S't. Andreae S't. Alexandri, Aquilae albae, et S'te Annae Eques

-<<< 9 >>>-

PORTRAIT OF COUNT KIRILL
GEORGIEVICH RAZUMOVSKII
ENGRAVED BY GEORG FRIEDRICH
SCHMIDT, 1762, AFTER THE 1758
ORIGINAL BY LOUIS TOCQUE. 47 X 35 CM
BORN INTO A HUMBLE COSSACK FAMILY,
RAZUMOVSKII (1728-1803) WAS TO
BECOME A FIELD-MARSHAL, PRESIDENT
OF THE ACADEMY OF SCIENCES AND
'HETMAN' OR CHIEFTAIN OF THE
UKRAINE. HE OWED HIS SUCCESS PARTLY
TO THE MORGANATIC MARRIAGE
BETWEEN HIS BROTHER ALEXEI AND THE
EMPRESS ELIZABETH.

-<<<->>>-

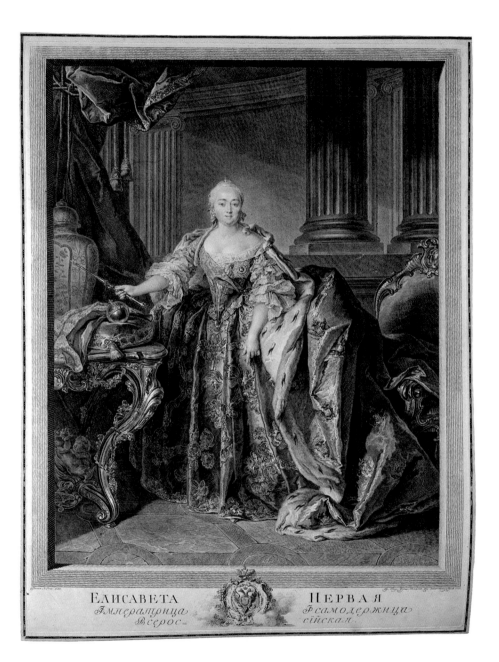

ЕЛИСАВЕТА ПЕРВАЯ
Императрица Всерос- и самодержица сійскам.

-<<< 10 >>>-

PORTRAIT OF ELIZABETH I, 1761
ENGRAVED BY GEORG FRIEDRICH
SCHMIDT (1712-75)
AFTER THE 1758 ORIGINAL BY
LOUIS TOCQUE. 68.7 X 51.8 CM
THE EMPRESS IS SHOWN IN HER FULL
IMPERIAL ROBES AND WEARING THE
ORDER OF ST ANDREW. HER LAVISH
SURROUNDINGS ILLUSTRATE THE
PREVAILING TASTE AT HER COURT FOR
EXTRAVAGANT FURNISHINGS AND
FASHION.

-<<<->>>-

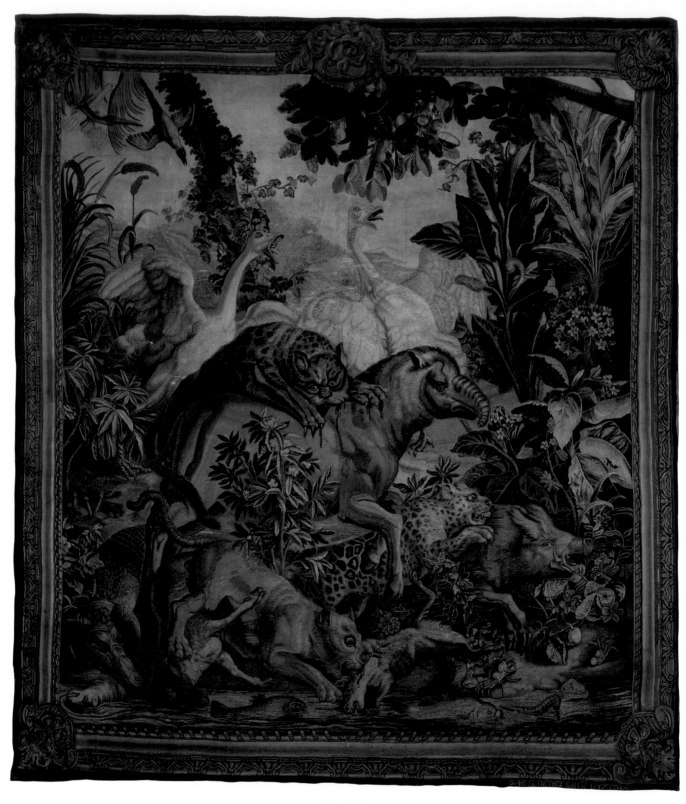

-<<< 11 >>>-

WILD BEASTS FIGHTING AT A WATERING HOLE. ST PETERSBURG, 1757. 315 X 280 CM

THE TAPESTRY IS A COPY FROM THE POPULAR 'INDIAN CARPET' SERIES DESIGNED BY D. DEPORT MUCH USED BY THE FRENCH GOBELINS FACTORY.

SEVERAL ARE SAID TO HAVE BEEN PRESENTED TO PETER THE GREAT WHEN HE VISITED FRANCE IN 1717 AND NUMEROUS COPIES WERE LATER MADE BY THE

ST PETERSBURG TAPESTRY FACTORY, SOME FOR THE STATE-ROOMS OF THE IMPERIAL PALACES.

-<<<->>>-

-<<< 12 >>>-

ARMCHAIR SLEDGE

PROBABLY RUSSIAN, MID-18TH CENTURY

WOOD, PAINT, GILDING, SILK.

HEIGHT 99 CM.

THE ARMCHAIR SLEDGE FIRST APPEARED

IN RUSSIA IN THE EARLY 18TH-CENTURY.

METAL SLIDES WERE FIXED TO THE TWO

WOODEN SUPPORTS. A LADY WOULD BE

SEATED IN THE CHAIR TO BE PUSHED

ACROSS THE ICE BY A MAN STANDING

BEHIND HER.

-<<<->>>-

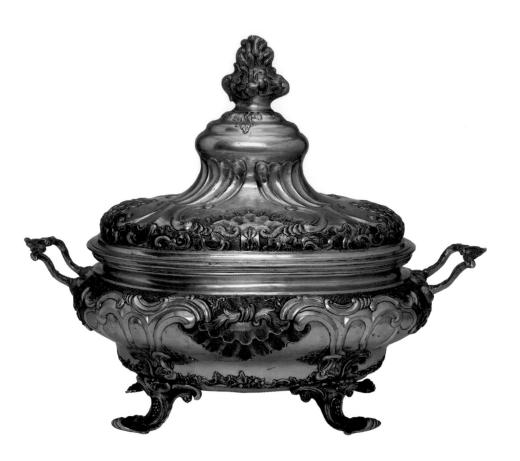

-<<< 13 >>>-
COVERED TUREEN
MASTER SILVERSMITH
IAKOV MASLENNIKOV
MOSCOW, MID-18TH CENTURY
SILVER, GILDING. 43 X 52 X 32 CM.
-<<<->>>-

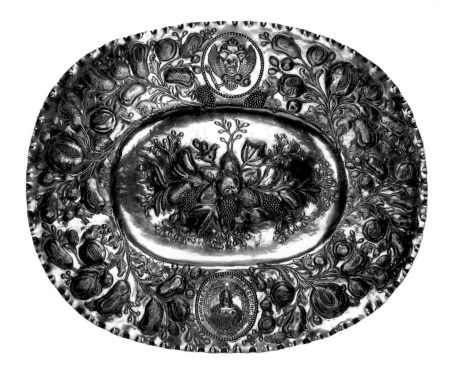

-<<< 14 >>>-
DISH
MOSCOW, 1751. SILVER. 80 X 64 CM
THE DISH IS THOUGHT TO HAVE BEEN
MADE TO MARK THE TENTH
ANNIVERSARY OF THE EMPRESS
ELIZABETH'S ACCESSION. IT BEARS A
PORTRAIT OF THE EMPRESS AS WELL AS
THE DOUBLE HEADED EAGLE, THE
IMPERIAL EMBLEM.
-<<<->>>-

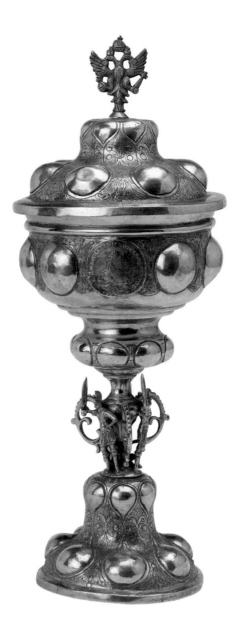
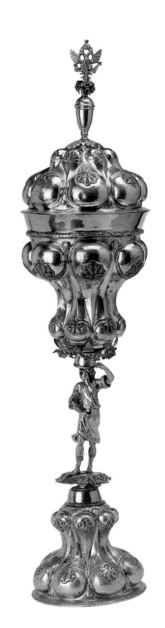

-<<< 15 >>>-

GOBLET

MASTER CRAFTSMAN GRIGORII PLOTOV

MOSCOW, 1753. SILVER, GILDING.

HEIGHT 62.3 CM

THE STEM INCORPORATES THE FIGURE

OF A YOUTH. THE COVER IS TOPPED BY

THE IMPERIAL INSIGNIA.

-<<<->>>-

-<<< 16 >>>-

COVERED GOBLET

ST PETERSBURG, 1762.

SILVER, GILDING. HEIGHT 31.3 CM

THE GOBLET IS DECORATED WITH COINS

OF PETER THE GREAT, CATHERINE I

AND ELIZABETH.

-<<<->>>-

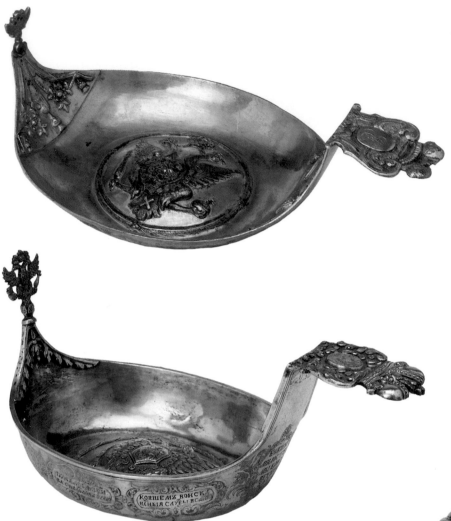

-<<< 17 >>>-
PRESENTATION KOVSH
ST PETERSBURG, 1752
SILVER, GILDING. 10.2 X 28.3 X 15 CM
IN ANCIENT RUSSIA, KOVSHES - BOAT
SHAPED SCOOPS - WERE USED FOR
DRINKING MEAD OR WINE. BY THE 18TH
CENTURY, HOWEVER, THEY HAD
LARGELY LOST THEIR ORIGINAL PURPOSE
AND WERE OFTEN GIVEN AS GIFTS OR
REWARDS. THIS WAS PRESENTED TO A
COSSACK WARLORD, OR 'ATAMAN', BY
THE EMPRESS ELIZABETH AND BEARS HER
MONOGRAM AND THE STATE INSIGINIA.
-<<<->>>-

-<<< 18 >>>-
PRESENTATION KOVSH
MOSCOW, 1782
SILVER, GILDING. 9 X 31.5 X 17.8 CM
THE INSCRIPTION ON THE KOVSH,
DECORATED WITH THE STATE INSIGNIA,
MAKES CLEAR THAT IT WAS A GIFT FROM
CATHERINE II TO A COSSACK ATAMAN.
-<<<->>>-

-<<< 19 >>>-
COVERED TANKARD
MOSCOW, 1740S. SILVER, ENAMEL. 29 X 27 X 20 CM
THE TANKARD, WITH ROCAILLE ORNAMENT, CARRIES EMPRESS ELIZABETH'S
MONOGRAM AND ENAMEL PORTRAITS OF EARLIER RUSSIAN RULERS.
-<<<->>>-

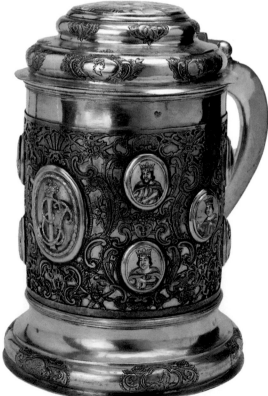

THE YOUNG COURT

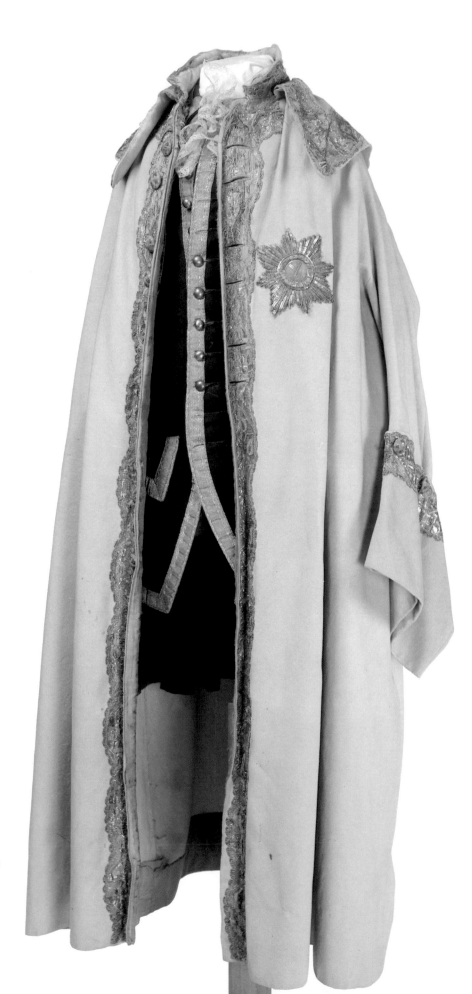

-<<< 1 >>>-
PETER III'S CLOAK
ST PETERSBURG, MID-18TH CENTURY
LENGTH 135 CM
THE LONG CLOAK OR 'EEPANCHA',
OFTEN LINED WITH FUR, WAS PART OF
THE STANDARD FORMAL COSTUME OF
THE RUSSIAN UPPER CLASSES OF THE
18TH CENTURY.
-<<<->>>-

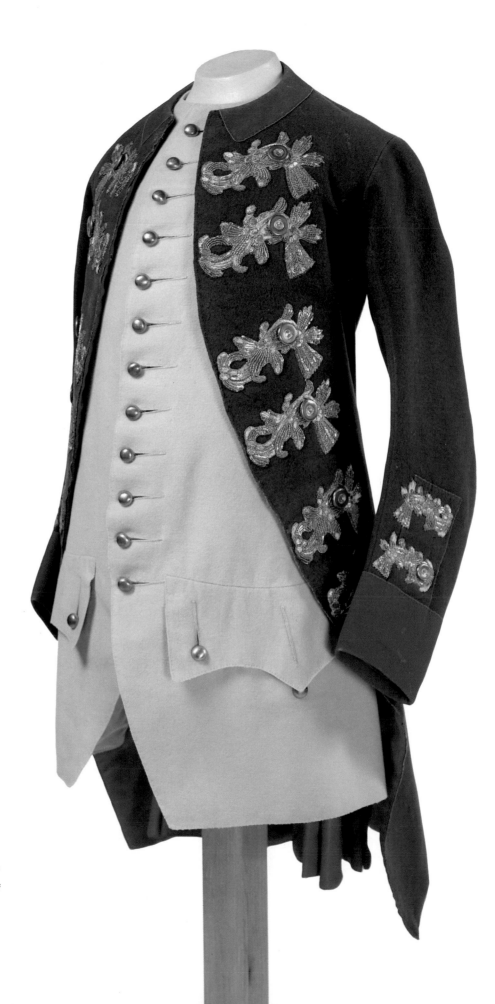

DRESS UNIFORM OF THE

PREOBRAZHENSKII GUARDS

WORN BY PETER III

ST PETERSBURG, BEFORE 1762

COAT LENGTH 95 CM

THE PREOBRAZHENSKII GUARDS WERE

FORMED BY PETER THE GREAT IN 1687,

TAKING THEIR NAME FROM A SMALL

VILLAGE NEAR MOSCOW. THE REGIMENT

SIDED WITH CATHERINE IN THE COUP OF

1762 WHICH SAW THE OVERTHROW OF

PETER III AND LED TO HER ACCESSION.

-<<<->>>-

-<<< 3 >>>-
AN OFFICER'S DRESS UNIFORM OF
THE PREOBRAZHENSKII GUARDS
WORN BY PETER III
ST PETERSBURG, BEFORE 1762
COAT LENGTH 100 CM
THE GUARDS REGIMENTS, RECRUITED
EXCLUSIVELY FROM THE NOBILITY,
FORMED AN INFLUENTIAL MILITARY
ELITE. BASED IN ST PETERSBURG, THEY
PERFORMED A RANGE OF FUNCTIONS
AT COURT AND OFTEN PLAYED AN
IMPORTANT POLITICAL ROLE.
-<<<->>>-

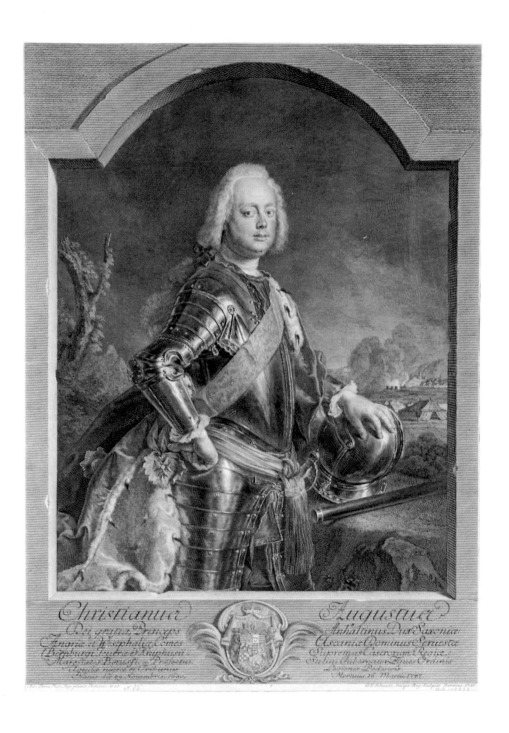

-<<< 4 >>>-

PORTRAIT OF PRINCE CHRISTIAN AUGUSTUS OF ANHALT-ZERBST

ENGRAVED IN 1750 BY GEORG FRIEDRICH SCHMIDT

AFTER A 1725 ORIGINAL BY ANTOINE PEINE (1683-1757). 51 X 36 CM

PRINCE CHRISTIAN AUGUSTUS (1690-1747), CATHERINE'S FATHER, WAS A MEMBER OF

AN OBSCURE GERMAN PRINCELY FAMILY. HE SERVED WITH DISTINCTION IN THE

PRUSSIAN ARMY AND WEARS THE PRUSSIAN ORDER OF THE BLACK EAGLE.

-<<<->>>-

-<<< 5 >>>-

PORTRAIT OF THE GRAND DUKE PETER-
FEODOROVICH, LATE 1750S
AFTER THE ORIGINAL BY
PIETRO ANTONIO ROTARI (1707-62)
OIL ON CANVAS. 112 X 85 CM
THE GRAND DUKE, LATER PETER III
(1728-62), WAS MARRIED TO CATHERINE
IN 1744. HE WAS PASSIONATELY
INTERESTED IN MILITARY AFFAIRS BUT
THE COUPLE HAD FEW SHARED
INTERESTS. WITHIN A FEW YEARS THEY
LIVED LARGELY SEPARATE LIVES.
A GRANDSON OF PETER THE GREAT, HE
WAS BORN IN GERMANY AND IS SEEN
WEARING A MILITARY UNIFORM FROM
HIS NATIVE HOLSTEIN. THE UNIFORM IS
DECORATED WITH THE HIGHEST
RUSSIAN ORDERS.

-<<<->>>-

-<<< 6 >>>-

PORTRAIT OF PETER III, 1752.
AFTER ALEXEI PETROVICH
ANTROPOV (1716-95)
OIL ON CANVAS. 132 X 95 CM
PETER, SHOWN HERE IN A COLONEL'S
UNIFORM OF THE PREOBRAZHENSKII
GUARDS, SPENT BARELY 6 MONTHS AS
EMPEROR BEFORE BEING DEPOSED WITH
CATHERINE'S ACTIVE SUPPORT.
A FEW DAYS LATER, HE WAS MURDERED
AT HIS COUNTRY ESTATE, AGED 34.

-<<<->>>-

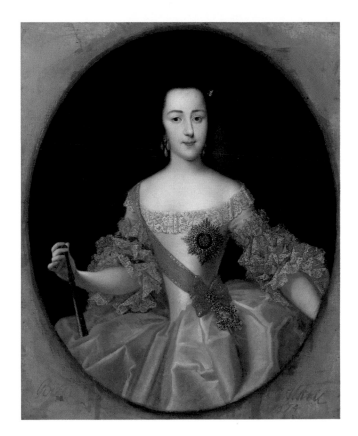

-<<< 7 >>>-
PORTRAIT OF THE GRAND DUCHESS
CATHERINE ALEXEEVNA,
LATER CATHERINE II, MID 1740S
GEORG CHRISTOPH GROOTH
OIL ON CANVAS. 105 X 85 CM
THE PORTRAIT SHOWS CATHERINE
SHORTLY AFTER HER ARRIVAL IN RUSSIA
AND HER MARRIAGE TO THE
GRAND DUKE PETER.
-<<<->>>-

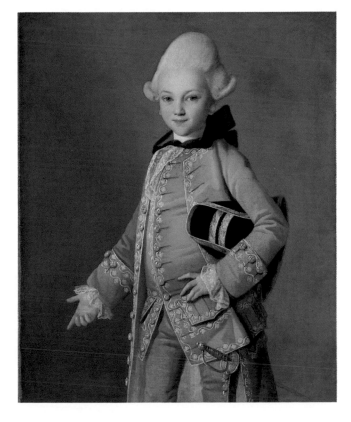

-<<< 8 >>>-
PORTRAIT OF COUNT ALEXEI
GRIGORIEVICH BOBRINSKII, 1769
CARL LUDWIG CHRISTINEK (C.1730-C.92)
OIL ON CANVAS. 90 X 73.5 CM
BOBRINSKII (1762-1813) WAS THE
BASTARD SON OF CATHERINE AND HER
LONG-STANDING FAVORITE, COUNT
GRIGORII ORLOV. HE WAS BROUGHT UP
AWAY FROM THE COURT BUT LATER
SERVED IN THE ARMY. AFTER RUNNING
UP HUGE DEBTS, HE WAS BANISHED TO
LIVE IN ESTONIA. HE LATER LIVED
NEAR TULA, WHERE HE OCCUPIED
HIMSELF WITH RUNNING HIS ESTATE
UNTIL HIS DEATH IN 1813.
-<<<->>>-

-<<< 9 >>>-

ITEMS FROM THE ORLOV SERVICE
THE IMPERIAL PORCELAIN FACTORY,
NEAR ST PETERSBURG, C.1765-70
THE ORLOV SERVICE, ONE OF THE FINEST
EXAMPLES OF RUSSIAN 18TH-CENTURY
PORCELAIN, WAS COMMISSIONED BY
CATHERINE FOR HER FAVORITE, COUNT
GRIGORII ORLOV. IT COMPRISES AROUND
300 PIECES FOR USE AT HIS TOILETTE AND
BREAKFAST. MANY ARE DECORATED WITH
ORLOV'S MONOGRAM, SCENES FROM
MILITARY LIFE - SOME ILLUSTRATING
ORLOV'S OWN CAREER - AND SKETCHES
BY GAVRIIL KUSLOV, COMMISSIONED
SPECIALLY FOR THE SERVICE.
TEAPOT: 19.7 X 22.5 X 13.5 CM,
LID 6 X 11.1 CM.
COVERED CREAMER: 6 X 8.5 X 5.5 CM,
LID 2.5 X 5.1 CM.
PATCH BOX: 5.6 X 5.5 X 4.4 CM,
LID 3.2 X 5.7 X 4.3 CM.
OVAL SWEET MEAT DISH: 3 X 17.2 X 15.1 CM.
SHAPED SIDE-PLATE: 1 X 17 X 11.2 CM.
SCALLOPED SPOON: 9.9 X 2.2 X 1 CM.

-<<<->>>-

THE RUSSIAN ORTHODOX CHURCH

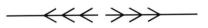

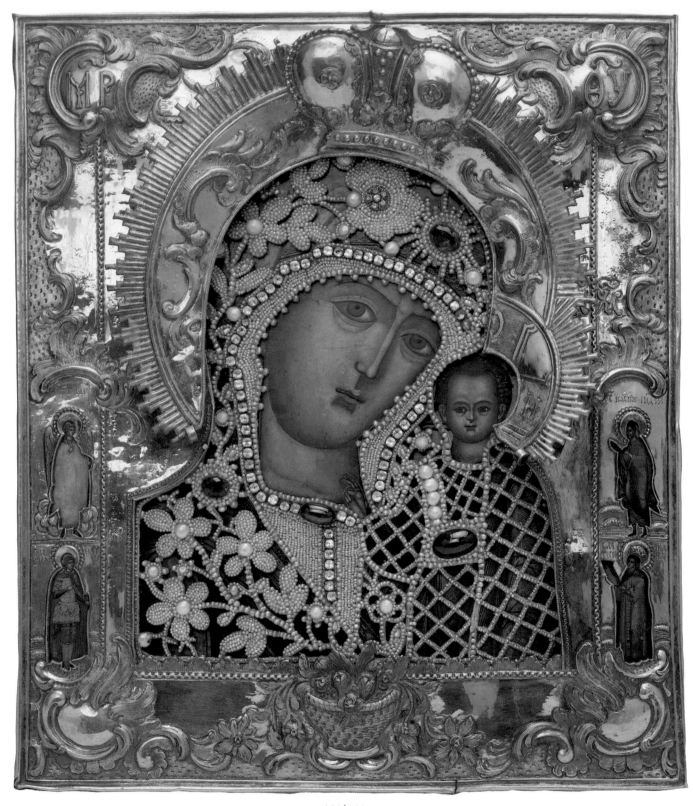

-<<< 1 >>>-

THE KAZAN MOTHER OF GOD

MASTER: IAKOV FROLOV. MOSCOW, 1775. SILVER, PEARLS, SEMI-PRECIOUS STONES, WOOD, CLOTH AND EMBROIDERY, GILDING. 33 X 28.6 CM

THE KAZAN MOTHER OF GOD, HERE BEHIND AN ORNATE FRAMEWORK OR 'OKLAD', WAS AMONG THE MOST REVERED ICONS IN ALL RUSSIA. SHE WAS REGARDED AS THE

DIVINE PATRONESS OF ST PETERSBURG. THE CHURCH HAD BEEN A POWERFUL FORCE THROUGHOUT RUSSIAN HISTORY AND BY THE TIME OF CATHERINE'S ACCESSION

OWNED AROUND ONE THIRD OF THE LAND AND OF THE SERF POPULATION.

-<<<->>>-

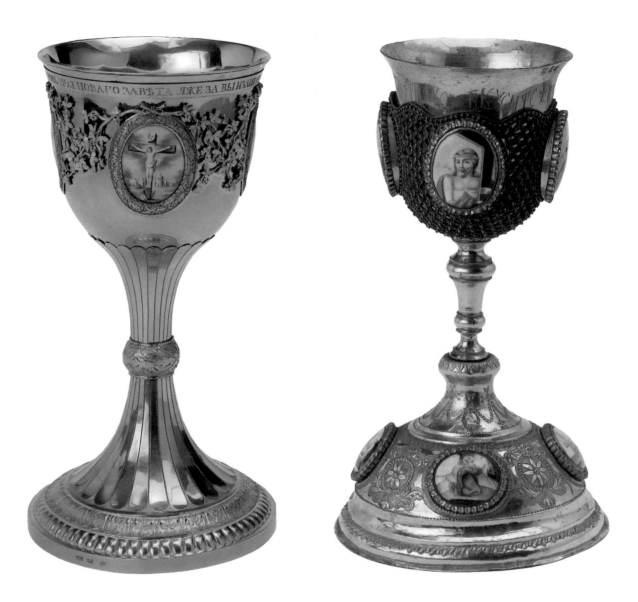

-<<< 2 >>>-

CHALICE

ST PETERSBURG, 1790S.

GOLD, ENAMEL. 22.3 X 10.9 X 11.8 CM

THE CHALICE IS ORNAMENTED WITH

A VINE LEAF PATTERN AND ENAMEL

MEDALLIONS.

-<<<->>>-

-<<< 3 >>>-

CHALICE

MASTER: FEODOR ALEKSEEV

MOSCOW, 1796

SILVER, COLORED GLASS, ENAMEL,

GILDING. 31.7 X 12.3 X 18.5 CM

-<<<->>>-

-<<< 4 >>>-

CLERICAL CAPE AND SURPLICE

LATE 18TH CENTURY

LENGTH 138 CM

AS A DEVOTEE OF THE ENLIGHTENMENT
CATHERINE SOUGHT TO MODIFY THE
CLOSE RELATIONSHIP BETWEEN CHURCH
AND STATE. SHE UNDERTOOK
FAR-REACHING REFORMS, EFFECTIVELY
CONFISCATING VAST TRACTS OF
CHURCH LANDS. IN THE PROCESS,
SHE OFFENDED MANY OF THE CLERGY,
DEEPLY ATTACHED TO TRADITION.
NEVERTHELESS THE CHURCH, WITH ITS
SUMPTUOUS RITUALS, REMAINED AN
ESSENTIAL PART OF LIFE FOR THE
GREAT MAJORITY OF HER SUBJECTS.

-<<<->>>-

-<<< 5 >>>-

'FELON' OR CAPE AND SURPLICE

LATE 18TH CENTURY

LENGTH 135 CM

THE CLERGY'S ROBES WERE OFTEN

MADE BY RELIGIOUS HOUSES,

SOMETIMES INCORPORATING RICH

FABRICS AND EMBROIDERY TAKEN FROM

CLOTHES OFFERED TO THE MONASTERY

BY RICH AND FASHIONABLE WOMEN.

-<<<->>>-

-<<< 6 >>>-
SURPLICE
LATE 18TH CENTURY
SILK BROCADE. LENGTH 135 CM
-<<<->>>-

-<<< 7 >>>-
SURPLICE
LATE 18TH CENTURY
FLORAL PRINTED LINEN.
LENGTH 125 CM
-<<<->>>-

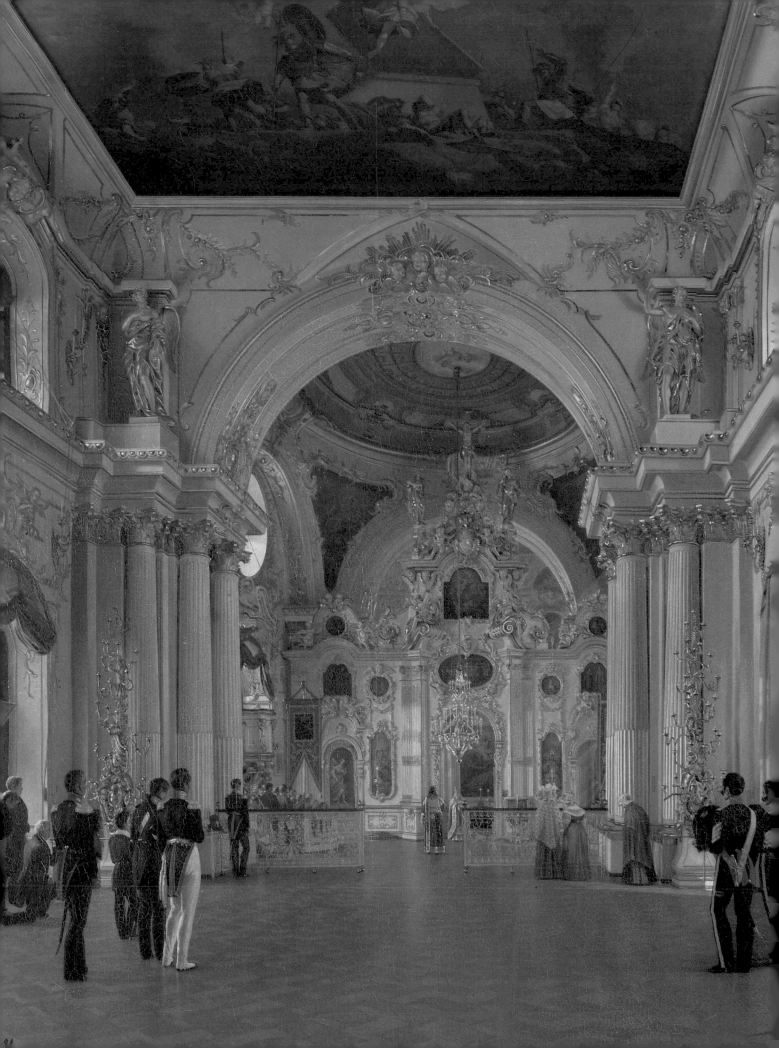

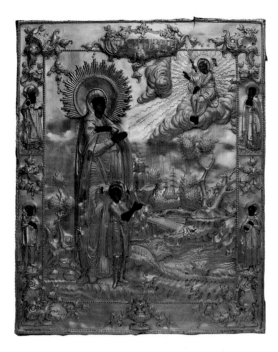

-<<< 9 >>>-
ICON OF ST NIKITA, WITH 'OKLAD'
MASTER: STEPAN SAVELYEV
MOSCOW, 1781. SILVER, WOOD,
GILDING. 31 X 25.5 CM
THE SAINT, AN EARLY CHRISTIAN
MARTYR, IS SEEN BEHIND AN ORNATE
CHASED AND ENGRAVED SILVER GILT
'OKLAD' IN THE BAROQUE STYLE.
'OKLADS' OR MOUNTINGS WERE
ORIGINALLY USED TO PROTECT THE
ICON FROM DAMAGE.
-<<<->>>-

-<<< 8 >>>-
THE GREAT CHAPEL AT THE
WINTER PALACE, 1829
ALEXEI VASIL'EVICH TYRANOV
(1808-59).
OIL ON CANVAS. 146 X 106 CM
THE CHAPEL WAS BUILT BETWEEN
1754 AND 1762 BY RASTRELLI.
ITS LAVISH RUSSIAN BAROQUE STYLE
WAS CHARACTERISTIC OF
ST PETERSBURG IMMEDIATELY
BEFORE CATHERINE'S ACCESSION.
ON THE CEILING IS
THE RESURRECTION OF CHRIST BY
FRANCESCO FONTEBASSO (1709-69),
ONCE A PUPIL OF SEBASTIANO RICCI.
IN THE BACKGROUND CAN BE SEEN
THE ICONOSTAS - THE DOORS
DECORATED WITH ICONS THAT
DIVIDED THE CHURCH - BY THE
BROTHERS BEL'SKII.
-<<<->>>-

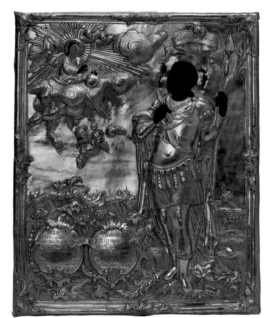

-<<< 10 >>>-
ICON OF SAINTS ULITA AND KIRIK,
WITH 'OKLAD'
MASTER: YEGOR PETROV
MOSCOW, 1789. SILVER, WOOD,
GILDING. 41 X 32.7 CM
-<<<->>>-

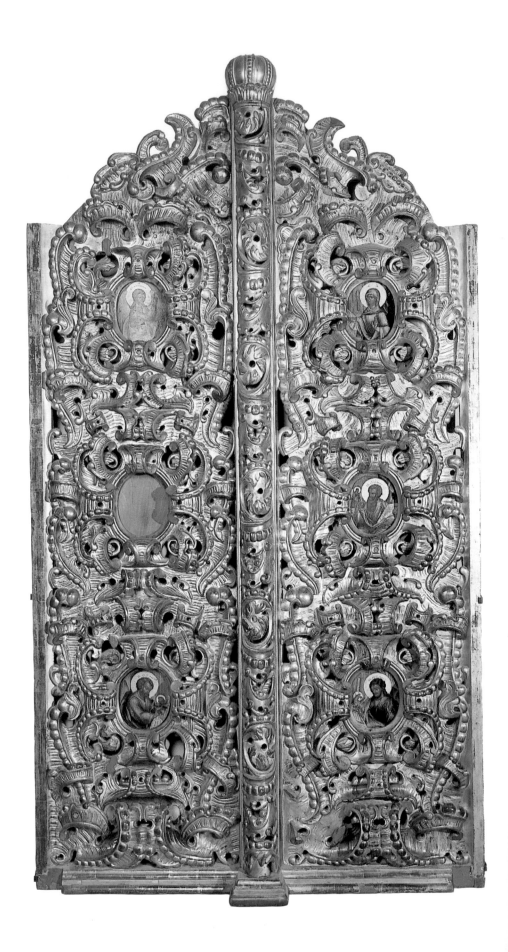

-<<< 11 >>>-

TSAR'S GATE, LATE 17TH CENTURY

WOOD, CARVING, GILDING

DOORS OF GATES 86.5 X 123.5 CM

THE TSAR'S GATE FORMS THE CENTRAL

PART OF THE SCREEN (ICONOSTAS)

FOUND IN RUSSIAN CHURCHES. NO LESS

MAGNIFICENT IS THE DECORATIVE

CARVING AND PAINTING OF THE ICONS

SET INTO THE SCREEN.

-<<<->>>-

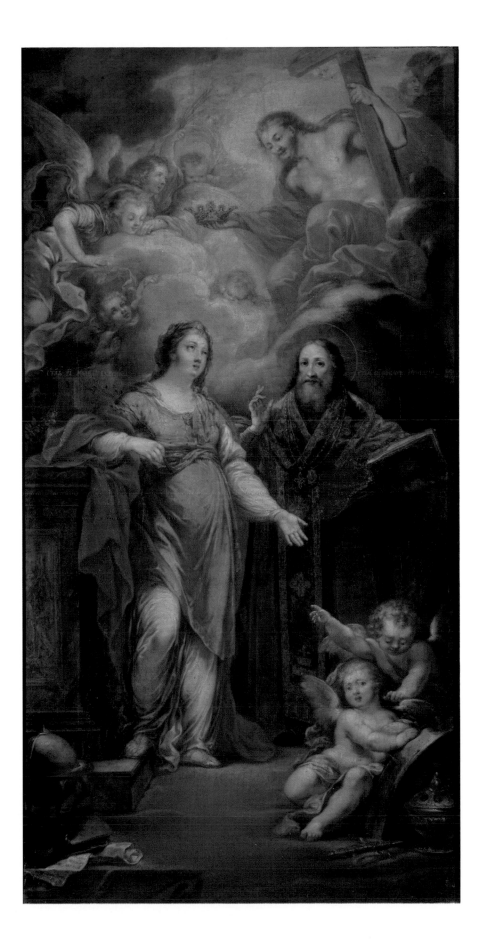

-<<< 12 >>>-
ICON OF SAINT CATHERINE AND SAINT
JANUARIUS, LATE 18TH CENTURY
ANDREI OSIPOVICH ZHDANOV (1755-1811)
OIL ON CANVAS. 147 X 75 CM
SAINT CATHERINE OF ALEXANDRIA WAS
WIDELY VENERATED IN RUSSIA. THE
ORDER OF SAINT CATHERINE, AWARDED
CHIEFLY TO WOMEN, WAS INSTITUTED
BY PETER THE GREAT.
-<<<->>>-

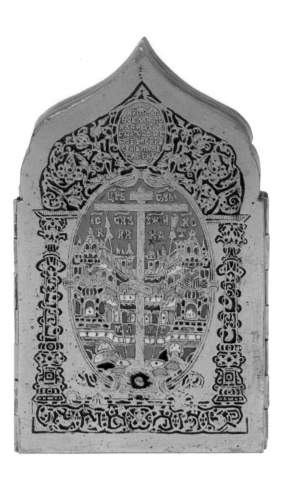

-<<< 13 >>>-
FOLDED QUADRIPTYCH
VIGOVSK MONASTERY, OLONETSK
PROVINCE, RUSSIA, EARLY 18TH
CENTURY. BRASS. 17.9 X 11 X 1.5 CM
THE FOUR FOLDS OF THE QUADRIPTYCH,
PART OF A TRAVELLING ALTAR SET,
ARE PAINTED TO ILLUSTRATE THE
12 MAJOR FEASTS OF THE CHURCH AND
THE CRUCIFIXION. VIGOVSK WAS A
FAMOUS CENTRE FOR RELIGIOUS
BRASSWORK, ESPECIALLY ICONS,
CROSSES AND ALTARS, IN THE 18TH
AND EARLY 19TH CENTURIES.
-<<<->>>-

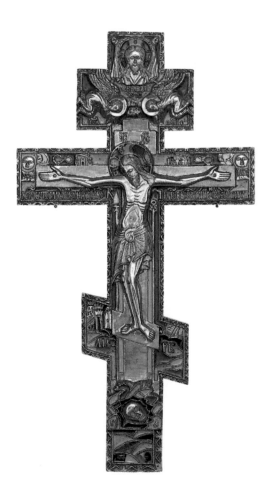

-<<< 14 >>>-
CRUCIFIX
VIGOVSK MONASTERY, OLONETSK
PROVINCE, RUSSIA, 18TH CENTURY
BRONZE, ENAMEL. 28.3 X 15.3 CM
-<<<->>>-

THE RUSSIAN ORTHODOX CHURCH

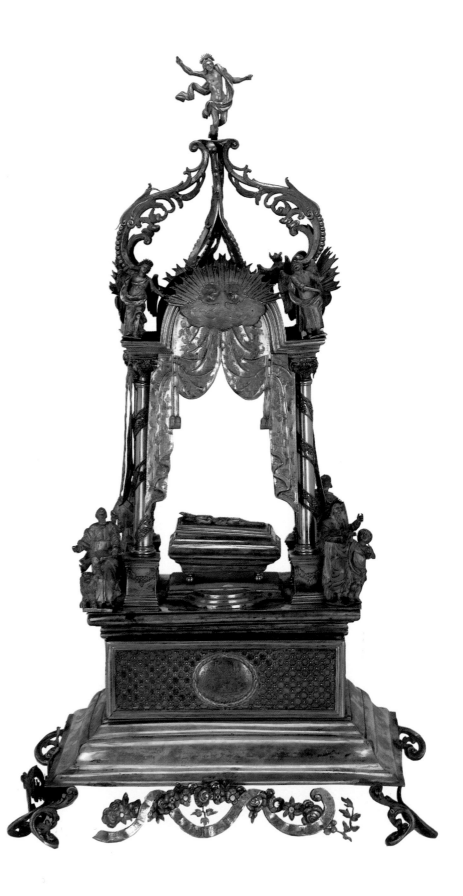

-<<< 15 >>>-

MONSTRANCE

MASTER: KARL BEKKER

ST PETERSBURG, 1780S. SILVER, GILDING.

87 X 47.7 X 37.7 CM

-<<<->>>-

-<<< 16 >>>-
ALTAR CROSS
ST PETERSBURG, 1760
SILVER, GILDING. 35 X 20 CM
-<<<->>>-

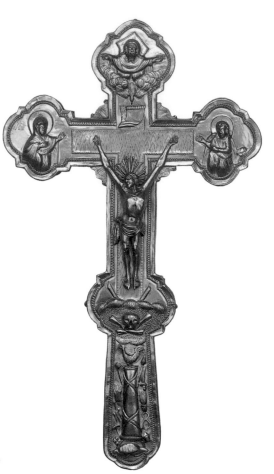

-<<< 17 >>>-
THE GOSPELS
MOSCOW, 1780S
SILVER, COLORED GLASS, PAPER,
LEATHER, ENAMEL, GILDING, NIELLO
48.5 X 33.5 CM
-<<<->>>-

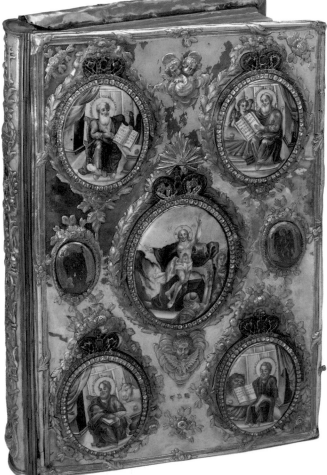

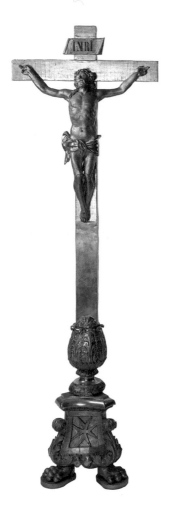

TWO CANDLESTICKS

ST PETERSBURG, 1798-1800

WOOD, GILDING. 136 X 39 X 39 CM

THESE CANDLESTICKS ARE ALSO FROM

THE KNIGHTS OF MALTA CHAPEL AND

SHOW THE KNIGHT'S CROSS, THE

ORDER'S EMBLEM.

-<<<->>>-

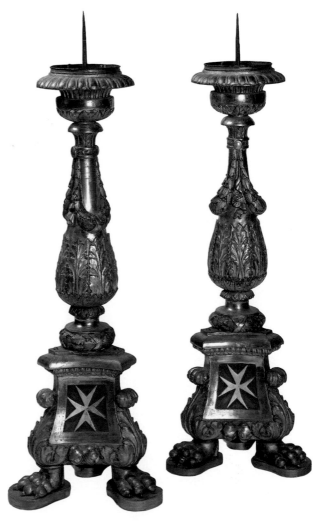

-<<< 18 >>>-

ALTAR CROSS

FROM A DESIGN BY

GIACOMO QUARENGHI

ST PETERSBURG, 1798-1800

WOOD, GILDING. 184 X 54 X 36 CM

THE CROSS WAS DESIGNED FOR

THE CHAPEL OF THE KNIGHTS OF

MALTA, BUILT IN ST PETERSBURG

FOLLOWING PAUL I'S APPOINTMENT

AS GRAND MASTER OF THE ORDER

IN 1798. THE EMPEROR ATTACHED

ALMOST MYSTIC SIGNIFICANCE

TO HIS POSITION WHICH CONFERRED

AT LEAST TITULAR CONTROL OVER

THE ISLAND OF MALTA.

-<<<->>>-

-<<< 20 >>>-

PORTRAIT OF ARCHPRIEST FEODOR
IAKOVLEVICH DUBIANSKII, 1761
ALEXEI PETROVICH ANTROPOV (1716-95)
OIL ON CANVAS. 99.5 X 76.5 CM
ARCHPRIEST DUBIANSKII WAS CONFESSOR
TO THE EMPRESS ELIZABETH AND TO
CATHERINE. HE WAS ENNOBLED IN 1761
AND GRANTED LANDS AND SERFS.

-<<<->>>-

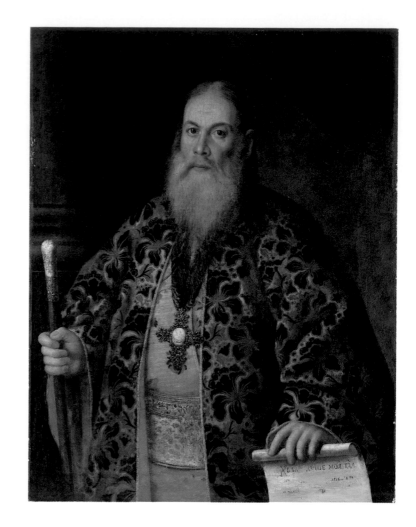

-<<< 21 >>>-

CORONATION OF THE MOTHER OF GOD
MIKHAIL FUNTUSOV, 1755
TEMPERA ON WOOD. 50 X 21 CM
FUNTUSOV WAS A SERF OF THE
IMMENSELY RICH SHEREMET'EV FAMILY,
GENEROUS PATRONS OF THE ARTS
WHO ASSEMBLED A VAST PRIVATE
COLLECTION. THEY SENT TALENTED
ARTISTS ABROAD OR TO ST PETERSBURG
TO STUDY.

-<<<->>>-

EMPRESS CATHERINE II

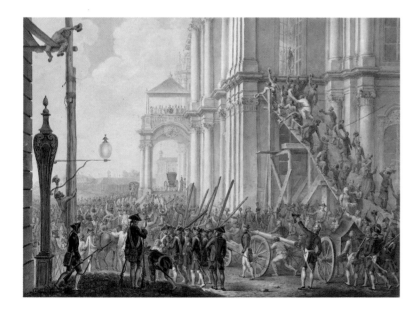

-<<< 1 >>>-

CATHERINE II ON THE STEPS OF THE
CATHEDRAL OF OUR LADY OF KAZAN,
ST PETERSBURG
AFTER THE ORIGINAL BY
JOACHIM CONRAD KEESTNER, 1760S
WATERCOLOR AND GOUACHE ON
THIN BOARD. 26 X 35 CM
CATHERINE SEIZED POWER FROM HER
HUSBAND ON 28 JUNE, 1762, BACKED BY
A SMALL GROUP OF CONSPIRATORS.
ON THE DAY OF THE COUP CATHERINE
WENT TO THE CATHEDRAL IN ST
PETERSBURG WHERE SHE WAS GREETED
BY THE CLERGY. TROOPS GATHERED AT
THE SCENE TO SWEAR LOYALTY TO THE
NEW EMPRESS. THE PICTURE IS PART OF
A SERIES COMMISSIONED BY CATHERINE
TO ILLUSTRATE HER ACCESSION.

-<<<->>>-

-<<< 2 >>>-

CATHERINE II ON THE BALCONY OF
THE WINTER PALACE
AFTER THE ORIGINAL BY
JOACHIM CONRAD KEESTNER, 1760S
WATERCOLOR AND GOUACHE ON
THIN BOARD. 26 X 35 CM
THE FINAL PICTURE IN KEESTNER'S
SERIES SHOWS CATHERINE AFTER HER
VISIT TO THE CATHEDRAL,
ACKNOWLEDGING THE ENTHUSIASTIC
WELCOME OF THE ARMY WHICH HAD
HELPED HER TO POWER. THE ORIGINALS
WERE HUNG IN THE WINTER PALACE.
KEESTNER WAS A GERMAN MINIATURE
PAINTER, WORKING AT THE GARDNER
PORCELAIN WORKS NEAR MOSCOW.

-<<<->>>-

-<<< 3 >>>-

PORTRAIT OF CATHERINE II, BEFORE 1766
ALEXEI PETROVICH ANTROPOV (1716-95)
OIL ON CANVAS. 51 X 38 CM
THE EMPRESS IS SEEN IN HER
CORONATION ROBES WITH THE CROWN,
ORB AND SCEPTRE. SHE IS WEARING THE
SASH OF THE ORDER OF ST ANDREW.

-<<<->>>-

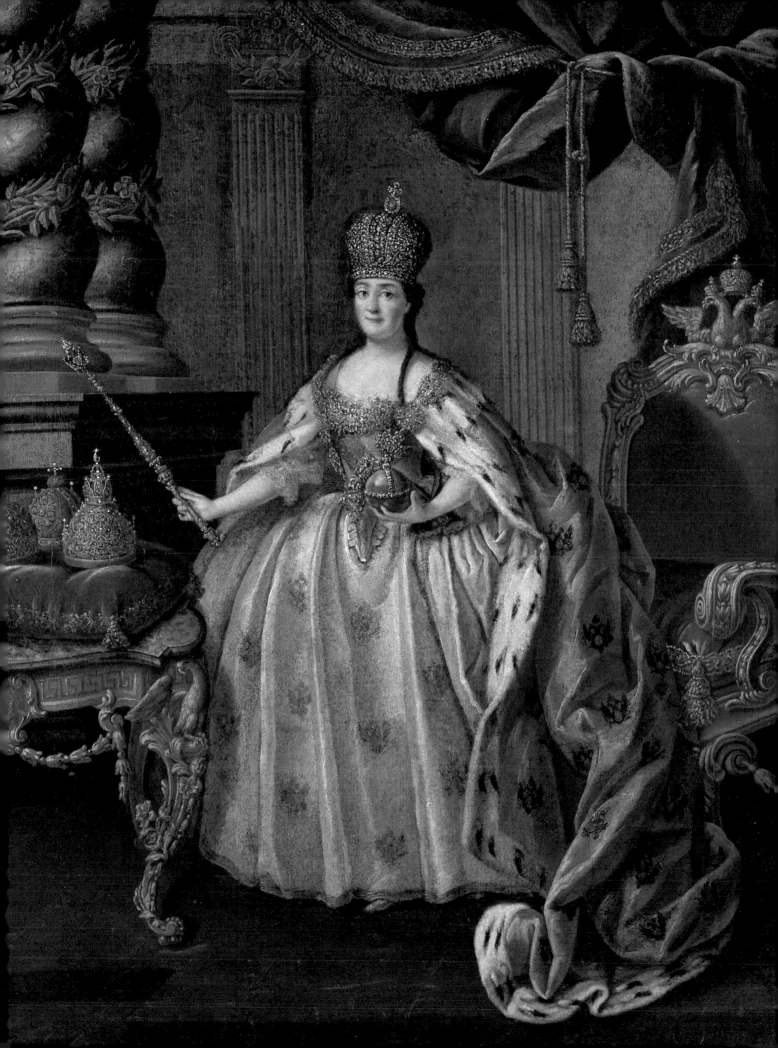

-<<< 4 >>>-

MEDAL TO COMMEMORATE
CATHERINE II'S ACCESSION
TO THE THRONE
JOHANN GEORG WAECHTER,
ST PETERSBURG, 1762.
SILVER. DIA 6.7 CM
CATHERINE'S SUPPORTERS LIKED TO
PORTRAY HER ACCESSION AS THE
BEGINNING OF A NEW ERA OF WISDOM
AND JUSTICE. SHE IS SHOWN HERE AS
MINERVA, THE ROMAN GODDESS OF
WISDOM. GOLD VERSIONS OF THE
MEDAL WERE SENT AS GIFTS TO
THE FRENCH ENLIGHTENMENT
PHILOSOPHERS, VOLTAIRE
AND DIDEROT

.<<<.>>>.

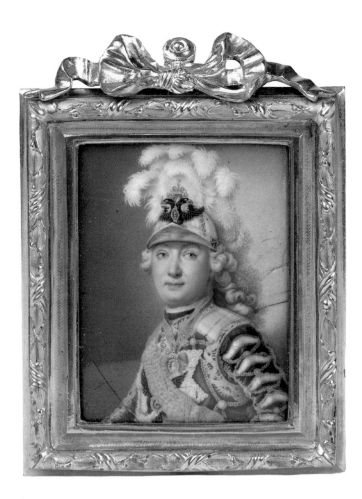

-<<< 5 >>>-
MINIATURE OF COUNT GRIGORII
GRIGORIEVICH ORLOV
ANDREI IVANOVICH CHERNYI,
AFTER A DETAIL OF A PORTRAIT
BY VERGILIUS ERIKSEN, LATE 1760S
ENAMEL ON COPPER. 7.2 X 5.3 CM
GRIGORII ORLOV (1734-83), A GOOD-
LOOKING YOUNG SOLDIER WITH A
REPUTATION FOR BRAVERY IN THE
FIELD, BECAME CATHERINE'S FAVORITE
IN 1761. HE REMAINED SUCH FOR 11
YEARS AND WAS THE FATHER
OF HER SON, ALEXEI BOBRINSKII.
HE IS SEEN HERE IN HIS MASQUERADE
COSTUME.
-<<<->>>-

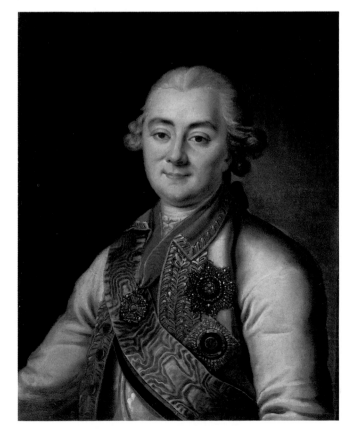

-<<< 6 >>>-
PORTRAIT OF COUNT ALEXEI
GRIGORIEVICH ORLOV CHESMENSKII
ARTIST UNKNOWN
OIL ON CANVAS. 72 X 55 CM
THE FIVE ORLOV BROTHERS PLAYED
A KEY ROLE IN THE COUP OF 1762.
ALEXEI (1735-1807) WENT ON TO
BECOME A DISTINGUISHED MILITARY
COMMANDER. THE TITLE 'CHESMENSKII'
WAS AWARDED AFTER HIS NAVAL
VICTORY OVER THE TURKS AT CHESME.
-<<<->>>-

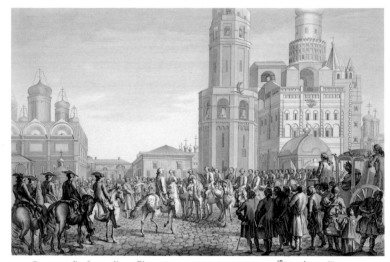

-<<< 7 >>>-

THE ANNOUNCEMENT OF CATHERINE II'S CORONATION IN MOSCOW

ENGRAVED BY ALEXANDER KIPRIANOVICH MELNIKOV (B.1803). COPY OF 1790S ENGRAVING AFTER ORIGINAL
DRAWING BY JEAN-LOUIS DE VELLIER AND MIKHAIL IVANOVICH MAKHAEV, 1762-63. 59.5 X 78.8 CM
THE ANNOUNCEMENT IS BEING READ TO THE CROWD OUTSIDE THE CATHEDRAL OF THE ARCHANGEL
MICHAEL IN THE HEART OF THE KREMLIN IN MOSCOW. THE SCENE FORMS PART OF A SERIES OF NINE
ENGRAVINGS ILLUSTRATING EVENTS SURROUNDING CATHERINE'S CORONATION.

-<<<->>>-

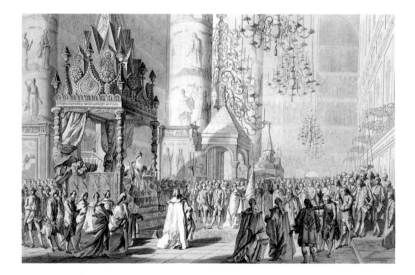

-<<< 8 >>>-

CATHERINE II AT HER CORONATION

ENGRAVED IN 1790S BY AN UNKNOWN ARTIST. FROM THE DRAWINGS BY JEAN-LOUIS DE VELLIER AND
MIKHAIL MAKHAEV, 1762-63. 62.1 X 78.8 CM
AS THE CLIMAX OF THE CORONATION SERIES, CATHERINE IS SHOWN SURROUNDED BY HER COURT IN THE
CATHEDRAL OF THE ARCHANGEL MICHAEL. SHE WAS CROWNED IN SEPTEMBER 1762, TWO MONTHS AFTER
HER HUSBAND'S DEATH.

-<<<->>>-

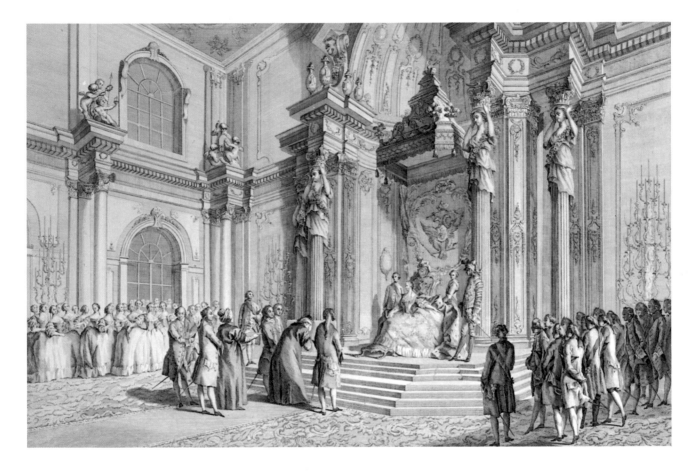

-<<< 9 >>>-

CATHERINE II RECEIVES THE TURKISH EMBASSY

ENGRAVED BY ANDREI IVANOVICH KAZACHINSKII, 1796. FROM ORIGINAL DRAWINGS BY

JEAN-LOUIS DE VELLIER AND MIKHAIL MAKHAEV, 1762-63. 59 X 78.5 CM

CATHERINE IS SEEN RECEIVING THE AMBASSADORS IN THE NEWLY COMPLETED AUDIENCE CHAMBER

OF THE WINTER PALACE IN 1764. RELATIONS WITH TURKEY WERE TO DOMINATE CATHERINE'S

FOREIGN POLICY AND THE TWO COUNTRIES TWICE WENT TO WAR.

-<<<->>>-

-<<< 10 >>>-

MINIATURE OF CATHERINE II HOLDING
THE *NAKAZ*, C.1770
ARTIST UNKNOWN
ENAMEL ON COPPER. 8 X 10.7 CM
THE *NAKAZ* OR *GREAT INSTRUCTION*
WAS CATHERINE'S OWN POLITICAL AND
PHILOSOPHICAL TESTAMENT. IT WAS
WRITTEN FOR THE GUIDANCE OF THE
LEGISLATIVE COMMISSION SHE
CONVENED IN 1767 TO DRAW UP A NEW
LEGAL CODE FOR RUSSIA.
FOR INSPIRATION CATHERINE LOOKED
TO THE IDEAS OF THE PHILOSOPHERS OF
THE 'ENLIGHTENMENT' IN WESTERN
EUROPE.

-<<<->>>-

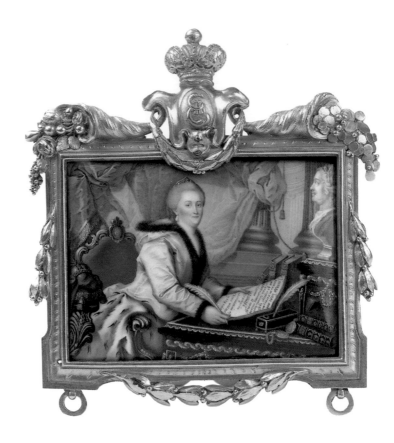

-<<< 11 >>>-

A GREEK TRANSLATION OF
CATHERINE II'S *NAKAZ*
ST PETERSBURG, 1771
LEATHER BINDING STAMPED IN GOLD.
320 PAGES, 21 X 13.5 CM

-<<<->>>-

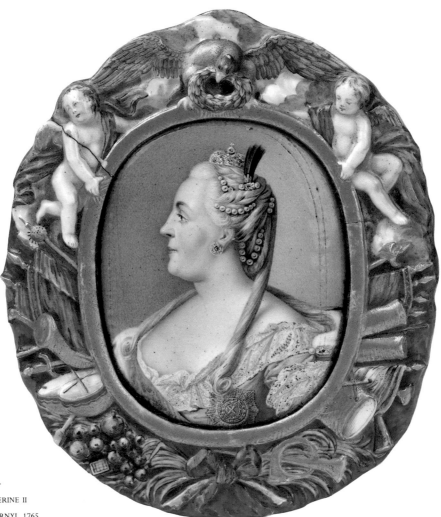

-<<< 12 >>>-

MINIATURE OF CATHERINE II

ANDREI IVANOVICH CHERNYI, 1765

AFTER THE ORIGINAL PAINTING BY

FEODOR ROKOTOV, 1763

ENAMEL ON COPPER IN PORCELAIN

FRAME. 9 X 7 CM

ROKOTOV'S ORIGINAL WAS AMONG THE

FIRST OF CATHERINE AFTER SHE CAME

TO POWER. THE ARTIST, A SERF

WORKING AT THE IMPERIAL PORCELAIN

FACTORY NEAR ST PETERSBURG, WAS

ONE OF THE FOREMOST PORCELAIN

PAINTERS OF HIS DAY. THE PORCELAIN

FRAME IS ITSELF A RARITY.

-<<<->>>-

-<<< 13 >>>-

UNIFORM DRESS OF CATHERINE II

ST PETERSBURG, 1773

SILK AND METAL THREAD EMBROIDERY.

LENGTH 155 CM

CATHERINE IS KNOWN TO HAVE

FAVORED SUCH UNIFORM DRESSES

WHICH SHE CONSIDERED FLATTERING.

THE DRESS IS MODELLED ON THE

UNIFORM OF THE LIFEGUARDS CAVALRY.

ITS LONG FOLDING SLEEVES REFLECT A

WISH TO RETURN TO TRADITIONAL

RUSSIAN DRESS THAT EXISTED BEFORE

PETER THE GREAT ENFORCED THE USE

OF WESTERN STYLES AMONG THE

NOBILITY.

-<<<->>>-

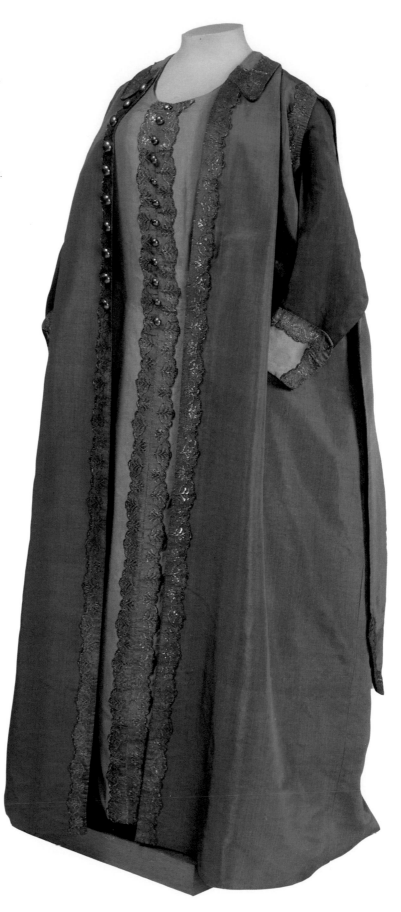

-<<< 14 >>>-

UNIFORM DRESS OF CATHERINE II
ST PETERSBURG, 1763
MODELLED CLOSELY ON THE UNIFORM
OF THE PREOBRAZHENSKII GUARDS OF
WHICH CATHERINE WAS COMMANDER-
IN-CHIEF, THE DRESS WOULD HAVE BEEN
WORN ON HER VISITS TO THE REGIMENT
FOR THEIR ANNUAL FEAST DAY.
THE CUT COMBINES ELEMENTS OF
FRENCH FASHION WITH RUSSIAN
MILITARY UNIFORM AND FOLK
COSTUME.

-<<<->>>-

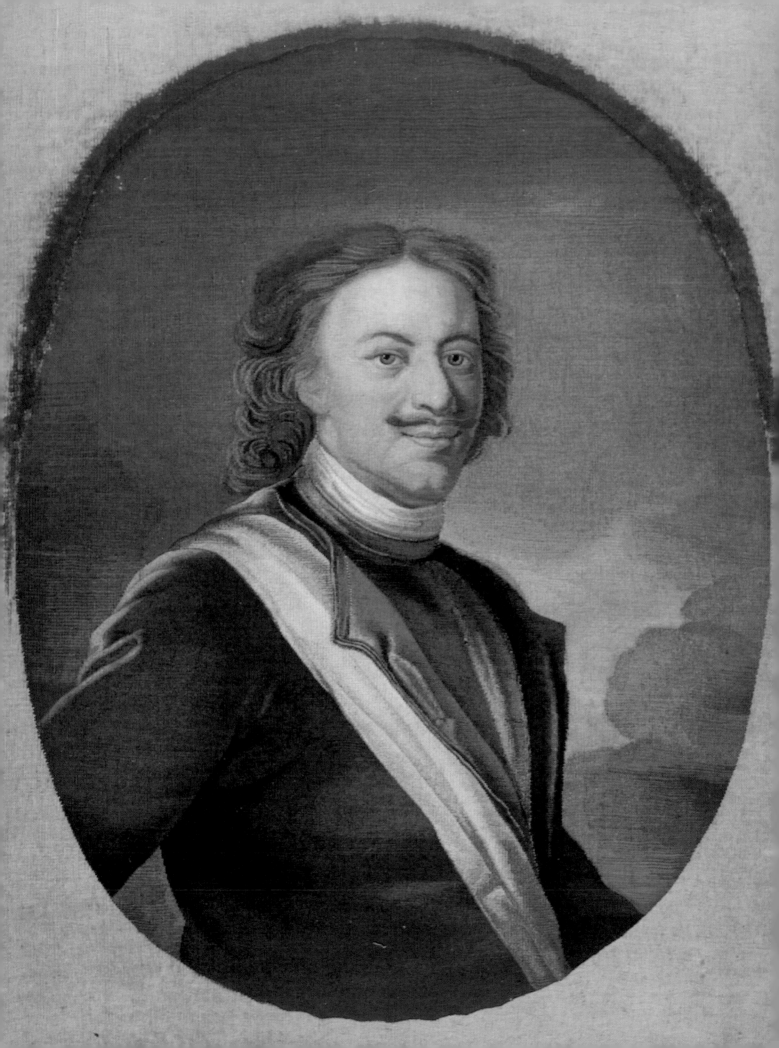

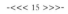

-<<< 16 >>>-

COMMEMORATIVE MEDAL TO MARK THE
DELIVERY OF THE 'THUNDERSTONE',
LATE 1770S
JOHANN GEORG CASPAR JAEGER
SILVER. DIA 65 MM
IN 1770 A VAST GRANITE MONOLITH,
KNOWN AS THE 'THUNDERSTONE' WAS
DRAGGED FROM THE BANKS OF THE
RIVER LAKHTA AND TAKEN INTO
ST PETERSBURG TO SERVE AS THE BASE
FOR A STATUE OF PETER THE GREAT.
HUGE CROWDS GATHERED TO WATCH
ITS PROGRESS, SEEN AS A REMARKABLE
FEAT OF ENGINEERING.

-<<<->>>-

-<<< 17 >>>-

COMMEMORATIVE MEDAL TO MARK THE
UNVEILING OF THE STATUE OF
PETER THE GREAT, 1782
JOHANN GEORG CASPAR JAEGER
SILVER. DIA 80 MM
THE EQUESTRIAN STATUE, OFTEN
REFERRED TO AS 'THE BRONZE
HORSEMAN' WAS BY THE FRENCH
SCULPTOR ETIENNE MAURICE FALCONET.
IT WAS FINALLY UNVEILED ON
7 AUGUST, 1782, THE 100TH
ANNIVERSARY OF PETER THE GREAT'S
ENTHRONEMENT. THE BASE OF THE
STATUE CARRIES THE INSCRIPTION: 'TO
PETER THE FIRST - CATHERINE THE
SECOND', SUGGESTIVE OF THE
PARALLELS BETWEEN THEIR
ACHIEVEMENTS.

-<<<->>>-

-<<< 15 >>>-

PORTRAIT OF PETER THE GREAT
ST PETERSBURG TAPESTRY FACTORY,
LATE 18TH CENTURY. WOOL, SILK
AND FLAX THREAD. 92 X 75 CM
CATHERINE WAS A KEEN ADMIRER OF
PETER THE GREAT AND SOUGHT TO
PROJECT HERSELF AS HIS NATURAL
SUCCESSOR. SHE EMULATED HIS POLICIES
OF EXPANSION AND MODERNISATION.

-<<<->>>-

-<<< 18 >>>-

THE DELIVERY OF THE THUNDERSTONE

1770S. ENGRAVED BY

JACOB VAN DER SCHLEY (1715-79)

AFTER A DRAWING BY IURI MATVEEVICH

FELTEN, 1770. 45 X 71 CM

THE ARCHITECT IURI MATVEEVICH FELTEN

CARRIED OUT A SERIES OF DRAWINGS OF

THE 'THUNDERSTONE' AND ITS PROGRESS.

CATHERINE CAN BE SEEN AMONG A GROUP

OF COURTIERS IN THE CENTER OF THE

PICTURE. 400 WORKMEN WERE BUSY

SHAPING THE STONE EVEN WHILE IT WAS

BEING TRANSPORTED.

-<<<->>>-

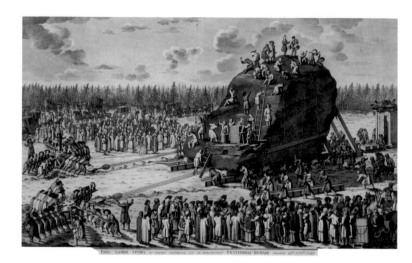

-<<< 19 >>>-

THE UNVEILING OF THE STATUE OF

PETER THE GREAT

ENGRAVED BY ALEXANDER MELNIKOV,

MID-19TH CENTURY. AFTER A DRAWING BY

ALEXEI PETROVICH DAVYDOV, 1782

65 X 83.7 CM

THOUSANDS GATHERED IN

ST PETERSBURG'S SENATE SQUARE TO

WITNESS THE UNVEILING CEREMONY.

CATHERINE AND HER COURT, TOGETHER

WITH FAVORED GUESTS AND FOREIGN

AMBASSADORS, CAN BE SEEN ON THE

BALCONY OF THE SENATE ON THE LEFT.

-<<<->>>-

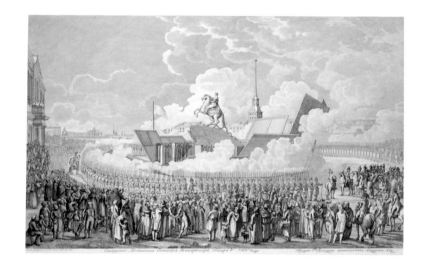

-<<< 20 >>>-

PORTRAIT OF PRINCE GRIGORII

POTEMKIN-TAVRICHESKII, C.1790.

GIOVANNI BATTISTA LAMPI THE ELDER

(1751-1830)

OIL ON CANVAS. 73.5 X 60.5 CM

POTEMKIN (1739-91) RANKS AS THE MOST

INFLUENTIAL OF ALL CATHERINE'S FAVORITES.

AFTER THE END OF THEIR BRIEF LIAISON HE

REMAINED HER TRUSTED FRIEND AND CLOSE

ADVISER, EVEN HELPING TO CHOOSE HER LATER

FAVORITES. IN PARTICULAR, HE HELPED TO

REALIZE CATHERINE'S DREAMS OF CONQUEST IN

THE SOUTH. HE DISTINGUISHED HIMSELF AS A

STATESMAN AND SOLDIER, COMMANDING THE

RUSSIAN FORCES IN THE SECOND RUSSO-

TURKISH WAR WHEN HE WAS AWARDED THE

TITLE TAVRICHESKII. SOME EVIDENCE SUGGESTS

THAT POTEMKIN AND CATHERINE MAY EVEN

HAVE MARRIED IN SECRET.

-<<<->>>-

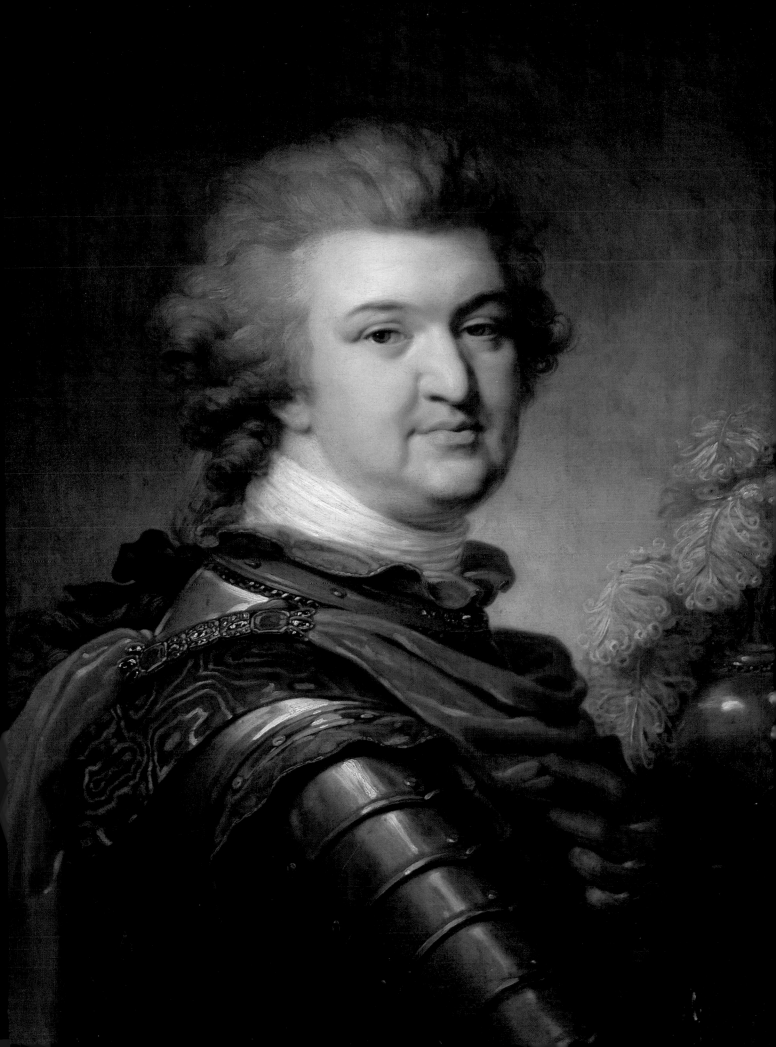

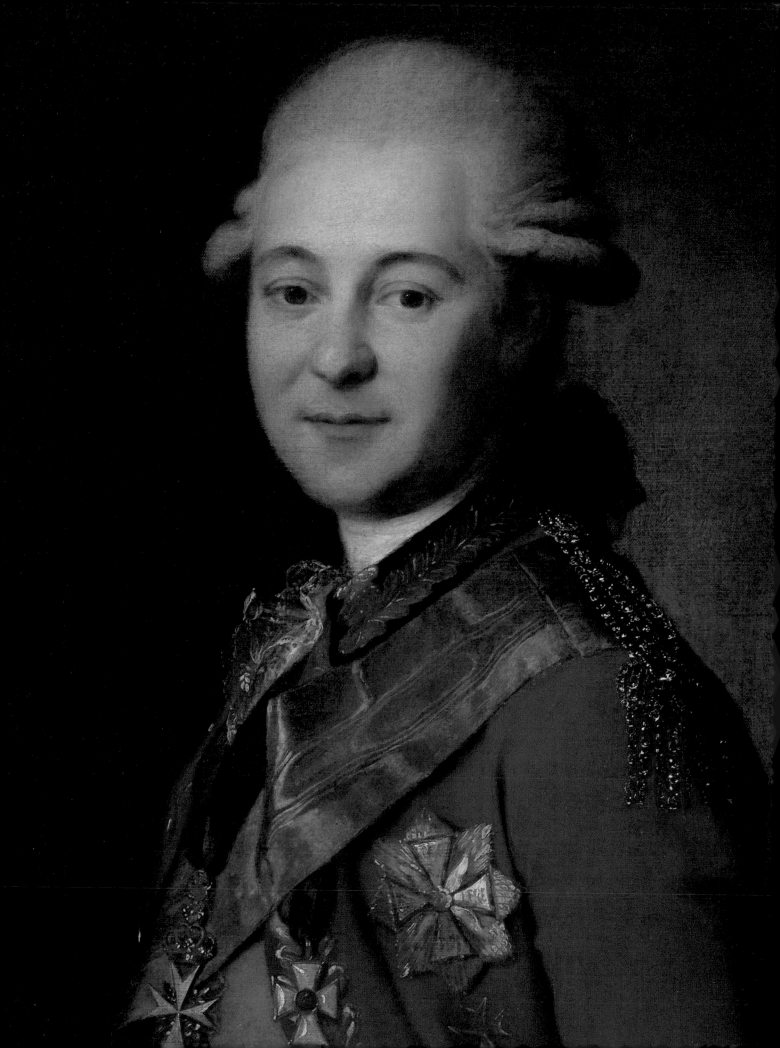

-<<< 22 >>>-

PORTRAIT OF COUNT ALEXANDER
MATVEEVICH DMITRIEV-MAMONOV
AFTER M.SHIBANOV
OIL ON CANVAS. 71.4 X 59 CM
DMITRIEV-MAMONOV (1758-1803),
A YOUNG GUARDS OFFICER -
GENERAL-ADJUTANT - AND AN AIDE OF
POTEMKIN'S, HAD AN AFFAIR WITH THE
EMPRESS WHO WAS NEARLY THIRTY
YEARS HIS SENIOR. HE WAS SHOWERED
WITH TITLES AND GIFTS BUT THE
RELATIONSHIP ENDED IN 1789 WHEN HE
MARRIED A RUSSIAN PRINCESS AFTER A
SECRET LIAISON.

-<<<->>>-

-<<< 23 >>>-

PORTRAIT OF
ALEXANDER IL'ICH BIBIKOV, 1770S
ARTIST UNKNOWN
OIL ON CANVAS. 143 X 106 CM
A DISTINGUISHED LIEUTENANT-GENERAL,
BIBIKOV (1729-74) ALSO PLAYED A
LEADING ROLE IN THE LEGISLATIVE
COMMISSION, CATHERINE'S ATTEMPT
TO OVERHAUL RUSSIA'S LEGAL SYSTEM.
HE WAS RESPONSIBLE FOR
SUPPRESSING PUGACHEV'S PEASANT
UPRISING OF 1773-74.

-<<<->>>-

-<<< 21 >>>-

PORTRAIT OF SEMEON GAVRILOVICH
ZORICH, LATE 18TH CENTURY
ARTIST UNKNOWN
OIL ON CANVAS. 54.7 X 44.5 CM
SERBIAN BY BIRTH, ZORICH (1745-99)
FOUGHT BRAVELY WITH THE RUSSIAN
ARMY. FOR A BRIEF SPELL IN 1777-78
HE WAS CATHERINE'S FAVORITE.

-<<<->>>-

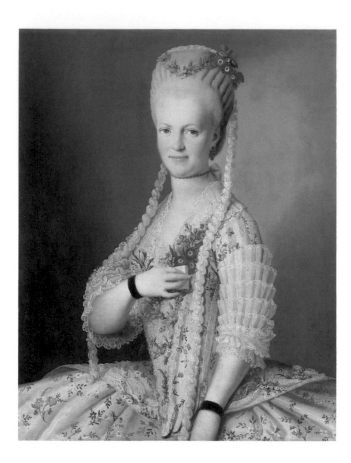

-<<< 24 >>>-

PORTRAIT OF SARA GREIG, 1770S
CARL-LUDWIG CHRISTINEK
OIL ON CANVAS. 90 X 73.5 CM
BORN INTO A BRITISH FAMILY,
SARA GREIG (1752-93) WAS THE WIFE OF
ADMIRAL GREIG, A SCOTSMAN SERVING
IN THE RUSSIAN NAVY. HE WAS KILLED
IN ACTION IN 1788 AFTER WINNING
FAME AS A COMMANDER IN THE
TURKISH AND SWEDISH WARS.

-<<<->>>-

-<<< 25 >>>-

PORTRAIT OF BARONESS NATALIA
MIKHAILOVNA STROGONOVA
CARL-LUDWIG CHRISTINEK
OIL ON CANVAS. 57 X 49 CM
NATALIA STROGONOVA (1743-1819)
WAS THE WIFE OF BARON
S.N.STROGANOV, A MEMBER OF THE
VASTLY RICH AND POWERFUL
STROGANOV FAMILY.

-<<<->>>-

-<<< 26 >>>-

PORTRAIT OF PRINCE PLATON

ALEXANDROVICH ZUBOV

ENGRAVED BY JAMES WALKER (1748-1808)

AFTER THE ORIGINAL PAINTING BY

GIOVANNI BATTISTA LAMPI, 1790S

39.5 X 28.5 CM

ZUBOV (1767-1822) WAS THE LAST

OF CATHERINE'S YOUNG FAVORITES

AND EXERCIZED CONSIDERABLE

POLITICAL INFLUENCE DURING THE

FINAL YEARS OF HER REIGN. HE TOOK

PART IN THE COUP OF 1801 WHICH

SAW THE OVERTHROW AND DEATH

OF HER SON, PAUL I.

-<<<->>>-

-<<< 27 >>>-

PORTRAIT OF

CATHERINE SERGEEVNA SAMOILOVA

GIOVANNI BATTISTA LAMPI

OIL ON CANVAS. 104.5 X 82.5 CM

CATHERINE SAMOILOVA (1763-1830),

WAS THE WIFE OF ALEXANDER

SAMOILOV AND ONE OF CATHERINE'S

LADIES IN WAITING FROM 1782.

-<<<->>>-

-<<< 28 >>>-

PORTRAIT OF ALEXANDER

NIKOLAEVICH SAMOILOV, C.1796

GIOVANNI BATTISTA LAMPI

OIL ON CANVAS. 108 X 89 CM

SAMOILOV (1744-1814) SERVED

CATHERINE AS PROCURATOR-GENERAL

AND FINANCE MINISTER.

-<<<->>>-

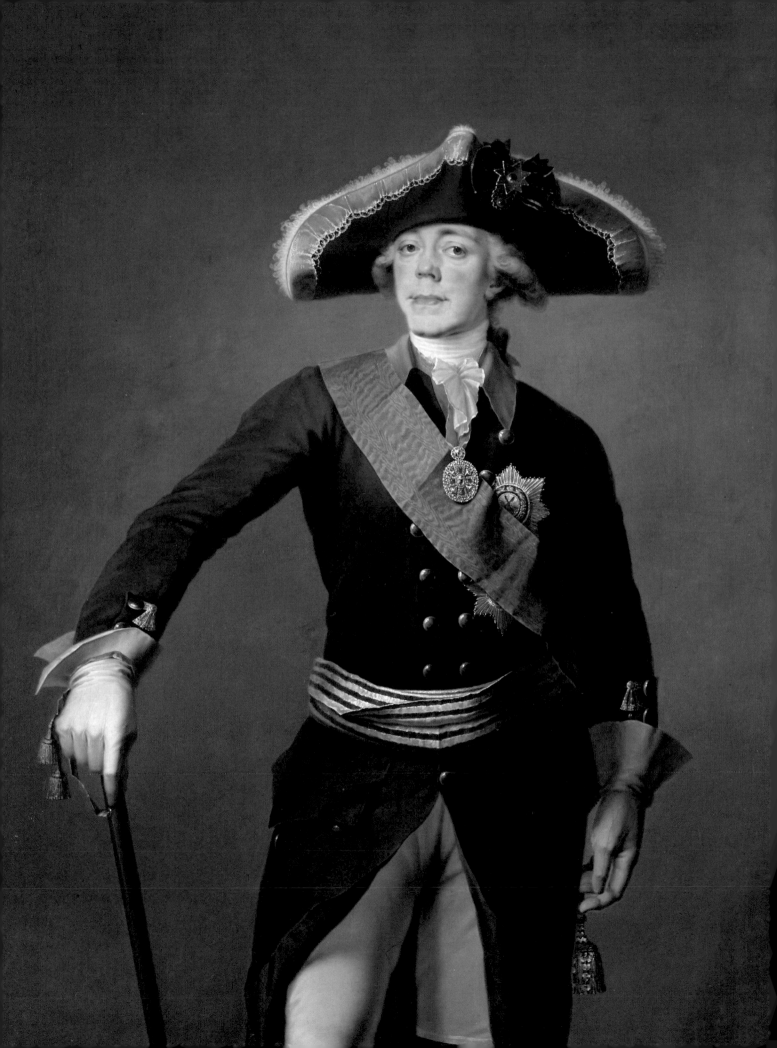

-<<< 30 >>>-
PORTRAIT OF
EMPRESS MARIA FEODOROVNA,
LATE 18TH CENTURY
AFTER GIOVANNI BATTISTA LAMPI
OIL ON CANVAS. 74 X 57 CM
MARIA FEODOROVNA (1759-1828),
BORN INTO THE ROYAL FAMILY OF
WURTTEMBURG, WAS MARRIED IN 1774
TO THE GRAND DUKE PAUL, THEN
HEIR TO THE THRONE, AFTER THE
DEATH OF HIS FIRST WIFE. SHE WAS
CONSIDERED GOOD-NATURED AND
BEAUTIFUL AND THE MARRIAGE
PROVED A SUCCESS.
-<<<->>>-

-<<< 31 >>>-
PORTRAIT OF THE
GRAND DUCHESS ELENA, BEFORE 1799
VLADIMIR LUKICH BOROVIKOVSKII
(1757-1825)
OIL ON CANVAS. 72 X 58 CM
ELENA PAVLOVNA (1784-1825) WAS THE
SECOND DAUGHTER OF PAUL I AND
THE EMPRESS MARIA FEODOROVNA.
IN 1799, SHE MARRIED THE CROWN
PRINCE OF MECKLENBURG-SCHWERIN.
-<<<->>>-

-<<< 29 >>>-
PORTRAIT OF PAUL I, 1796-97
STEPAN SEMEONOVICH SHUKIN
(1762-1828)
OIL ON CANVAS. 154 X 116 CM
PAUL I (1754-1801), CATHERINE'S SON
BY HER MARRIAGE TO PETER III,
SUCCEEDED TO THE THRONE ON HER
DEATH IN 1796. PAUL'S RELATIONS
WITH HIS MOTHER WERE UNEASY AND
AFTER HIS ACCESSION HE SET ABOUT
REVERSING MUCH OF HER WORK.
HE WAS DEPOSED AND MURDERED IN
A PALACE COUP IN 1801.
-<<<->>>-

-<<< 32 >>>-

PORTRAIT OF

THE GRAND DUKE PAUL

(LATER PAUL I). 1770S.

JOHANN GEORG CASPAR JAEGER

MARBLE AND SLATE IN ORMOLU FRAME.

24.5 X 19.5 CM

-<<<->>>-

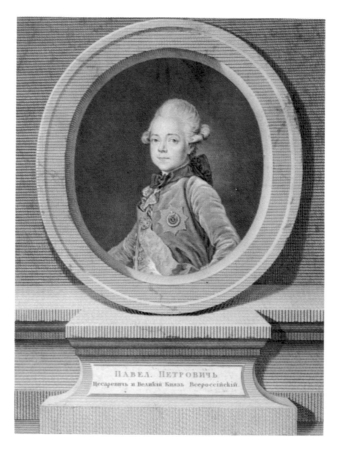

-<<< 33 >>>-

PORTRAIT OF THE

GRAND DUKE PAUL AS A CHILD

ENGRAVED BY FRANCOIS ANTOINE

RADIGUES (1719/21-1809) IN

1773 AFTER THE 1771 ORIGINAL BY

JEAN LOUIS VOILLE (1744-69)

43.5 X 30 CM

-<<<->>>-

-<<< 34 >>>-

PORTRAIT OF THE GRAND DUKE

CONSTANTINE AS A CHILD

AFTER ROKOTOV

OIL ON CANVAS. 63. 5 X 50 CM

THE SECOND SON OF PAUL I,

CONSTANTINE (1779-1831) PURSUED

A MILITARY CAREER. ON THE DEATH

OF HIS BROTHER, ALEXANDER I,

HE RENOUNCED ANY CLAIM TO

THE THRONE.

-<<<->>>-

-<<< 35 >>>-

DECORATIVE PLAQUE WITH PORTRAIT OF
THE GRAND DUKE ALEXANDER
AS A CHILD. KHOLMOGORYI, ARCHANGEL
PROVINCE, LATE 18TH CENTURY.
CARVED WALRUS TUSK. 12 X 9 CM
DECORATIVE PLAQUES INCORPORATING
PORTRAIT MINIATURES WERE POPULAR
AMONG THE RUSSIAN ARISTOCRACY
OF CATHERINE'S DAY. CATHERINE DOTED
ON HER YOUNG GRANDSON, ALEXANDER
PAVLOVICH (1777-1825) , AND TOOK
CHARGE OF HIS UPBRINGING. HE WAS
EVENTUALLY TO COME TO THE THRONE
AS ALEXANDER I IN 1801.

-<<<->>>-

-<<< 36 >>>-

THE GRAND DUKE ALEXANDER'S
TOY DRUM, C.1782
LEATHER, SILVER, GOLD.
15.5 X 15.5 X 15 CM
ON THE SIDE IS A PORTRAIT IN PROFILE
OF THE FUTURE GUSTAV IV OF SWEDEN
WHO WAS THEN COURTING -
UNSUCCESSFULLY - CATHERINE'S
GRANDDAUGHTER, ALEXANDRA.

-<<<->>>-

-<<< 37 >>>-

INKSTAND WITH TWO CANDLESTICKS
ST PETERSBURG, 1780S
SILVER, GILDING.
INKSTAND HEIGHT 6.1 CM
CANDLESTICK HEIGHTS 12.8 & 12.4 CM
THE THREE PIECES ARE FROM A
WRITING SET PRESENTED BY CATHERINE
TO HER GRANDSON,
THE GRAND DUKE ALEXANDER.

-<<<->>>-

-<<< 38 >>>-
FORMAL DRESS OF
THE GRAND DUKE ALEXANDER
ST PETERSBURG, 1784
SILK EMBROIDERED WITH GOLD AND
OTHER METAL THREAD.
JACKET LENGTH 76 CM
WAISTCOAT 53 CM
BREECHES 44 CM
THE OUTFIT, DESIGNED FOR
THE GRAND DUKE AT THE AGE
OF SEVEN, WOULD HAVE BEEN WORN
FOR FORMAL OCCASIONS.
-<<<->>>-

-<<< 39 >>>-
ARMCHAIR FOR THE PRESIDENT
OF THE ARMY COLLEGE
ST PETERSBURG, C.1784
GILDED WOOD, VELVET WITH
GOLD EMBROIDERED BANDS.
153 X 75 X 68 CM
THE CHAIR WAS APPARENTLY DESIGNED
FOR POTEMKIN WHEN HE WAS
PRESIDENT OF THE COLLEGE.
-<<<->>>-

-<<< 40 >>>-
ARMCHAIR OF
THE EMPRESS MARIA FEODOROVNA
ST PETERSBURG, LATE 18TH CENTURY
GILDED WOOD, WOOL AND
SILK, EMBROIDERY ON CANVAS.
99 X 77 X 66 CM
THE CHAIR IS THOUGHT TO HAVE
BEEN USED BY THE EMPRESS IN HER
CAPACITY AS PATRON OF THE SMOLNY
INSTITUTE, A SCHOOL IN ST PETERSBURG
FOR THE DAUGHTERS OF THE NOBILITY.
MARIA FEODOROVNA INSTITUTED
THE TEACHING OF EMBROIDERY
AND THE PUPILS MAY HAVE WORKED
ON THIS CHAIR.
-<<<->>>-

-<<< 41 >>>-

CATAFALQUE WITH THE COFFINS OF

PETER III AND CATHERINE II IN

THE WINTER PALACE, 1796-97

ENGRAVED BY AN UNKNOWN ARTIST

55 X 47.5 CM

PAUL I CAME TO THE THRONE

DETERMINED TO REDRESS THE WRONGS

DONE TO HIS FATHER, PETER III.

HE AT ONCE ORDERED THAT PETER'S

COFFIN SHOULD BE DISINTERRED FROM

THE NEVSKII MONASTERY WHERE IT

HAD BEEN BURIED AFTER HIS MURDER

AND TAKEN TO THE WINTER PALACE

TO BE LAID BESIDE CATHERINE'S.

THE TWO WERE THEN BURIED SIDE BY

SIDE AT THE SS PETER AND PAUL

CATHEDRAL IN ST PETERSBURG.

-<<<->>>-

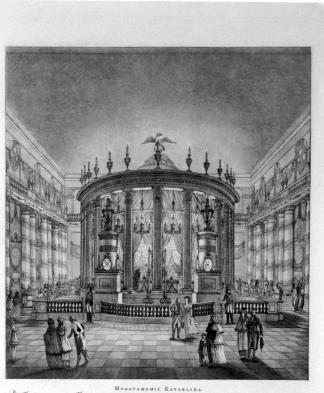

Изображеніе Катафалка
Въ Залѣ могшешищихъ Государей ИМПЕРАТОРА ПЕТРА ТРЕТЬЯГО и ИМПЕРАТРИЦЫ ЕКАТЕРИНЫ ВТОРЫЯ
устроеннаго въ Зимнемъ Дворцѣ

-<<< 42 >>>-

STATE CARRIAGE

GOBELINS FACTORY, FRANCE. C.1700-25

OAK, BEECH, ASH, PINE, IRON, STEEL,

COPPER, BRONZE, SILVER, GLASS,

LEATHER, CLOTH.

700 X 250 X 300 CM

INVENTORIES SUGGEST THAT THE

COACH WAS ORDERED BY PETER THE

GREAT WHEN HE VISITED THE GOBELINS

WORKS AND THAT IT WAS FIRST USED

FOR THE CORONATION OF HIS WIFE,

CATHERINE, IN 1724. THE PAINTING

WORK APPEARS TO BE BY THE FAMOUS

FRENCH ARTIST, FRANCOIS BOUCHER.

THE COACH WAS LATER USED FOR THE

CORONATION OF CATHERINE II AND

SUCCEEDING EMPERORS. IT WAS

RESTORED IN 1856 IN TIME FOR THE

CORONATION OF ALEXANDER II.

-<<<->>>-

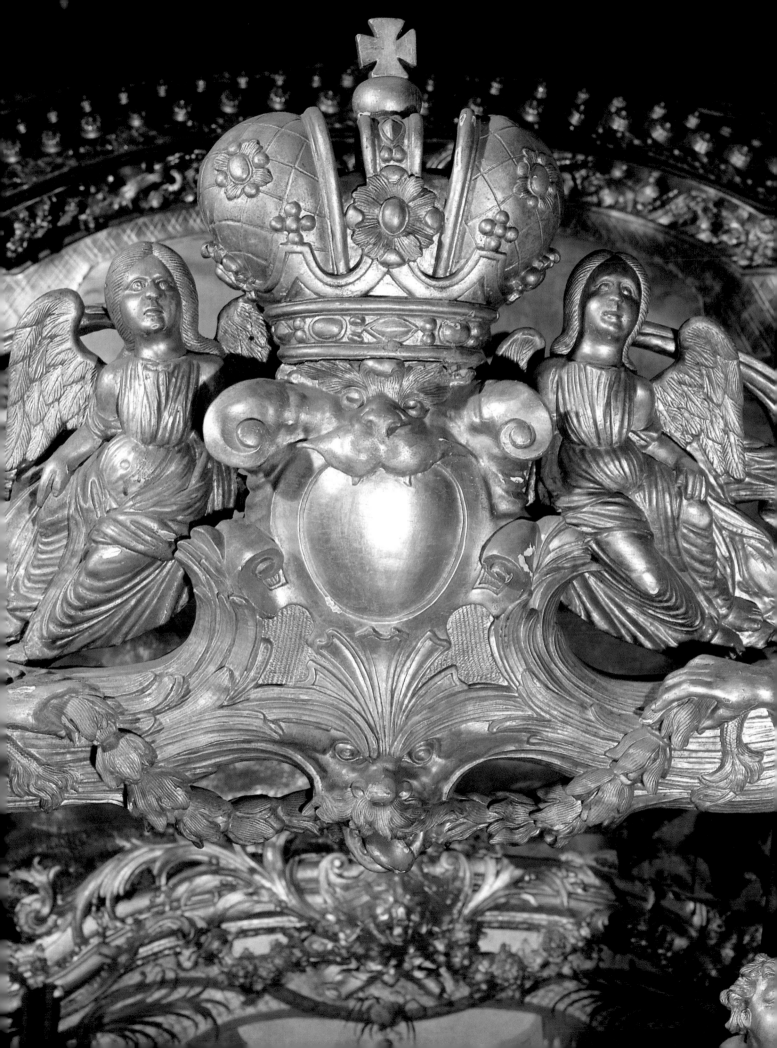

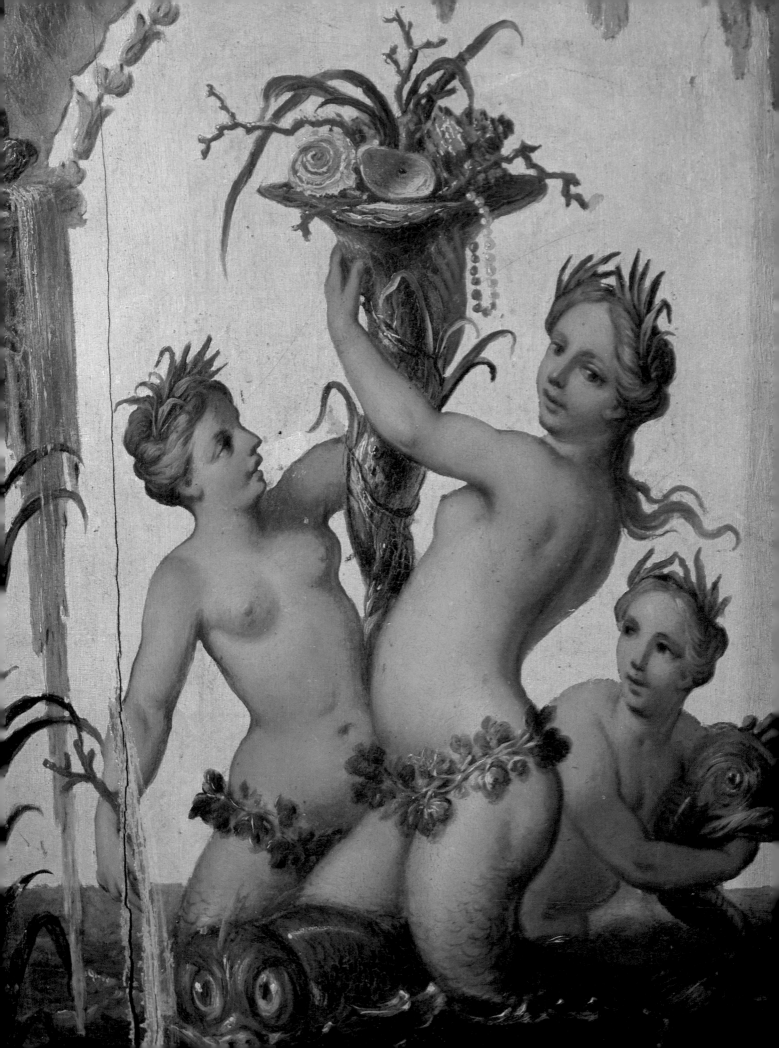

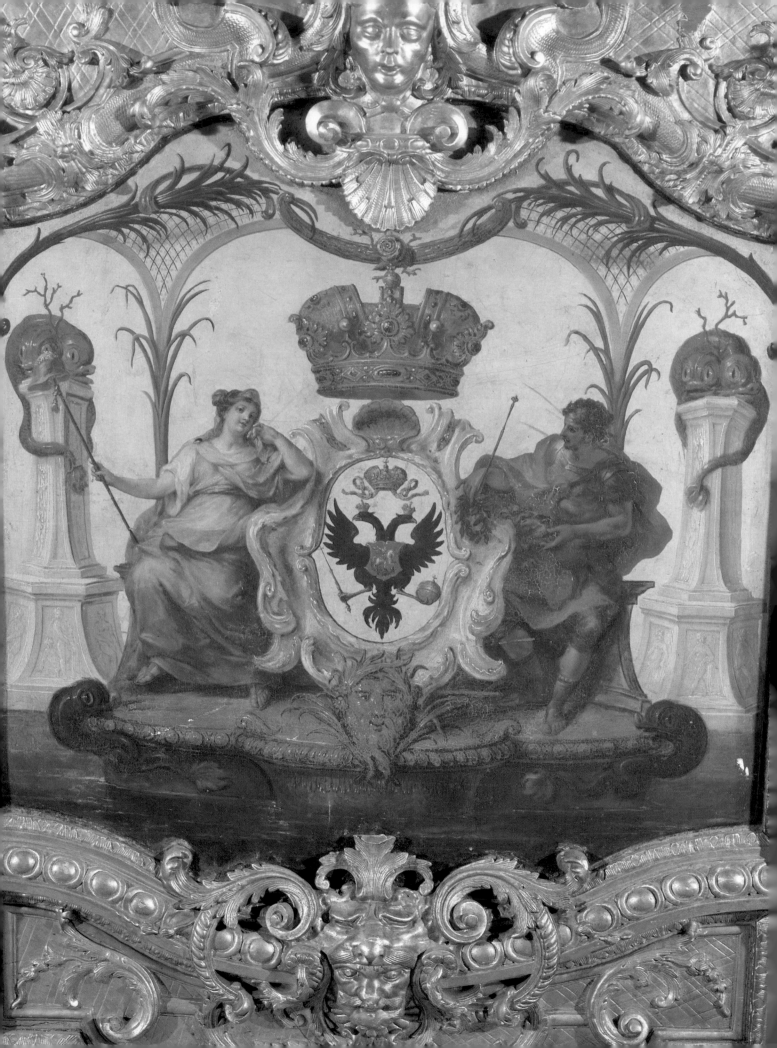

CATHERINE THE GREAT
THE CULTURAL HERITAGE

ЗАПИСКИ

КАСАТЕЛЬНО

РОССІЙСКОЙ

ИСТОРІИ.

ЧАСТЬ I.

Въ Санктпетербургѣ.
Печатано въ Императорской Типографіи,
1787 года

-<<< 1 >>>-

NOTES ON RUSSIAN HISTORY
IMPERIAL PRINTING HOUSE,
ST PETERSBURG, 1787-94
RED LEATHER STAMPED WITH GOLD.
22.15 X 15 CM
CATHERINE HERSELF COMPOSED THE
NOTES FOR THE INSTRUCTION OF HER
GRANDCHILDREN. SHE COMPLAINED
THAT MOST HISTORIES OF RUSSIA HAD
BEEN WRITTEN BY FOREIGNERS WHO
HAD NO ACCESS TO THE ARCHIVE
MATERIALS OR HAD A POOR GRASP OF
THE LANGUAGE. BY CONTRAST,
CATHERINE MADE LAVISH USE OF
SOURCE MATERIAL AND ATTEMPTED
TO DISTINGUISH FACT FROM MYTH.

-<<<->>>-

СОБЕСѢДНИКЪ
ЛЮБИТЕЛЕЙ
РОССІЙСКАГО СЛОВА,
Содержащій разныя сочиненія въ сти-
хахъ и въ прозѣ нѣкоторыхъ Россій-
скихъ писателей.
ЧАСТЬ II.

Въ САНКТПЕТЕРБУРГѢ,
иждивеніемъ Императорской Академіи Наукъ
1783 года.

-<<<->>>-

FOUR BOOKS FROM THE IMPERIAL
HERMITAGE LIBRARY,
CATHERINE'S OWN COLLECTION.

-<<<->>>-

-<<< 2 >>>-

THE RUSSIAN LANGUAGE LOVERS'
COMPANION (PART 2)
PUBLISHED BY THE ACADEMY OF
SCIENCES, ST PETERSBURG, 1783
RED LEATHER BINDING STAMPED WITH
GOLD. 192 PAGES, 20.5 X 12.5CM
THE COMPANION, A LITERARY MAGAZINE
PUBLISHED EACH MONTH, WAS RUN BY
CATHERINE WITH THE HELP OF
PRINCESS DASHKOVA.
THE EMPRESS HERSELF WAS A MAJOR
CONTRIBUTOR.

-<<<->>>-

-<<< 3 >>>-

FOUNDATION STATUTES OF
THE IMPERIAL ORPHANAGE AND
LYING-IN HOSPITAL FOR POOR
MOTHERS IN MOSCOW
PUBLISHED BY THE ACADEMY OF
SCIENCES, ST PETERSBURG, 1763
RED LEATHER BINDING
STAMPED WITH GOLD. 18.5 X 12 CM
THE HOSPITAL WAS ESTABLISHED
IN 1764 ON THE INITIATIVE OF
IVAN BETSKOI WITH CONSIDERABLE
FINANCIAL SUPPORT FROM CATHERINE,
WHO WAS KEEN TO ENCOURAGE
BETTER HEALTH CARE.

-<<<->>>-

-<<< 4 >>>-

AN ANCIENT RUSSIAN BIBLIOGRAPHY
1773-75. LEATHER BINDING.
19 X 12 CMS
THE WORK, COMPILED BY THE
INDEPENDENT PUBLISHER
NIKOLAI IVANOVICH NOVIKOV,
REPRODUCED HISTORIC DOCUMENTS
AND MANUSCRIPTS FROM THE MAJOR
RUSSIAN ARCHIVES AS WELL AS FROM
CATHERINE'S PRIVATE LIBRARIES. THIS
EDITION BELONGED TO CATHERINE'S
FAVORITE, ALEXANDER LANSKOI.

-<<<->>>-

-<<< 5 >>>-

THE INITIAL INSTRUCTION OF OLEG
SCHOOL OF MINING PRINTING HOUSE,
ST PETERSBURG, 1791
RED LEATHER BINDING
STAMPED WITH GOLD. 41 X 27 CM
CATHERINE WAS HERSELF AN
OCCASIONAL PLAYWRIGHT AND
LIBRETTIST. SHE BASED *THE INITIAL
INSTRUCTION OF OLEG* ON
THE LIFE OF THE 10TH CENTURY
RUSSIAN PRINCE OLEG. IT WAS NEVER
PERFORMED AS A PLAY BUT, IN 1791,
WAS SET TO MUSIC AS AN OPERATIC
BALLET. THE PIECE, WRITTEN AGAINST
THE BACKGROUND OF THE RUSSO-
TURKISH WARS, HAD A CLEAR
PROPAGANDA MESSAGE AS ITS HERO,
PRINCE OLEG, LED A SUCCESSFUL
ASSAULT ON THE BYZANTINE EMPIRE.

-<<<->>>-

-<<< 6 >>>-

*A BRIEF RUSSIAN CHRONICLE WITH
GENEALOGY*
MIKHAIL VASIL'EVICH LOMONOSOV
(1711-65). PUBLISHED BY
THE ACADEMY OF SCIENCES, 1760
18TH CENTURY BINDING.
87 PAGES, 18 X 12.5 CM
LOMONOSOV'S CHRONICLE INCLUDES
A COMPLETE DYNASTIC HISTORY OF
RUSSIA'S RULING FAMILIES FROM THE
DAYS OF RURIK, THE COUNTRY'S
SUPPOSED FOUNDER. IT ALSO
CONTAINS HIS POEMS TO THE
GRAND DUKE PETER, THE FUTURE
PETER III.

-<<<->>>-

Façade de la Scène

-<<< 7 >>>-

THE HERMITAGE THEATER:
AN ALBUM OF ENGRAVINGS, 1787
UNKNOWN ENGRAVER
AFTER ORIGINAL DRAWINGS BY
GIACOMO QUARENGHI
64.5 X 45.5 CM
THE ALBUM IS DEVOTED LARGELY
TO QUARENGHI'S DESIGNS FOR THE
COURT THEATER, BUILT BETWEEN 1773
AND 1789. THE EMPRESS' OWN PLAYS
WERE PERFORMED HERE.

-<<<->>>-

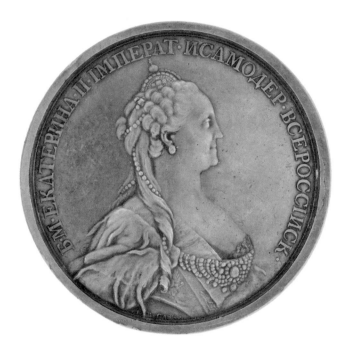

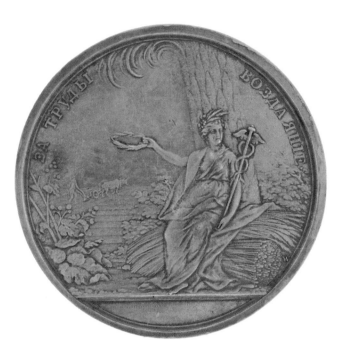

-<<< 8 >>>-

COMMEMORATIVE MEDAL OF THE
FREE ECONOMIC SOCIETY, AFTER 1765
JOHANN GEORG WAECHTER AND
JOHANN GASS
SILVER. DIA 66 MM
THE FREE ECONOMIC SOCIETY WAS
FOUNDED IN 1765 BY A GROUP OF
ENLIGHTENED ARISTOCRATS INFLUENCED
BY THE IDEAS OF THE FRENCH
'PHYSIOCRATS'. IT SET OUT TO
PROMOTE LIBERAL IDEAS ON THE
ECONOMY, FREE TRADE, AGRICULTURE
AND OTHER TOPICS.
-<<<->>>-

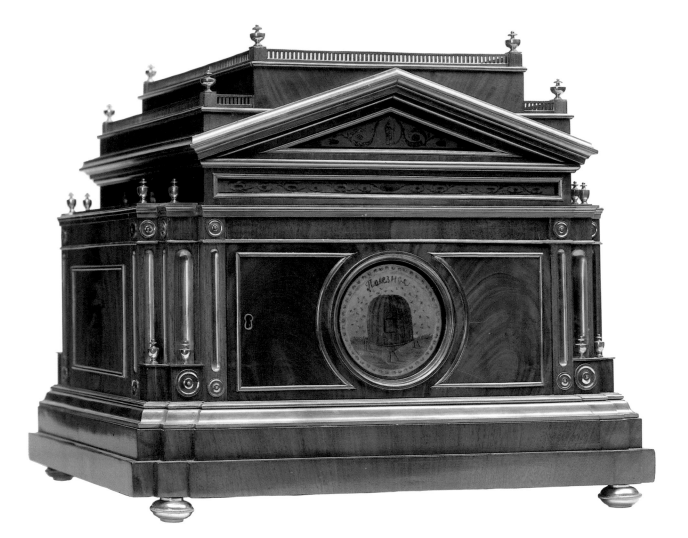

-<<< 9 >>>-

THE COFFER OF THE

FREE ECONOMIC SOCIETY

ST PETERSBURG, 1765-66.

MAHOGANY AND BRONZE.

47 X 59 X 40 CM

CATHERINE WAS A KEEN PATRON

OF THE SOCIETY AND THIS BOX

MAY HAVE CONTAINED HER ORIGINAL

GIFT OF 6,000 GOLD COINS. IT CARRIES

HER PERSONAL MOTIF AND MOTTO:

A BEEHIVE AND THE WORD 'USEFUL'.

-<<<->>>-

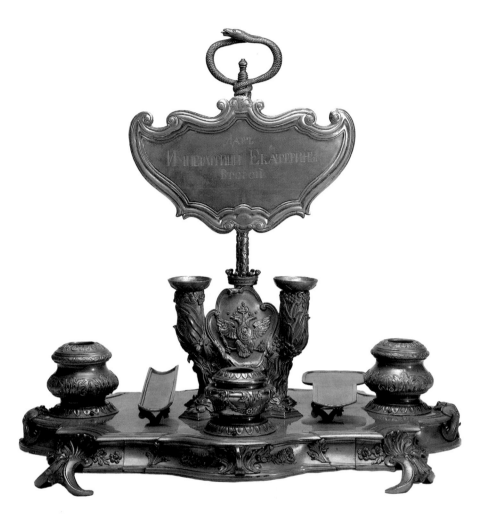

-<<< 10 >>>-
WRITING SET
TROITSKII WORKS, URAL, RUSSIA, C.1771
COPPER. 47 X 48 X 38 CM
THE SET WAS PRESENTED TO CATHERINE
BY A FACTORY OWNER ON HIS
ADMISSION TO THE FREE ECONOMIC
SOCIETY. THE EMPRESS LATER GAVE IT
TO THE SOCIETY. IT INCORPORATES
CANDLESTICKS, INKWELLS AND
PEN TRAYS. THE INSCRIPTION READS:
'A GIFT TO THE EMPRESS CATHERINE II.
URAL 1771. TROITSKII WORKS OF
A.F.TURCHANINOV'.
-<<<->>>-

-<<< 11 >>>-
TOKENS OF THE
FREE ECONOMIC SOCIETY
ST PETERSBURG, C.1770
GOLD. 3.3 X 3.3 CM
THE TOKENS WERE DISTRIBUTED
AMONG THE SOCIETY'S MEMBERS.
ON THE REVERSE ARE CATHERINE'S
MOTTO AND BEEHIVE EMBLEM.
-<<<->>>-

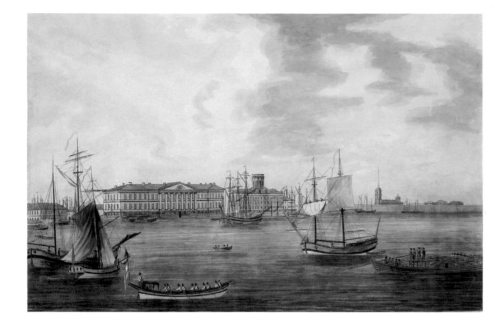

-<<< 12 >>>-

A VIEW OF ST PETERSBURG
FROM THE NEVA, 1789
ENGRAVED BY THOMAS MALTON
FROM AN ORIGINAL DRAWING
BY JOSEPH HEARN
AQUATINT, WATERCOLOR.
33.7 X 50.8 CM
THE ACADEMY OF SCIENCES, COMPLETED
IN 1789, IS SHOWN AT THE
CENTER OF THE PICTURE. TO THE
RIGHT ARE THE KUNSTKAMERA,
THE PUBLIC MUSEUM OPENED BY
PETER THE GREAT, AND
THE PETER AND PAUL FORTRESS.

-<<<->>>-

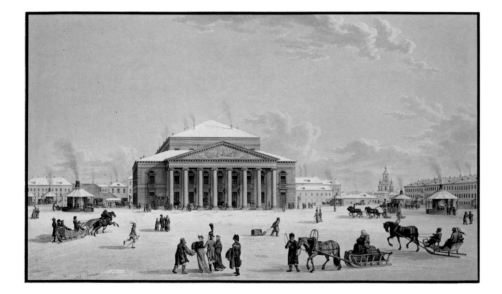

-<<< 13 >>>-

A VIEW OF THE BOLSHOI THEATER,
ST PETERSBURG
ENGRAVED BY GABRIEL OR
MATTHIAS LORY, EARLY 1800S
AFTER AN ORIGINAL PAINTING BY
JOHANN GEORG DE MAYR, 1790S
SKETCH ENGRAVING, WATERCOLOR.
46.3 X 73.5 CM
THE BOLSHOI THEATER, DESIGNED BY
RINALDI, WAS COMPLETED IN 1783 FOR
PERFORMANCES OF OPERA AND BALLET.
IT WAS DESTROYED BY FIRE IN 1811 BUT
LATER REBUILT. THE SHEDS ON EITHER
SIDE WERE USED BY COACHMEN
WAITING TO COLLECT THEIR MASTERS.

-<<<->>>-

КНЯГИНЯ ЕКАТЕРИНА РОМАНОВНА ДАШКОВА

Урожденная Графиня Воронцова, обер Его Императорскаго Величества Гофмейстерина ордена Св. Екатерины первой степени Кавалерь, Императорской Академии наукъ и Россійской Императорской Академіи Члень Стокгольмской Академіи, Дублинскаго Общества, Берлинскаго, Санктпетербургскаго Экономическаго Берлинскаго Любителей Натуральной Исторіи, Филодельфискаго въ Филаделфіи и Московскаго Императорскаго Университета Члень

-<<< 14 >>>-

PORTRAIT OF PRINCESS CATHERINE
ROMANOVNA DASHKOVA IN EXILE
ENGRAVED BY ALEXEI AGAPIEVICH
OSIPOV (1717-91)
AFTER THE ORIGINAL BY
NIKOLAI IVANOVICH TONCHI,
(SALVATORE TONCI), 1796. 50.6 X 35.5 CM
PRINCESS DASHKOVA (1733-1810) WAS
ONE OF CATHERINE'S EARLIEST
SUPPORTERS, TAKING AN ACTIVE PART
IN THE 1762 COUP. HER WIDERANGING
INTERESTS IN SCIENCE AND THE ARTS
EARNED HER THE POST OF DIRECTOR
OF THE ACADEMY OF SCIENCES.
SHE WAS ALSO PRESIDENT OF THE
RUSSIAN ACADEMY, SUPERVIZING WORK
ON THE FIRST RUSSIAN DICTIONARY.
AFTER CATHERINE'S DEATH SHE SPENT
SEVERAL YEARS IN INTERNAL EXILE.

-<<<->>>-

ІВАНЪ ПЕРФИЛЬЕВИЧЪ ЕЛАГИНЪ,

Эгора Ея Императорскаго Величества Оберъ Гофмейстеръ, Кабинета членъ Сенаторъ и разныхъ орденовъ Кавалеръ, родился 1725 году, ноября 30го, служить началъ съ 1743го ноября 25го и продолжилъ по день смерти его 1793го сентября 22го

-<<< 15 >>>-

PORTRAIT OF
IVAN PERFILIEVICH ELAGIN, 1790S
ENGRAVED BY
JOHANN CHISTOPH DE MAYR
AFTER AN ORIGINAL BY
JEAN LOUIS VOILLE
MEZZOTINT. 46.7 X 33 CM
ELAGIN (1725-93) WAS A FRIEND OF
CATHERINE WHO SERVED HER NOT
ONLY AS SECRETARY BUT ALSO AS
DIRECTOR OF SPECTACLES AND
MUSIC AT COURT. HE WAS A WRITER
HIMSELF AND PATRON TO MANY
OF RUSSIA'S YOUNG PLAYWRIGHTS
OF THE PERIOD.

-<<<->>>-

-<<< 16 >>>-

PORTRAIT OF AN UNKNOWN MAN, 1780S

DMITRI GRIGORIEVICH LEVITSKII

(1735-1822)

OIL ON CANVAS. 83 X 68 CM

FOR EIGHTEEN YEARS LEVITSKII HEADED

THE PORTRAIT CLASS AT THE ACADEMY

OF ARTS, INFLUENCING A GENERATION

OF ARTISTS.

-<<<->>>-

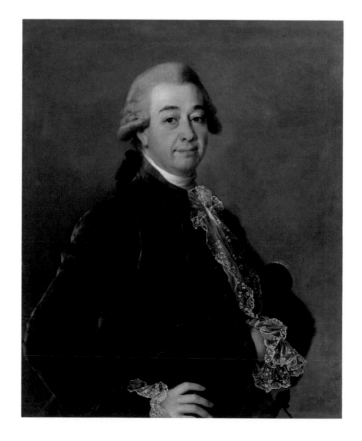

-<<< 17 >>>-

PORTRAIT OF

GAVRIIL ROMANOVICH DERZHAVIN, 1790S

IVAN SMIRNOVSKII

OIL ON CANVAS. 69.5 X 56 CM

DERZHAVIN (1743-1816) WAS AMONG

THE FOREMOST POETS OF THE DAY AS

WELL AS WORKING AS A SENIOR

OFFICIAL UNDER CATHERINE II.

HE ALSO SERVED HER SON, PAUL I, AS

PROCURATOR GENERAL AND HER

GRANDSON, ALEXANDER I, AS MINISTER

OF JUSTICE.

-<<<->>>-

-<<< 18 >>>-
BUST OF VOLTAIRE, 1770S
SCULPTOR UNKNOWN
MARBLE. 48 X 28 CM
FRANCOIS MARIE AROUET (1694-1778),
BETTER KNOWN AS VOLTAIRE, WAS
AMONG THE LEADING THINKERS OF
THE 'ENLIGHTENMENT'. HE WAS A
PHILOSOPHER, POET, DRAMATIST AND
AUTHOR, WHO WAS FIERCELY CRITICAL
OF THE CHURCH AND THE ARBITRARY
AND DESPOTIC GOVERNMENT OF
HIS NATIVE FRANCE. HE WAS AN
ADMIRER OF BOTH PETER THE GREAT
AND CATHERINE, WITH WHOM HE KEPT
UP A LONG CORRESPONDENCE.
-<<<->>>-

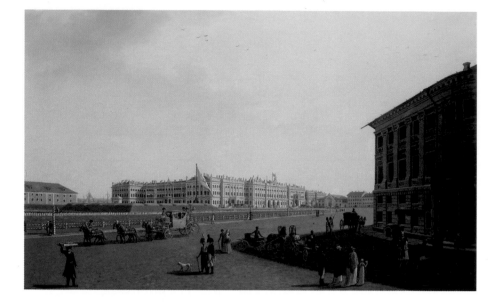

-<<< 19 >>>-

VIEW OF PALACE SQUARE FROM

NEVSKII PROSPEKT, 1801

BENJAMIN PATERSSEN (1750-1815)

OIL ON CANVAS. 64 X 99 CM

IN THE CENTER CAN BE SEEN THE

WINTER PALACE, FLANKED ON THE

LEFT BY OLD EARTHWORKS IN FRONT

OF THE ADMIRALTY BUILDINGS.

-<<<->>>-

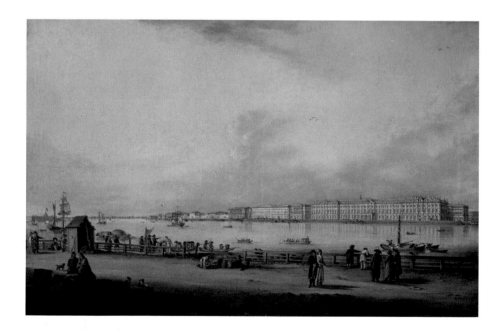

-<<< 20 >>>-

VIEW OF THE PALACE EMBANKMENT,

ST PETERSBURG, FROM

VASIL'EVSKII ISLAND, 1799

JOHANN GEORG DE MAYR (1760-1816)

OIL ON CANVAS. 76 X 117 CM

THE PICTURE, ONE OF THE BEST-KNOWN

AND MOST IMPOSING ASPECTS OF

ST PETERSBURG, SHOWS (FROM RIGHT),

THE WINTER PALACE, THE SMALL

HERMITAGE, THE OLD HERMITAGE

AND THE HERMITAGE THEATER.

MANY OF THE BUILDINGS ALONG THE

EMBANKMENT WERE COMMISSIONED

BY CATHERINE.

-<<<->>>-

-<<< 21 >>>-

PORTRAIT OF NIKOLAI IVANOVICH NOVIKOV,

AFTER 1797

AFTER DMITRI GRIGORIEVICH LEVITSKII

OIL ON CANVAS. 73.7 X 69.7 CM

A PROMINENT LIBERAL AND INDEPENDENT

PUBLISHER, NOVIKOV (1744-1818) WAS JAILED IN

1792 AND ONLY FREED AFTER CATHERINE'S

DEATH. HE WAS A FREEMASON AT A TIME WHEN

FREEMASONARY WAS ASSOCIATED WITH

DANGEROUS RADICALISM AND FOREIGN

INFLUENCES. NOVIKOV ALARMED THE

AUTHORITIES WITH HIS ATTACKS ON SERFDOM.

-<<<->>>-

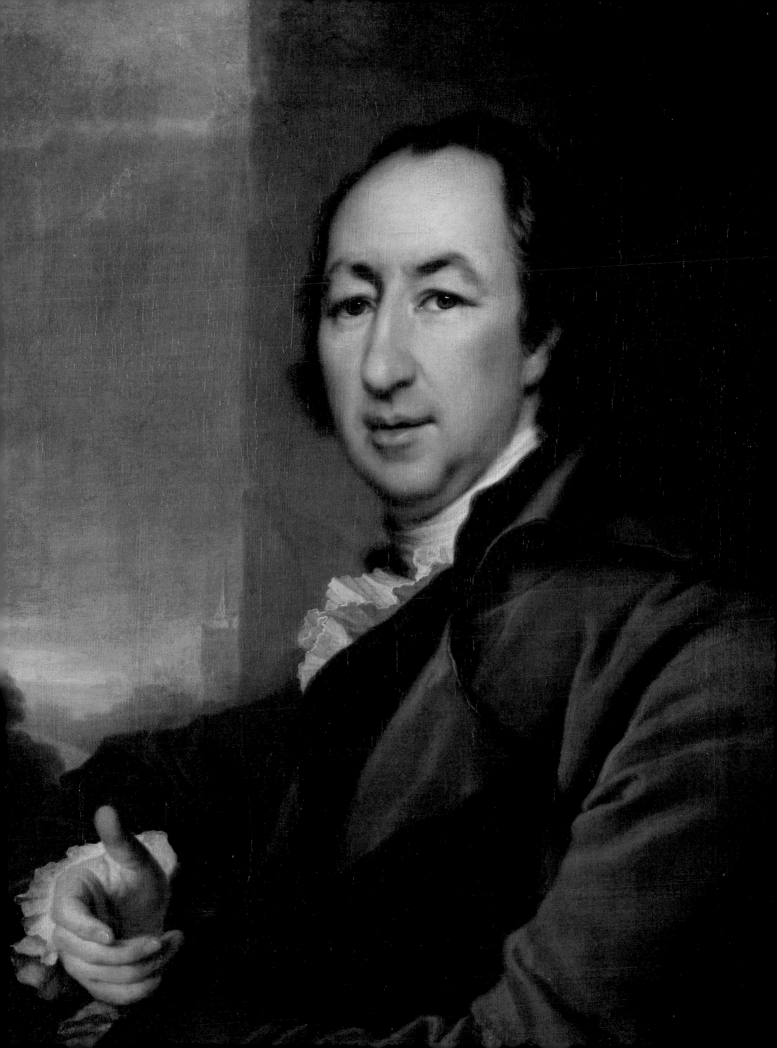

-<<< 22 >>>-

PORTRAIT OF IVAN IVANOVICH BETSKOI
ENGRAVED BY FRANCOIS ANTOINE
RADIGUES (1719/21-1809), 1794
AFTER THE 1777 ORIGINAL PAINTING
BY ALEXANDER ROSLIN (1718-93)
52 X 37 CM
BETSKOI (1704-95) WAS CATHERINE'S
PRINCIPAL COLLABORATOR ON
EDUCATIONAL REFORM AS WELL AS
HELPING TO OVERSEE THE BUILDING
OF ST PETERSBURG AND SERVING AS
PRESIDENT OF THE ACADEMY OF ARTS
AND DIRECTOR OF THE CADET CORPS,
WHERE YOUNG NOBLEMEN
WERE TRAINED.
-<<<->>>-

-<<< 23 >>>-

PORTRAIT OF COUNT ALEXANDER
SERGEEVICH STROGANOV
ENGRAVED BY JAMES WALKER, 1790S
AFTER THE 1790S ORIGINAL BY
GIOVANNI BATTISTA LAMPI
37.5 X 27 CM
ALEXANDER STROGANOV
(1734-1811), PATRON AND COLLECTOR,
WAS CONSIDERED ONE OF THE MOST
CULTIVATED MEN OF HIS DAY.
HE WAS PRESIDENT OF THE ACADEMY
OF ARTS, A MEMBER OF THE IMPERIAL
COUNCIL, DIRECTOR OF THE
ST PETERSBURG PUBLIC LIBRARY AND A
PROMINENT EDUCATIONALIST.
-<<<->>>-

-<<< 24 >>>-

BUST OF ALEXANDER NIKOLAEVICH

SAMOILOV, C.1796

FEDOT IVANOVICH SHUBIN (1740-1805)

MARBLE. 63 X 42 X 30 CM

-<<<->>>-

-<<< 25 >>>-

VIEW OF THE ACADEMY OF ARTS
IN ST PETERSBURG FROM
VASIL'EVSKII ISLAND
ENGRAVED BY THOMAS MALTON
THE ELDER, 1789
FROM THE ORIGINAL BY JOSEPH HEARN
AQUATINT. 34 X 32 CM
HEARN, AN ENGLISH ARTIST, LIVED
FOR SEVERAL YEARS IN ST PETERSBURG
AND DREW A SERIES OF VIEWS OF THE
CITY. THIS SHOWS THE BUILDING OF
THE ACADEMY OF ARTS, CARRIED OUT
BY THE ARCHITECTS VALLIN
DE LA MOTTE AND KOKORINOV
BETWEEN 1764 AND 1788 UNDER
CATHERINE'S PATRONAGE.

-<<<->>>-

-<<< 26 >>>-

A VIEW OF THE PALACE
EMBANKMENT, ST PETERSBURG FROM
VASIL'EVSKII ISLAND
ENGRAVED BY
BENJAMIN PATERSSEN, 1799
ENGRAVING AND WATERCOLOR.
47.8 X 61.6 CM

-<<<->>>-

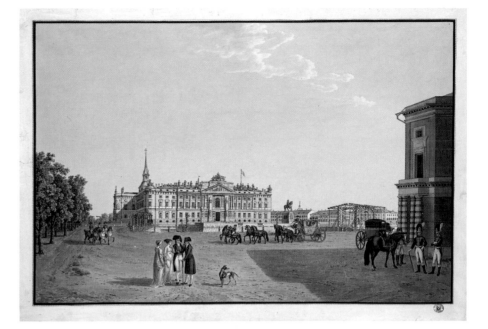

-<<< 27 >>>-

A VIEW OF THE MIKHAIL CASTLE,
ST PETERSBURG
FROM THE ENGRAVING BY
BENJAMIN PATTERSEN, C.1800
ENGRAVING, WATERCOLOR.
51.4 X 78 CM
THE PICTURE SHOWS THE CASTLE,
COMPLETED IN 1800 BY THE ARCHITECTS
BAZHENOV AND BRENNA, BUILT FOR
PAUL I AS A POSSIBLE PLACE OF REFUGE
FROM HIS ENEMIES. OUTSIDE IS AN
IMPERIAL COACH AND, BEYOND THE
BRIDGE, AN EQUESTRIAN STATUE OF
PETER THE GREAT.

-<<<->>>-

-<<< 28 >>>-

A VIEW OF MOSCOW FROM THE
BALCONY OF THE KREMLIN PALACE
ENGRAVED BY GABRIEL OR
MATTHIAS LORY, C.1800
AFTER AN ORIGINAL BY
GERARD DE LA BARTHE, 1797
ENGRAVING, WATERCOLOR. 48 x 71.5 CM
THE KREMLIN PALACE WAS BUILT FOR
THE EMPRESS ELIZABETH BUT WAS
DEMOLISHED IN THE EARLY 19TH
CENTURY. THE VIEW INCLUDES, FROM
THE LEFT, PART OF THE CATHEDRAL OF
THE ARCHANGEL MICHAEL AND OF THE
CATHEDRAL OF THE ANNUNCIATION AS
WELL AS THE KREMLIN WALL.

-<<<->>>-

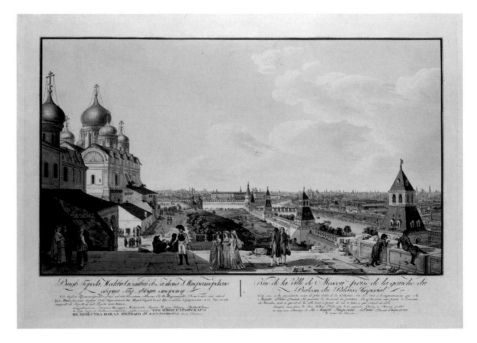

-<<< 29 >>>-

A VIEW OF THE PARK AT TSARKOE SELO
ENGRAVED BY JOHANN CHRISTOPH AND
JOHANN GEORG DE MAYR, 1790S
AQUATINT. 43.5 X 61.7 CM
THE VIEW SHOWS THE KAGUL OBELISK,
ERECTED TO COMMEMORATE THE
RUSSIAN VICTORY OVER THE TURKS
AT KAGUL IN 1770, AND, IN THE
BACKGROUND, THE CHINESE PAVILION
OR GRAND CAPRICE BUILT FOR
CATHERINE. IN SUMMER SHE SPENT
MUCH OF HER TIME AT TSARKOE SELO,
THE IMPERIAL PALACE OUTSIDE
ST PETERSBURG.

-<<<->>>-

-<<< 30 >>>-

CATHERINE WALKING IN THE
PARK AT TSARKOE SELO
ENGRAVED IN 1827 BY
NIKOLAI IVANOVICH UTKIN (1780-1863)
AFTER THE 1794 ORIGINAL BY VLADIMIR
LUKICH BOROVIKOVSKII (1757-1825)
63.5 X 46 CM
THE EMPRESS, ACCOMPANIED BY A
FAVORITE DOG, IS SEEN STANDING
BESIDE THE KAGUL OBELISK.

-<<<->>>-

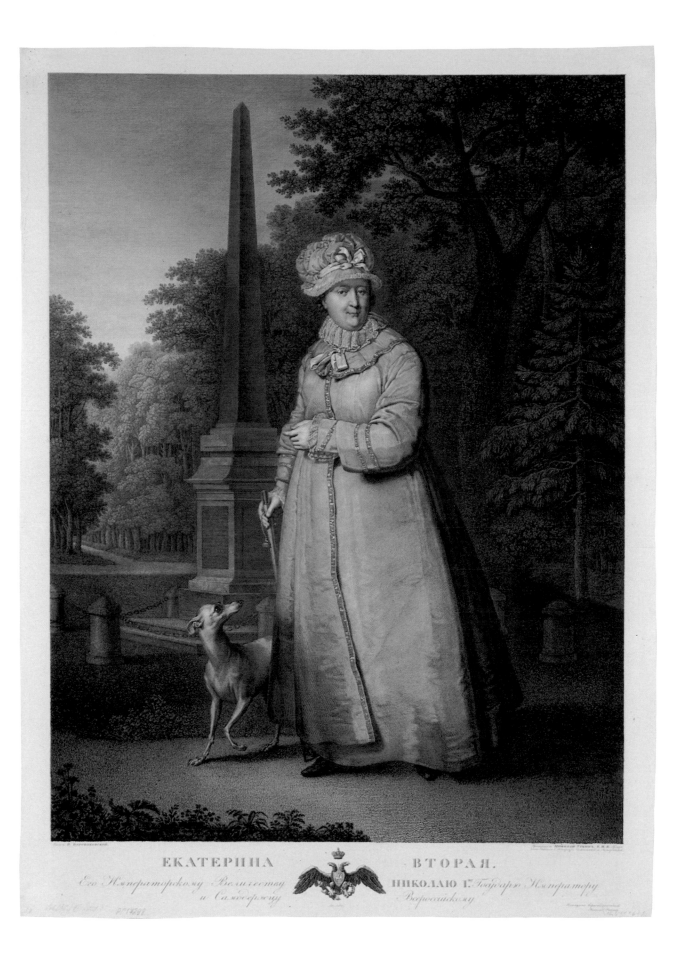

ЕКАТЕРИНА ВТОРАЯ.

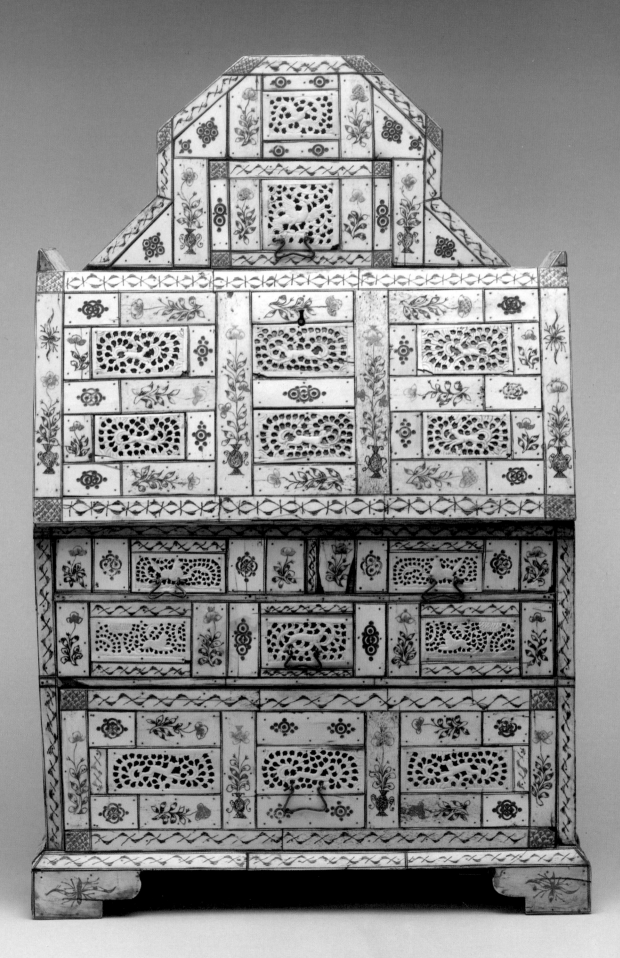

-<<< 31 >>>-
TABLE BUREAU
ARCHANGEL, RUSSIA, C.1750-70
BONE. HEIGHT 54.5 CM
THE CABINET, WHICH CONTAINS
SLIDING DRAWERS, WAS INTENDED TO
STAND ON A DESK. THE LID COMES
DOWN TO FORM A FLAT SURFACE.
COLORED FOIL SHOWS THROUGH THE
CARVED PANELS, DELICATELY
DECORATED WITH ANIMAL AND
FLOWER MOTIFS.
-<<<->>>-

-<<< 32 >>>-
BALLOT BOX
MASTER: ANDREI SIMON
ST PETERSBURG, 1780
BRONZE, SILVER, GILDING.
40 X 22 X 21.5 CM
THE THREE COLUMNS, DESIGNED TO
RECEIVE THE VOTES, ARE INSCRIBED
'FOR', 'AGAINST' AND 'ABSTAIN'.
THE BOX WAS USED AT THE
ACADEMY OF ARTS AND BEARS THE
MONOGRAM OF ITS FOUNDER,
THE EMPRESS ELIZABETH.
-<<<->>>-

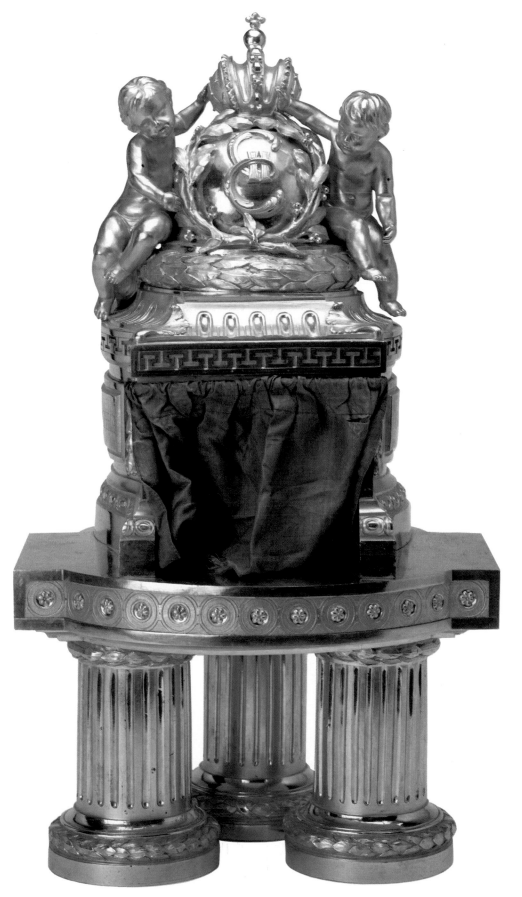

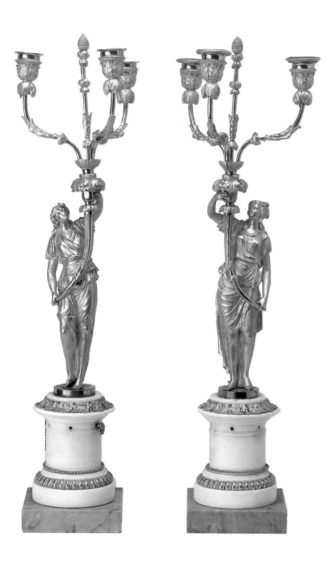

-<<< 33 >>>-
PAIR OF CANDELABRA WITH
FEMALE FIGURES
ST PETERSBURG, C.1800
BRONZE, GILDING. HEIGHT 59.5 CM
-<<<->>>-

-<<< 34 >>>-
PAIR OF VASES
IMPERIAL PORCELAIN FACTORY,
NEAR ST PETERSBURG, C.1800
PORCELAIN. HEIGHT 51.5 CM
THE IMPERIAL PORCELAIN FACTORY
SERVED ONLY THE NEEDS OF THE
IMPERIAL FAMILY. THESE VASES WERE
MADE FOR THE PAVLOVSK PALACE,
RESIDENCE OF PAUL I AND HIS WIFE,
MARIA FEODOROVNA. THE VASES ARE
DECORATED TO CATHERINE'S TASTE:
SHE LIKED HER CHINAWARE TO BE
'THE GAYER THE BETTER'.
-<<<->>>-

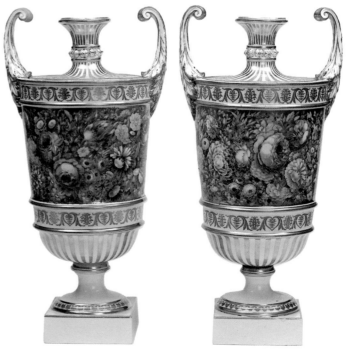

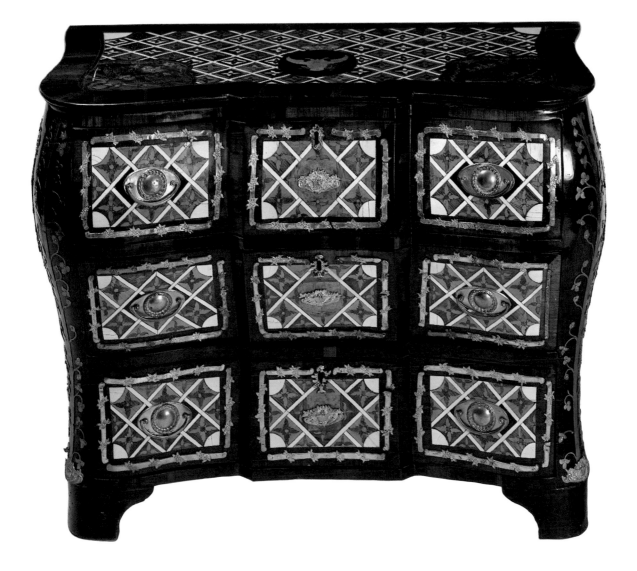

-<<< 35 >>>-

CHEST OF DRAWERS

ST PETERSBURG, 1762-65

FINE WOODS, IVORY. HEIGHT 76 CM

INSPIRED BY GERMAN MODELS,

THE CHEST IS DECORATED ON TOP

WITH CATHERINE'S MONOGRAM,

A DOUBLE-HEADED EAGLE AND

THE EMBLEM OF SIBERIA.

-<<<->>>-

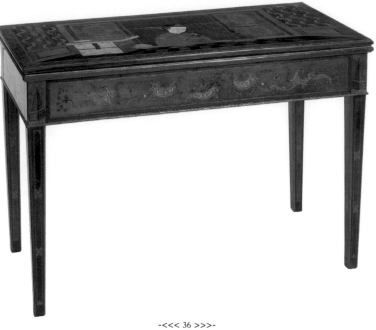

-<<< 36 >>>-

GAMING TABLE

ST PETERSBURG, 1770-80. FINE WOODS, IVORY, EBONY. HEIGHT 76 CM

-<<<->>>-

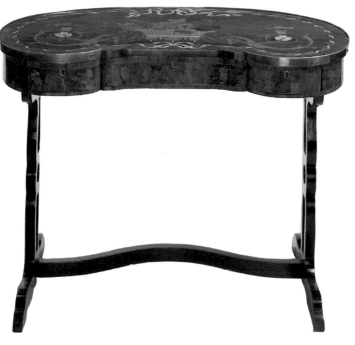

-<<< 37 >>>-

KIDNEY TABLE

ST PETERSBURG, 1780-90. ROSEWOOD, BOX, MAPLE, BEECH, IVORY. HEIGHT 71 CM

THE TABLE CAME FROM THE WORKSHOP OF MATVEI IAKOVLEVICH VERETENNIKOV, ONCE A

SERF OF COUNT SALTYKOV. HIS HIGHLY SUCCESSFUL BUSINESS ATTRACTED THE

PATRONAGE OF CATHERINE, PAUL I AND HIS WIFE, MARIA FEODOROVNA.

-<<<->>>-

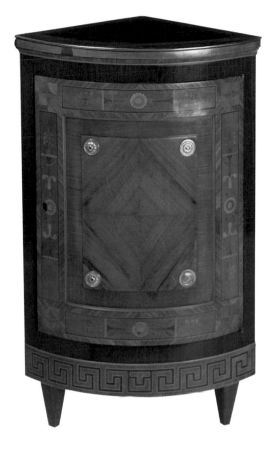
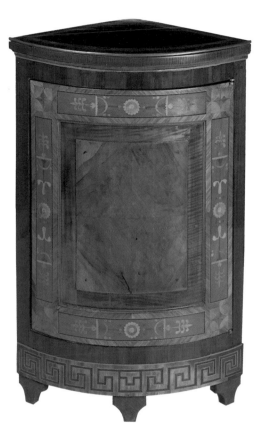

-<<< 38 & 39 >>>-

TWO CORNER CUPBOARDS

ST PETERSBURG, 1787. ROSEWOOD, MAHOGANY, STAINED MAPLE, BRASS INLAY. HEIGHT 92 CM

THESE CUPBOARDS WERE MADE BY CHRISTIAN MEYER, ST PETERSBURG'S FOREMOST

CABINET MAKER, WHO WAS THE AUTHOR OF NUMEROUS PIECES FOR THE IMPERIAL FAMILY.

HE WAS CHOSEN BY CATHERINE AS CARPENTRY TUTOR TO HER GRANDSONS,

THE GRAND DUKES ALEXANDER AND CONSTANTINE.

-<<<->>>-

-<<< 40 >>>-

BUST OF CATHERINE II
FROM AN ORIGINAL BY F.I.SHUBIN, 1783
ST PETERSBURG, LATE 18TH CENTURY
BRONZE. HEIGHT 36 CM
CROWNED WITH A LAUREL WREATH
AND WEARING THE RIBBON OF
ST ANDREW, SHUBIN'S BUST WAS ALSO
CARVED IN MARBLE AND WAS
REPRODUCED IN PORCELAIN AT THE
IMPERIAL PORCELAIN FACTORY.

-<<<->>>-

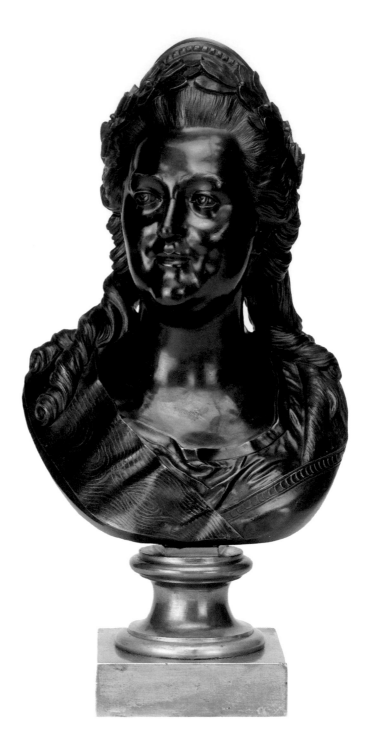

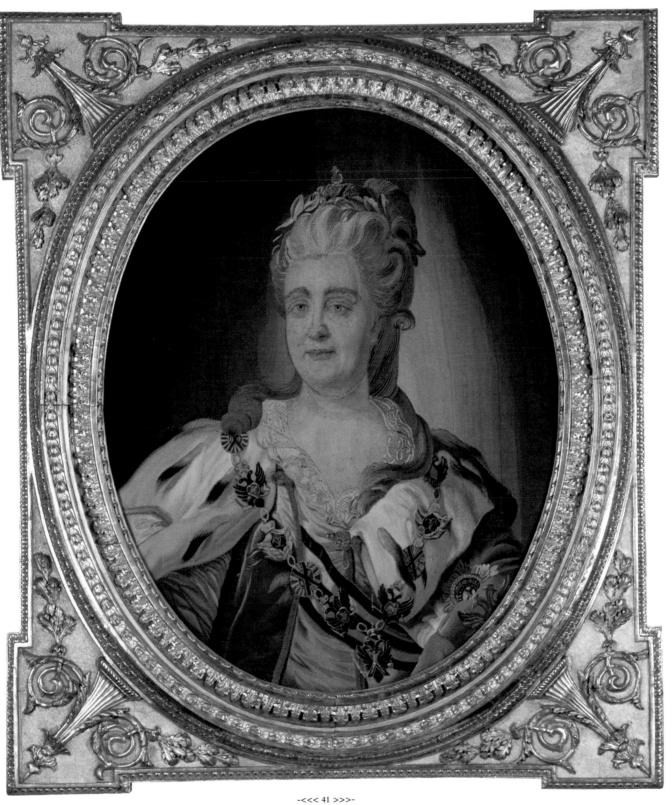

-<<< 41 >>>-

TAPESTRY PORTRAIT OF CATHERINE II

FROM THE ORIGINAL BY F.ROKOTOV, 1779. ST PETERSBURG TAPESTRY FACTORY, 1782-3. WOOL, SILK, METAL THREAD. 82 X 62 CM

TAPESTRY COPIES OF FAMOUS PORTRAITS APPEAR FREQUENTLY ON LISTS OF DIPLOMATIC GIFTS. THEY WERE MADE AT THE TAPESTRY FACTORY IN ST PETERSBURG,

THEN AT THE HEIGHT OF ITS ACTIVITY.

-<<<->>>-

-<<< 43 >>>-

PORTRAIT OF COUNTESS
ANNA PETROVNA SHEREMET'EVA, C.1766
AFTER LIGOTSKII. OIL ON CANVAS. 138 X 87 CM
ANNA SHEREMET'EVA (1744-68), A LADY IN
WAITING TO CATHERINE, IS SHOWN IN A
MASQUERADE DRESS, PROBABLY FOR THE FIRST
MASQUERADE EVER STAGED IN RUSSIA, HELD
IN ST PETERSBURG'S PALACE SQUARE IN JUNE
1766. SHE WAS ENGAGED TO COUNT NIKITA
PANIN BUT SADLY DIED OF SMALLPOX ON
THE EVE OF THE WEDDING.

-<<<->>>-

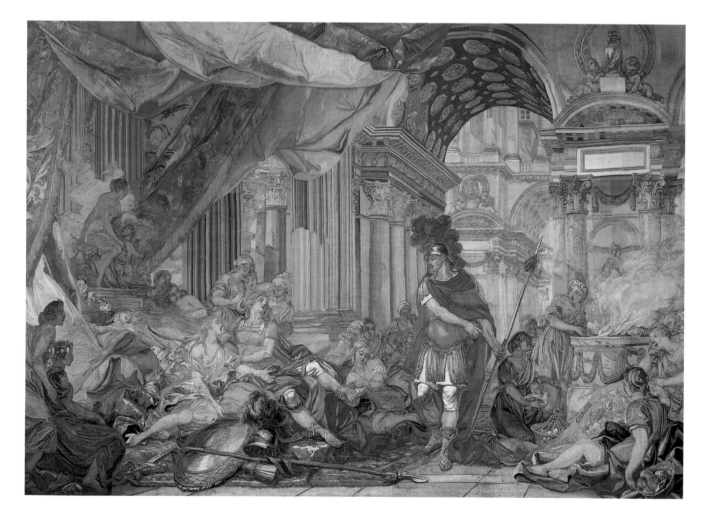

-<<< 42 >>>-

HECTOR REPROACHES PARIS
ST PETERSBURG TAPESTRY FACTORY, 1773
SILK, WOOL. 400 X 500 CM
THIS TAPESTRY WAS AMONG THE FIRST
OF THE FACTORY'S OUTPUT TO TAKE ITS
SUBJECT FROM CLASSICAL LITERATURE,
HERE A SCENE FROM HOMER'S *ILIAD*.

-<<<->>>-

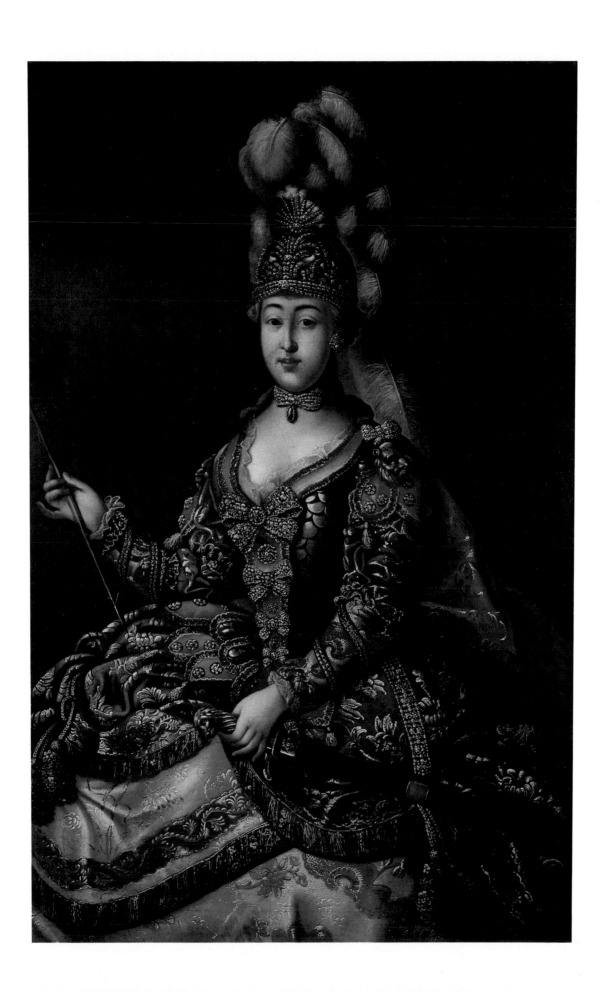

-<<< 44 >>>-

CARNIVAL SLEIGH WITH FIGURES OF

ST GEORGE AND THE DRAGON

ST PETERSBURG, C.1770

WOOD, IRON, VELVET.

LENGTH 350 CM, HEIGHT 174 CM

-<<<->>>-

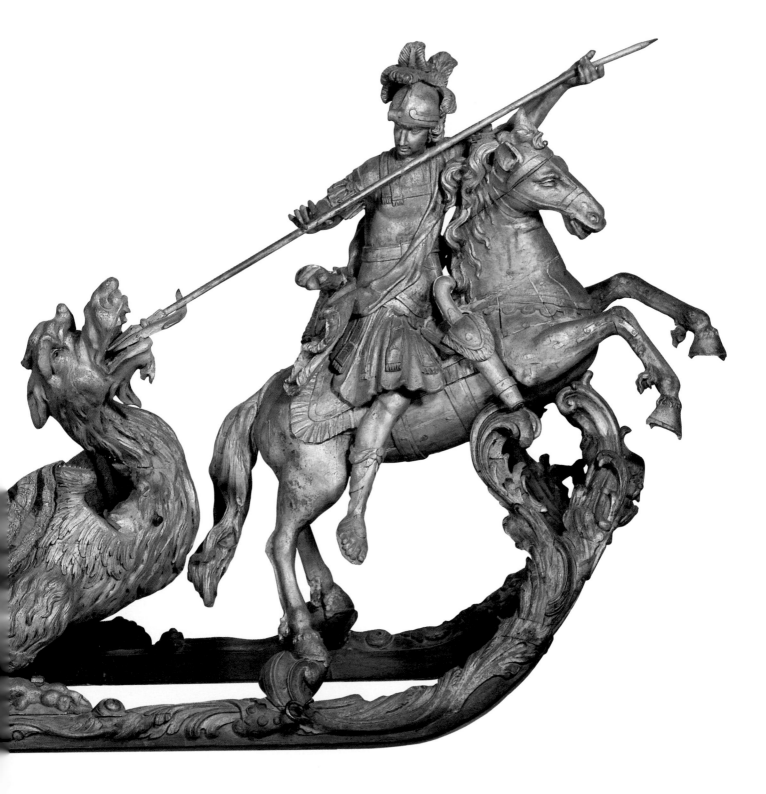

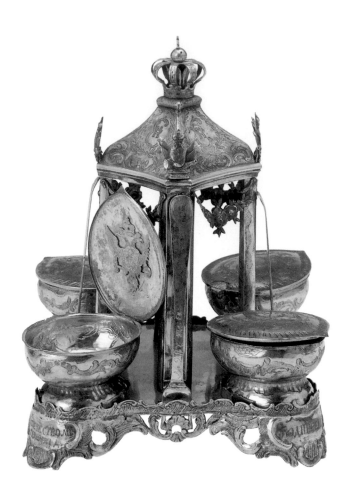

-<<< 45 >>>-

COMPOSITE SALT CELLAR

ST PETERSBURG, 1769

SILVER, GILDING. HEIGHT 18.3 CM

THIS PIECE WAS PRESENTED TO

THE EMPRESS BY THE MERCHANTS OF

ST PETERSBURG. IT IS DECORATED

WITH THE EMPRESS' MONOGRAM

AND THE IMPERIAL CROWN.

-<<<->>>-

-<<< 46 >>>-

SHELL SNUFF BOX

VELIKII USTIUG, RUSSIA, 1768

SILVER, GILDING, SHELL, NIELLO.

5.7 X 10.8 X 7.3 CM

THE SNUFF BOX IS DECORATED WITH

A SCENE FROM A FRENCH PLAY OF

THE PERIOD. VELIKII USTIUG WAS A

CENTRE FOR THE FINEST NIELLO

WORK OF THE DAY. NIELLO WAS

A POPULAR FORM OF DECORATION

WHEREBY A BLACK COMPOUND,

TYPICALLY SULPHUR AND SILVER,

WAS USED AS AN INLAY ON

METAL SURFACES.

-<<<->>>-

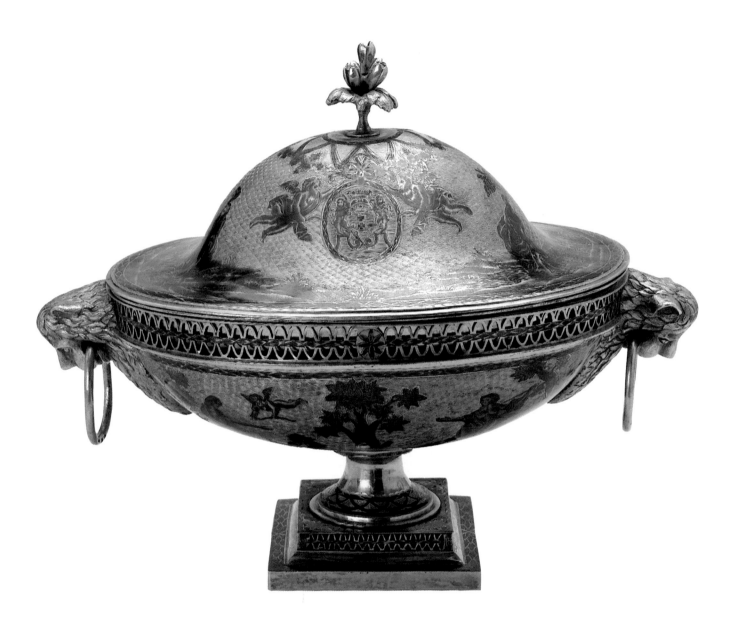

-<<< 47 >>>-

TUREEN

MASTER: SIMEON KUZOV. MOSCOW, 1798-99

SILVER, GILDING, NIELLO. HEIGHT 30.7 CM

PART OF THE KONOVNITSIN DINNER SERVICE, THE TUREEN IS DECORATED

WITH THE FAMILY'S COAT OF ARMS. IT WAS MADE FOR THE WEDDING OF

PETER PETROVICH KONOVNITSIN TO ANNA IVANOVNA RIMSKAIA-KORSAKOVA.

-<<<->>>-

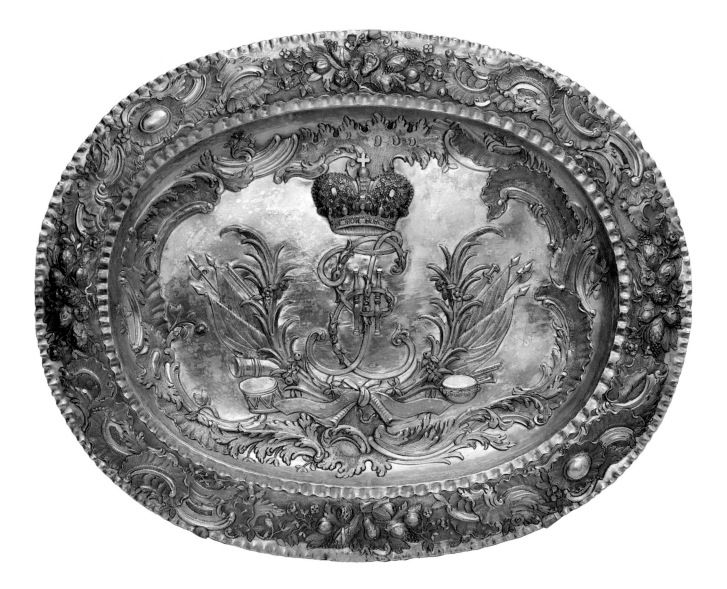

-<<< 48 >>>-

OVAL DISH

MASTERS: A. POLOZOV AND

A. GERASIMOV

MOSCOW, 1762

SILVER, GILDING. 58 X 46 CM

THE CHASED AND ENGRAVED DISH

SHOWS THE CROWN AND

MONOGRAM OF CATHERINE II.

-<<<->>>-

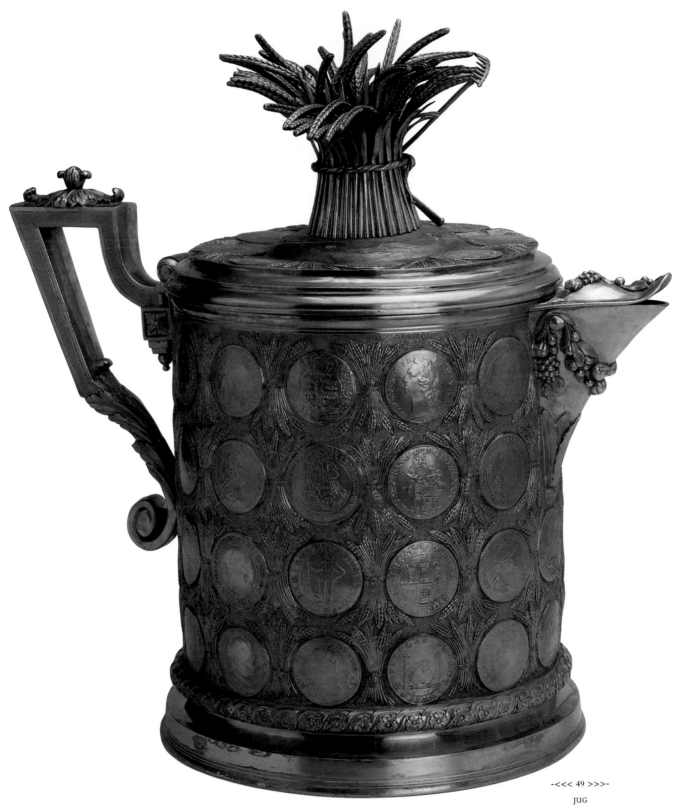

-<<< 49 >>>-
JUG
ST PETERSBURG, 1789
SILVER, GILDING. HEIGHT 42.3 CM
THE JUG IS STUDDED WITH 69
RUSSIAN AND FOREIGN COINS AND
IS SURMOUNTED BY A SHEAF OF CORN.
IT WAS MADE FOR THE
FREE ECONOMIC SOCIETY.
-<<<->>>-

-<<< 50 >>>-

VASE

PETERHOF LAPIDARY WORKS, NEAR ST PETERSBURG, 1790S

QUARTZ. HEIGHT 28 CM

-<<<->>>-

-<<< 51 >>>-

VASE ON A PEDESTAL

PETERHOF LAPIDARY WORKS, NEAR ST PETERSBURG

MARBLE, GRANITE, BRONZE, GILDING. HEIGHT 26.5 CM

-<<<->>>-

-<<< 52 >>>-

ORMULU-MOUNTED OBELISK

PETERHOF LAPIDARY WORKS, NEAR ST PETERSBURG, C.1770

LAZURITE, MARBLE, QUARTZ, BRONZE. HEIGHT 20 CM

-<<<->>>-

-<<< 53 >>>-

ITEMS FROM THE 'CABINET'
PORCELAIN SERVICE
IMPERIAL PORCELAIN FACTORY,
PETERHOF, NEAR ST PETERSBURG, 1793-95
TUREEN ON STAND: HEIGHT 36.5 CM
SOUP BOWL: DIA 23.7 CM
DINNER PLATE: DIA 24.1 CM
WINEGLASS HOLDER: HEIGHT 12.5 CM
THE SERVICE IS DECORATED WITH THE
PICTURESQUE RUINS OF ANCIENT ROME,
TAKEN FROM PIRANESI PRINTS, AND
FLORAL GARLANDS ON GILDED BORDERS.
IT WAS MADE AT CATHERINE'S ORDER
FOR HER CLOSE ADVISER,
COUNT ALEXANDER BEZBORODKO AND
SERVED AS A MODEL FOR MANY
SUBSEQUENT SETS FROM THE IMPERIAL
FACTORY. THE NAME IS DERIVED FROM
THE USE OF A REPLICA SERVICE BY
THE IMPERIAL CABINET IN THE
MID-19TH CENTURY.

-<<<->>>-

-<<< 54 >>>-

ITEMS FROM CATHERINE'S
'CAMEO' SERVICE
SEVRES PORCELAIN FACTORY, FRANCE,
1777-79. DESIGNED BY SIMON BOIZOT
PORCELAIN, OVERGLAZE
PAINTING, GILDING
OVAL TRAY WITH TWO COVERED
CUPS: HEIGHT 15.5 CM
DINNER PLATE: DIA 26.5 CM
DOUBLE BOTTLE HOLDER: HEIGHT 12 CM
COVERED GRAVY BOAT: HEIGHT 14 CM
WINE GLASS HOLDER: HEIGHT 12.5 CM
CATHERINE ASKED POTEMKIN TO
COMMISSION THIS SERVICE, TO BE USED
AT STATE BANQUETS. HE TOLD THE
SEVRES FACTORY THAT IT SHOULD BE
'IN THE BEST AND NEWEST STYLE, WITH
HER MAJESTY'S MONOGRAM ON EVERY
PIECE...PRECISELY COPIED FROM THE
ANTIQUE WITH REPRODUCTIONS OF
CAMEOS'. IT TOOK OVER A YEAR FOR
THE DESIGN TO BE AGREED.
IN 1779 LOUIS XVI IS BELIEVED TO HAVE
VISITED THE FACTORY TO SEE THE
SERVICE BEFORE ITS DESPATCH TO
ST PETERSBURG. SUCH WERE THE
TECHNICAL DIFFICULTIES OF MAKING
SUCH A VAST SERVICE, USING SOFT PASTE
AND SEVRES' UNIQUE TURQUOISE
COLORED GROUND, THAT 3,000 PIECES
WERE FIRED TO ACHIEVE 800 OF
SUFFICIENT QUALITY. CATHERINE
BAULKED AT THE HIGH PRICE AND IT
WAS NOT UNTIL 1792 THAT SHE MADE
THE FINAL PAYMENT.

-<<<->>>-

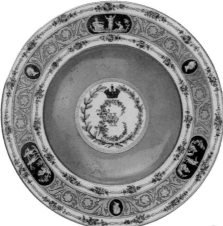

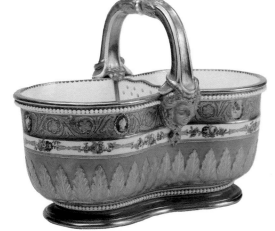

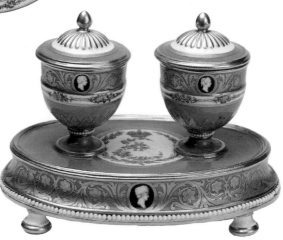

-<<< 55 >>>-

VASE

MASTER CRAFTSMAN IOSIF BOTTOM

PETERHOF LAPIDARY WORKS, 1777

SIBERIAN JASPER. 37 X 17 X 17 CM

-<<<->>>-

-<<< 56 >>>-

VASE

IMPERIAL PORCELAIN FACTORY,
PETERHOF, NEAR ST PETERSBURG. C.1790
PORCELAIN, OVERGLAZE PAINTING.
70 X 41.6 X 31.4 CM

THE VASE WAS MADE AS A PRESENT
FOR CATHERINE'S BIRTHDAY WHICH FELL
ON NOVEMBER 24. THE DECORATION
ON ONE SIDE INCORPORATES THE
NUMBER '24' AND THE FIGURE OF
SAGITTARIUS, HER BIRTH SIGN.
THE OTHER SHOWS A FIGURE OF GLORY
HOLDING A SHIELD EMBLAZONED WITH
CATHERINE'S MONOGRAM. THE
IMPERIAL PORCELAIN FACTORY
CUSTOMARILY MADE SUCH GIFTS TO
CELEBRATE CHRISTMAS, EASTER AND
THE EMPRESS' BIRTHDAYS.

-<<<->>>-

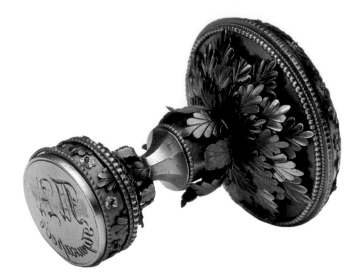

-<<< 57 >>>-

HAND-SEAL

TULA, C.1800. STEEL, BRASS, GLASS. LENGTH 8.7 CM

THE TRADITION OF FINE WORK IN STEEL, PECULIAR TO RUSSIA IN THE 18TH CENTURY, WAS BEGUN BY
CRAFTSMEN AT THE ROYAL ARMORY AT TULA, NEAR MOSCOW. THEY REFINED THE TECHNIQUES USED FOR THE
MANUFACTURE OF HIGH QUALITY ARMS - CHASING, BLUEING AND OVERLAY - TO PRODUCE FURNITURE AND
DECORATIVE OBJECTS. UNDER CATHERINE THE ART OF CUTTING METAL TO MAKE STEEL 'DIAMONDS',
CHARACTERISTIC OF TULA PIECES, WAS PERFECTED. THE TULA WORKS FLOURISHED UNTIL IMPERIAL PATRONAGE
CEASED WHEN CATHERINE'S SON, PAUL I, ANTAGONISTIC TO HIS MOTHER AND ALL THINGS ASSOCIATED WITH
HER, CAME TO THE THRONE. TULA'S FORTUNES DECLINED AND IN 1808, DURING THE WAR WITH FRANCE, THE
WORKS WERE INSTRUCTED TO DEVOTE THEIR ENERGIES ENTIRELY TO THE MAKING OF ARMS. BY 1824, WHEN THE
EMBARGO WAS FINALLY LIFTED, THE ART WAS LOST.

-<<<->>>-

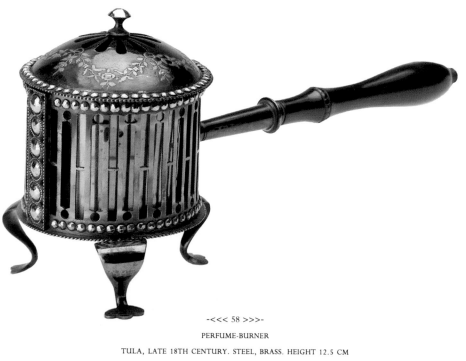

-<<< 58 >>>-

PERFUME-BURNER

TULA, LATE 18TH CENTURY. STEEL, BRASS. HEIGHT 12.5 CM

PERFUME-BURNERS, USED TO SCENT ROOMS, WERE POPULAR IN EUROPE IN THE 17TH AND 18TH CENTURIES.

-<<<->>>-

-<<< 60 >>>-

CANDLESTICK

TULA, 1780S

STEEL, BRONZE, SILVER,

BRASS, GILDING.

HEIGHT 33CM

-<<<->>>-

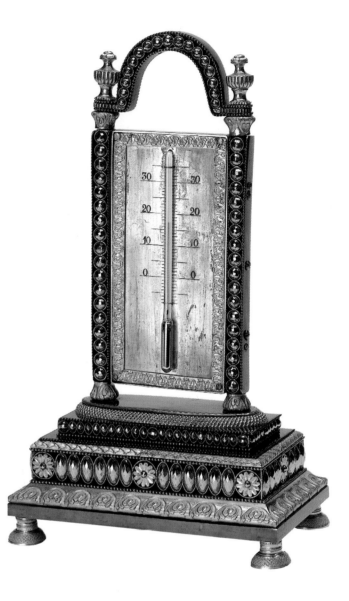

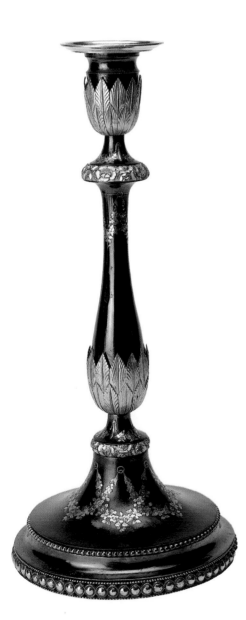

-<<< 59 >>>-

THERMOMETER

TULA, LATE 18TH CENTURY

STEEL, GILDING. HEIGHT 27 CM

THE THERMOMETER IS SET INTO

AN ELABORATE STAND WHICH

INCORPORATES A SLIDING DRAWER

AND HAS A MIRROR

ON THE REVERSE.

-<<<->>>-

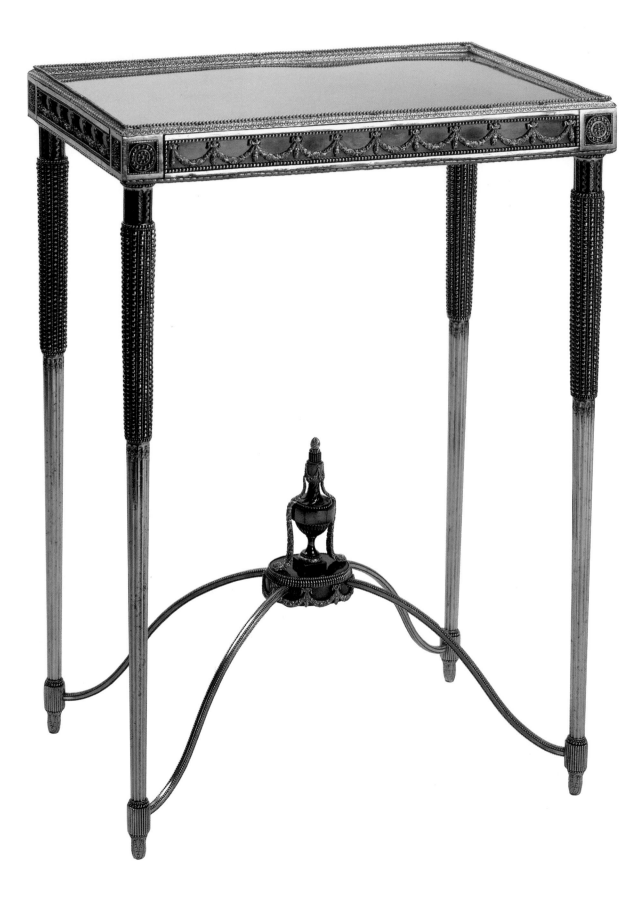

-<<< 61 >>>-

DRESSING TABLE

TULA, C.1800

STEEL, BRONZE, GILDING.

HEIGHT 77 CM

THE TABLE, DECORATED WITH

GARLANDS, ROSETTES AND STEEL

'DIAMONDS', WAS A GIFT TO THE

EMPRESS MARIA FEODOROVNA.

-<<<->>>-

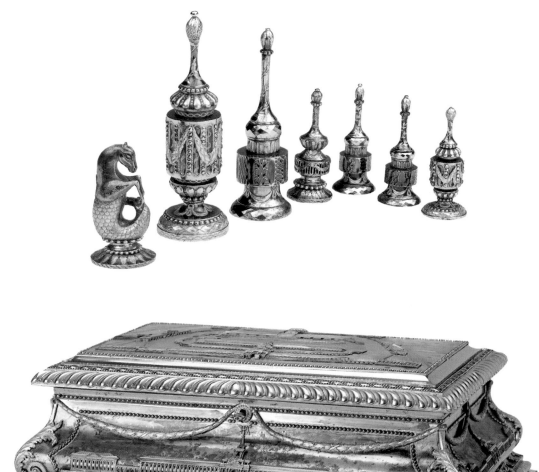

-<<< 62 >>>-

CHESS SET AND BOX

MASTER: ANDREAN SUKHAROV. TULA, 1782.

STEEL, BRONZE, SILVER, GOLD, GILDING. BOX: 17 X 50 X 31 CM

THIS SET WAS DESIGNED FOR A RARE FORM OF RUSSIAN FOUR-HANDED CHESS. THE BOX

CONTAINED EIGHTY PIECES AND WAS A GIFT TO CATHERINE. IT IS DECORATED WITH

A VIEW OF THE TULA ARMS FACTORY.

-<<<->>>-

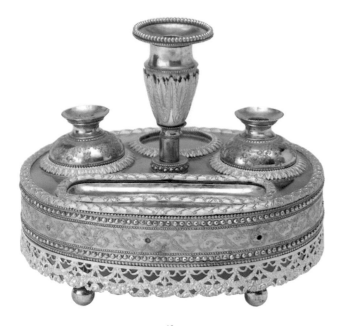

-<<< 63 >>>-

DESK SET WITH INKSTAND, SANDBOX, CANDLESTICK AND PEN HOLDER

TULA, LATE 18TH CENTURY

STEEL, BRONZE, SILVER, BRASS, GILDING. HEIGHT 16 CM

-<<<->>>-

-<<< 65 >>>-

CATHERINE II IN A KOKOSHNIK

LONDON, 1773

ENGRAVED BY WILLIAM DICKINSON

(1746-1823)

AFTER THE ORIGINAL BY

VERGILIUS ERIKSEN, 1769

MEZZOTINT. 45 X 32 CM

THE EMPRESS, WHO DISLIKED SLAVISH ADHERENCE TO FRENCH FASHIONS, IS WEARING RUSSIAN DRESS INCLUDING THE TRADITIONAL 'KOKOSHNIK' OR BONNET. HER SECRETARY IN THE 1790S NOTED: 'ON ORDINARY DAYS THE EMPRESS WORE A SILK DRESS MOST SIMILAR TO THOSE CALLED 'MOLDAVIAN'. THE OVERCOAT WAS USUALLY LILAC OR DARK GREY WITHOUT ORDERS, AND BENEATH IT WHITE...'. THE ORIGINAL PAINTING WAS PRESENTED BY CATHERINE TO HER ENGLISH PHYSICIAN, THOMAS DIMSDALE, WHO HAD VACCINATED HER AND HER FAMILY AGAINST SMALLPOX.

-<<<->>>-

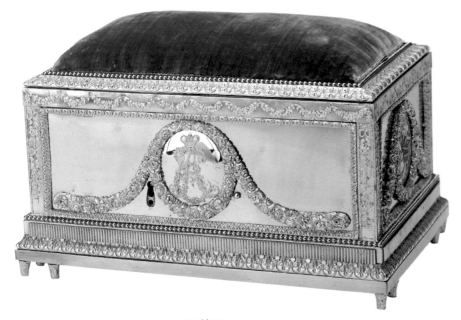

-<<< 64 >>>-

SEWING BOX WITH VELVET PINCUSHION SHOWING

CATHERINE II'S MONOGRAM

TULA, LATE 18TH CENTURY

STEEL, BRONZE, VELVET, SILVER, BRASS, GILDING. HEIGHT 17 CM

-<<<->>>-

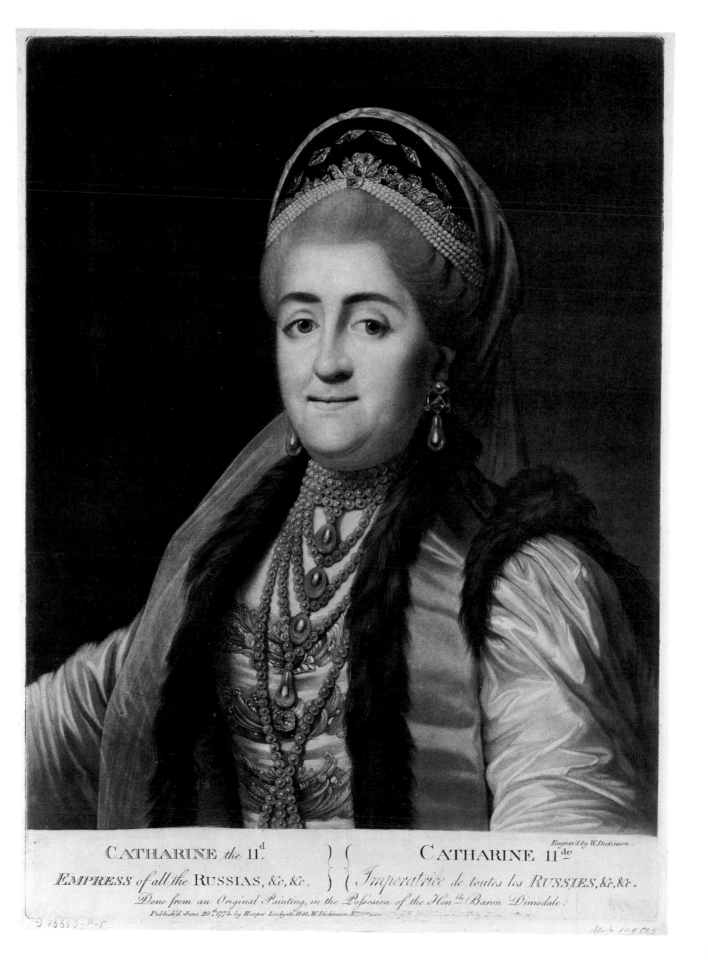

CATHARINE the 11.d CATHARINE 11.de

Engrav'd by W.Dickinson.

EMPRESS of all the RUSSIAS, &c, &c. Imperatrice de toutes les RUSSIES, &c, &c.

Done from an Original Painting, in the Possesion of the Hon.ble Baron Dimsdale.

Publish'd June 20.th 1773, by Hooper Ludgate Hill, W.Dickinson N.º

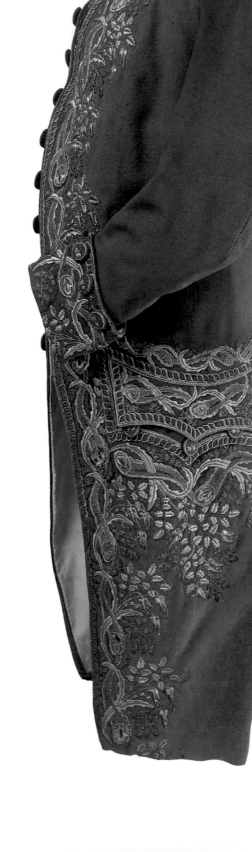

-<<< 66 >>>-

FORMAL CUT-AWAY COAT WITH

GOLD EMBROIDERY,

MADE FOR COUNT VLADIMIR ORLOV

RUSSIA, 1790S

SILK, WOOL, METAL THREAD

EMBROIDERY. LENGTH 116 CM

WEALTHY COURTIERS SUCH AS

COUNT ORLOV, DIRECTOR OF THE

ACADEMY OF SCIENCES, WOULD HAVE

BOUGHT THEIR CLOTHES FROM ABROAD

OR, AS HERE, USED THE SKILLS OF

SERF-SEAMSTRESSES AND TAILORS

WORKING ON THEIR ESTATES.

-<<<->>>-

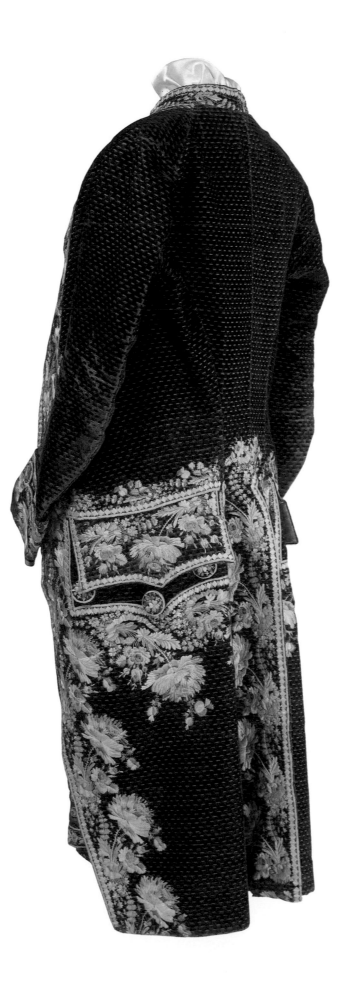

-<<< 67 >>>-
FORMAL CUT-AWAY COAT OF
LACED VELVET, EMBROIDERED WITH
SHADOW SATIN-STITCH
RUSSIA, C.1750-1800
SILK, VELVET, EMBROIDERY.
LENGTH 115 CM
-<<<->>>-

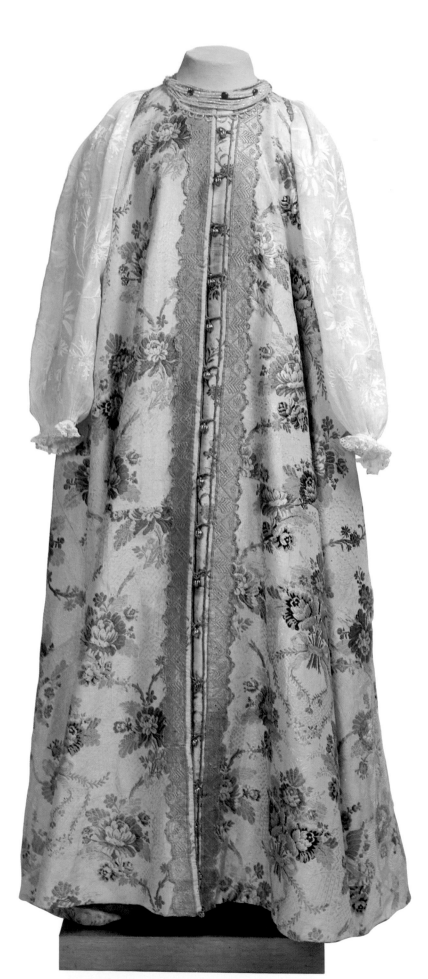

-<<< 68 >>>-
WOMAN'S FOLK DRESS
UPPER VOLGA REGION, RUSSIA, C.1800
SILK, LINEN, MUSLIN, GOLD LACE,
METAL THREAD, COTTON, FLAX,
SILVER, GLASS, PEARLS.
LENGTH 137 CM
SUCH AN OUTFIT - A 'SARAFAN' (LONG
SLEEVELESS DRESS), 'DUSHEGREIA', AND
NECKLACE WOULD HAVE BEEN WORN
ON FESTIVE OCCASIONS BY PEASANTS
AND SOME TOWNSPEOPLE IN CENTRAL
AND NORTHERN RUSSIA IN THE 18TH
AND EARLY 19TH CENTURIES.
THEY WERE CAREFULLY MAINTAINED
AND PASSED FROM ONE GENERATION
TO ANOTHER.
-<<<->>>-

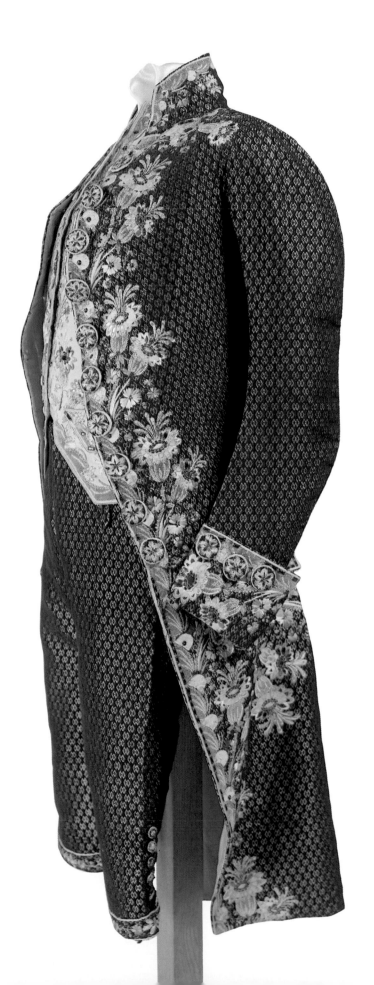

-<<< 69 >>>-

MAN'S FORMAL SUIT

PROBABLY RUSSIAN, C.1790

VELVET, TULLE, SILK THREAD, MIRROR

GLASS, SATIN STICH, APPLIQUE WORK.

COAT LENGTH: 114 CM

RUSSIA'S RULING CLASSES WERE OBLIGED

TO ABANDON TRADITIONAL DRESS BY

PETER THE GREAT AND ADOPTED

WESTERN FASHIONS. THE CUT-AWAY

COAT, WAISTCOAT AND BREECHES

FORMED A TYPICAL SUIT FROM PETER'S

DAY UNTIL IN CATHERINE'S REIGN.

THE CUT CHANGED IN THE 1780s AS

THE OUTLINE NARROWED, THE FLAPS

WERE REDUCED IN SIZE AND THE

WAISTCOAT WAS SHORTENED AND

BECAME SLEEVELESS. AT THIS TIME

MEN'S FORMAL WEAR WAS USUALLY

MADE OF SILK AND VELVET DECORATED

WITH A SMALL GEOMETRICAL PATTERN,

OFTEN ORNAMENTED WITH RICH AND

INTRICATE EMBROIDERY.

-<<<->>>-

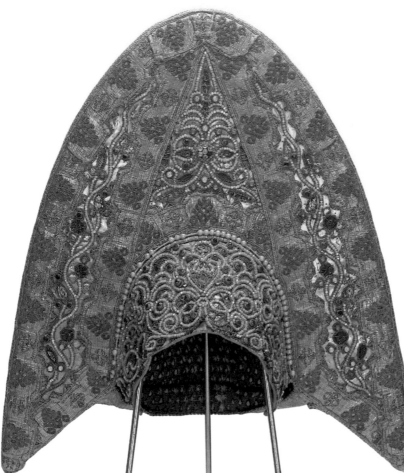

-<<< 70 >>>-

KOKOSHNIK

UPPER VOLGA REGION, RUSSIA, C.1800

VELVET, GLASS, GOLD THREAD, FOIL,

MOTHER OF PEARL, COPPER,

EMBROIDERY. 42.5 X 37.5 CM

KOKOSHNIKS WERE TYPICAL WOMEN'S

HEADWARE TO BE WORN ON FESTIVE

OCCASIONS. THE RUSSIAN PROVINCES

OF NIZHNYI NOVGOROD AND VLADIMIR

WERE NOTED FOR THEIR SUMPTUOUS

KOKOSHNIKS. THEIR HIGH 'HORNED'

SHAPES WERE, AS HERE, EMBELLISHED

WITH RICH EMBROIDERY, COLORED

GLASS AND PEARLS.

-<<<->>>-

-<<< 71 >>>-

KOKOSHNIK

KOSTROMA PROVINCE, RUSSIA,

C.1700-50. VELVET, CALICO, SILK,

GOLD LACE, METAL THREAD,

SEQUINS, FOIL, PEARLS, MOTHER OF

PEARL, TURQUOISE, GLASS, SILVER,

EMBROIDERY. 22 X 30 CM

THE CONICAL SHAPE IS

CHARACTERISTIC OF

THE KOSTROMA PROVINCE.

-<<<->>>-

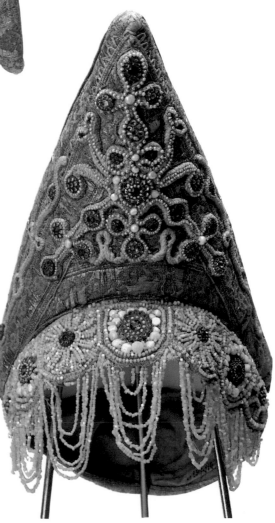

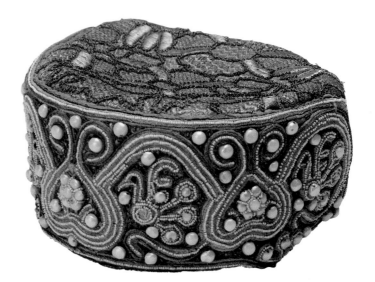

-<<< 72 >>>-

KOKOSHNIK

OLONETSK PROVINCE, RUSSIA,
C.1750-1800. LINEN, METAL THREAD,
PEARLS, BEADS, EMBROIDERY.

9.5 X 14 X 16 CM

UP TO THE LAST CENTURY IT WAS
CONSIDERED PROPER FOR WOMEN
TO KEEP THEIR HEADS COVERED
WHENEVER THEY LEFT THE HOME.
GIRLS WERE ALLOWED TO APPEAR
WITH THEIR HAIR IN PLAITS OR
TIED WITH RIBBON.

-<<<->>>-

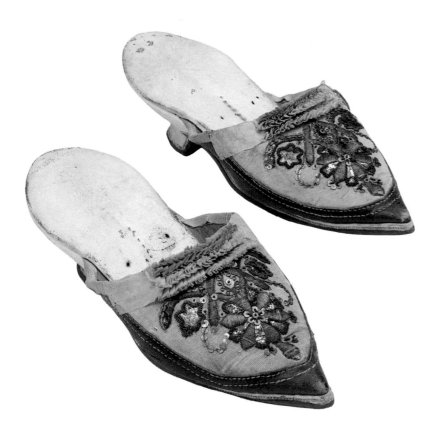

-<<< 73 >>>-

PAIR OF LADY'S SHOES
PROBABLY FROM ST PETERSBURG,
C.1750-1800
LEATHER, SILK, METAL THREAD,
SEQUINS, GOLD LACE,
COLORED FOIL GLASS

-<<<->>>-

-<<< 74 >>>-

FAN

PROBABLY RUSSIAN, C.1750-1800

GOUACHE ON PAPER, BONE,

MOTHER OF PEARL, METAL THREAD,

SEQUINS, COPPER, GLASS.

LENGTH 26.5 CM

FOLDING FANS WERE POPULAR IN

RUSSIA FROM EARLY IN THE 18TH

CENTURY, OFTEN IMPORTED FROM

FRANCE, ENGLAND AND GERMANY.

AS THE CENTURY PROGRESSED THEY

BECAME INCREASINGLY ELABORATE.

MANY, LIKE THIS ONE, WERE

DECORATED WITH ROMANTIC SCENES

ILLUSTRATING THE CLOTHES AND

CUSTOMS OF THE PERIOD.

-<<<->>>-

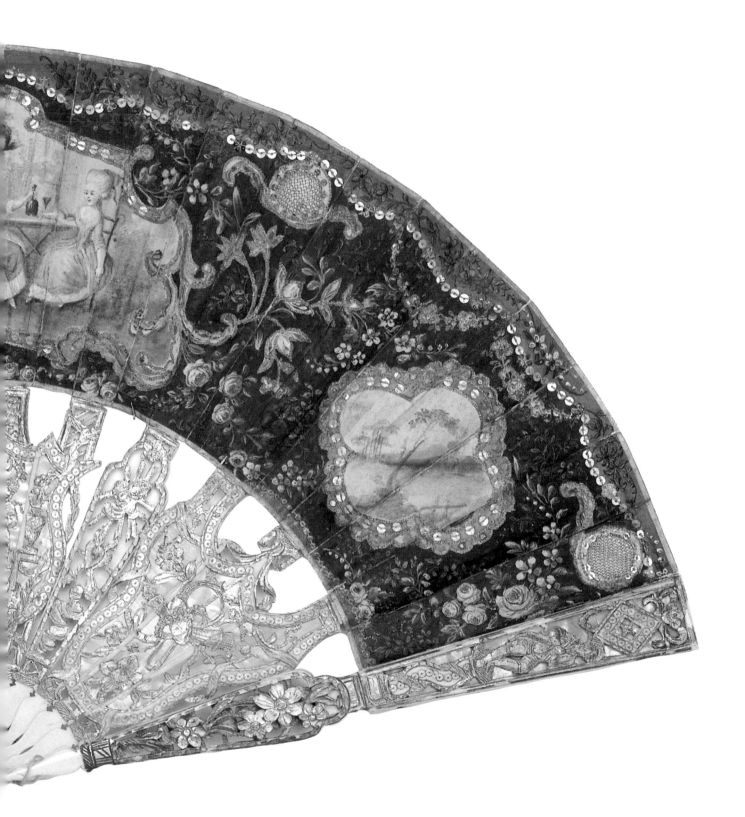

-<<< 75 & 76 >>>-

TWO PAIRS OF EARRINGS

RUSSIA, C.1800. COPPER, RIVER PEARLS, HORSEHAIR, GLASS. 7.8 X 4.1 CM

ELABORATE EARRINGS, MADE OF PEARLS FOUND IN THE RIVERS OF NORTHERN RUSSIA,

WOULD HAVE BEEN PART OF A RICH RUSSIAN LADY'S FORMAL WARDROBE.

THEY TOOK A WIDE RANGE OF SHAPES INCLUDING, AS IS SHOWN HERE,

BASKETS AND SPIDERS' WEBS.

-<<<->>>-

THE TREASURY

-<<< 1 >>>-

GOBLET

ST PETERSBURG, LATE 18TH CENTURY

GOLD, SILVER, DIAMONDS, RUBIES,

ENAMEL. HEIGHT 20.7 CM

THE GOBLET, DECORATED WITH

CATHERINE'S MONOGRAM, WAS A

WEDDING PRESENT FROM THE EMPRESS

TO HER FAVORITE GRANDSON,

THE GRAND DUKE ALEXANDER, IN 1793.

IT WAS SUBSEQUENTLY USED AT THE

WEDDINGS OF OTHER MEMBERS OF THE

IMPERIAL FAMILY.

-<<<->>>-

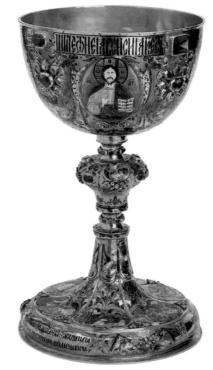

CHALICE

KREMLIN ARMORY, MOSCOW, 1677

GOLD, DIAMONDS, EMERALDS,

SAPPHIRES, RUBIES, SPINEL, GLASS

HEIGHT 28 CM

THE CHALICE WAS USED DURING

CATHERINE'S REIGN IN THE GREAT

CHAPEL OF THE WINTER PALACE.

SKILLS DEVELOPED IN THE WORKSHOPS

OF THE KREMLIN ARMORY WERE

ALSO APPLIED TO THE MANUFACTURE

OF FINE METALWARE.

-<<<->>>-

-<<< 3 >>>-

CHALICE

JEAN FRANCOIS BOUDDE,

ST PETERSBURG, 1790

ENAMEL PAINTING BY GAVRIIL KOZLOV

GOLD, ENAMEL, FILIGREE. DIA 16.5 CM

THE CHALICE WAS ORDERED BY

CATHERINE FOR THE CHURCH IN HER

PALACE AT TSARKOE SELO. LIKE SO

MANY OF HIS FELLOW CRAFTSMEN,

BOUDDE WAS NOT A NATIVE RUSSIAN.

HE CAME TO ST PETERSBURG FROM

HAMBURG IN 1765 AND BECAME A

LEADING MEMBER OF THE GUILD OF

FOREIGN JEWELLERS. HE MADE A

WIDE VARIETY OF OBJECTS, RANGING

FROM ARMS TO CRUCIFIXES.

-<<<->>>-

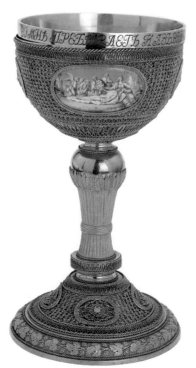

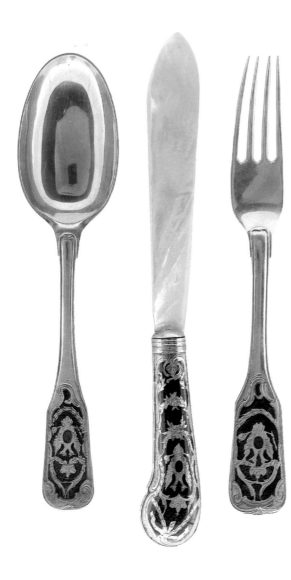

-<<< 4 >>>-
ITEMS FROM CATHERINE II'S
TRAVELLING SERVICE
ST PETERSBURG, 1780S
GOLD, GUILLOCHE, ENAMEL,
MOTHER OF PEARL
SALT CELLAR: 4.5 X 5 X 6.7 CM
KNIFE: 21.7 CM
FORK: 19.4 CM
SPOON: 19.4 CM

-<<<->>>-

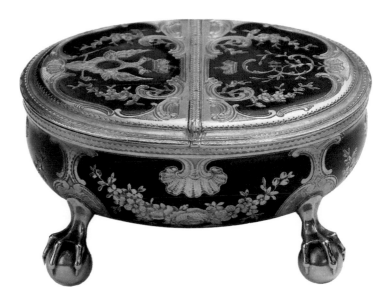

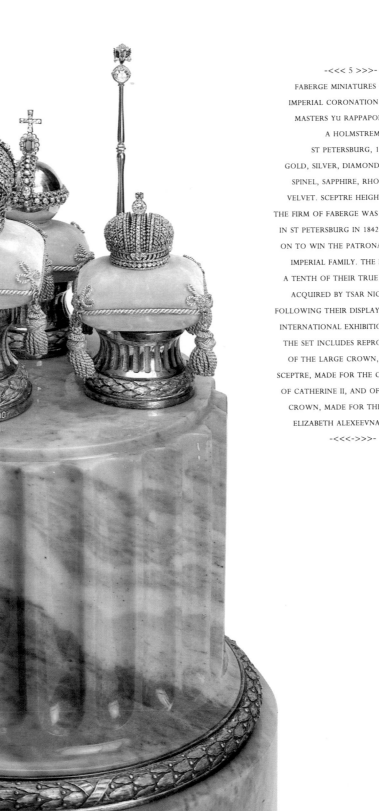

-<<< 5 >>>-

FABERGE MINIATURES OF THE
IMPERIAL CORONATION REGALIA
MASTERS YU RAPPAPORT AND
A HOLMSTREM
ST PETERSBURG, 1900
GOLD, SILVER, DIAMONDS, PEARLS,
SPINEL, SAPPHIRE, RHODONITE,
VELVET. SCEPTRE HEIGHT 15.8 CM
THE FIRM OF FABERGE WAS ESTABLISHED
IN ST PETERSBURG IN 1842 AND WENT
ON TO WIN THE PATRONAGE OF THE
IMPERIAL FAMILY. THE REGALIA,
A TENTH OF THEIR TRUE SIZE, WERE
ACQUIRED BY TSAR NICHOLAS II
FOLLOWING THEIR DISPLAY AT THE 1900
INTERNATIONAL EXHIBITION IN PARIS.
THE SET INCLUDES REPRODUCTIONS
OF THE LARGE CROWN, ORB AND
SCEPTRE, MADE FOR THE CORONATION
OF CATHERINE II, AND OF THE SMALL
CROWN, MADE FOR THE EMPRESS
ELIZABETH ALEXEEVNA IN 1801.

-<<<->>>-

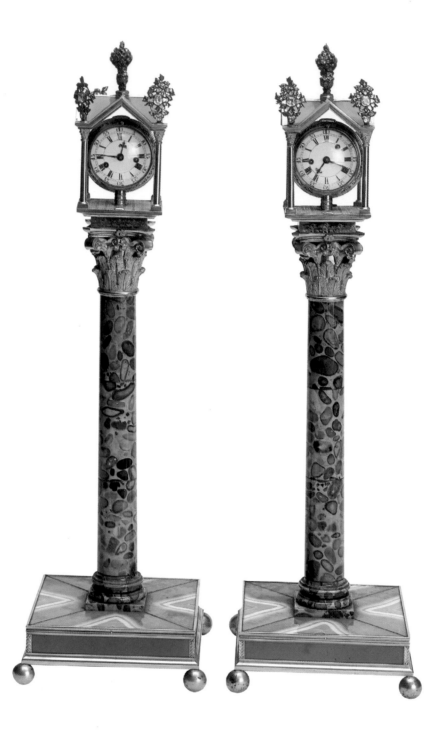

-<<< 6 & 7 >>>-

PAIR OF COLUMN CLOCKS

A HUNTER, LONDON, 1770-90

GOLD, SILVER, DIAMONDS, RUBIES, EMERALDS, TOPAZ, ENAMEL, GLASS, AGATE.

HEIGHT 42.6 X 11.3 CM & 42.8 X 11.9 CM

-<<<->>>-

-<<< 8 >>>-
COVERED EGG CUP
ST PETERSBURG, 1780
GOLD, TINTED GLASS, IVORY.
HEIGHT 10.3 CM
-<<<->>>-

-<<< 9 >>>-
EGG-SHAPED NECESSAIRE
FRANCOIS BEECKAERI, PARIS, 1757-58
GOLD, DIAMONDS, BRILLIANTS,
SILVER, ENAMEL. 8.3 X 6.4 CM
THE EXQUISITE NECESSAIRE
INCORPORATES A WATCH AND
CONTAINS A TINY TOILETRY SET.
IT IS THOUGHT TO HAVE BEEN AN
EASTER GIFT TO THE EMPRESS
ELIZABETH I FROM A FRENCH
AMBASSADOR. THE ENAMEL SCENE
LIFTS TO REVEAL THE CONTENTS.
THE INSCRIPTION READS 'NEE POUR
ORNER UNE COURONNE'
('BORN TO ADORN A CROWN').
-<<<->>>-

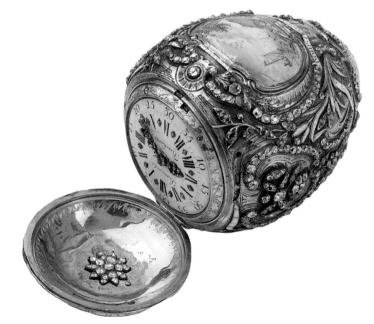

-<<< 10 >>>-
FILIGREE COASTER
JEAN FRANCOIS BOUDDE,
ST PETERSBURG, 1780
GOLD. HEIGHT 3.7 CM
ON THE SIDE OF THE COASTER
IS CATHERINE'S MONOGRAM
UNDER THE IMPERIAL CROWN.
IT MAY HAVE FORMED PART
OF A SERVICE.
-<<<->>>-

-<<< 11 >>>-
SNUFF BOX SHOWING THE
MONUMENT TO PETER THE GREAT,
LATE 18TH CENTURY
GOLD, OPALS, ENAMEL.
HEIGHT 7.5 X DIA 2.3 CM
THE LID SHOWS THE 'BRONZE
HORSEMAN', THE STATUE OF PETER
THE GREAT IN ST PETERSBURG
UNVEILED IN 1782. THE IMAGE IS TAKEN
FROM THE MEDAL BY JOHANN
BALTHASAR GASS AND
JOHANN GEORG WAECHTER.
-<<<->>>-

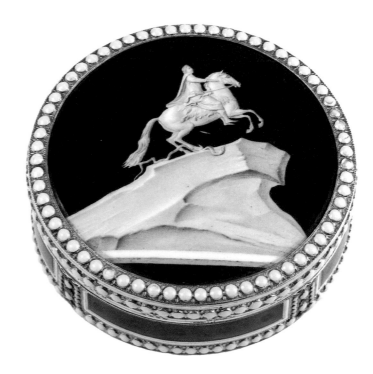

-<<< 12 >>>-
SNUFF BOX WITH AGATE CAMEO
OF CATHERINE II
DAVID RUDOLF , ST PETERSBURG, 1780S
GOLD, JASPER, AMETHYSTS, TOPAZ,
PASTE. HEIGHT 2.8 X DIA 8.3 CM
THE BOX IS ORNAMENTED WITH
SIBERIAN JASPER AND CARRIES THE
SIBERIAN COAT OF ARMS ON ITS BASE.
SUCH BOXES, KNOWN AS 'STUDIES IN
STONE', WERE POPULAR IN RUSSIA AND
WESTERN EUROPE THROUGHOUT THE
1770S AND 1780S.
-<<<->>>-

-<<< 13 >>>-
SNUFF BOX WITH A PICTURE
OF CATHERINE II RECEIVING THE
KEYS OF BENDERI
JEAN PIERRE ADOR, ST PETERSBURG,
C.1771-72
GOLD, ENAMEL, SILVER, DIAMONDS.
HEIGHT 3.2 X DIA 7.3 CM
DEPICTED ON THE LID IS AN
ALLEGORICAL SCENE, SHOWING
CATHERINE RECEIVING THE KEYS OF
BENDERI, A TOWN TAKEN FROM THE
TURKS IN 1770.
-<<<->>>-

-<<< 14 >>>-

SNUFF BOX WITH CHERUBS
JOHANN BALTHASAR GASS,
ST PETERSBURG, 1775-77
GOLD, SILVER, DIAMONDS.
3.5 X 7.3 X 5.4 CM
GASS, ONE OF THE BEST KNOWN
JEWELLERS AND MEDAL MAKERS OF HIS
DAY, WAS APPOINTED IMPERIAL
MEDAL MAKER IN 1773.
-<<<->>>-

-<<< 15 >>>-

SNUFF BOX WITH CATHERINE II IN
CLASSICAL DRESS AT AN ALTAR
ALEXANDER LANG, ST PETERSBURG, 1776
GOLD, SILVER, DIAMONDS, GARNETS.
3.5 X 7.5 X 5.3 CM
AROUND THE SIDE OF THE BOX ARE
MEDALLIONS SYMBOLIZING HOPE,
ABUNDANCE, JUSTICE AND PLENTY.
-<<<->>>-

-<<< 16 >>>-

SNUFF BOX
JEAN PIERRE ADOR, ST PETERSBURG,
1774. GOLD. 3.3 X 8.2 CM
THE LID OF THE BOX PICTURES
CATHERINE AS MINERVA, THE
GODDESS OF WISDOM. IT IS BASED ON
THE FAMOUS COMMEMORATIVE MEDAL
BY JOHANN GEORG WAECHTER TO
MARK HER ACCESSION. ADOR MADE 30
SUCH BOXES TO BE DISTRIBUTED
AMONG SUPPORTERS OF THE COUP
THAT BROUGHT HER TO POWER.
HE WAS THE BEST KNOWN JEWELLER
IN ST PETERSBURG.

-<<<->>>-

-<<< 17 >>>-

SNUFF BOX WITH MONOGRAM OF
EMPRESS MARIA FEODOROVNA
CARL BARBE, ST PETERSBURG, C.1828-29
GOLD, MOTHER OF PEARL, ENAMEL,
GLASS. 3.7 X 8.5 X 6.6 CM
THE FUNERARY URN AND LOCK OF
HAIR ON THE LID INDICATE THAT THE
BOX WAS MADE TO COMMEMORATE
THE DEATH OF THE EMPRESS MARIA
FEODOROVNA, WIDOW OF PAUL I.
HER MONOGRAM CAN BE SEEN
BELOW THE URN.

-<<<->>>-

-<<< 18 >>>-
SNUFF BOX SHOWING THE
MONUMENT TO CATHERINE II
JOHANN GOTTLIEB SCHARFF,
ST PETERSBURG, 1776
GOLD, ENAMEL, DIAMONDS, SAPPHIRES,
SILVER. HEIGHT 1.9 X DIA 6.9 CM
THE ENAMEL GRISAILLE MINIATURE
SET INTO THE LID WAS COMMISSIONED
FROM THE ARTIST GAVRIIL IGNATIEVICH
KOZLOV BY PRINCE POTEMKIN
AND SHOWS SHUBIN'S STATUE
OF CATHERINE.
-<<<->>>-

-<<< 19 >>>-
SNUFF BOX WITH PORTRAIT OF THE
GRAND DUKE ALEXANDER PAVLOVICH,
LATER ALEXANDER I, AS A CHILD
JEAN FRANCOIS BOUDDE,
ST PETERSBURG, C.1780
GOLD, ENAMEL, DIAMONDS, SILVER.
HEIGHT 1.7 X DIA 7 CM
-<<<->>>-

-<<< 20 >>>-

SNUFF BOX WITH CAMEO PORTRAIT
OF COUNT ALEXEI ORLOV
JOHANN GOTTLIEB SCHARFF,
ST PETERSBURG, 1778
GOLD, ENAMEL, SILVER, DIAMONDS.
2.2 X 6.9 X 3.6 CM
ORLOV, A LEADING PARTICIPANT IN
THE 1762 COUP, WHO WAS TO BECOME
ONE OF CATHERINE'S GREATEST
MILITARY COMMANDERS, IS
REPRESENTED AS A CLASSICAL HERO
IN HELMET AND ARMOR.

-<<<->>>-

-<<< 21 >>>-

SNUFF BOX WITH VIEW OF THE PARK
AT TSARKOE SELO AND THE
CHESME COLUMN
THEREMIN BROTHERS WORKSHOP,
ST PETERSBURG, 1795
GOLD, ENAMEL. 1.5 X 6.5 X 4.8 CM
THE MINIATURE ON THE LID SHOWS
THE CHESME COLUMN, ERECTED TO
COMMEMORATE THE VICTORY OF THE
RUSSIAN FLEET OVER THE TURKS IN 1770.
THE BOX WAS SENT BY CATHERINE TO
COUNT ALEXEI ORLOV, THE
COMMANDER AT THE BATTLE.

-<<<->>>-

-<<< 22 >>>-

FILIGREE TAZZA WITH TRAY

MASTER: PETER CARAMAQUE

ST PETERSBURG, 1793

GOLD. TAZZA HEIGHT: 3.4 CM

SUCH FILIGREE WORK WAS ESPECIALLY

POPULAR IN RUSSIA AT THE END OF

THE 18TH CENTURY. THE TAZZA IS

SAID TO HAVE BEEN PRESENTED TO

CATHERINE FILLED WITH

PRECIOUS STONES.

-<<<->>>-

-<<< 23 & 24 >>>-

OPENWORK BASKET

AND SET OF COUNTERS

JOHANN MEISSNER, ST PETERSBURG,

C.1768-69. GOLD. DIA 19.3 CM

ON THE DISH AND THE COUNTERS

ARE ENGRAVED CATHERINE'S MOTTO

AND BEEHIVE EMBLEM. THE

COUNTERS WOULD HAVE BEEN USED

FOR CARD GAMES.

-<<<->>>-

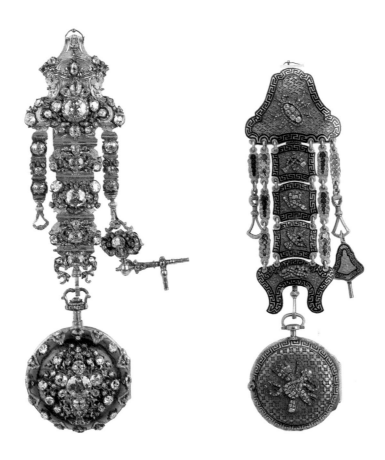

-<<< 25 >>>-

JEWELLED WATCH AND CHATELAINE

ST PETERSBURG, 1760S. GOLD, ENAMEL, DIAMONDS, SILVER.

CHATELAINE: 18.4 X 4.7 CM. WATCH: DIA 4.6 CM

CHATELAINES WERE ORIGINALLY MADE TO BE HUNG FROM A WOMAN'S BELT IN

ORDER TO CARRY KEYS AND OTHER USEFUL SMALL ITEMS.

THEY DEVELOPED TO BECOME HIGHLY DECORATIVE PIECES OF JEWELRY.

-<<<->>>-

-<<< 26 >>>-

WATCH ON A CHATELAINE

JEAN PIERRE ADOR, ST PETERSBURG, C.1780. GOLD, ENAMEL, GLASS, SILVER.

CHATELAINE: 18 X 5 CM. WATCH: DIA 4.7 CM

-<<<->>>-

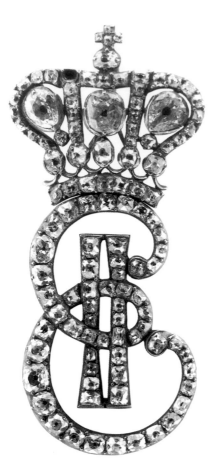

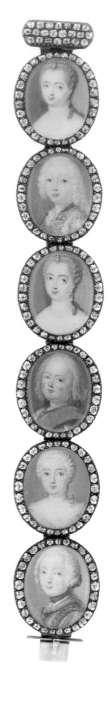

-<<< 27 >>>-

JEWELLED MONOGRAM OF CATHERINE II

ST PETERSBURG, C.1770-80

SILVER, GOLD, DIAMONDS

SUCH BROOCHES WERE GIVEN TO THE

EMPRESS' MAIDS OF HONOR.

THE 'E' STANDS FOR 'EKATERINA'.

-<<<->>>-

-<<< 28 >>>-

BRACELET WITH PORTRAIT MINIATURES

ST PETERSBURG, C.1760-70

GOLD, SILVER, CRYSTALS, DIAMONDS,

ENAMEL. 17 X 2.2 CM

THE PORTRAITS ARE BELIEVED TO BE

OF MEMBERS OF THE IMPERIAL FAMILY,

CATHERINE'S FATHER, AND THEIR

FOREBEARS.

-<<<->>>-

-<<< 29 >>>-

CAMEO RING WITH PORTRAIT

OF CATHERINE II

ST PETERSBURG, C.1780-90

GOLD, SILVER, AGATE CAMEO,

DIAMONDS. 2.8 X 2.5 CM

THE CAMEO PORTRAIT USES THE

DESIGN BY WAECHTER AND GASS IN

1782 ON THEIR COMMEMORATIVE

MEDAL FOR THE UNVEILING OF THE

MONUMENT TO PETER THE GREAT

IN ST PETERSBURG.

-<<<->>>-

THE RUSSIAN EMPIRE

-<<< 1 >>>-

A DESCRIPTION OF THE PEOPLES

OF RUSSIA

BY JOHANN GOTTLIEB GEORGI

(1729-1802)

45 ENGRAVINGS BY CHRISTOPHER ROTH

ST PETERSBURG, 1776-77

18TH-CENTURY BINDING. 28.5 X 22 CM

CATHERINE'S REIGN SAW AN UPSURGE

OF INTEREST IN EXPLORATION OF

RUSSIA'S REMOTE FAR EAST, PROMPTED

BY TRADE AND A NEW SPIRIT OF

INTELLECTUAL CURIOSITY. GEORGI,

A TRAVELLER AND ETHNOGRAPHER,

ATTEMPTED TO GIVE THE FIRST

COMPREHENSIVE PICTURE OF THE

PEOPLES OF RUSSIA, THEIR CUSTOMS

AND WAY OF LIFE. HE DREW ON HIS

OWN OBSERVATIONS AS WELL AS THE

EXPERIENCES OF OTHER TRAVELLERS,

RUSSIAN AND FOREIGN. IT WAS

TRANSLATED INTO GERMAN

AND FRENCH.

-<<<->>>-

-<<< 2 >>>-

CATHERINE IN TRAVELLING COSTUME,

AFTER 1787

AFTER MIKHAIL SHIBANOV

OIL ON CANVAS. 52.2 X 65.8 CM

THE ORIGINAL PORTRAIT WAS PAINTED

DURING CATHERINE'S VISIT TO KIEV IN

1787. AT THE TIME SHE WAS HEADING

SOUTH TO VISIT THE CRIMEA AND HER

OTHER NEWLY-ACQUIRED TERRITORIES.

THE ARTIST, SHIBANOV, WAS ONE OF

POTEMKIN'S SERFS.

-<<<->>>-

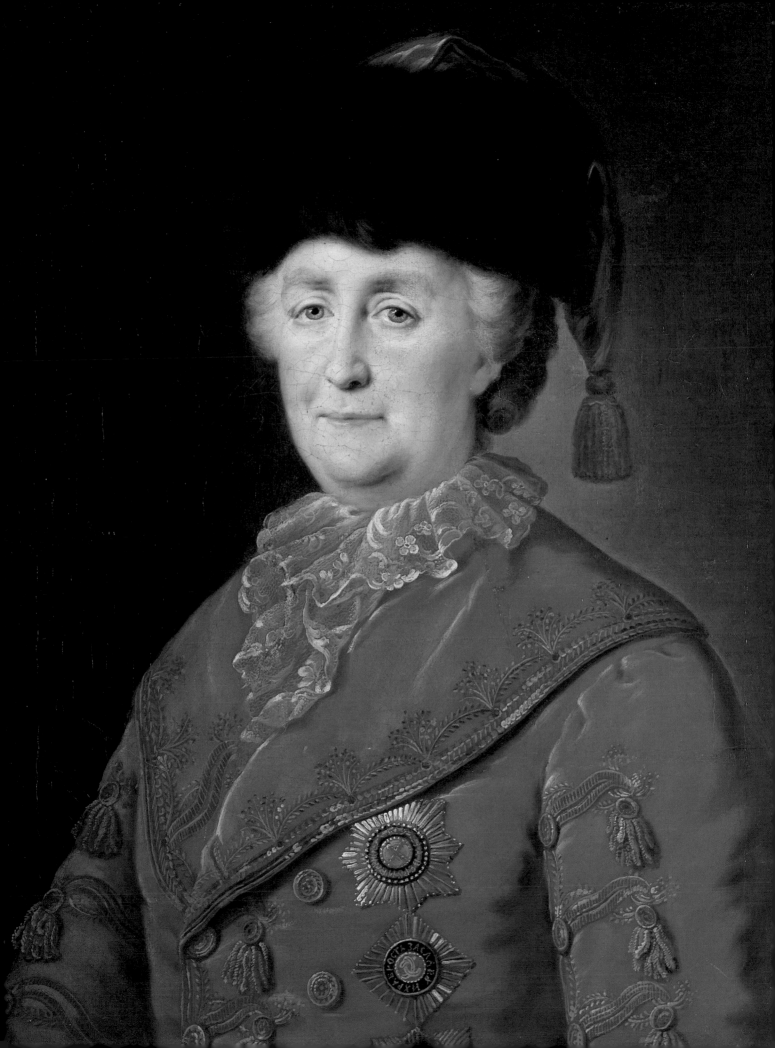

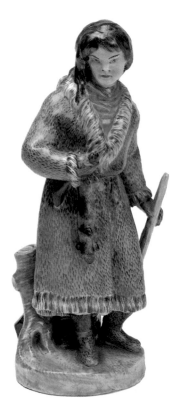

-<<< 3 >>>-
KAMCHATKA MAN
20.3 CM
-<<<->>>-

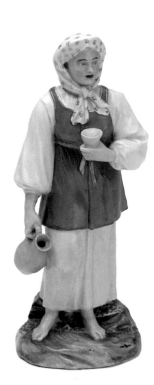

-<<< 4 >>>-
RUSSIAN MILKWOMAN
19.2 CM
-<<<->>>-

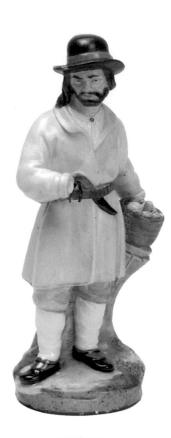

-<<< 5 >>>-
CHUKHON PEASANT
21 CM
-<<<->>>-

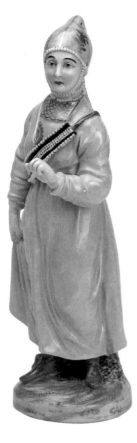

-<<< 6 >>>-

KAZAN TARTAR WOMAN

23 CM

-<<<->>>-

-<<< 7 >>>-

KAMCHATKA WOMAN

20.7 CM

-<<<->>>-

-<<< 8 >>>-

ICE PEDLAR

20.2 CM

-<<<->>>-

-<<< 3-8 >>>-

FIGURES FROM THE *PEOPLES OF RUSSIA*

SERIES AND OTHERS, 1780S

FROM MODELS BY

DOMINIQUE RACHETTE (1744-1809)

IMPERIAL PORCELAIN FACTORY,

NEAR ST PETERSBURG. PORCELAIN,

OVERGLAZE PAINTING, GILDING

THE FIGURES WERE INSPIRED BY GEORGI'S

DESCRIPTION OF THE PEOPLES OF RUSSIA.

AT THE SAME TIME THE FACTORY ALSO

PRODUCED FIGURES OF TRADESMEN AND

CRAFTSMEN

TO ACCOMPANY THE SET.

-<<<->>>-

-<<< 11 >>>-

A JOURNEY THROUGH DIFFERENT PROVINCES
OF THE RUSSIAN EMPIRE
BY PETER SIMON PALLAS (1741-88)
PUBLISHED BY THE ACADEMY OF
SCIENCES, ST PETERSBURG, 1773-88
THE EXPLORER PETER SIMON PALLAS
TRAVELLED FAR INTO SIBERIA, THE
URALS, THE NORTHERN CAUCASUS AND
AROUND THE SEA OF AZOV.
HIS ACCOUNT CONTAINS A VAST RANGE
OF ETHNOGRAPHICAL, BOTANICAL AND
GEOLOGICAL INFORMATION.

-<<<->>>-

-<<< 9 >>>-

ALEUTIAN FISHING CANOE
LATE 18TH CENTURY. WALRUS TUSK. 8 X 31.5 X 4.5 CM
RUSSIAN EXPLORERS FIRST MADE CONTACT WITH THE ESKIMO POPULATION OF THE
ALEUTIAN ISLANDS, OFF THE COAST OF ALASKA, IN THE 1740S. THE CARVING, BY A LOCAL
CRAFTSMEN, SHOWS THREE FISHERMEN WITH THEIR CATCH IN A LEATHER CANOE.

-<<<->>>-

-<<< 10 >>>-

CAPTAIN SARYCHEV'S JOURNEYS IN NORTH-EASTERN SIBERIA,
THE ARCTIC AND PACIFIC OCEANS. ST PETERSBURG, 1802
LATE 18TH CENTURY LEATHER BINDING STAMPED WITH GOLD. 26.5 X 21 CM
GAVRIIL SARYCHEV (1763-1831) SPENT EIGHT YEARS TRAVELLING OFF RUSSIA'S EASTERN
COAST AS A LEADER OF AN OFFICIAL EXPEDITION TAKING IN THE SEA OF OKHOTSK
AND ALEUTIAN ISLANDS.

-<<<->>>-

П. С. Палласа,

Доктора Медицины, Профессора Натуральной
исторіи и члена Россійской Императорской Ака-
деміи Наукъ, и Санктпетербургскаго Вольнаго
Экономическаго Общества, также Римской Импе-
раторской Академіи изпытателей естества и
Королевскаго Аглинскаго ученаго собранія,

ПУТЕШЕСТВІЕ

по

разнымъ провинціямъ

РОССІЙСКОЙ ИМПЕРІИ.

Часть первая.

Цѣна 3 руб. 50 коп.

ВЪ САНКТПЕТЕРБУРГѢ
при Императорской Академіи Наукъ 1773 года.

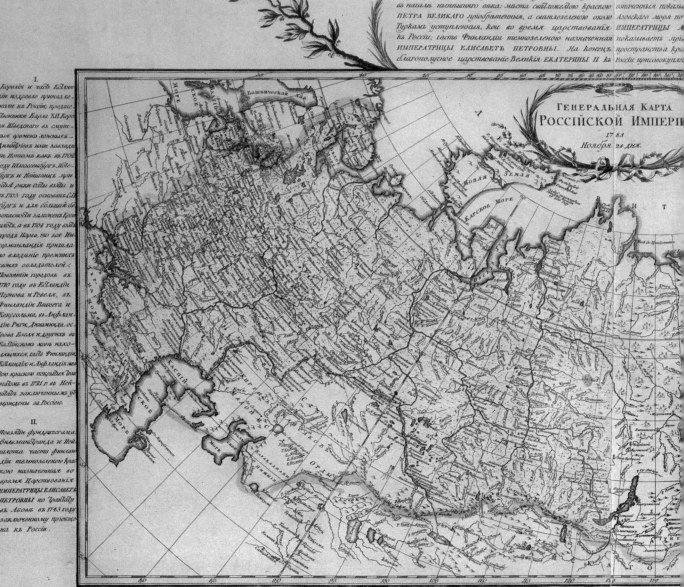

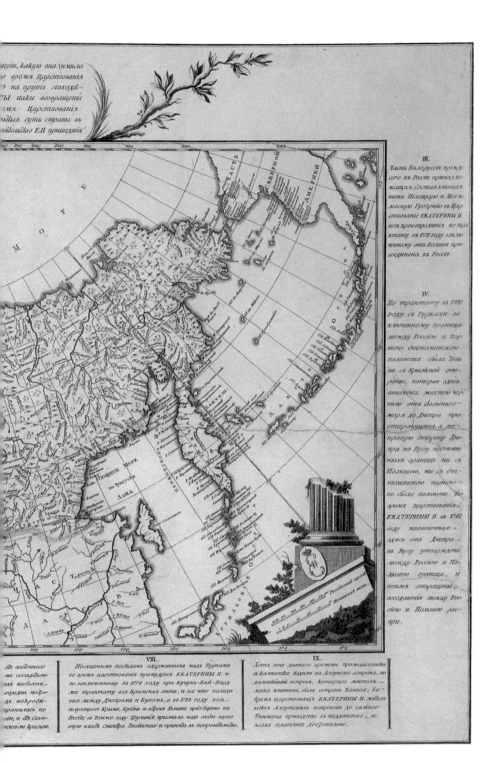

-<<< 12 >>>-
MAP OF THE RUSSIAN EMPIRE IN 1783
ENGRAVER UNKNOWN
ENGRAVING, WATERCOLOR.
62.5 X 111 CM
THE MAP WAS PROBABLY PREPARED
BY THE GEOGRAPHY DEPARTMENT OF
THE ACADEMY OF SCIENCES. THE TEXT
AROUND THE BORDER DETAILS THE
GROWTH OF RUSSIA SINCE THE
ACCESSION OF PETER THE GREAT.
-<<<->>>-

-<<< 13 >>>-
GLOBE
ST PETERSBURG, COMPLETED 1773
BRASS, PAPER, WOOD. DIA 61 CM
THE HAND-PAINTED GLOBE WAS
DESIGNED BY IVAN TRESCOT,
A GEOGRAPHER AT THE ACADEMY OF
SCIENCES 'ACCORDING TO THE LATEST
ASTRONOMIC OBSERVATIONS'. IT WAS
COMMISSIONED BY CATHERINE AND
KEPT IN HER PRIVATE APARTMENTS.
-<<<->>>-

-<<< 14 >>>-

MEDAL FOR LEADERS OF THE NATIVE COMMUNITY IN NORTH-WEST AMERICA AND ADJOINING ISLANDS
OLONETSK IRON FOUNDRY, RUSSIA, 1789. CAST IRON. DIA 80 MM

THE EXPEDITION FOR WHICH THESE MEDALS WERE ORDERED WAS ABANDONED BECAUSE OF THE
RUSSO-SWEDISH WAR. THE HOOKS ALLOWED THE MEDALS TO BE WORN AS ORNAMENTS. THE EXPEDITION
WAS ALSO TO HAVE CARRIED CAST-IRON POLES, BEARING THE RUSSIAN INSIGNIA, TO BE ERECTED TO
ESTABLISH RUSSIAN SOVEREIGNTY OVER UNCLAIMED TERRITORY.

-<<<->>>-

-<<< 15 >>>-

MEDAL FOR LEADERS OF THE NATIVE COMMUNITY IN NORTH-WEST AMERICA AND ADJOINING ISLANDS
ST PETERSBURG MINT, 1785. SILVER. DIA 62 MM

THE MEDALS WERE FOR DISTRIBUTION BY MEMBERS OF THE SECRET RUSSIAN EXPEDITION OF 1785-93
WHICH AIMED TO EXPLORE RUSSIA'S FAR-EASTERN SHORES AS WELL AS THE ALEUTIAN ISLANDS,
THE ALASKAN ARCHIPELAGO AND THE NORTH-WEST COAST OF AMERICA. THEY WERE INTENDED AS
A 'SYMBOL OF RUSSIAN FRIENDSHIP' AND MAY HAVE BEEN INTENDED TO MARK RUSSIAN SOVEREIGNTY.
THE SHIP ON THE REVERSE IS THE *GLORY OF RUSSIA* WHICH SAILED WITH THE EXPEDITION.

-<<<->>>-

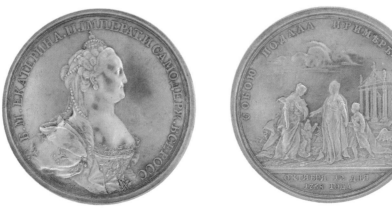

-<<< 16 >>>-

COMMEMORATIVE MEDAL FOR THE INTRODUCTION OF SMALLPOX VACCINATION INTO RUSSIA
ST PETERSBURG, 1772. SILVER. DIA 64 MM

IN 1768 CATHERINE WAS THE FIRST EUROPEAN MONARCH TO BE VACCINATED AGAINST SMALLPOX.
ALARMED AT AN OUTBREAK OF THE DISEASE AT COURT, SHE SUMMONED A DOCTOR FROM ENGLAND
TO INNOCULATE HERSELF, THE GRAND DUKE PAUL AND OTHER MEMBERS OF THE ROYAL FAMILY
AND COURT. THE REVERSE CARRIES THE INSCRIPTION 'SHE GAVE AN EXAMPLE'.

-<<<->>>-

-<<< 17 A & B >>>-

TWO SHEETS FROM *THE JOURNEY OF
CAPTAIN SARYCHEV'S FLEET ALONG THE
COAST OF NORTH-EAST SIBERIA, THE ARCTIC
AND THE EASTERN OCEAN*, 1802
ENGRAVED BY IVAN VASIL'EVICH CHESKII
(1779/80-1848)
A. 'A VIEW OF SHELIKHOV'S
SETTLEMENT AT MANIKAKSIAK HARBOR
ON KODIAK ISLAND'
32.8 X 50.8 CM
B. 'NATIVE AMERICANS RESTING
UNDER THEIR OVERTURNED BOATS AT
SHUGACHSKAIA BAY'
32.8 X 50.8 CM
SHELIKHOV FOUNDED HIS FIRST
SETTLEMENT ON KODIAK ISLAND IN 1764
WHICH WAS SOON FOLLOWED BY
OTHER COLONIES IN THE REGION.

-<<<->>>-

Видъ селенія Бутца Шелихова на Островъ Кадьякъ съ Гавани Маникаксакъ или Трехъ Совятителей.

Американцы Шугачской губы расположившіеся начевать подъ опрокинутыми своими байдарами.

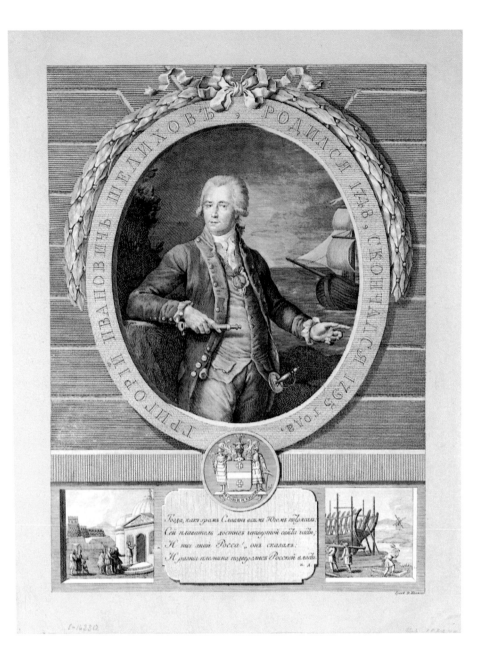

-<<< 18 >>>-

PORTRAIT OF GRIGORII IVANOVICH SHELIKHOV

ENGRAVED BY VASILII IVANOV (1773-AFTER 1809).41.5 X 33.3 CM

SHELIKHOV (1748-95), SOMETIMES KNOWN AS THE 'RUSSIAN COLUMBUS', ESTABLISHED

RUSSIA'S FIRST COLONY IN ALASKA. HE WAS THE FOUNDER OF A TRADING COMPANY

IN KAMCHATKA TO EXPLOIT THE REGION'S WEALTH AND PIONEERED EXPLORATION

OF THE KURIL AND ALEUTIAN ISLANDS.

-<<<->>>-

-<<< 19 >>>-

PORTRAIT OF FIELD-MARSHAL
ALEXANDER VASIL'EVICH SUVOROV
MOSCOW, 1812
ENGRAVED BY ALEXANDER
ALEXANDROVICH FLOROV
AFTER A PASTEL BY JOHANN HEINRICH
SCHMIDT, 1800. 68.5 X 55 CM
SUVOROV (1730-1800) WAS THE
GREATEST RUSSIAN GENERAL OF
THE 18TH CENTURY. HE TOOK PART
IN ALMOST EVERY RUSSIAN CAMPAIGN,
LEADING HIS FORCES AGAINST THE
TURKS, THE FRENCH AND THE POLES.

-<<<->>>-

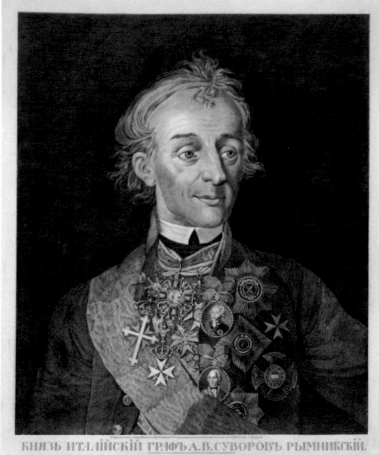

КНЯЗЬ ИТАЛІЙСКІЙ ГРАФЪ А.В.СУВОРОВЪ РЫМНИКСКІЙ.

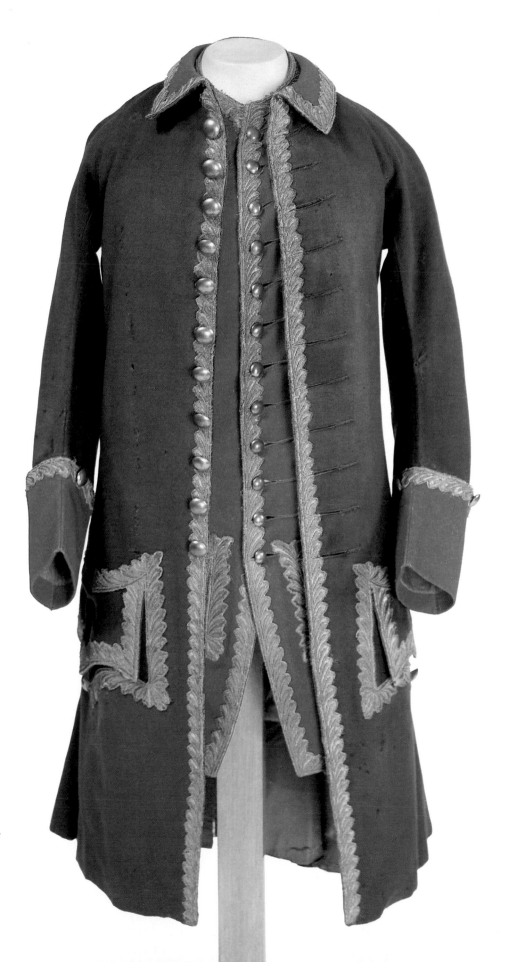

-<<< 20 >>>-
BRIGADIER'S DRESS UNIFORM OF
FIELD-MARSHAL SUVOROV
ST PETERSBURG, LATE 18TH CENTURY
WOOL, SILK, METAL, THREAD,GILT.
COAT LENGTH 98 CM
-<<<->>>-

-<<< 21 >>>-

COMMEMORATIVE MEDAL IN HONOR OF COUNT ALEXEI GRIGORIEVICH ORLOV

ST PETERSBURG, 1771. SILVER. DIA 91 MM

THE MEDAL WAS STRUCK TO MARK THE FIRST ANNIVERSARY OF ORLOV'S VICTORY OVER THE TURKS

AT CHESME IN THE AEGEAN SEA IN 1770. THE INSCRIPTION ON THE OBVERSE READS 'A.G. ORLOV:

VICTOR AND DESTROYER OF THE TURKISH FLEET', WHILE ON THE REVERSE, WHICH SHOWS A MAP

OF THE BATTLE, IS AN INSCRIPTION BY CATHERINE HERSELF: 'JOY AND GAIETY TO RUSSIA' AND

'IN GRATITUDE TO THE VICTOR FROM THE ADMIRALTY'.

-<<<->>>-

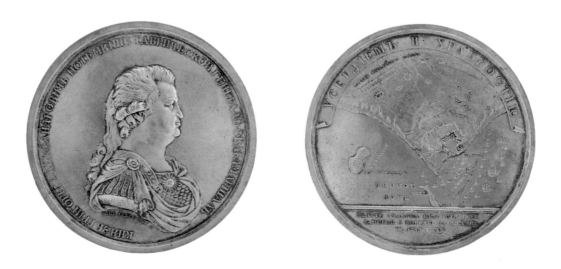

-<<< 22 >>>-

COMMEMORATIVE MEDAL IN HONOR OF PRINCE POTEMKIN

ST PETERSBURG, 1789. SILVER. DIA 92 MM

CATHERINE ORDERED THE MEDAL TO CELEBRATE POTEMKIN'S CAPTURE OF OCHAKOV IN 1788,

A HIGH POINT OF THE SECOND RUSSO-TURKISH WAR. THE MEDAL WAS PART OF A SET OF

THREE DESIGNED TO COMMEMORATE HIS DIFFERENT ACHIEVEMENTS. THE REVERSE, A PLAN OF

THE BATTLE, IS INSCRIBED AROUND THE EDGE 'THROUGH ASSIDUITY AND COURAGE'.

-<<<->>>-

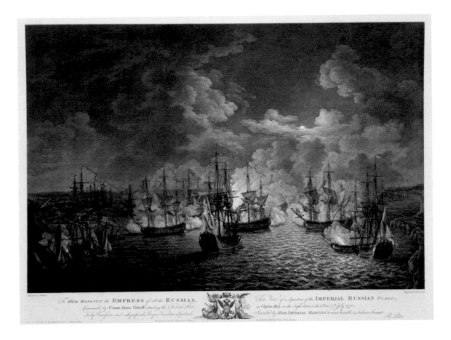

-<<< 23 >>>-

THE BATTLE OF CHESME

ENGRAVED BY PIERRE CANOT, 1777. AFTER AN ORIGINAL BY RICHARD PATON, 1771. 50.3 X 68.3 CM

THE PICTURE SHOWS A CRUCIAL EPISODE IN THE BATTLE AS RUSSIAN WARSHIPS STAGE A NIGHT ATTACK.

A SINGLE EXPLOSION SPREAD FIRE FROM SHIP TO SHIP IN THE TURKISH FLEET, WITH THE LOSS OF

THOUSANDS OF LIVES. THE ORIGINAL PAINTINGS FORM A SET COMMISSIONED FROM AN ENGLISH ARTIST

BY THE RUSSIAN AMBASSADOR IN LONDON. THEY WERE LATER HUNG AT PETERHOF NEAR ST PETERSBURG.

-<<<->>>-

-<<< 24 >>>-

THE ASSAULT BY RUSSIAN TROOPS ON THE FORTRESS OF ISMAIL IN 1790

ENGRAVED BY SCHIFLAR, 1790S. AFTER A DRAWING BY MIKHAIL IVANOV

THE POWERFUL TURKISH FORTRESS ON THE BANKS OF THE DANUBE IS SEEN UNDER ATTACK FROM

RUSSIAN TROOPS DURING THE SECOND RUSSO-TURKISH WAR. ITS SEIZURE, AFTER A LONG SIEGE,

HELPED FORCE THE TURKS TO SUE FOR PEACE.

-<<<->>>-

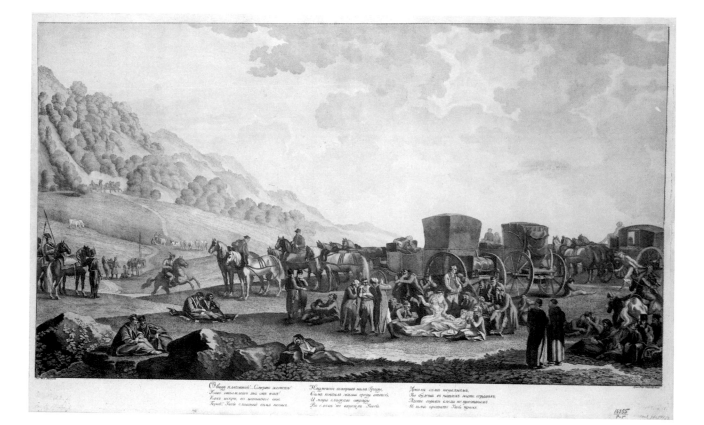

-<<< 25 >>>-

THE DEATH OF PRINCE POTEMKIN

ENGRAVED BY

GAVRIIL SKORODUMOV, 1792.

AFTER THE ORIGINALS BY

MIKHAIL IVANOV AND

FRANCESCO CASANOVA, 1791

POTEMKIN DIED OF A FEVER WHILE

TRAVELLING IN BESSARABIA - A DISTANT

PROVINCE ON THE BLACK SEA - IN 1791,

ONLY MONTHS AFTER CONCLUDING THE

TREATY WHICH SEALED HIS ARMY'S

SUCCESS IN THE SECOND RUSSO-TURKISH

WAR. CATHERINE WAS DEVASTATED BY

THE NEWS OF HIS DEATH.

-<<<->>>-

-<<< 26 >>>-

STATUE OF PRINCE POTEMKIN, C.1794-95

IVAN MARTOS (1754-1835)

MARBLE. HEIGHT 100 CM

THE COURT'S ARCHIVES NOTE THAT

MARTOS WAS PAID 3000 ROUBLES

FOR THE STATUE, COMMISSIONED BY

CATHERINE AFTER POTEMKIN'S

DEATH IN 1791.

-<<<->>>-

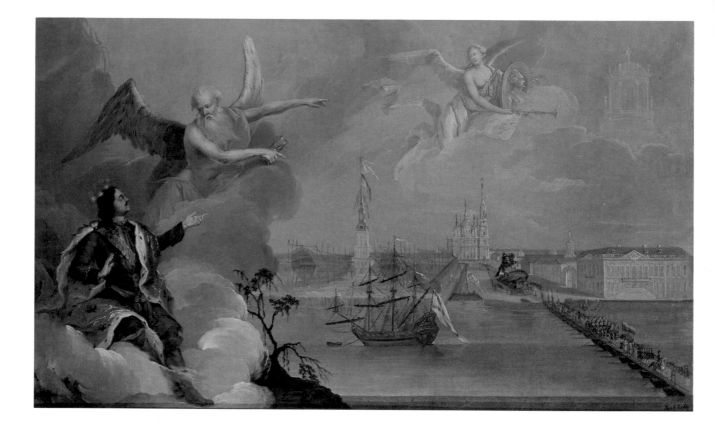

-<<< 27 >>>-

AN ALLEGORY OF RUSSIA'S VICTORY OVER

THE TURKS, 1768-74

HEINRICH BUCHHOLTZ (1735-80), 1777

OIL ON CANVAS. 75 X 127.2 CM

THE PICTURE ILLUSTRATES ONE OF

CATHERINE'S FAVORITE THEMES:

HER LINKS WITH PETER THE GREAT AND

THE PARALLELS BETWEEN THEIR AIMS

AND ACHIEVEMENTS. PETER IS SEEN

WITH THE ALLEGORICAL FIGURES OF

TIME AND GLORY WATCHING AS THE

VICTORIOUS RUSSIAN TROOPS AND

THEIR TURKISH CAPTIVES CROSS THE

NEVA AND PLACE THEIR FLAGS AT THE

FOOT OF HIS STATUE AFTER THE

FIRST RUSSO-TURKISH WAR.

-<<<->>>-

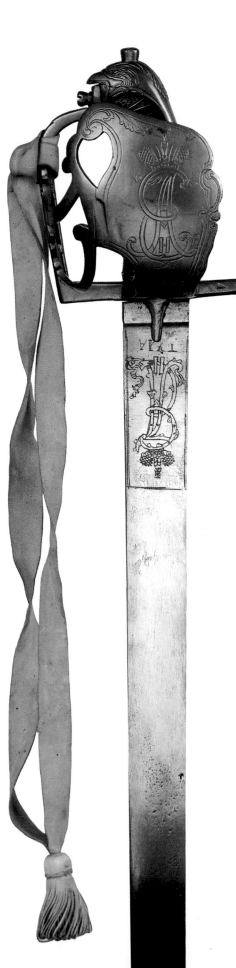

-<<< 28 >>>-

OFFICER'S BROADSWORD

RUSSIA, 18TH CENTURY.

STEEL, BRONZE, COPPER, GILDING.

LENGTH 104 CM

THE BLADE HAS ENGRAVED ON IT A

DOUBLE-HEADED EAGLE WITH THE

FIGURE OF SAINT GEORGE UNDER THE

IMPERIAL CROWN. THE HILT IS

DECORATED WITH

CATHERINE'S MONOGRAM.

-<<<->>>-

-<<< 29 >>>-

CUIRASSIER BROADSWORD

TULA, 1772

STEEL, BRASS, LEATHER, LENGTH 106 CM

-<<<->>>-

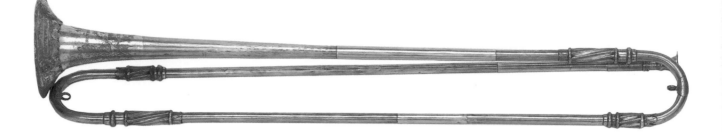

-<<< 30 >>>-

TRUMPET PRESENTED TO THE

ST PETERSBURG CARABINIERS

DRESDEN, C.1760

SILVER, GILDING. LENGTH 71 CM

IN THE SEVEN YEARS WAR THE

REGIMENT WAS PRESENTED WITH THE

TRUMPET AS A REWARD FOR ITS PART

IN THE TAKING OF BERLIN IN 1760.

IT IS ENGRAVED WITH THE IMPERIAL

CROWN AND THE INSCRIPTIONS 'WITH

SPEED AND VALOR' AND 'THE CAPTURE

OF BERLIN, SEPTEMBER 28, 1760'.

-<<<->>>-

-<<< 31 & 32 >>>-

PAIR OF PISTOLS

TULA, C.1780

STEEL, WOOD, INLAY, GILDING.

LENGTH 35 CM. CALIBRE 13 MM

-<<<->>>-

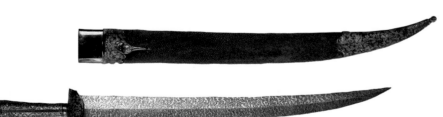

-<<< 33 >>>-

HUNTING DAGGER

TULA, 1780S

STEEL, SNAKESKIN. LENGTH 54 CM

-<<<->>>-

-<<< 34 >>>-

STANDARD OF THE LIFE GUARDS

CUIRASSIER REGIMENT, C.1762-96

SILK, METAL THREAD, WOOD, BRONZE.

50 X 50 CM

THE EMPRESS MARIA FEODOROVNA WAS

COMMANDER-IN-CHIEF OF THE

REGIMENT FROM 1796.

-<<<->>>-

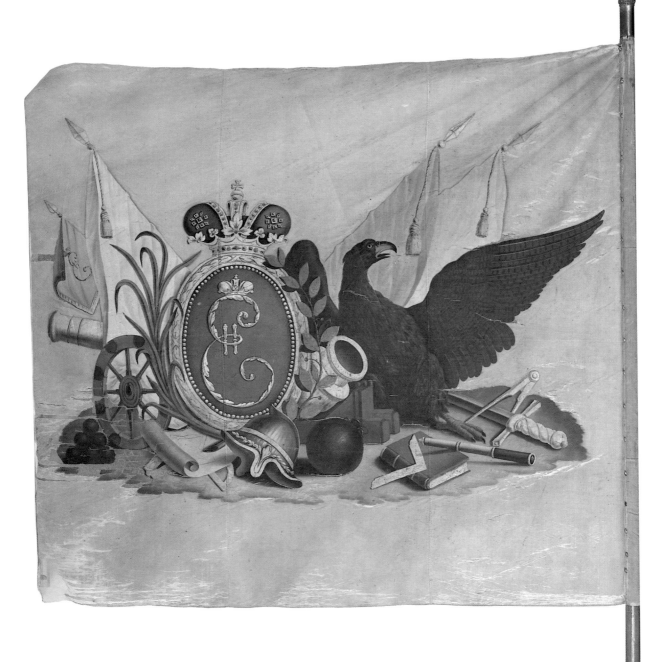

STANDARD OF THE
HORSEGUARDS REGIMENT, 1762
SILK, METAL, WOOD, BRONZE. 50 X 50 CM
THE HORSEGUARDS WAS AMONG THE
GRANDEST REGIMENTS IN THE RUSSIAN
ARMY, COMPOSED OF MEMBERS OF
RUSSIA'S LEADING FAMILIES. THIS
STANDARD IS OF THE TIME OF PETER III
AND CONTAINS HIS COAT OF ARMS.

-<<<->>>-

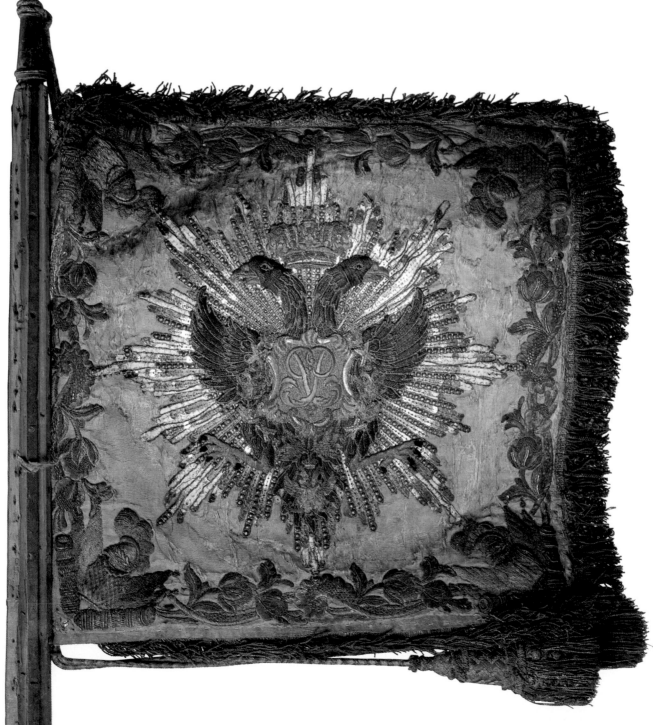

-<<< 36 >>>-

BANNER OF THE GREEK CORPS
'THE COMPANY OF FOREIGN
BELIEVERS', 1793
SILK, WOOL, BRONZE. 142 X 155 CM
IN 1775 POTEMKIN FOUNDED A UNIT OF
200 GREEK STUDENTS TO BE TRAINED IN
RUSSIAN MILITARY TECHNIQUES IN
PREPARATION FOR THEIR RETURN TO
GREECE AND THEIR PART IN THE
PLANNED LIBERATION OF THEIR HOME-
LAND FROM TURKISH DOMINATION.

-<<<->>>-

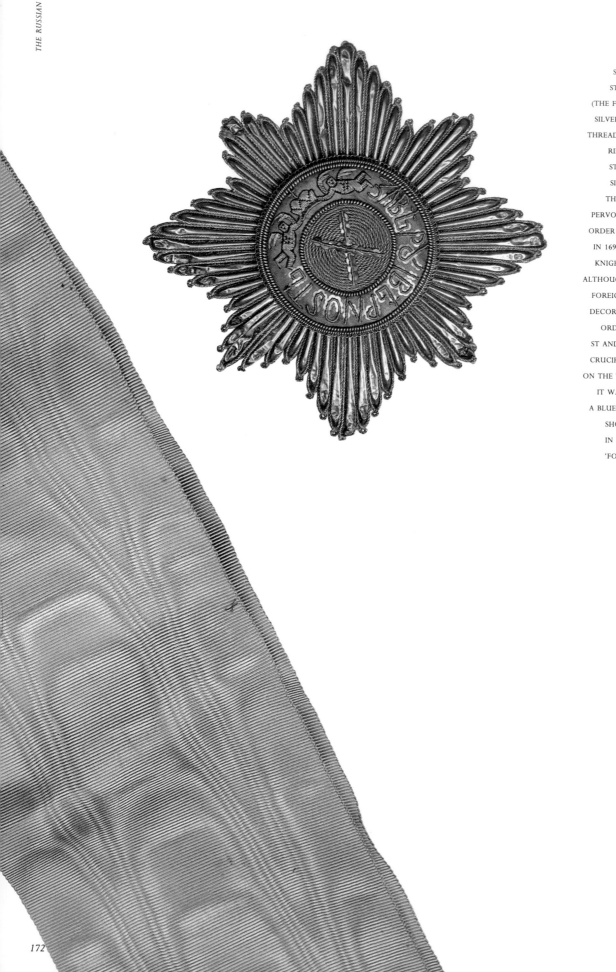

<<< 37 & 38 >>>-
STAR OF THE ORDER OF
ST ANDREW PERVOZANNYI
(THE FIRST CALLED), 18TH CENTURY
SILVER FOIL, METAL WIRE, METAL
THREAD, SEQUINS, SILK. 11.6 X 10 CM
RIBBON OF THE ORDER OF
ST ANDREW PERVOZANNYI
SILK, MOIRE. 10 X 116 CM
THE ORDER OF ST ANDREW
PERVOZANNYI - THE FIRST RUSSIAN
ORDER - WAS INSTITUTED BY PETER I
IN 1698. THE NUMBER OF RUSSIAN
KNIGHTS OF THE ORDER WAS 24,
ALTHOUGH AN UNLIMITED NUMBER OF
FOREIGNERS COULD BE GIVEN THE
DECORATION. THE EMBLEM OF THE
ORDER SHOWS THE CROSS OF
ST ANDREW WITH A PICTURE OF A
CRUCIFIED APOSTLE SUPERIMPOSED
ON THE TWO-HEADED RUSSIAN EAGLE.
IT WAS WORN ON THE HIP ON
A BLUE RIBBON, HUNG ACROSS THE
SHOULDER. THE MEDAL HAS
IN ITS CENTER THE WORDS
'FOR FAITH AND LOYALTY'.
-<<<->>>-

-<<< 39 & 40 >>>-

STAR OF THE MILITARY ORDER OF
ST GEORGE, MARTYR AND VICTOR
18TH CENTURY
METAL WIRE, METAL THREAD, SEQUINS,
SILK. 8.2 X 8.2 CM
RIBBON OF THE MILITARY ORDER OF
ST GEORGE, MARTYR AND VICTOR
SILK, MOIRE. 9.8 X 165 CM
THE MILITARY ORDER OF ST GEORGE
WAS CREATED ON 26 NOVEMBER, 1769.
THE STATUTE, WRITTEN THE
FOLLOWING DAY, DECLARED THAT IT
SHOULD BE AWARDED TO REWARD
SPECIFIC DEEDS IN BATTLE. IT WAS
DIVIDED INTO FOUR CLASSES AND ANY
OFFICER WHO PROVED HIMSELF ON THE
FIELD OF BATTLE COULD BE DECORATED
WITH THE ORDER. HOWEVER, BESIDES
CATHERINE HERSELF, ONLY EIGHT
PEOPLE WERE AWARDED THE FIRST
CLASS OF THE ORDER IN THE 18TH
CENTURY.
THE MEDAL TAKES THE FORM OF AN
EQUAL-SIDED CROSS WITH A PICTURE OF
ST GEORGE SLAYING THE DRAGON.
IT WAS ATTACHED TO A RIBBON,
CONSISTING OF THREE BLACK AND
YELLOW STRIPES, WHICH WAS WORN
ACROSS THE RIGHT SHOULDER UNDER
THE FULL-DRESS UNIFORM.
THE MEDAL IS INSCRIBED WITH THE
MONOGRAM 'GS' (ST GEORGE) AND
WITH THE WORDS 'FOR SERVICE AND
COURAGE', THE ORDER'S MOTTO.

-<<<->>>-

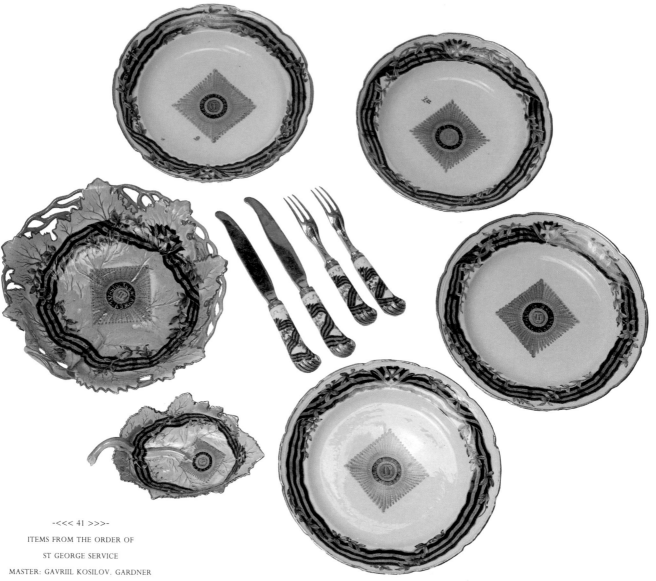

-‹‹‹ 41 ›››-

ITEMS FROM THE ORDER OF
ST GEORGE SERVICE
MASTER: GAVRIIL KOSILOV. GARDNER
PORCELAIN FACTORY, MOSCOW, 1778
THE ORDER OF ST GEORGE SERVICE WAS
ONE OF FOUR MADE FOR CATHERINE
BY THE GARDNER FACTORY IN 1777.
EACH OF THE FOUR SERVICES WAS
DECORATED WITH THE STAR AND
RIBBON OF A DIFFERENT ORDER:
ST GEORGE, ST ALEXANDER NEVSKII,
ST ANDREW AND ST VLADIMIR.
EACH SET WAS USED AT THE ANNUAL
DINNER AT THE WINTER PALACE FOR
MEMBERS OF THE ORDER.

-‹‹‹-›››-

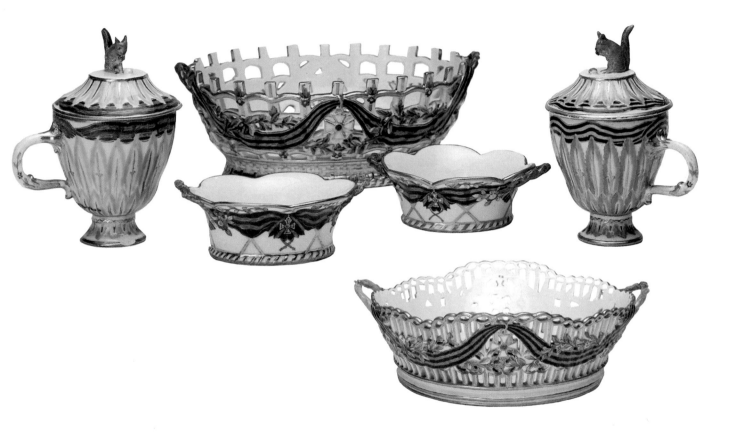

-<<< 42 >>>-

ITEMS FROM THE

POTEMKIN SERVICE, 1778

IMPERIAL PORCELAIN FACTORY,

NEAR ST PETERSBURG, C.1796-1801

PRINCE POTEMKIN'S DINNER AND

DESSERT SERVICE WAS MADE FOR HIM

BY THE BERLIN ROYAL PORCELAIN

FACTORY IN 1778. THESE PIECES

REPLACED BROKEN ONES AND WERE

COMMISSIONED BY HIS NEPHEW AND

HEIR, COUNT SAMOILOV, FROM THE

IMPERIAL PORCELAIN FACTORY.

THE DINNER SERVICE IS DECORATED

WITH SCENES FROM THE RUSSO-

TURKISH WAR OF 1768-74 AND

WITH LANDSCAPES, TOWNSCAPES AND

SEASCAPES. THE DESSERT SERVICE

USES VIRGIL'S *AENEID* FOR ITS

DECORATIVE INSPIRATION.

-<<<->>>-

-<<< 43 >>>-

DETAILS OF THE FIELD TENT PRESENTED

TO CATHERINE II IN 1793 BY A TURKISH

ENVOY ON BEHALF OF SULTAN SELIM III

TURKEY, LATE 18TH CENTURY

SILK EMBROIDERED WITH GOLD, SILVER

AND COLORED SILK THREAD, LEATHER.

CUPOLA HEIGHT: 300 CM.

WALL HEIGHT: 250 CM.

OUTER DIMENSIONS: 510 X 103 CM

-<<<->>>-

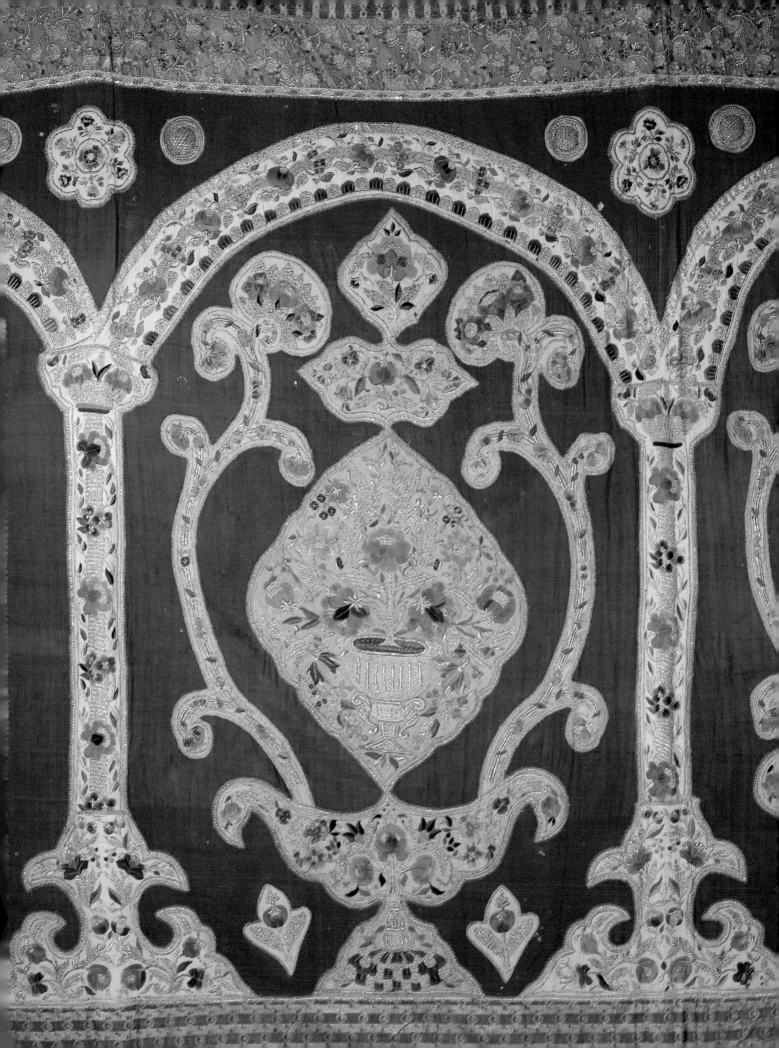

-<<< 43 >>>-

THE TENT WAS A GIFT TO CATHERINE FROM THE SULTAN AFTER THEIR TWO COUNTRIES HAD

SIGNED THE PEACE TREATY ENDING THE SECOND RUSSO-TURKISH WAR.

TURKEY WAS FAMOUS FOR THE SUPERB QUALITY OF ITS TEXTILES AND EMBROIDERY AS CAN BE

SEEN IN THESE EXAMPLES WHICH INCLUDE THE REMARKABLE TENT WINDOW OPPOSITE.

-<<<->>>-

THE ARCHITECTURE OF ST PETERSBURG IN THE TIME OF CATHERINE THE GREAT

by Dr G N Komelova

'No matter how much I tried to imagine the magnificence of Petersburg I was completely overawed by its buildings, by its beautiful chambers, wide streets…'

Elizabeth Vigée Lebrun, French artist, 1790s

By the second half of the 18th century St Petersburg had become one of the most beautiful cities in the world. Its splendid location on the banks of the River Neva, broad avenues and squares, straight embankments, majestic buildings, parks, gardens, boulevards, numerous canals and picturesque islands gave it a unique charm.

The French ambassador to St Petersburg, the Comte de Ségur, wrote in the mid-1740s: 'I was pleasantly surprised when, in places where once there were only spacious, barren and stinking marshes, I saw the beautiful buildings of the city founded by Peter which became, in less than a century, one of the richest and most wonderful cities in Europe.'

The city was born in the flames of the Northern War between Russia and Sweden. Founded in 1703, it grew with fabulous speed. The construction of the buildings - two and three storied buildings to start with - was strictly regulated, by Peter himself and his architect Domenico Trezzini (c.1670-1730). The expanses of the Neva determined the character of the city.

The first buildings were located around the Peter and Paul Fortress (founded on May 16, 1703, the date now celebrated as the city's birthday) and on Hare Island with its Cathedral of SS Peter and Paul. The Tsar's first palaces, the houses of the nobility, public buildings such as Russia's first public museum, the Kunstkamera, and the Admiralty shipyard, were built on the banks of the Neva. The city's radial layout was determined in the first 20 years of its life. The first broad avenues, including Nevskii Prospekt, which were to play as a crucial a role in the city's life as the Rue de Rivoli or the Champs-Elysées in Paris, were laid out at the same time. In the 19th

century, the French writer Théophile Gautier wrote of St Petersburg that Nevskii Prospekt was 'the same as Regent Street in London or the Alcala in Madrid. It is the city's main thoroughfare, its most crowded and busy place.'

The architecture of St Petersburg during the first years of its existence was distinguished by its simplicity and reserve. But in the mid-18th century, the reign of Peter's daughter, the Empress Elizabeth, was marked by the rapid development of the Russian state and the change was matched by a transformation of the city's appearance. The small bustling settlement became a city of magnificent palaces and cathedrals. One of the leading architects of his day, Francesco Bartolomeo Rastrelli (1700-71) was responsible for much of the work. Together with his contemporary, the Russian architect Savva Chevakinskii (1713-80), he created a national variant of the baroque style, drawing on the rich traditions of both Russian and foreign architecture. Fine monuments were built to their designs, remarkable in their grandeur and scope, the richness and splendor of their ornamentation, the abundance of carving and molding, the use of many colors and the overall harmony. Many of the buildings of the period survive to this day: the Anichkov Palace, built by Elizabeth for her favorite, Alexei Razumovskii, Count Stroganov's palace in Nevskii Prospekt, the Vorontsov Palace in Sadovaia Street, the Sheremet'ev Palace on the Fountain Embankment, the Smolny Convent with its magnificent cathedral, the Cathedrals of St Nicholas and St Andrew and many others.

Rastrelli's principal work was to be the Winter Palace, now the home of the State Hermitage Museum, situated beside the Neva in the very heart of the city. 'The building of the stone Winter Palace is solely for the glory of Russia,' wrote Rastrelli of his most remarkable creation. It was here, in the Winter Palace, that Catherine, absolute mistress of the palace as well as of her huge empire, lived for 34 years. Here matters of state were decided, foreign ambassadors were received and celebrations were staged to mark national feast days.

The construction of St Petersburg entered a new stage with Catherine's accession in the

mid-18th century. The rich exuberance of the baroque was replaced by the noble simplicity and calm grandeur of classicism, the style founded on principles laid down in antiquity. The architecture of the nations's capital naturally reflected the huge social, economic, industrial and cultural changes of the later 18th century. The city's population grew. In 1725 there were probably less than 100,000 inhabitants yet, by the end of Catherine's reign, the figure had doubled and by 1800 St Petersburg held around 220,000 people. The intensive development of the city presented the architects with new town planning demands. These were met with the use of regular and symmetrical street patterns.

In December 1762 a regulatory body was set up known as the Commission for the Building in Stone of St Petersburg and Moscow. One of its main tasks was 'to give the city of St Petersburg the splendid appearance worthy of a great state'. Alexei Kvasov, a talented town planner, was nominated to head the Commission, and after his death his place was taken by another great architect, Ivan Starov.

The Commission, taking into consideration the existing buildings, sketched out a plan for the city comprising broad, straight thoroughfares with beautiful squares at their intersections. No building was to be built higher than the Winter Palace. The main thoroughfares were still Nevskii Prospekt and the Neva Embankments. From 1762 work began to replace the old wooden embankments with granite structures. This work was carried out by Iuri Felten, one of the leading architects of early classicism. The first embankments to take shape were on the left bank of the Neva, chiefly on the Palace Embankment. At the same time, in the 1770s and 1780s, the banks of the canals and rivers were dressed in granite as were the walls of the Peter and Paul Fortress. Numerous granite inclines leading down to the water and canal bridges highlighted the beauty of the embankments. 'The Neva is dressed up in granite/the bridges hang across the water/the islands are covered in dark green orchards' wrote the great Russian poet, Alexander Pushkin.

In the second half of the 18th century St Petersburg attracted architects whose names are famous not only in the history of the city

but also in the history of world architecture: Alexander Kokorinov (1726-70), Jean Baptiste Vallin de la Motte (1729-80), Ivan Starov (1745-1808), Antonio Rinaldi (c.1710-94), Charles Cameron (1740-1812), Giacomo Quarenghi (1744-1817) and many others.

The 1760s saw intense construction work on the Palace Embankment and across the Neva on Vasil'evskii Island. One major event was the opening there in 1764 of the Academy of Arts which was to become the center of artistic life in Russia. The magnificent Academy building on Vasil'evskii Island was built between 1764 and 1768 to the designs of Kokorinov and Vallin de la Motte. It is generally considered one of the triumphs of Russian architecture. The main facade overlooking the Neva was particularly majestic. At its center projected a portico with Tuscan columns and a triangular pediment; between the columns were statues of Hercules and Flora. Above the conference hall was a small cupola holding Ivan Prokoviev's statue of Catherine, a work which has not survived.

The Small Hermitage, next to the Winter Palace, was begun in 1764 to designs by Vallin de la Motte. In the same year Catherine acquired her first collection of paintings by West European artists, a collection which was to form the nucleus of the future State Hermitage museum, now the largest in the world. The growth of the collection required the construction of a second building, the Large Hermitage, now known as the Old Hermitage, designed by Iuri Felten and erected between 1775 and 1782.

The Small Hermitage is in the early classical style. The facade onto the Neva has columns on the second and third storeys and an eight-column portico topped by an attic which incorporates a sculpted group. The later Old Hermitage already conforms to the strict canons of mature classicism: the facade is simple with only minor decorative features to mark the center and side wings.

Beside the Old Hermitage Quarenghi, on Catherine's orders, built the Hermitage Theater. Its completion in 1789 after six years' work, and the building of the Marble Palace, between 1767 and 1785, completed the entire Palace Embankment which stretched from the Winter Palace to the Marsovoe Pole or 'Field of Mars' where parades were staged.

The Marble Palace was designed by the architect Antonio Rinaldi, who had been invited to Russia from his native Italy. In St Petersburg he created one of the masterpieces of the early classical style. The palace takes its name from the facings of different Russian stone that Rinaldi used. Their rich color range makes the building one of the most flamboyant in the city. The first floor is faced with pink and the second and third with light grey stone. The row of pilasters is of polished pink-veined marble, a striking contrast against the granite background. The facades are strictly classical. The one overlooking a small garden is flanked by decorated columns and has a clocktower in the center. Colored stone was used for the interior of the Palace - many craftsmen took part in its decoration including the great Russian sculptor Fedot Shubin. Jean Bernoulli, who visited St Petersburg in 1776, wrote: 'I saw a beautiful palace which the Empress is building for Prince Orlov and which is nearly ready. It is embellished with marble doors and window cornices, statues etcetera. The walls of the staircase are faced with marble panels. It's undoubtedly the most beautiful palace in St Petersburg and, although smaller, surpasses even that of the Tsar.'

The Marble Palace was built for Catherine's long-term favorite, Count Orlov, and after his death in 1782 passed to the State.

For another of Catherine's favorites, the great statesman, Prince Potemkin, the architect Ivan Starov built one of the most famous monuments in St Petersburg, the Tauride Palace (1783-88). Later it was to become the prototype for numerous country houses and its design was copied for many hospitals and educational establishments. The palace was built in what was then a remote area of the city near the Smolny Convent and was surrounded by a spacious garden. A small canal and quay in front of the building linked the palace to the Neva. It is distinguished by a striking simplicity and purity of design. The reception rooms are in the projecting two-storey central block which is crowned by a low cupola behind a monumental six column portico. Single-storey galleries connect the center with the two side wings which extend in a great sweep to form the drive along which carriages approached the main entrance. The austere facade hides a splendid interior. Particularly striking is the huge columned hall with a view of a winter garden. At the center of the garden once stood the statue of Catherine by Fedot Shubin, now in the Russian State Museum. The poet, Gavriil Derzhavin wrote: 'The exterior of the palace does not glow with gilt, carvings or other decorations: its ancient, refined taste is its main merit. It is simple and majestic.'

The year 1782 was marked by an important event in the city's history, the ceremonial unveiling of the equestrian monument to Peter the Great. The statue is now known as 'The Bronze Horseman' after the eponymous poem by Alexander Pushkin. The statue is the work of Etienne Maurice Falconet, a French sculptor who came to Russia in 1776. Many years were taken to complete the monument. The Emperor is shown on a rearing horse, as if he were on the edge of a steep cliff. The twisting snake under the horse's hind legs symbolizes the forces opposed to Peter's reforms.

Also important in the city's cultural life was the opening of the Bolshoi Theater, finished in 1783. The austere and monumental building was designed by Rinaldi, a brilliant exponent of classicism who lived in Russia for more than thirty years. He only left the country after a tragic accident when he fell from the scaffolding of a building under construction. Between 1802 and 1806 the theater was substantially rebuilt only to be burnt to the ground in 1811. It was later rebuilt once again and stood until 1866 when it was demolished to make way for the Conservatoire. The exterior of the theater can be seen in the engravings by the Swiss artists Gabriel Ludwig and Matthias Gabriel Lory.

In September 1783 an opera entitled *On the Moon* by the Italian composer Giovanni Paisiello was performed at the opening of the theater in the presence of Catherine the Great and her court. For many years it was the main theater of St Petersburg. Both local performers and travelling companies appeared on its stage. The theater had a severe appearance: its main facade on the Kriukov Canal included a majestic eight column

portico beneath a sculpted pediment. In size and decoration it was one of the most important buildings in St Petersburg.

For four decades, from the 1780s, a major role in the building of St Petersburg was played by Giacomo Quarenghi, an Italian who found a second home in Russia. His creative talents as a disciple of classicism were well matched to the requirements of the age. Scores of buildings were constructed to his designs in the capital and in provincial cities. Many survive to this day. 'The architectural monuments are like a book in which each generation writes its own page', wrote the French author, Anatole France. One of the brightest such pages in the history of Leningrad/St Petersburg was written by Quarenghi.

He came to Russia in 1779 and was immediately enlisted for the intensive building program then under way. During the first 12 years he created his best works for a wide range of purposes: palaces, suburban estates, merchants' yards, churches, private houses, a bank and so on.

One of his best buildings is the Academy of Sciences on the Neva Embankment, almost opposite the Winter Palace. It was founded by Peter the Great in 1724-25 but previously had no permanent headquarters. The main facade of Quarenghi's Academy, built between 1783 and 1789, stretched out along the Neva. The basement was faced with granite and the calm smoothness of the symmetrical wings contrasted with a solemn eight-column portico and small pediment. The portico's external granite staircases led to the main entrance and the central vestibule with its own grand stairway. On the landing of the second floor is the huge mosaic known as 'the Battle of Poltava' which was made in Mikhail Lomonosov's workshop between 1762 and 1764.

Among Quarenghi's other works are the Hermitage Theater (1783-90), the Assignationnyi Bank on Sadovaia Street (1783-90), the silver shops on Nevskii Prospekt (1784) and the Yusopov Mansion on the Fontanka River (1790s).

In the 1780s Quarenghi rebuilt the Bezborodko estate in Polyustrovo, the area of St Petersburg opposite the Smolny Convent. In the 1770s a three-storey house with round towers on either side, designed by Vasilii Bazhenov, had been built on the site. Quarenghi added two symmetrical wings connecting them with the central block by arched galleries. To the old block he added a triangular pediment and a small portico with double columns on the ground floor. An interesting feature is the line of twenty seated lions, holding chains in their mouths, which form a fence connecting the side wings. Quarenghi was also an expert decorator of interiors. Among his works were a concert hall, ante-chamber and the Large Gallery overlooking the Neva in the Winter Palace. All are remarkable for their magnificence and strictness of ornamentation, richly embellished with numerous statues and columns of colored marble. The rooms were slightly altered during restoration by Vasilii Stasov after the fire of 1837. Quarenghi also designed the so-called 'Raphael loggias', replicas of the loggias in the Vatican Palace.

Between 1806 and 1808 Quarenghi built another of his best creations, the Smolny Institute, an establishment for the daughters of the aristocracy.

Simple and strictly planned but majestic and magnificent, Quarenghi's buildings make a vast contribution to the city's appearance.

The story of St Petersburg's architecture would not be complete without mentioning the palaces built on the islands that were then outside the city.

The Neva has several tributaries which, in turn, branch off and are diverted into canals. The result is a patchwork of islands. Those in the north-west of the city - the Kamennyi, Krestovskii, Elagin, Apotekaryi and others - in the second half of the 18th century made up the most picturesque and verdant areas of the capital. Today they are districts of Leningrad but are still referred to as islands.

One of these islands was presented by Catherine the Great to her son, the Grand Duke Paul, and between 1776 and 1781 a palace was constructed for him on it. The name of the architect of the Stony Island or Krestovskii Palace remains unknown but the work was carried out by Iuri Felten. In the early 19th century the palace was rebuilt more than once. The building was modelled on a country estate, in a picturesque setting and with one wing overlooking the Neva. There were porticoes on the facade but in general the palace followed a plain and simple design both inside and out. Opposite the Stony Island in the district of the so-called 'New' and 'Old' villages, one of the richest people of the day, Count Alexander Stroganov, future President of the Academy of Arts, built a brightly decorated pavilion. The pavilion, accessible by boat, had a shallow cupola and a beautiful stone pier onto the Neva. The latest research suggests that the construction was carried out by the architect Feodor Demertsov helped by the young Andrei Voronikhin.

The palaces and parks around St Petersburg have been described as 'the city's precious necklace'. Most are to be found to the south, fifteen to thirty miles away from the center. Among them are Peterhof, Tsarkoe Selo (now Pushkin), Pavlovsk, Gatchina and Oranienbaum (now Lomonosov). Some of these imperial residences were built before Catherine's accession, under Peter the Great and his immediate successors.

One example are the Peterhof palaces with their famous fountains and parks which were built by the mid-18th century. It was in one of their pavilions that Catherine lived for a few days before the coup that brought her to power and it was from here that she began her triumphal progress to the Winter Palace in June 1762.

Tsarkoe Selo, which was to become Catherine's favorite residence and her summer home, was also taking shape by the mid-18th century.

The leading role in the building of Peterhof and Tsarkoe Selo was taken by Rastrelli whose mastery of baroque form determined the look of both.

The furthest of the imperial residences from St Petersburg was Gatchina, the property of Catherine's favorite Count Grigorii Orlov. Rinaldi was commissioned to build a palace and lay out a park on the site between 1776 and 1781. After Orlov's death Catherine bought Gatchina from his heirs and presented it to her son, Paul, who lived there even after

his accession in 1796. He later ordered the architect Vincenzo Brenna to reconstruct the old palace adding stone bastions and a moat. It was transformed into a military town where Paul arranged numerous parades and training exercises.

The palace's severe appearance, with its two five-faceted towers and two side squares, differs markedly from the splendor and brilliance of the palaces at Tsarkoe Selo and Peterhof.

Pavlovsk, not far from Tsarkoe Selo, appeared later than the other suburban palaces. It was Catherine's gift to the Grand Duke Paul and was the favorite residence of his wife, Maria Feodorovna. The park and palace were masterpieces of design by Charles Cameron between 1782 and 1786. They were later remodelled by Vincenzo Brenna, A.Voronikhin and C.Rossi. The palace stands high above the Slavianka River and can be seen from all over the surrounding park. The center is crowned by a drum-shaped cupola adorned with sixty-two Doric columns. The side blocks, linked to the centre by two semi-circular galleries, form a courtyard and a triple linden avenue leads from the park to the main entrance. The ornamentation inside the palace, which is strikingly rich and elegant, was dictated by Maria Feodorovna herself, who was considered a discerning patron of the arts. Good proportions, the contrast between the rich decoration of the central block, with its columns and moldings, and the simple wings blended into the landscape, give Pavlovsk its particular charm.

In the second half of the 18th century St Petersburg had already taken on the graceful features later praised by Pushkin. Many Russian and foreign architects had lovingly devoted their talents to creating the city on the Neva.

The beauty of the Russian capital, sometimes called the 'Palmyra of the North', was deeply appreciated by contemporaries. Views of St Petersburg became a favorite theme for Russian and foreign artists. Mikhail Makhaev made a series of outstanding pencil drawings, later printed in the engraving chamber of the Academy in the mid-18th century. Many were later copied by other artists. Also interesting are the views of the city by the English artist,

Thomas Malton, after sketches by his compatriot Hearn. St Petersburg also inspired the Swedish painter, Benjamin Paterssen, who lived in the city for more than thirty years, creating scores of paintings and engravings. The Swiss artists Gabriel and Matthias Lory, engraved a series of city views, remarkable in their accuracy and refinement. In the engraving and landscape classrooms of the Academy of Arts the Russian landscapist, Semeon Shchedrin, devoted his efforts to depicting the St Petersburg suburbs. The exhibition contains many such works.

In conclusion, one should include two opinions on St Petersburg, those of a French artist and a Polish composer, who visited the city at the end of Catherine's reign. Elizabeth Vigée Lebrun, known for her many portraits of the Russian court in the 1790s, wrote an enthusiastic account of her impressions:

'The beautiful Neva, light and transparent runs through the city, covered with ships ceaselessly making their way up and down, rendering this beautiful city ever more lively. The embankments of the Neva are of granite and so too are many of the big canals dug by Catherine inside the city. On one side of the river is the Academy of Arts, the Academy of Sciences and many other buildings which are reflected in the water. I was told that there was no finer sight than these buildings in the moonlight...they look like ancient temples.'

The Polish composer, M.Oginski, wrote to his wife in 1793: 'What a city, my dear friend! After what I have seen in London, Berlin, Dresden and Vienna I was, nevertheless, stunned as I rode in a carriage along the broad streets of this capital, which did not exist a century ago.'

FINE ART

by Augusta Pobedinskaya

The main centers for Russia's artistic talent in the later 18th century were the Academy of Arts in St Petersburg and the imperial court. The Academy had been established in 1757 under the Empress Elizabeth, largely through the work of Ivan Shuvalov and Mikhail Lomonosov, two of the most remarkable champions of the arts in Russian history. Catherine, however, was keen to take credit for its foundation and ordered that 1764 should be considered as its official opening date. In the same year a new charter was adopted and work began on the construction of the Academy's building to the designs of Jean Baptiste Vallin de la Motte and Alexander Kokorinov, who was to be the Academy's first rector.

Cultivated Russians of the day had great hopes for the Academy. The famous poet and playwright, Alexander P. Sumarokov, said at the opening ceremony that a painter's main aim should be to reflect history through the faces of the great. The Academy was expected to fulfil the highest ideals of architecture, sculpture and painting and to set standards of excellence. Such aims reflected a general trend in the arts at a time when the classicist movement was emerging which drew on the philosophy of the ancient world as well as its styles and forms.

It was in the early 18th century, under Peter the Great, that Russia first entered Europe's artistic mainstream. On her arrival in Russia in 1744, the young Catherine would have witnessed the blossoming of an indigenous Russian baroque style, best exemplified by Francesco Bartolomeo Rastrelli's work on the Winter Palace which was then under way.

On her accession in 1762, however, Catherine ordained a change of style. The new Empress, aware of trends in painting and architecture, favored classicism and Rastrelli was obliged to leave the country in which he had carried out his best work. In his place, Catherine invited a bright Italian architect well versed in the new style, Giacomo Quarenghi.

It is little surprise therefore that the Academy should have become a center for the

dissemination of classicist ideas. Indeed, the Academy produced some of its greatest exponents: in architecture, Vasilii Bazhenov, Matvei Kozakov, Nikolai Lvov, Ivan Starov, in sculpture: Fedot Shubin, Feodor Gordeev and Mikhail Kozlovskii, and in painting: Anton Losenko, Ivan Akimov and Grigorii Ugriumov.

Boys were admitted to the Academy's training school from the age of five or six and their education continued for 15 years. When they reached the senior level pupils specialized and those who won the Academy's Gold Medal were given the chance to continue their studies abroad, in Italy, France and Germany. Outside Russia they not only came to master their particular skill but also met the leading painters of the day. Their training at the Academy included copying the works of the great masters of the past. The Academy has its own collection of works by western artists as well as casts of antiquities. Meanwhile, the Hermitage was becoming one of the world's largest collections thanks to lavish spending by the Empress herself.

As dictated by the teachings of classicism, pupils at the Academy looked to history, mythology and literature for their subject matter. A founder of the historical genre was Losenko whose works include the *Sacrifice of Abraham*, *Zeus and Thetis*, *The Miraculous Draught of Fishes* and *Hector Parting with Andromache*.

Like many of his contemporaries Losenko became interested in the painting of narrative history. His *Vladimir and Rogneda* depicting a scene from the history of 10th-century Novgorod, proved particularly influential on the future development of the school. Among his followers was his own pupil, Akimov, who portrayed the great Prince Sviatoslav of Kiev. Ugriumov too created such works as *The Triumphal Entry of Alexander Nevskii into Pskov after his Victory over the Teutonic Knights*, and the *Election of Mikhail Feodorovich to the Throne*, for the first time showing the Russian people as a driving force in history. The patriotic aspirations of the painters were similar to those of Russian playwrights and poets of the time. Both Alexander Sumarokov and Iakov Kniazhnin glorify the idea of service to the Motherland in their works. Such ideas can also be found in the plays written by

Catherine herself and in works performed at the Opera House and the Hermitage Theater.

Portraiture was the most important branch of Russian art throughout the 18th century, reaching new heights in the final decade. Some remarkable people emerged into public life and interest in such individuals helped to promote portraiture in painting, sculpting and drawing. The portraits of the day give a good picture of Russian life at different levels of society. There are, for example, formal portraits of Catherine surrounded by the emblems of imperial power, of senior members of the aristocracy and the army in richly embroidered uniforms, of the clergy in lavish brocade vestments, of the artistic elite - writers, poets, actors, musicians - of provincial landowners, merchants, townsfolk, craftsmen and peasants.

Although historical painting was considered important, all the great masters of the Academy also honored the art of portraiture. Even though individual patrons might make special demands of the artist, Russian portraits of the period were characterized by their realism and a determination to reveal the subject's true personality, while still obeying the strict rules of classicism. The Russian portrait somehow combined aspects of medieval iconography, folk art and contemporary west European styles. All these elements can be found not only in the art of a single epoch but in the work of a single artist.

Before the foundation of the Academy many painters were trained by private teachers, both foreign and Russian, but the largest single supplier of craftsmen was the Construction Office. Its employees took part in the building and decoration of St Petersburg's mansions, painted churches, designed scenery, did decorative carving and even built ships. The Office was also a training ground for young artists and, for many years, its painting department was headed by such artists as Andrei Matveev and Ivan Vishniakov.

One of Vishniakov's pupils was Alexei Antropov, also closely connected with the Construction Office, who carried out a wide range of work in the capital. He is best known, however, as a painter of remarkably faithful portraits of his contemporaries.

Antropov's origins were typical of the period. The son of a fitter in the St Petersburg Armory, his humble beginnings probably determined his later style. His portraits are distinguished by their objective and straightforward approach, and the absence of flattery or idealization, even in his depictions of leading figures or members of the imperial family.

His portrait of Peter III, for example, shows all the features of the usual formal portrait: solemn surroundings, columns and the attributes of power. Yet, at the same time, the Emperor lacks any of the stateliness normally associated with such pictures. According to one point of view Antropov deliberately chose to stress the worst aspects of Peter's personality, an attitude later condoned when Catherine sought to justify her illegal seizure of power. But it is doubtful whether any painter could have set out deliberately to expose the Emperor's weaknesses. Sharpness and objectivity were the principal features of Antropov's art - he neither exaggerated nor criticized his subjects, instead he fixed precisely their facial features using the smallest details of a man's appearance to illuminate his character.

Antropov painted not only the Empress and the ladies of the court - such as Anastasia Izmailova and M.A.Rumiantseva - but also eminent clergymen, such as Archbishop Kuliabka and Archpriest Dubianskii, and members of the St Petersburg and Moscow nobility. All are distinguished by their realism, the liveliness of their faces, the meticulous draughtsmanship and the use of strong colors. Antropov was a good teacher and numbered many famous portrait painters among his pupils, including Dmitri Levitskii.

Russian portrait painters of the mid- and late-18th century followed traditions established under Peter the Great, creating an expressive image and to trying to capture the subject's true character and spirit.

In the 1760s and 70s new aspects of portrait painting became apparent in the works of Feodor Rokotov and Dmitri Levitskii. Little is known of Rokotov's life, especially his early years. It has been established only that he came from a family of serfs which was later emancipated. His talent was soon spotted and, owing to the patronage of Ivan Shuvalov, he

was admitted to the Academy where he became a postgraduate student. He was commissioned by Shuvalov to paint the Grand Duke Peter, heir to the throne. The picture spread his fame at court, where his paintings were much admired. Rokotov went on to paint one of the first formal portraits of Catherine. After winning the Empress' approval it was agreed that he should paint six further portraits based on the first. Other painters also used the original as the basis of their own pictures.

Rokotov later painted Catherine's heir, the Grand Duke Paul in childhood, Ivan Shuvalov, Grigorii Orlov, Nikita and Peter Panin and other members of the aristocracy. His contemporaries noticed that many of his paintings were completed with the help of his assistants.

Rokotov was an important and influential figure. He managed to fix on canvas not only the subject's features but also those hidden qualities often invisible to the world at large. This gave his work an original and enchanting quality especially in his handling of women's faces. His portraits have certain recurrent color schemes: a preference for hazy, melting tones, silver-blue, pink-beige and brown-gold. His painting technique - quick, energetic brushstrokes - helped to give an impression of excitement. His aesthetic principles were in tune with a certain mood of sentimentalism, also apparent in the works of his followers.

Antropov's pupil, Dmitri Levitskii, raised Russian portraiture to new heights and his work is considered among the best of the 18th century. Born in the Ukraine, he received his early education from his father who was both a priest and an engraver. He was noticed by Antropov while working on the painting of St Andrew's Cathedral in Kiev. After being invited to St Petersburg, Levitskii soon came to be regarded as one of the finest painters of his day. In 1770 he was elected to the Academy where he headed the portrait-painting class for 17 years. His portraits were alien to the outward formality usual among many other artists of that era and there was nothing commonplace about them. Each one showed man as an individual, original and important, irrespective of his position in society.

Nevertheless his works cannot be described as intimate. They include many of the attributes of the formal portrait although these are not allowed to conceal the person's true nature. Good examples are his portraits of the President of the Academy, Alexander Kokorinov, the founder of the Orphanage, P.A.Demidov, the merchant, N.A.Sezemov, and the famous patron of the arts, Alexander Stroganov.

One of Levitskii's greatest successes was the series of portraits of pupils at the Smolny Convent, commissioned by Catherine. Each of the subjects is portrayed either against a landscape or with a range of objects to reveal particular interests or talents. The sincerity, beauty and fascination of youth are all skilfully conveyed. Levitskii managed to find something different in each sitter and to bring out minor but important details.

Levitskii painted a great many portraits. Ranked among the best are those of Nikolai Lvov, Maria Diakova-Lvova, Nikolai Novikov and Denis Diderot. Every character created by an artist is of course original and unique. Those of Levitskii stand out by virtue of the texture of his brush strokes. He worked like a sculptor, forming shapes with his brush: faces were highlighted against dark backgrounds. Despite the realism of Levitskii's work there is always a hidden depth hinting at the subject's inner life. Levitskii's style has a quality of haziness and uncertainty that distinguishes it from the bold, hard images of Rokotov.

Levitskii painted Catherine often. Among his most famous portraits is *Catherine II in the Temple of the Goddess of Justice,* painted in 1783. The Empress is shown as a wise lawgiver. The picture itself and the symbolism used by Levitskii are strictly classical. Thus the Empress wears a crown of laurel leaves and the Order of St Vladimir, there are poppies and books at her feet and Mercury, the God of Trade, is depicted on a shield. All suggest the cares she had undertaken for the sake of Russia. The picture was a great success, inspiring Gavriil Derzhavin to write an ode to the glory of the Empress and Ippolit Bogdanovich to salute the artist in verse.

Levitskii's work brought Russian portraiture to international notice and acclaim.

His younger contemporary, Vladimir Borovikovskii, who flourished at the end of the 18th century and in the early l9th century, enjoyed the same professional and commercial success as Levitskii. Borovikovskii, a master of the use of color, found a new way of putting across his message. He showed people occupying a certain rank in society, not mere private individuals locked into their own worlds.

Like Levitskii, Borovikovskii was born in the Ukraine and studied under his father who painted icons and portraits. When Catherine travelled south on her great tour of 1787 he took part in the painting of many of the palaces at which she stayed. On his arrival in St Petersburg he took lessons from Giovanni Battista Lampi and probably from Levitskii.

The portrait of Catherine walking at Tsarkoe Selo is one of Borovikovskii's early works. His intimate approach, showing her private life, was different from the formal and official portraits. Catherine sometimes referred to herself as the 'Kazan landowner' and this was another side of her life that had to be shown to the public.

His portraiture displays the peculiarities characteristic of Borovikovskii's works, an attempt to convey not only the state of a man's soul but also his links with Nature. A subtle lyricism can be seen in much of his work, in the soft outlines of the figures and landscapes and the gentle, subdued colors.

Somewhat apart from the other painters of his day stands Mikhail Shibanov, once a serf working for Prince Potemkin. He was one of only a few painters who dedicated himself to the depiction of the everyday life of ordinary people. Among his works are *The Peasant Lunch* and *The Feast after the Wedding Contract*. During Catherine's trip to the Crimea, organized by Potemkin, Shibanov painted excellent portraits of the Empress in her travelling costume and of her then favorite, Alexander Dmitriev-Mamonov. The nobility of the colors and the delicacy of touch say much about Shibanov's talent.

Important work was also being carried out in the field of drawing and engraving. One of the most talented engravers of the period was Evgraf Chemessov who had a good command of the techniques of woodcut, etching and dry point. He died at only 28 after a life of almost uninterrupted triumph. He was an Academician, headed the Academy's engraving class and served as its conference secretary. He left superb portraits of the Empress Elizabeth, Ivan Shuvalov and of the actor Feodor Volkov, and a self-portrait notable for its sensitive approach to portraying personality. Chemessov's ideals were close to those of Rokotov and another famous master, Ivan Bersenev, who also made woodcuts based on engravings made from Rokotov's paintings.

A remarkable versatility is apparent too in the work of Gavriil Skorodumov whose talents extended to the painting of miniatures and watercolors, stipple engraving and mezzotint. Skorodumov worked not only on portraits but also on compositions and even caricatures.

The art of the portrait miniature became widespread in the second half of the 18th century. From 1779 the Academy ran special classes headed for many years by Peter Zharkov, whose place was later taken by his pupil Paul Ivanov. Both were established masters of the art of painting miniatures on enamel. Miniaturists were also employed at the Imperial Porcelain Works, prominent among them being Andrei Chernyi. Little is known of his life but he left a remarkable body of work, particularly his portraits of Catherine and Grigorii Orlov.

Dmitri Evreinov also painted members of the imperial family and courtiers. He sometimes produced silhouettes, which were becoming increasingly popular in Europe and Russia as interest in classicism gained strength.

Painting on bone also enjoyed a vogue. The best known practioner, who left more than 700 works, was Augustin Christian Ritt. His miniatures, executed with rare brilliance and ease, give a marvellous picture of Russian aristocratic society at that time.

Meanwhile there were developments in landscape painting. Townscapes were already being painted in the time of Peter the Great. These were primarily of St Petersburg where new avenues squares and buildings were being laid out. The perspective views of Mikhail Makhaev enjoyed a long period of popularity and were widely copied. So too were views of the city made in different engraving techniques by both Russian and foreign masters. Among these were Grigorii Kachalov, Andrei Ukhtomskii, Alexander Melnikov, Gabriel Lory, Johann Georg de Mayr, Thomas Malton and Benjamin Paterssen.

In the 1770s and 80s landscape painting changed radically. The cold formalism of the past was abandoned, landscapes were charged with emotion to reveal man's love of nature. Leading exponents of this style included Semeon Shchedrin. In his views of St Petersburg - and of Pavlovsk, Peterhof and Gatchina reality is combined with a poetic perception. As with portrait painting, the art of landscape was influenced by romanticism, when man aspires to become as one with Nature.

An essential role in the development of landscape painting was played by Mikhail Ivanov, who worked mainly in watercolor. He depicted scenes of the Ukraine and Armenia as well as the sites of several major battles in the Russo-Turkish War, for example Ochakov and Izmail. Another leading landscape painter was Feodor Alexeev. Like Ivanov he visited the south of Russia, the Crimea and the new towns of Nikolaev and Kherson. Alexeev painted broad panoramic views filled with light, air, the fragrance of nature and everyday life. His best qualities were displayed in his series dedicated to St Petersburg and Moscow.

One further trend is evident in the landscape painting of the day. Its principal exponent was Feodor Matveev, who worked at the end of the 18th century and into the early decades of the l9th. His speciality was the classical landscape, with antiquities and ancient ruins.

In Catherine's day many foreign artists worked in Russia. The links established with western Europe under Peter the Great became ever closer.

In 1756 the French painter LouisTocqué arrived in Russia at the invitation of the Imperial Chancellor, Roman Vorontsov, and painted a portrait of the Empress Elizabeth in the solemn style of the court of Louis XIV. Tocqué proved a success at the Russian court and was commissioned to undertake numerous

portraits of society figures. His subjects included Ivan Shuvalov, Anna Vorontsova and Catherine Golovkina, painted in the style of the French Rococo. However he was to have little impact on Russian painters.

Under the Empress Elizabeth the Grooth brothers arrived from Germany. The elder Grooth was best known as a portrait painter while his brother was distinguished for his animal paintings. Among Georg Christoph Grooth's work is an elegant equestrian portrait of the Empress Elizabeth. Grooth's works are known for the elegance of their draughtsmanship and an approach to color that is typical of the European rococo.

Close to Grooth was the Italian Pietro Rotari whose gentle, romantic portraits of women became very popular. Both artists painted portraits of the imperial family and of the St Petersburg aristocracy. Their work is notable for its semi-formal, semi-intimate character. No less fashionable was the French portrait-painter Jean Louis Voille, who became the official painter at the court of the Grand Duke Paul in 1780. Among his best known works are portraits of the Grand Duke, his wife, the Grand Duchess Maria Feodorovna, and their children. In 1793 all French painters living in Russia were ordered to sign a decree from Catherine breaking all ties with their homeland, then in the grip of revolution. Voille refused and was forced to leave although he was later to return to St Petersburg. His noble manner and his psychological approach to portraiture matched the best Russian masters of the day.

Among the foreign painters to make their mark on Russia at the end of the 18th century was Giovanni Battista Lampi, who came to St Petersburg with his family in 1792. His son, Giovanni Battista Lampi the Younger, was also a portrait painter and their success was so great that, according to contemporary accounts, almost every member of the court was painted by one or other of them.

Lampi's works impressed his clients with the nobility of pose, the pleasant facial expressions and the excellence of the detail. Lampi executed several formal portraits of Catherine, which were widely admired and favored by the Empress herself. This was not

always the case: Catherine so disliked a portrait by Vergilius Eriksen that reproductions were banned.

Lampi's most famous works were his portraits of Potemkin, Platon Zubov, Alexei Kurakin, Alexander Samoilov and his wife, the Emperor Paul, Maria Feodorovna and their children. Lampi particulary influenced the work of Levitskii and Borovikovskii.

Besides Eriksen two other notable Scandinavian artists worked in Russia at the time: Carl Ludwig Christinek, who stayed for 34 years, and Alexander Roslin. Christinek's portraits are somewhat cold, though elegant and gently colored, whereas Roslin is more brilliant and showy. Roslin was especially good at painting silk, velvet and glistening ornaments, a skill that compensated for his sometimes poor likenesses.

One name always linked with St Petersburg is that of Benjamin Pattersen, who came to the city in 1787 and stayed until the end of his life. He painted beautiful cityscapes which captured exactly not only the beauty of the streets, embankments and palaces but also the atmosphere and colors of the great city of the northern plains.

Foreign artists introduced a multitude of artistic influences. Many foreigners - painters, engravers and sculptors - taught at the Academy. Their work enriched Russian culture, which assimilated the achievements of western Europe without losing its own distinctive character. Advances made in the decorative arts of the period are closely linked with the work of the Academy. Before this period sculptors working in Russia had chiefly been engaged in architectural work. A significant influence was the sculptor François Gillet, who came to Russia at the invitation of Ivan Shuvalov.

Although a sculptor of only modest abilities, Gillet turned out to be an excellent teacher. For 20 years he headed the sculpture class at the Academy, teaching both practical studies and a course in theory. He wrote: *An Explanation of Man's Proportions* for his pupils, among whom were such great masters as Fedot Shubin, Feodor Gordeev, Mikhail Kozlovskii, Shchedrin, Ivan Prokofiev and Ivan Martos.

The story of Fedot Shubin is typical of the period. He was born in a remote northern village near Archangel, also the birthplace of Mikhail Lomonosov. The area was known for its tradition of skilled bone-carving. Shubin took the skill to St Petersburg, where his talent was noticed and a recommendation to the Academy followed. There, under Gillet's guidance, his talents were developed. Winning a Gold Medal gave him the chance to go to Italy, France and England on an Academy scholarship. On returning to his native land he executed a number of busts that were to put him in the first rank of Russian portraitists. He left us with images of some of his most outstanding contemporaries: Mikhail Lomonosov, Grigorii Potemkin, Alexander Golitsyn, Alexander Samoilov, Ivan Betskoi and the Emperor Paul. Shubin made a number of bas-reliefs, group sculptures and a statue of *The Empress Catherine as Lawgiver*. Although he attained technical perfection in the carving of marble he is chiefly remembered for his ability to capture the essential character of his subjects.

Another outstanding sculptor of the time was Mikhail Gozlovskii, who created the famous statue *Catherine as Minerva*, evidence of his adherence to the tenets of classicism. Most of his portraits are of heroic subjects - two examples being the monument to General Alexander Suvorov in St Petersburg and the colossal statue *Samson Opens the Lion's Jaws*, part of the Fountain of the Great Cascade at Peterhof.

In Catherine's day many sculptors helped to embellish St Petersburg. One work that stands out above all is the monument to Peter the Great in Senate Square. Its author was the prominent French sculptor Etienne Maurice Falconet, who came to St Petersburg on Diderot's recommendation. Fascinated by the task of creating a monument to the great reforming Tsar, Falconet made his first sketch in Paris in 1765. Outlining his ideas for the concept and shape of the monument he wrote: 'My monument will be simple, I shall limit myself to making only the statue of a hero whom I shall treat neither as a great warrior nor as a victor, although he was both. It is more important to create a personality, a lawgiver...this is what is to be shown to the people.'

The work on the life-size model was completed by 1770. The head of Peter the Great was done by his pupil, Maria-Anna Callot. The casting was carried out under the guidance of the Russian craftsman Feodor Gordeev. The monument, weighing 275 tons, was finally unveiled in 1782. On the pedestal ran the inscription: 'From Catherine II to Peter I', in both Latin and Russian. The political message is clear. The monument, known as the 'Bronze Horseman', is not only the finest in St Petersburg but is also among the finest equestrian statues ever made.

This selection, which brings together the painting, engraving and sculpture of the middle and second half of the 18th century, does not claim to do full justice to the richness of Russian culture of the time. Nevertheless it includes some of the great artists, both Russian and foreign, who were then at work: Antropov, Rokotov, Levitskii, Borovikovskii, Shubin, Chemessov, Skorodumov, Lampi, Tocqué, Grooth, Christenek, Paterssen and many others. It aims to give some impression of Catherine the Great's reign, her personality and achievements in the political, economic and cultural worlds. It also intends to give a picture of the Empress' entourage: statesmen, aides and members of her family and of St Petersburg, the capital of the Russian Empire - its avenues, squares, architecture and monuments. Indeed, it should illuminate many diverse aspects of society.

APPLIED ARTS

by Tamara Kudriavtseva

The reign of Catherine the Great, remarkable for its political and cultural developments, also saw the proliferation of Russian arts and crafts. The movement started when, imitating other European countries, Peter the Great and his successors opened a number of factories and workshops. By the mid-18th century they were achieving a standard of workmanship comparable to their European counterparts.

Catherine, ambitious to establish the splendor of Russia in the eyes of the world, encouraged her native craftsmen to meet and learn from foreign masters, who were welcomed to St Petersburg. Her contribution was soon remarked upon by her contemporaries. According to the French envoy, the Comte de Ségur: 'Catherine's energies know no bounds. She has founded an Academy and public banks in St Petersburg and as far away as Siberia. It is to her that Russia owes the introduction of steel works, leather factories, the cultivation of silk worms in the Ukraine and countless other enterprises.'

Under Catherine the ideals of enlightened absolutism took on the magnificent and harmonious forms of classicism. Rich and fanciful baroque shapes made way for the strict rules of rhythmical proportion - idealized images inspired by antique prototypes glorified the deeds of an enlightened ruler. Classical motifs joined the decorative vocabulary: swags, crowns, pearls, Greek key patterns, cameos and stylized acanthus leaves.

The labor and talents of the army of Russian and foreign architects, decorators and craftsmen meant that St Petersburg, Moscow and many other Russian towns took on that unique appearance which so enchanted many travellers. Countless enthusiastic accounts have survived of their impressions.

One historian of the day, Bilbasov, wrote: 'The Russian court has been living in a European manner ever since the days of Peter the Great and is by no means inferior to Versailles which itself set the fashion for the entire world. With its towering halls, decorated with full-length mirrors, mosaic floors and painted ceilings, Peterhof was

recognized by foreign ambassadors to be even more luxurious than Versailles. In these palaces crowds of courtiers gather in their gold-embroidered velvet coats, the women's gowns are encrusted in diamonds, their hair is powdered, their faces fashionably rouged and adorned with beauty spots. By the doors stand the imperial guards, all around are chasseurs, hussars, messengers and dwarves. Everything is magnificence, richness and splendor. What a life is to be had in these palaces!' Witnesses recall however, that behind the dazzling facade the reality of everyday life was very different and the glamor concealed the lack of even basic necessities.

The pace of construction of the imperial palaces and the mansions of the nobility outstripped the production of furniture. Catherine, describing her life as a Grand Duchess at the court of the Empress Elizabeth, mentions more than once the poverty of the furniture in her private apartments. 'The court at that time was so poorly furnished that mirrors, beds, chairs and chests-of-drawers would be removed from the Winter Palace to the Summer Palace, from there on to Peterhof and once we even went to Moscow with them. When moving the furniture we broke much of it but would put it back in its place without it being repaired.'

Catherine had been brought up in still more modest conditions in Stettin. On her own initiative she began to obtain for herself the necessary furniture for her rooms in the Winter and Summer Palaces. After her accession she devoted much effort to the task.

The historian A.Brikner wrote: 'Catherine enjoyed luxury, comfort and the beautiful location of her palaces, summer houses, hot houses and gardens. She left many detailed descriptions of them in her letters to various of her correspondents. Catherine was always pleased when foreign visitors praised her taste in the layout of her parks and orchards and admired the beauty of Peterhof, Tsarkoe Selo etcetera. She liked to describe the luxurious refinement of mirrored halls and colonades, pictures and statues, the splendor and comfort of the rooms at the Hermitage, the imposing architecture of the buildings, designed by such architects as Quarenghi, Cameron, Felten, Rinaldi, Starov, Kokorinov, de la Motte and

the others who took part in the embellishment of St Petersburg.'

Among those who supplied furniture to the Russian court were the famous European makers David Rontgen and Jean-Henri Riesener. Rich families furnished their homes with German, Dutch and English pieces as well as copies by Russian craftsmen. In the second half of the 17th century a body of skilled furniture makers emerged, refining the traditional skills of the wood carver.

The Okhta settlement in St Petersburg, founded by Peter the Great in 1721, supplied skilled mahogany carvers, carpenters and joiners from different provinces across Russia. The Okhta craftsmen were used for shipbuilding and a huge range of carpentry work during the rapid expansion of the city. They made expensive and delicate furniture for the palaces of St Petersburg and the imperial residences. Among them were the talented Noskov family who created the unique inlaid furniture for Tsarkoe Selo. Innumerable unknown craftsmen, who worked alongside famous architects on the decoration of the palaces, perfected their skills while learning of the latest developments in European furniture making.

The art of furnishing was spread across Russia as the gentry sought to improve their estates. The process quickened after the decree of 1762 which freed the gentry from enforced state service, allowing them to begin providing amenities for their own properties. Thanks to the work of many talented serf-craftsmen architectural interiors took on a new refinement. The estates of the richest Russian nobles, such as the Bezborodkos the Kurakins, the Sheremet'evs and the Yusupovs, emerged as centers for applied and fine arts, theater and music. On occasions these serf-craftsmen reached the same standard as the famous European masters of the day. Furniture by Matvei Veretennikov, a serf of Count Saltykov, inlaid with a brilliant mosaic of fine woods, was often mistaken for the work of Riesener.

In Catherine's day Russian furniture was embellished with carved wood, painted and gilded. Sometimes it was faced in mahogany and other valuable woods, ornamented with bronze inlay and decorated with mythological

scenes or floral compositions. Marquetry was used on bureaus, chests-of-drawers, consoles, tables, wardrobes, sofas and armchairs. In everyday use were intricate bureaus - fitted with small, hidden drawers - folding card tables and small kidney tables. It was at such a table that the Empress began her day. Her secretary, Adrian Gribovskii, wrote: 'She came into the bedroom at 10 and sat on a chair (not an armchair) upholstered in silk, in front of a curved table. A similar table and chair, for her secretary, faced her. The table tops were adorned with inlaid bouquets landscapes and diverse ornamentation.'

Card tables were decorated in a similar style - the Empress frequently ended her day relaxing over a game of cards with a few friends. 'She played racamboul or whist, mostly with P.A. and E.V.Chertkov or Count Stroganov. Card tables were also put out for the guests', wrote Gribovskii.

Carriage-building techniques reached new heights. Sleighs and carriages were decorated with ornate carving, gilding and painting. The design of the latter reflected a family's status. When the Comte de Ségur came to Russia he was very surprised to find a strict hierarchy: 'Anyone above the rank of colonel has to ride in a carriage pulled by four or six horses, according to his precise rank, with a long-bearded coachman and two postilions. While I was paying my first visit to a lady living in a neighboring house one of my coachmen was already nearly at her gate while I was still outside my own house. In winter the wheels are taken off the carriages and replaced by runners.'

Carriages were distinguished by differing degrees of ornamentation and splendor. Some carriages, built for special occasions, such as Catherine's Coronation Coach, are works of art in themselves.

Young noblemen's clothes lent a special grandeur and magnificence to the Russian court. The effect was particularly striking on the young Catherine, who recorded in her memoirs: 'I came to Russia with rather a poor wardrobe. I needed a great many dresses as at the Russian court they changed three times a day.' The fashion was set by the Empress Elizabeth, who outshone all others by the opulence of her dress. After her death

Peter III found in her wardrobe 'more than 15,000 dresses rarely or never worn, two cases full of silk stockings, ribbons, pairs of boots and up to several thousand shoes, not to mention over 100 pieces of French and other fabric.' According to her contemporaries scarcely a single European monarch could have matched the empress of Russia for her clothes.

The Russian court quickly learnt the current French fashions: the subtly powdered hair arrangements and abundant jewelry. The court jeweller, Jeremiah Posier, describing the masked balls at the court of the Empress Elizabeth, wrote: 'The ladies of the court are experts at dressing and, moreover, manage to retain their looks in the most impossible ways...their clothes are very rich as are their gold ornaments - they are in the habit of wearing a great many. Even the ladies of lower rank wear jewelry worth between 10,000 and 12,000 roubles and don't leave home unless burdened with jewels.'

Both Elizabeth and Catherine issued decrees trying to curb the nobility's heavy spending on clothes. Protectionist laws compelled suppliers to buy their fabrics from Russian factories. Catherine condemned the wasteful extravagance of court life under her predecessor and adopted a deliberately modest lifestyle for herself. This was in marked contrast, however, to her treatment of favorites and courtiers and to the lavish life led at court.

Normally she wore a loose-cut 'Moldavian' coat with broad sleeves of lilac made of wild silk above a white dress with pleated sleeves without jewelry or orders. On feast days or holidays she wore a 'Russian' dress of brocade or velvet with the sashes and stars of St Andrew, St Vladimir, St George and a high coiffure topped by a small crown. The Empress attended the feast days of the different guards' regiments in a uniform dress similar to the uniform of the particular regiment.

It was Catherine who introduced the court to the fashion of wearing Russian dresses, and herself deliberately chose to follow aspects of Russian tradition: deep folding sleeves and kokoshniks.

In the 1780s fashion took on a more classical

look. The heavy, luxurious robes were replaced by light, draped tunics in styles taken from antiquity. In her memoirs the painter, Elizabeth Vigée Lebrun, described Catherine in just such a garment: 'For one celebration she was wearing the sashes of three orders, but her dress was noble and simple, a muslin tunic embroidered with gold, gathered in folds at the waist in an oriental manner. Over the tunic she wore a waist-length jacket of red velvet with very short sleeves. A cap, pinned to her hair, was decorated not with ribbons but with diamonds of rare beauty.'

Catherine liked to collect rare precious stones and the finest jewels. To store them, a special 'Diamond Chamber' was created in 1764 in one of the Empress' rooms in the Winter Palace. She generously dispensed snuff-boxes, rings and other trinkets to her courtiers.

In the second half of the 18th century many famous jewellers were working in St Petersburg including Jean-Pierre Ador, Johann-Gottlieb Scharff and Jean-François Bouddé. The arrival of classicism put an end to the richly baroque approach to jewelry where precious stones competed in brilliance, size and color. In its place came a search for harmony of color, proportion and materials. Pale shades prevailed in combinations using colorless stones, such as diamonds and pearls, against a background of blue enamel or gilded platinum. The main elements of decoration, notably garlands, wreaths and medallions followed the geometrical shapes of the objects themselves: circular, oval and polygonal.

In St Petersburg such talented silversmiths as Johann Friedrich Kepping, Justus Nicolas Lundt, and Johann Heinrich Blom were creating remarkable pieces for the houses of Russia's leading aristocrats. Nevertheless, in Moscow, silversmiths still using traditional Russian techniques continued to flourish, among them Alexei Polozov, Ivan Vereshchagin, Iakob Maslennikov, Alexei Afanasiev and Simeon Kuzov. In other well established centers of silverware - Velikii Ustiug and Kaluga, Vologda and Tobolsk, Iaroslavl and Pskov, and Kiev - specialist skills were used for niello work, enamel painting and filigree. The oldest center for both niello work and enamel painting was in Velikii Ustiug, where the Popov brothers ran a

successful factory from 1761 until 1766, producing a range of dishes and utensils. Interest in precious and ornamental stones reached new heights in the second half of the 18th century, when they were used both for decorative work and for sets of grandiose vases. A fashion grew up for collecting minerals and objects made from the different stones. Among the greatest collectors were Catherine herself, Prince Potemkin, Count Alexander Stroganov and the Sheremet'ev family.

The discovery of Russia's rich mineral resources was the foundation for developments in the art of stonecutting. In the 17th and 18th centuries deposits were found in the Urals, the Altai and Siberia of jasper, porphyry, lapis lazuli, agate, malachite, amethyst and cornelian. Leading centers for stoneware were the St Petersburg Lapidary Works, founded in 1723, and its counterpart in Ekaterinburg, opened in 1774 in the Urals. A further factory was launched in the Altai and was later transferred to Kolyvan where there were richer deposits of ornamental stone.

The stonecutting of the second half of the 18th century is famous for its high quality. Craftsmen discovered how to mold the stone while bringing out the quality, texture and color of their material. Bronze decoration was used only to define the object's form and for no other purpose.

Obelisks achieved particular popularity, used as monuments to Russian military triumphs. They also crowned cornices, formed centerpieces, were included in fireplace garnitures and stood on their own as decorative objects.

There were advances too in the manufacture of tapestries. In the 17th and early 18th centuries tapestries were brought to Russia, chiefly from France. Peter the Great, however, after studying the work of the Gobelins Factory, took steps to develop a native tapestry industry. In 1718 St Petersburg saw the opening of its first tapestry workshop, headed by the architect J.B.Leblanc. A French craftsman, Philippe Begagle, was appointed director. The factory carried out commissions for the imperial palaces and for the nobility. In 1755, for

example, the Empress Elizabeth ordered a tapestry depicting her coronation for the Winter Palace, then under construction.

The factory flourished under Catherine. Production was reorganized and the number of craftsmen reached 150. Dozens of pupils had already been trained and the production work was largely in the hands of Russian craftsmen.

The choice of subject matter was broad. The walls of the great houses of St Petersburg were hung with tapestries and woven rugs showing battles, historical scenes, allegorical compositions, portraits of emperors and the court, still lives, animals and birds.

A successful native industry also emerged for the manufacture of glass and porcelain. The Imperial Glass and Porcelain Workshops, founded in the first half of the 18th century, entered a new period of prosperity under Catherine. These workshops mainly served the needs of the court, making 'named services', decorative vases and sculptures for the imperial palaces and items to furnish the Empress' own apartments. Pieces for everyday use were made there too. On the Empress' orders unique items were created to be given as gifts to foreign dignitaries, favorites and courtiers. The *Orlov Service*, presented by Catherine to her favorite, Grigorii Orlov, is an interesting example made in a transitional period. In its brilliance it marks the end of the early period of Russian porcelain when baroque shapes and decoration held sway, and the beginning of classicism. It was designed by the famous painter-decorator Gavriil Ignatievich Kosilov.

By custom, the 18th century nobleman enjoyed a lengthy levée, when he often took breakfast with guests. Items were therefore needed both for his toilette and for the serving of food. The owner's monogram was shown in gold on the service which was adorned by an appropriate choice of decoration. For the Orlov Service the painting was carried out by the talented miniaturist Andrei Chernyi. The subjects include views of an army camp, trophies of war and shields, all indicating Orlov's own past as a soldier, when he served in the artillery. For subtlety and diversity it is regarded as a masterpiece of early Russian porcelain.

In the final years of the 18th century the Imperial Porcelain Factory was to become one of Europe's leading producers of porcelain where master craftsmen and painters carried out the most complex work. With great skill and patience grandiose services were produced: *The Yacht*, *Arabesque*, *Cabinet* and *Yusupov*. Each required its own particular set of paintings and sculptural compositions. One of the finest, the *Cabinet Service*, made for Catherine between 1793 and 1795, consisted of 800 pieces. It achieved a near-perfect harmony between round, plastic shapes and the colorful painting of garlands of wild flowers which formed a background. Oval medallions contained views of Rome and its surroundings, copied from Piranesi's engravings. Thus the diner could admire the sights of distant lands without leaving his own table! In effect it was a porcelain album of architectural antiquities depicting some monuments which have disappeared from the Rome of today.

Another splendid service of Catherine's time was the 933-piece *Arabesque*. The service had an idealogical as well as a functional purpose: it was intended to glorify Catherine's rule. The decorative scheme was worked out by the poet, Gavriil Derzhavin, and the architectural painter and poet, Nikolai Lvov, before being realized in eight allegorical compositions made of biscuit. The maker was Jean Dominique Rachette, who headed the model shop of the Imperial Porcelain Factory from 1779. Rachette extended the scope of the factory by producing castes of classic figures in porcelain such as Shubin's bust of Catherine and Canova's *Cupid and Psyche*. Rachette's workshops were also responsible for the first series of figures known as *The Peoples of Russia*. Thus was launched a favorite subject for Russian porcelain makers. The series was inspired by the works of the famous ethnographer and traveller, Johann Gottlieb Georgi, author of *A Description of the Peoples of Russia*. Work on the series was undertaken with the help of Rachette's pupils and continued from 1780 until 1804. Further figures of tradesmen and craftsmen, based on engravings by Mikhail Kozlovskii and Jean Baptiste Leprince, were later added and the full series comprised 60 figures.

The period also saw a rapid expansion of Russia's successful glass blowing industry. In

the 1760s there were some 25 workshops in Russia, the best known being the Imperial Factory, leased to Potemkin until 1792, and the Nikolo-Bakhmetevo plant. The Russian scientist and polymath, Mikhail Lomonosov, played an important role in the development of glass blowing. In 1754 he founded a factory to revive the production of mosaic 'smalts' and undertook scores of experiments to find new ways of making colored glass. Lomonosov's 'smalts' were used to depict battles and portraits and to decorate panels and table tops. Mosaic decoration was extensively used in the Glass Bead Study at the Chinese Palace in Oranienbaum.

In the second half of the 18th century Russian glass blowers pursued Lomonosov's experimental work to create beautiful pieces from colored glass and precious stones, competing with each other for purity and depth of color. In the glass blower's palette were manganese and cobalt, amethyst glass, golden ruby, turquoise, yellow, green and subdued, milky hues - whites, pinks and blues. Colored glass was used to make vases and dishes, standard lamps, candelabra, chandeliers, furniture and architectural details. Great architects designed glass pieces. Among them were Gavriil Kosilov, Giacomo Quarenghi, Charles Cameron, Ivan Starov and, later, Andrei Voronikhin, Vladimir Stasov, Jean de Tomon and Carlo Rossi. From drawings by Kozlov, the talented inventor and engineer, Ivan Kulibin, designed the startling 'Mirrored Slope' of moving cascades, in the winter garden of the Tauride Palace. The windows looking onto the winter garden were obscured by palm trees, their leaves made from multicolored glass. Lamps in the shape of melons and pineapples were laid out on the grass. The architect, Charles Cameron, in his designs for the Empress' bedroom and the 'Snuff Box Study' at Tsarkoe Selo used graceful columns, medallions and tiles made of colored and milky glass to give the interiors a peculiar elegance. Huge mirrors, crystal chandeliers and sconces magnified the candlelight, lending reception rooms an added magnificence.

Vases, cutlery and dishes were produced in an endless diversity of forms. The formal dinner table was crowded with graceful goblets and cups with engraved monograms,

painted porcelain and glistening silver.

The Russian nobility used their precious dishes for a constant round of feasts and parties. The Vice-Chancellor, Count Ivan Osterman, gave four ceremonial parties a year in honor of the Empress, to mark her baptism, her birthday, her accession and her coronation. The table would be laid with 300 places, each with its own silver plates.

The Comte de Ségur describes how Catherine was entertained by Count Sheremet'ev, one of the richest landowners in Russia, at his Moscow estate. The evening began with a performance of a Russian opera in the count's own serf-theater, followed by a dinner party which was 'as luxurious as the performance. Never have I seen so many gold and silver cups, so much porcelain, marble and porphyry. It may seem incredible to many that all the glass on a table, set for a hundred people, was adorned with the most valuable stones of all colors and kinds. Thus Russian noblemen are copying the patricians of ancient Rome just as they start on the path of the Enlightenment. Not a single Lucullus can now be found in Moscow.'

Steelworking had begun in Tula in the 16th century. The blacksmiths made both weaponry and civilian artefacts. The Comte de Ségur, who accompanied Catherine on her tour to the Crimea in 1787, wrote: 'On the way to Moscow we saw nothing more wonderful than Tula. It should be considered Catherine's creation, so valuable has been her patronage to it. Tula has long been known for its production of weaponry. It supplies the whole Russian army. Steel articles are also made here and, thanks to the concern of the Empress, this industry has now reached such a peak of perfection that it must surely compete with the English. Her Majesty presented us with very skillfully made examples of the factory's production.' Indeed the Empress had bought items worth around 12,000 roubles. She herself received generous gifts from Tula, among them an elegant dressing table with vases and other objects which now are in the collection at Pavlovsk. The Tula works carried out commissions from the Empress and from the nobility: armchairs, tables, writing cases, needlework boxes, candlesticks, chandeliers, rings and buttons, decorated with gold and

silver ornamentation, inlaid into a background of burnished steel. Such articles sparkled with the cut steel 'diamonds' typical of Tula ware.

The powerful Prince Potemkin had Tula craftsmen specially trained in St Petersburg to carry out work on his behalf. His niece, the Princess Branitskaia, was presented with a bed covered with a steel canopy.

Tula ware was much esteemed in the 18th century. Like other rarities in the Hermitage they were kept in the 'Cabinet of Curiosities' which was to become the Gallery of Treasures in the 19th century. Today the State Hermitage Museum houses the largest collection of Tula ware in the world, with an estimated 300 works by Andrian Sukhanov, Evtei Gurianov, the gunsmith Ivan Lialin, the needlework box by Rodion Leontiev, and the chess box with a view of the Tula Armaments Factory on the lid.

The State Hermitage Museum possesses an exceptionally wide and rich collection of monuments to the applied arts of Russia from the 17th to the 19th centuries. A major place is taken by works made under Catherine's reign, a golden age for the development of many branches of the arts. In this selection are works from all the leading centers and factories, a combination which gives a spectacular picture of the age of Catherine the Great.

RUSSIAN CULTURE AND SCIENCE

by Irina Uchanova

Russian culture in the 18th century took shape against a background of historical change. Its scientific and artistic achievements were linked to the country's economic development, a new system of education and changes in literature, art and thought.

Science already held an important place in the hierarchy of Russian cultural values by the second half of the 18th century. In the words of Mikhail Lomonosov: 'Science set out to explain outward phenomena in relation to a body's inner workings.' The activities of scientists and travellers, writers and artists were based on the experiences of those who went before.

When the young Catherine arrived in St Petersburg she began to study the country that was to become her second motherland with genuine interest and set about examining the principal characteristics of Russian life: its people, culture and art. She read widely, corresponded extensively, took time to develop her thoughts and to study literature. In St Petersburg, she had the chance to meet some of the greatest scientists of the day. At that time Mikhail Lomonosov, Daniel Bernoulli, G. Miller, and Leonhard Euler, were all working at the Academy of Sciences in the city. Their work spanned the reigns of two empresses: Elizabeth, the daughter of Peter the Great who had founded the Academy, and Catherine the Great, a truely enlightened monarch of the second half of the 18th century.

Founded in 1724, the Academy was to be devoted to research, the training of specialists and the dissemination of learning. Scientists were required to help the State in developing new techniques, geographical research and the study of Russia's natural resources. Much attention was paid to both fundamental research and the applied sciences, the publication of scientific works and their translation.

The Academy ran its own printing house which published scientific works as well as fiction and school books. They were sold in a special bookshop nearby which opened in 1728.

By the mid-18th century a number of foreign scientists were working in St Petersburg, their works being circulated abroad among the various royal and private libraries that promoted international contacts. The Academy's own library was particularly important for science and education.

From 1741 to 1764 the name of the great Russian encyclopaedist, Mikhail Lomonosov, is indissolubly linked with the Academy. His youth was spent in the northern province of Archangel. It was a region where serfdom was unknown, a factor crucial to many aspects of his future life. Lomonosov was brought up in an area with cultural links with not only the surrounding provinces but also with neighboring states, and there were always well-read and learned people in the vicinity. He came to Moscow to study at the Academy of Slavic and Classical Studies where he learnt Latin, then the language of science. Apart from the sciences, he was also attracted to history and the arts. Lomonosov completed his education in Germany where special attention was paid to physics, mining, mathematics and other exact sciences. His strength of will, powers of understanding and thirst for knowledge were dominant characteristics. In his first biography, compiled by some of his closest acquaintances, a leading figure of the Russian Enlightenment, Nikolai Novikov, wrote: 'He was a good-natured figure, laconic and witty, who liked to make jokes in his lectures, loyal to his friends and to his country, he enjoyed poetry and literature and writers enjoyed his patronage. He was usually gentle and merciful towards those who sought his protection although at the same time he had a fiery temper.' (*Observations on the Historical Dictionary of Russian Writers*, 1772).

Lomonosov was a man of many parts. His interests embraced science, the arts, poetry and even painting in its very oldest form - the making of mosaics from colored smalts.

He wrote serious works on physics, astronomy, meteorology, the theoretical basis of oratory and literature, mining, history, geography and geology. He was also responsible for some outstanding discoveries,

advancing new ideas and predictions which were only afterwards developed. It was with his help that Moscow University was founded. Alexander Pushkin described Lomonosov himself as 'our first university'. In fact he was a typical representative of the Enlightenment, active and energetic in the widest possible sphere. His works were much appreciated by the greatest mathematician of the 18th century, Leonhard Euler. He commented: 'Now such geniuses are rare. Most people work on experiments but have no wish to pursue their results.' Lomonosov's hypotheses were tested by experiments and the theoretical explanations which followed helped to determine the course of science.

Lomonosov's contribution to the arts was considerable, particularly in the fields of history and poetry. Catherine herself was supposed to be very familiar with his *History of Ancient Russia up to the Death of the Grand Duke Iaroslavl* , published in 1766. Evidence of its importance is that the book was translated first into German and later into French at the Court Library in France. A writer in one French magazine lamented the fact that Lomonosov had not covered the entire period up to the accession of Peter the Great. With Voltaire's *History of the Russian Empire under Peter the Great* there would then have been a complete history of Russia.

It is known that when writing his own history Voltaire drew not only on the advice of the Secretary of the Academy, G.Miller, but also on Lomonosov's work. Indeed, advances in the study of history exemplified the closening ties between Russia, France and other countries.

The Translator's Foreword to Eidut's French edition of Lomonosov's *History of Ancient Russia* reads: 'I translated it from German and it is not to me that the public should be grateful but to a man distinguished for his irreproachable honesty, his knowledge and love of literature who was so kind as to lend me the German edition. Everything there was new, strange and interesting.' This 'friend' was the prominent philosopher Paul Golbach who, like Voltaire, was an honorary member of the Academy of Sciences in St Petersburg.

The Academy was not only a center for scientific study in Russia, it was also part of a greater European network. It helped to produce an entirely new class of professionals in the sciences, researchers, laboratory workers, librarians and administrators in the Academy's offices. There were also honorary Academicians whose works had been recognized as particularly important.

In the century of enlightened absolutism, Catherine considered herself as a patron not only of the arts but also of the sciences. At the beginning of her reign she set out to follow the advice of the leading figures of the French Enlightenment, Diderot, Montesquieu, Helvetius and, of course, Voltaire.

Catherine conducted a long correspondence with these philosophers, invited Diderot to St Petersburg where he became librarian at the Winter Palace, and acquired Voltaire's library after his death. At first, enthusiam for Voltaire and his ideas was widespread both in St Petersburg and in the provinces. But Pugachev's peasant revolt in the 1770s and the French Revolution of 1789 worked a major change in the outlook of the Empress and the nobility. The attempt to forge contacts with progressive writers and philosophers was slowly abandoned as a new conservatism took hold. The change in official attitudes affected the fate of progressives in Russia itself, notably Nikolai Novikov (1744-1818) and Alexander Radishchev (1749-1802), who shared many of the same views.

Novikov ran a publishing house at Moscow University which produced thousands of works on economic and political reform in Russia. Novikov, a defender of native Russian culture, put out such satirical magazines as *Zhivopisets* (*The Painter*) and *Trutien* (*The Drone*) which took contributions from the wonderful satirist, Denis Fonvizin.

Novikov's activities were broken off on Catherine's orders and he found himself under arrest and imprisoned in St Petersburg's Schlusselburg fortress.

Radishchev's *A Journey from St Petersburg to Moscow* (1790), clearly portrays the hard lives led by Russian peasants and serfs and the important events of the last thirty years of the 18th century.

Worsening relations between England and her North American colonies erupted into the War of Independence of 1775 to 1783, in which many Russian volunteers took part. Thus ended the feudal system of landownership and the newly independent country was given fresh scope for capitalist enterprises. Then, in 1789, came the French Revolution and the storming of the Bastille. An article, printed by Moscow University in 1790, commented: 'In 1789 the whole world was shaken so violently that everywhere extraordinary movements appeared, starting an entirely new era in the history of mankind.'

The events that shook America and Europe were reported in Russian newspapers and could not fail to influence on the works of progressive thinkers.

The appearance of Radishchev's book excited not only the reading public but also the Empress. Comparing Radishchev's views with those of the French philosophers and revolutionaries, she concluded that he was 'worse than Pugachev'.

The author's descriptions of his visits to towns and settlements between Moscow and St Petersburg and his accounts of meetings with people of different social rank caused no particular offence. The opinions he expressed, however, were so outspoken that the Empress ordered his exile to Siberia and the burning of all copies of his book. Radishchev spent seven years in exile and only returned to St Petersburg after Catherine's death.

The period was notable for the foundation of numerous educational establishments. In 1755 Moscow University opened, during the 1760s gymnasiums for the children of noble families were launched in large towns, in 1773 the School of Mining in St Petersburg opened its door to students and, in 1786, the School of Medicine was launched.

Much attention was paid to the upbringing of children under Catherine. Indeed part of her New Charter of 1767, 'The Mandate', was devoted to the subject. A special commission was convened to investigate the improvement of educational opportunities for peasant children.

'Upbringing is the root of good and evil' stated I.I.Betskoi (1704-95), President of the

Academy of Arts, and under his auspices a school for talented children was established at the Academy. In addition a high school, an infantry and naval cadet college, a school of commerce, and a training establishment for illegitimate and orphaned children were opened. In 1764, on Betskoi's initiative, the Institute for the Daughters of the Nobility (The Smolny Institute) opened with a broad educational brief. In the second half of the 18th century the system of public education took shape.

In the 1760s the activities of the Free Economic Society had considerable effect on Russian culture. It was launched in 1765 under the protection of the Empress who awarded it her emblem: the beehive, and her motto: the word 'useful'. The society busied itself with questions of agriculture and the study of new knowledge. For ten years it published its own magazine *The Works of the Free Economic Society*. It was intended for educated noblemen who, freed from enforced state service in 1762, were turning their attentions to the farming of their estates.

Among other ventures, the Free Economic Society set up a program of mass publishing, greatly increasing public access to knowledge. Levels of culture and training for the ordinary Russian were greatly raised by such programs. Often an education in Russia was followed by further training abroad.

Great scientists, astronomers, mathematicians, historians, doctors, palaeontologists and botanists, were constantly invited to Russia. They not only worked at the Academy of Sciences but also took part in numerous expeditions. In the 1760s and 1770s five major expeditions were organized to study the flora and fauna, ethnography and mineral resources of different regions. In a relatively short period scientists managed to explore vast tracts of the country. For example, Ivan Lepekhin, the Academy Secretary and head of its Botanical Gardens, travelled down the Volga and into the provinces of Orenburg and Astrakhan. In the same year, his party also ventured into the Urals and crossed the Olonets region in 1768. In 1772, Lepekhin published his *Daytime Notes - Travels through various Provinces of Russia*. They contained a detailed account of the animal and plant

world, descriptions of mines, places of interest, towns and villages as well as of the everyday life of the indigenous peoples.

Further fruitful expeditions were led by Peter Pallas, Samuel Gmelin, Anton Gildenstedt, Johann Falk and others. Every expedition was accompanied by professional artists to record everything of importance.

The two decades are often seen as the great age of the scientific expedition. The results appeared in detailed scholarly works with illustrations and marvellous engraved atlases. The rich material collected during these trips went to the academic museum, the Kunstkamera in St Petersburg.

By 1774 the Academy had accumulated a vast amount of information, collections and cartographical surveys. An important role was played by the Academy's Geography Department.

Cartography had been a particular interest of Peter the Great. As early as 1717 he entered into negotiations with the famous cartographer and astronomer, J.B.Delisle, who was later invited to St Petersburg where he was appointed to head the Geography Department. His principal assistant and deputy was the mathematician Leonhard Euler. Lomonosov paid particular attention to the department's work and drew up a special curriculum for it.

During his last years, Lomonosov was much occupied with ideas of Arctic exploration, and his dream of finding a sea route through the Arctic to the Pacific. He wrote: 'The northern ocean is a spacious field where Russian glory may swell. Its practical value may also be immense through the discovery of a sea route between the Orient and America.'

Lomonosov worked on his own theory about such a passage. In 1763 he wrote *A Short Description of various Trips Along the Northern Seas and Evidence of a Possible Passage to the East Indies through the Siberian Ocean*. The work confirms the remarkable range of scientific interests of a great scholar who understood the practical value of his own research.

In 1764 a naval expedition under V.Chichagov (1726-1809) was organized to test Lomonosov's theories. But when it returned to Archangel after a first attempt, the man who had inspired the whole enterprise was dead. Lomonosov had died a month earlier in 1765. Another expedition was soon undertaken.

The idea of a sea route between the Arctic and the Pacific had occupied Russian minds for centuries. In the 18th century the search continued for unknown lands and seas in the Far East as well as the Arctic. The voyages of Alexei Chirikov and Vitus Bering in the 1740s opened up the the shores of North Western America and the Aleutian Islands, the goal of regular hunting expeditions, for further study.

The process of opening up new lands within Russia itself had begun at the end of the 16th century with the expeditions of the Cossack explorer Ermak and was completed in the first half of the 18th century with the discovery of North-Western America. Not only the Academy of Sciences but also the Ministry of Marine and the Senate played important roles in organizing these expeditions. The successful expeditions of V.I.Bering, P.I.Krenitsyn, Mikhail Levashov, I.I.Billings and Gavriil Sarychev, as well as those of numerous other sailors and traders, led to the exploration of eastern Asia, Kamchatka, the Kuriil Islands, the Aleutian Islands and north western America. Between 1765 and 1786 there were 48 such expeditions.

In 1767, Vasilii Shilov produced a new map of the Aleutian Islands, a useful aid for seamen in the region. The Chukchi scholar, N.I. Daurkin, made a journey across Chukotka between 1763 and 1764 and the next year produced a map of north-eastern Asia and North America. The information he gathered testifies to the long-established links between the Chukchi and the Eskimos of North America.

In 1764 Catherine instructed the governor of Siberia, General Dmitri Chicherin that two naval officers and several pilots were being sent by the Admiralty to carry out work in Tobolsk. The mission, which was headed by P.I.Krenitsyn and M.D.Levashov, was to leave from Okhotsk. Despite numerous difficulties and poor weather, it brought back to St Petersburg a rich crop of material on geography, ethnography, zoology and icon painting.

No less complex and equally important were the results of the Pacific voyages undertaken by I.I.Billings and Gavriil Sarychev between 1785 and 1795. Much important material was collected on the geography and ethnography of the Aleutian Islands before they finally reached the shores of America in 1790 . Their ship, *The Glory of Russia*, which had been built in Okhotsk, was depicted on a special medal honoring the Russian explorers of the Pacific. A detailed account of the expedition was later published, encouraging further travel and settlement in the region. By 1788 there were up to 500 Russians living in the Aleutians or on the shores of North America and by 1794 the number had climbed to more than 800. In the 1780s and 1790s Russian fortresses were built on the island of Kodiak and at other sites. By 1799 New Archangel had emerged as the center for Russian America.

Much of the credit for the exploration of the region belongs to Grigorii Shelikhov, the traveller, navigator and explorer, described by the Russian poet Derzhavin as the 'Russian Columbus'. Shelikhov travelled widely in Siberia before reaching the shores of the Pacific and beginning his studies. Between 1773 and 1785 he carried out a thorough study of the islands and currents, basing himself on Kodiak for two years. On his departure he left orders with those who remained 'to encourage the settlement of Russian people, to create friendly relations with the native Americans and to uphold the reputation of the Russian empire in the lands of America and California up to the 40th degree.' This was the first Russian order ever issued about the occupation of these borderlands. Shelikhov persuaded the Russian authorities of the need to build fortresses and establish permanent settlements, and to launch a trading company. At first, Catherine disliked the idea of the new Russian-American Trading Company, but Shelikhov continued to argue for its creation and finally the Empress gave way. She wrote: 'Trade is one thing, possession another.' Thereafter construction work went ahead with greater vigor. At every site settled by Russian pioneers, a copper plate was buried, claiming Russian sovereignty over the land. By 1799, the new company had monopoly trading rights in Alaska, the Aleutians and the Kuriil Islands.

An outstanding figure, even in an age crowded with scientific and artistic talent, is Catherine Dashkova (1743-1810), who headed the Academy of Sciences. Energetic, brilliant and well-educated, her life was closely linked with Catherine the Great.

The mid-l9th century writer, Alexander Herzen wrote: 'The character of all Russian womanhood is revealed in that of Dashkova. It had been roused by Peter the Great and emerged declaring its own worth and demanding a right to participate in affairs of state, in science and in the reform of Russia. She deserves a place alongside Catherine the Great.' Herzen said that he saw in Dashkova the same energy and versatility as in Peter the Great or Lomonosov.

After her appointment to the Academy in 1783, she took special care of its publishing house and of the geographical department. It was under her auspices that maps and scientific works were printed and that a special interpreters' section was set up. On her initiative, public lectures were started at the Academy, broadening the spread of education.

At the same time Dashkova was also appointed president of the new Russian Academy which devoted itself exclusively to the arts. And it was this that came to dominate her work. The Russian Academy became the center for the study of the Russian language and philology. Its main task was 'the glorification of the Russian tongue, its range, wealth and beauty'. In just six years the first ever Russian dictionary was produced. Contemporaries praised both the speed of the work and the dictionary itself.

Dashkova was also responsible for launching the *Russian Language Lovers' Companion* in 1783. It numbered some of the best writers of the 18th century among its contributors, Derzhavin, Kniazhnin, Fonvizin and others. It was here that Catherine published her own *Notes on Russian History*. The 18th century was a remarkable period in both the public and spiritual life of Russia.

In the words of Mikhail Lomonosov: 'The sciences show the way to the arts, and the arts hasten the development of the sciences.' All changes in society are interlinked and interwoven, enriching one another. This produces a complex and sometimes paradoxical unity, characteristic of the Russian culture.

COMMEMORATIVE MEDALS

by Yevgeniya Schukina

The appearance of commemorative medals began in Russia with the monetary reforms of Peter the Great and the production of large minted coins in the early 18th century. The medals made in Peter's time were dedicated to Russian victories in the Northern War and to major historical events. By the middle of the 18th century the art of medal-making in Russia had reached a high artistic standard and, by the end of the 18th century was flourishing.

Catherine and her entourage lent further support to the craft by commissioning medals to commemorate important episodes in history and to honor prominent statesmen. Medal committees were set up in 1757, which included such academics and historians as M.M.Shcherbatov, M.M.Kheraskov, A.A.Nartov, the painter G.I.Kosilov and a professor of the Academy of Sciences, I.von Stelin who, earlier that year, was asked to report on Russian medal production. The Empress herself designed a number of medals based on events in the history of ancient Russia. Ninety-four such projects were undertaken and the series was only halted after Catherine's death.

In 1764 the Academy of Arts introduced classes in engraving on steel and hard stones. Pierre-Louis Verniet was invited from France as instructor and Sergei Vasiliev was one of his first students.

In the second half of the 18th century nearly all Russian medals bore the stamp of the St Petersburg Mint. For over 30 years two remarkable craftsmen, Timofei Ivanov and Samoila Iudin worked within its walls. Later their younger contemporaries, P.Bobrovshchikov and N. and S. Alekseev, carried on the skilled and painstaking traditions of carving on steel.

The Mint became increasingly busy, striking large numbers of commemorative medals in addition to the minting of coins and military campaign medals. The lack of skilled craftsmen meant extra staff had to be recruited abroad.

In the first half of the 18th century it was common for 'guest' workers to return eventually to their native countries. Later, however, it became normal for foreign medal-makers to settle permanently in Russia. Thus foreign and native traditions of medal-making were able to merge. German craftsmen like the brothers Waechter, I.B.Gass and I.K.Jaeger made significant contributions to the development of Russian medalmaking.

In the 1760s and 1770s traditions of baroque design remained current. Portraits shown on medals were given the highest possible relief with abundant incidental decorative detail. Particular to the reverse of Russian medals were detailed landscapes and many-figured compositions. Sophisticated technical skills and consummate command of the tiniest grada-tions of relief gave the powerful illusion of depth and space.

In the 1780s the influence of classicism was felt on medal design. This can be seen most clearly in the work of the leading craftsman of the day, Karl Leberecht.

The art of medal-making in the second half of the 18th century has left us with a generous number of commemorative works. Despite their tiny scale, they are rich in the depth and content given to them by the painstaking efforts of talented craftsmen and they offer us a marvellous glimpse into Russian history.

LITERARY PUBLICATIONS IN RUSSIA DURING THE REIGN OF CATHERINE THE GREAT

by Olga Zimina

Literary publications played an important part in the history of Russian culture during the second half of the 18th century. Traditions established under Peter the Great were still current and, at the same time, fresh influences were being felt in political, literary, scientific and artistic spheres. In the period following Catherine's accession, seven times more books were being printed than at the beginning of the century.

This era, often called the Russian Enlightenment, was a time of intense interest in foreign literature, facilitated by the rapid development of links with western European countries.

The books of such members of the French Enlightenment as Voltaire, Diderot, Montesquieu and Rousseau enjoyed enormous popularity. Voltaire led the field and almost all his fiction was published by this time. For many years Catherine, an enthusiastic supporter of the French philosophers, sustained a lively correspondence with Voltaire and Diderot. She purchased their libraries and, in compiling her political treatise known as the *Nakaz*, drew on the works of Montesquieu. She also encouraged the activities of Ivan Betskoi who, in the spirit of Rousseau, was engaged in the setting up of schools. The demand for western, particularly French, fiction was strong. Russian readers were enthusiastic over the work of Molière, Mercier, Marmontel, Lesage, Corneille, Beaumarchais as well as Boccaccio, Cervantes, Swift, Shakespeare and Defoe. Constant reprints were necessary. Lesage's *Gil Blas*, for example, ran to seven editions. The works of foreign writers were read both in the original and in Russian translation.

The Committee for the Translation of Foreign Books into the Russian Language was set up in Moscow in 1768. At its head was the Director of the Academy of Sciences, Vladimir Orlov, and V.G.Kozitskii, Catherine's secretary, acted as administrator.

The Committee sat until 1783 and, in that time, published 112 books: 18th century geographical and historical works, and those of earlier times. Professional translators were hired: N.M.Mantsev, Pavel Besak, Vasilii Lebedev, Alexei Polenov, Samson Volkov and Vasilii Kostygov. Other literary figures, too, took part in the projects: Iakov Kniazhnin, Vasilii Levshin, Nikolai Ozeretskovskii, Alexander Radishchev, Feodor Tumanskii. The Committee paid special attention to the translation of classical authors.

The flood of books from abroad did not prevent an increase in the number of Russian editions. Many remarkable Russian writers were published in the second half of the 18th century: Alexander Sumarakov, Mikhail Kheraskov, Ippolit Bogdanovich, Iakov Kniazhnin and Nikolai Novikov. Their works appeared both singly and in multi-volume editions. It was they who were responsible for the development of Russian as a literary language. They brought the ideas of the Russian Enlightenment into works of poetry, prose, drama and into their political and economic writings.

One of the most important publishers was the Academy of Science. It produced the works of its members and thus popularized scientific books as well as printing textbooks and manuals. Many members of the Academy were foreigners who were published both in their own languages and in translation. The Academy also organized numerous expeditions to explore the remote and little known regions of Russia, to the North, South and East. Exciting new cartographical, geographical, ethnographical, botanical and zoological information became available when the works of such explorers as Samuel Gmelin, Nikolai Ozeretskovskii, Ivan Lepekhin, Johann Georgi, Johann Fisher and Gavriil Sarychev were published. Also fascinating are the drawings made during their expeditions by such draughtsmen as Nikita Dmitriev, Ivan Borisov and Mikhail Shalaurov. These were engraved at the Engraving Workshop at the Academy of Science where practically all such work was undertaken.

In the second half of the 18th century interest, increased in Russias own history and this brought the publication of scientific studies and historical works, both fiction and non-fiction. Historical works of the early and mid century were published in large editions, up to 1200 copies. Authors included Vasilii Tatishchev, Mikhail Lomonsov, Mikhail Shcherbatov - the first volumes of whose *History of Russia* appeared at this time - F.O.Tumanskii and Ippolit Bogdanovich. Historical documents and manuscripts were also published, among them Novikov's *Ancient Russian Bibliography*, *Ancient Monuments of Russian Literature*, *Russian Truth*, *The Teachings of Prince Vladimir Monomakh*, published by A.I.Musin-Pushkin and the writings of Abraham Palitsyn on the siege of the Trinity-Sergius Monastery. Such books contributed to Catherine's own enthusiasm for Russian history, which resulted in the *Notes on Russian History* which she wrote for her grandsons. She also wrote an historical play, *The Initial Instruction of Oleg*.

During Catherine's reign the number of periodicals increased to over 100. These were literary, satirical and philosophical magazines to which academics, scientists, literary and public figures contributed, not to mention Catherine herself.

Among these periodicals were *The Drone* (1769-70) and *The Painter* (1772-93), edited by Nikolai Novikov. Krylov and Co, headed by I.A.Krylov, the famous author, fable writer and journalist, published *The Mail of Spirits* (1789) and *The Spectator* (1792). I.G.Rakhmaninov, the well-known translator of Voltaire, edited *The Morning Hours* (1788-89). Such was the popularity of *The Saint Petersburg Gazette* that its circulation exceeded 1000, a considerable figure for that time.

Design became an important aspect of book production in the second half of the 18th century. Many editions were now illustrated. The Academy of Arts Engraving Class instructed book engravers, among them I.Srebrenshchikov, D.Gerasimov, Ivan Bugreev, Elisei Koshkin and E.Khudiakov. At the same time foreign engravers were at work: I.K.Nabholz, Christopher Roth, Johann Meir, Joseph Saunders and Christian Shenberg, to name but a few. In Catherine's day books were usually adorned with fine head and tail pieces, vignettes, frontispieces and title pages, exemplified in *Notes on Famous Places Visited by Her Majesty in Belorussia* or Ivan Betskoi's *On Founding an Educational Establishment*. Until

1783 all publishing in Russia was restricted to a few official publishing houses. In St Petersburg there were, for example the Academy of Sciences, the School of Mining and the Cadet Corps, while in Moscow there was the university press. The School of Mining publishing house was used by Catherine herself in the last two decades of the 18th century for the publication of her opera *Favei*, her play *The Initial Instruction of Oleg* and her collection *Receuil des Pièces de l'Hermitage*.

In the 1770s, however, private presses were opened in St Petersburg. The first was established with the government's permission in 1771 by I.M.Hartung to publish foreign books. Hartung was a skilled craftsman who had previously worked in the Senate's printing house. In 1774 Johann Weitbrecht and Johann Shor opened another press, under the protection of the imperial household and it was here that Catherine's *Notes on Russian History* was printed. Two years later Shor broke with his partner and won permission to print Russian books. In 1783 all restrictions were lifted, allowing anyone to publish freely in any language. Over the next 13 years private presses appeared in many towns, among them St Petersburg, Moscow, Iaroslavl, Tambov, Kostroma and Tobolsk. In St Petersburg the main book publishing centers, were the publishing houses of Bernard Breitkopf, Emelian Vilkovskii, Peter Bogdanovich and Johann Meir. In Moscow there were the Annenkov, Lopukhin and Novikov publishing houses. In 1791 the editor I.A.Krylov began operations, joining with friends to buy the publishing house and bookshop of I.G.Rakhmaninov. In the next five years it produced around 20 books, mainly translations. The independent publishing houses survived only until 1796 when they were closed on Catherine's orders at the same time as she imposed censorship. The new rules meant that official permission was needed to print or import a book from abroad. The move was a reaction to the French Revolution and to fears that revolutionary ideas would spread to Russia.

Imported and Russian literature was usually sold in bookshops. Information about the books was published in the *St Petersburg Gazette* in a supplement or separate leaflet, as well as

in catalogs or lists. A total of 130 were issued in the second half of the 18th century.

The largest number of bookshops was in St Petersburg. The first proprietors were German, mainly bookbinders or booksellers. There was a lively trade in books in the shops of Carl Miller, N.Rospini and I.G.Klosterman. Many of them also traded in works of art and some had their own publishing houses. In the mid-1780s such Russian booksellers as Matvei Glazunov, Feodor Sveshnikov and the Zaikins opened. They competed successfully with the foreign booksellers, enlarging the market for books. Altogether St Petersburg had more than 70 bookshops. They were to be found mainly in the center of the city, between the Admiralty and the Kazan Cathedral in Nevskii Prospekt and in the streets near Isaac Square. The shops sold foreign and Russian literature as well as periodicals, calendars, textbooks, children's books, historical works, travelogs and good housekeeping guides. These were in great demand and the booksellers bought directly from the publishing houses.

The most remarkable figure in the publishing world was Nikolai Novikov who began his career in 1776. He was not only the editor of the magazines *The Drone*, *The Painter*, *St Petersburg Gazette*, encyclopaedias and dictionaries, but he was also often the author. Some of the best writers of the day worked on his periodicals. At first he worked as a publisher in St Petersburg but after 1778 he rented a printing shop at Moscow University. In the thirteen-year existence of his five printing houses he published more than 1,000 books and magazines, a third of all material printed in Russian. Novikov's bookshops were opened in St Petersburg, Moscow, Nizhnii Novgorod, Kazan, Simbirsk, Tobolsk, Oreol, Astrakhan and Irkutsk. In Moscow his bookshops had the first reading rooms and libraries.

The subjects of Novikov's books were extremely varied. He produced newspapers, periodicals, children's books, school textbooks, dictionaries and works of reference, books on all branches of knowledge, Russian and foreign literature, travelogs, philosophical and theological works, historical literature and books listing archive and source material. Particularly popular were his books on

housekeeping and cures. Novikov mainly produced small books, modestly illustrated, on cheap paper. This meant that they could be sold at affordable prices. The bookshops of the second half of the 18th century were often run by skilled bookbinders, especially in St Petersburg. In the shops of Hans Richter, Christian Tourneau, Wallenberg, Fauconnier, Carl Miller, I.Shubotz, Weber and Thomas Mier one could acquire unbound books, which could later be bound. Many of the bookbinders were masters of their craft, carrying out commissions even for the Empress herself, among them were: Christian Tourneau, I.Shubotz, Hans Richter and Fauconnier. Bookbindings for the libraries of the rich and aristocratic were in themselves marvellous examples of applied art. The craftsman used thin, well-processed leather of different colors, red, green or brown. The bindings were stamped in gold floral and geometrical patterns. The binders also used fabrics such as silk, brocade and velvet. Particularly decorative were the spines of books, ornamented with classical motifs: vases, urns, bows, flowers and garlands.

In the second half of the 18th century the Russian nobility collected books as well as works of art. By the end of the century some of their collections were already famous, among them were the collections of the Vorontsov family, Alexander Stroganov, the Shuvalov family, Ivan Betskoi, Nikolai Yusupov, Catherine Dashkova and Alexei Musin-Pushkin. They were admired not only for their size but also for the range of historical, artistic, scientific and cultural information that they contained.

The Empress herself set an example as a collector. From its foundation in 1762 the Imperial Library never ceased to grow, swelling with artistic literature, travelogs, descriptions of towns and historical monuments, and works on philosophy, politics and history in Russian and foreign languages. The St Petersburg book dealers Klosterman, Rospini and Weitbrecht regularly supplied both books and works of art. Over the course of some thirty years Catherine acquired the libraries of foreign collectors. These included those of Voltaire, Diderot, Bushing and of great Russian bibliophiles such as Mikhail Shcherbatov, Alexander Lanskoi. Johann

Georgi, the famous traveller and writer, who
visited the Hermitage in 1794 remarked that
there were then, in effect, seven libraries,
each kept seperately: those of the Italian
Marchese Galliani, around 1,000 books bought
in 1776, of Diderot, 2,904 books bought in
1791, the 13,000 books bought by the Berlin
dealer C.N.Nikolai for the Empress, 4,513
books belonging to Peter III, and Catherine's
personal library of 4,000 books. By the mid-
1770s the books taken from the Winter Palace
to the Hermitage were known as the Imperial
Hermitage Foreign Library. From 1768 there
was also a Russian library for members of the
court in which the books were all labelled
'from the Court Library'. Catherine's personal
collection, Georgi noticed, was conspicuous
because of the books' red morocco bindings
and gold edges. By the end of the 18th
century the Foreign Library had around 40,000
volumes while the Russian held 4,360.

The book collections which took shape in the
second half of the 18th century were unique
monuments to the culture of their day. Many
of the books of the period are works of art in
themselves such is the refinement of their
bindings, decoration and engravings. But there
were not only expensive books on the market.
Large editions of moderately priced books
opened up literature for all, a trend that was
to have a major effect on Russian culture.

LIST OF ARTISTS

ADOR Jean Pierre
b.1724 (Switzerland), d.1784
(St Petersburg). Worked as goldsmith and master of enamel work. Arrived in Russia early 1760s and became leading St Petersburg jeweller of his day. Worked independently of Guild of Foreign Jewellers. Established own workshop. In 1764 opened haberdashery factory. Work included snuff-boxes, vases, clocks, medals and decorated arms. Owned outstanding numismatic collection.

ANTROPOV Alexei Petrovich
b.1716, d.1795 (St Petersburg). Painter of icons, portraits, landscapes and miniatures. Studied under M Matveev, M A Zakharov, L Caravaque, P.Rotari. Worked for the painting section of the Construction Office from 1739 and for the Holy Synod from 1761. Worked in St Petersburg, Moscow, Kiev.

BARBÉ Carl Helfried
b. 1777. German jeweller. Worked in St Petersburg as apprentice in 1799. Master of Guild of Foreign Jewellers, 1806. A Russian subject from 1811 and became member of Russian Guild of Jewellers.

BOROVIKOVSKII Vladimir Lukich
b.1757 (Mirgorod), d.1825 (St Petersburg). Painter of portraits, icons and miniatures. Son and pupil of L Borovikovskii. From 1787 studied in St Petersburg under D G Levitskii and G B Lampi. Academician, 1795. Councillor of the Academy, 1802.

BOUDDÉ Jean François Xavier
Dates unknown. German jeweller. Came to St Petersburg from Hamburg, 1765. Master of Guild of Foreign Jewellers, 1769. Headed Guild, 1779-85. Maker of ecclesiastical objects, weapons, snuff boxes, ornaments, rings, orders.

BUCHHOLTZ Heinrich
b.1735, d.1780. German portrait painter and decorator. Worked in Russia 1760-70. Helped on Lomonosov's 'Battle of Poltava' mosaic.

CANOT Pierre Charles
b.1710 (Paris), d.1777 (London). Engraver. Worked in France and England. Chiefly reproduced works by other artists, including sea-battles and landscapes.

CARAMAQUE Peter
Dates unknown. Jeweller. Came to St Petersburg from Copenhagen. Member of Guild of Foreign Jewellers from 1787.

CHERNYI Andrei Ivanovich
Dates unknown. Miniaturist. Probably learnt skills of working with ceramic and enamel from his father I A Chernyi, a Sheremet'ev family serf and early porcelain painter. From 1750 worked at Imperial Porcelain factory near St Petersburg.

CHESKII Ivan Vasil'evich
b.1779-80, d.1848 (St Petersburg). Engraver, graphic artist. From 1791, studied engraving at Academy of Arts under A Radigues and I Klauber. Academician, 1807. Engraved portraits views of St Petersburg and suburbs, illustrations for travel books.

CHRISTINEK Carl Ludwig
b.1730-32 (St Petersburg), d. before 1794 (St Petersburg). Painter of portraits and icons. Born into a family of German colonists in Russia. In 1761, supervised work on cartoon for Lomonosov's 'Battle of Poltava' mosaic. Academician, 1785.

DE MAYR Johann Christoph
b.1764 (Nuremberg), d.1812 (St Petersburg). Brother of J G de Mayr. Engraver, graphic artist. Worked in St Petersburg from 1785. Chief engraver at Academy of Sciences until 1796, then worked on private commissions. Specialized in portraits, plans maps and illustrations for travel books.

DE MAYR Johann Georg
b.1760 (Nuremberg), d.1816 (St Petersburg). Painter of portraits and townscapes. Brother of J C de Mayr. Graphic artist and watercolorist. Taught painting at Academy of Sciences from 1778.

DICKINSON William
b.1746 (London), d.1823 (Paris). Engraver and graphic artist. Owned workshop in London. From mid-1790s worked in Paris. Engraved works by a wide variety of European painters.

FABERGÉ Gustav
b.1814, d.1893. Jeweller. Opened workshop in St Petersburg, 1842. Business flourished under son, Carl. The firm also had branches in Moscow, Odessa, Kiev and London.

FLOROV Alexander
b.1788, d.1830 (Moscow). Engraver. Studied at Academy under I Klauber, 1792-1806. Worked at Moscow University Museum, 1806-22, then on private commissions. Specialized in portraits and book illustrations.

FUNTUSOV Mikhail
Dates unknown. Serf of Sheremet'ev family. Only four of his works known to have survived - three are to be found at the Hermitage.

GASS Johann Balthasar
b.1730, d.1813 (St Petersburg). German medal-maker. From 1760 worked at Foreign Jewellers' workshop in St Petersburg. From 1768, worked at St Petersburg Mint. Member of mint staff, 1772. Awarded title of 'Imperial Medalmaker', 1773. Retired, 1797. Executed more than 50 medal dies.

GREKOV Alexei Angileievich
b.about 1726, d.after 1769. Engraver. From 1735 studied under Wortmann, Sokoloff and Schmidt at Academy of Sciences, and there, from early 1760s headed engraving class. Retired 1770. Specialized in portraits and views of St Petersburg.

PRENNER Georg Caspar von
b.1720 (Vienna), d.1766 (Rome). Painter and engraver. Worked in Russia 1750 - 55.

GROOTH Georg Christoph
b. 1716 (Stuttgart), d. 1749 (St Petersburg). Portrait painter and teacher. Arrived Russia, 1739. From 1741 court painter to Princess Anna Leopoldovna, later to Empress Elizabeth. From 1743, curator of Imperial Art Gallery.

IVANOV Mikhail Matveievich
b.1748, d.1823 (St Petersburg). Landscape
painter. Pupil of Grooth. Studied in Paris under
J B Le Prince. Fought in Russo-Turkish War.

IUDIN Samoil Iudich
b.1730, d. after 1800. Studied under B Scott in
St Petersburg Mint. Worked with T I Ivanov.
Made numerous medals during the reign of
Catherine II.

IVANOV Timofei Ivanovich
b.1729 (St Petersburg), d.1802-3
(St Petersburg). Son of a coin-maker at the
St Petersburg Mint. Studied under B Scott and
attended drawing class at Academy of Sciences.
From 1757 worked as independent coin and
medal die maker. Executed more than 100
medals including many portraits of Catherine II.

IVANOV Vasilii Ivanovich
b.1773, d. after 1809. Engraver. A serf until
1779. Studied at Academy of Arts, 1779-94,
from 1785 under A Radigues and I Klauber.
Engraver at Academy of Sciences, 1796-1805.
Engraved portraits and book illustrations.

JAEGER Johann Georg Caspar
Dates unknown. Sculptor, medal-maker, carver
of hard stones. Worked at St Petersburg Mint,
1770. Taught at Academy of Arts, 1776-78.

KAZACHINSKII Andrei Ivanovich
b.1774 (St Petersburg), d.1814 (St Petersburg).
Engraver. Studied at Academy of Arts, 1779-
94, under A Radigues and I Klauber. From
1797 worked at Imperial Map Depot. Worked
privately on book illustrations, maps, portraits
and townscapes.

KEESTNER Joachim Conrad
Dates unknown. German miniaturist working in
Russia late 18th century. Employed at Gardner
Porcelain Factory near Moscow, 1770s.

LAMPI Giovanni Battista, The Elder
b.1751 (Romeno, S.Tyrol), d.1830 (Vienna).
Portrait painter and miniaturist. Studied in
Salzburg. Worked in Verona, Trieste, Vienna
(from 1783) and Warsaw (from 1788). Invited
by Potemkin to Russia, 1791. Worked in Jassy,
then St Petersburg until 1779. Honorary
member of Academy of Arts.

LANG Alexander
b. St Petersburg, dates unknown. Jeweller.
Apprentice to J B Gass. Master of the Guild of
Foreign Jewellers from 1773.

LEBERECHT Carl Alexandrovich
b.1755 (Meiningen), d.1827 (St Petersburg).
Medalmaker and carver of hard stones. Trained
in Germany. Arrived in St Petersburg, 1770.
Worked at St Petersburg Mint from 1778.
Chief medalmaker, 1799. Head of Academy of
Arts medal class, 1800. Honorary member of
Berlin and Stockholm academies.

LEVITSKII Dmitri Grigorievich
b.1735 (Kiev), d.1822 (St Petersburg).
Portrait painter. Studied under his father,
G K Levitskii and A P Antropov. Academician,
1770. Head of Academy portraiture class,
1771-89. Academy councillor, 1807.

LORY Gabriel Ludwig
b.1763 (Bern, Switzerland), d.1840 (Bern).
Engraver, watercolorist. Father and partner of
Matthias Gabriel Lory (1784-1846). Famous
for numerous views of Switzerland. Worked
on engraved series of views of St Petersburg
and Moscow by various artists 1797-1805.

MAKHAEV Mikhail Ivanovich
b.about 1718, d.1770. Painter, engraver and
draughtsman. Studied engraving at Academy
of Sciences. Executed series of views of St
Petersburg.

MALTON Thomas, The Elder
b.1726 (London), d.1801 (Dublin). Graphic
artist and engraver. From 1785 taught in
Dublin. Drew and engraved views of Oxford
and London. Painted a series of views of St
Petersburg after originals by Joseph Hearn.

MARTOS Ivan Petrovich
b.1754 (Ichna, Chernigov province), d.1835
(St Petersburg). Sculptor. Pupil of L Rollan
and N F Gillet. Studied at Academy of Arts,
1764-73. Academy scholarship in Rome,
1774-79. Academician, 1782; senior professor,
1794; rector of Academy 1814-35. Worked on
decoration of palaces of Tsarkoe Selo, Pavlovsk
and Peterhof. Best known for memorial
sculpture.

MELNIKOV Alexander Kiprianovich
b.1803, d. after 1855. Engraver. Studied at
Academy of Arts 1813-24, under N I Utkin
and S F Galaktionov. Worked for Academy of
Sciences and map office of General Staff
headquarters.

MEYER Christian
b. about 1750. Headed furniture workshop in
St Petersburg in 1780s working exclusively for
the imperial court. In early 1780s was
carpentry tutor to Catherine II's grandsons,
Alexander and Constantine.

NATTIER Jean Marc
b.1685 (Paris), d.1766 (Paris). Portrait
painter. Studied under his father, M Nattier
and J Jouvenet. Brother of J-B Nattier.
Member of French Academy, 1718. French
court painter, 1740s. Commissioned to paint
portraits by Peter the Great after 1717
meeting in Amsterdam.

OSIPOV Alexei Agapievich
b.1770 (Moscow), d. after 1848 (Moscow?).
Engraver. Born into serf family. Taught at
school in Moscow for serf engravers and worked
at Moscow natural history exploration society.

PATERSSEN Benjamin
b.1750 (Varberg, Sweden), d.1815 (St
Petersburg). Painter, engraver. Arrived in
St Petersburg, 1787. From 1793 worked
exclusively on townscapes; especially
watercolors and engravings of St Petersburg.
Member of Stockholm Academy, 1798.

PATON Richard
b.1717 (London), d.1791 (London). Engraver
and marine painter. Orphan adopted by
Admiral Knowles. Served in Navy and
Customs. Exhibited at Royal Academy and
Society of Artists, 1762-80. Famous for series
of battle scenes.

RADIGUES François Antoine
b.1719-21 (Rheims), d.1809 (St Petersburg).
Engraver. Studied and worked in France,
Holland and England. Invited to St Petersburg
in 1764 to head, from 1769, engraving
workshop of Academy of Sciences. Also taught
engraving class at Academy of Arts 1765-67,
1789-95. Academician, 1794. Worked chiefly
on portraits.

ROKOTOV Feodor
b. about 1735, d.1808 (St Petersburg). Portrait painter. Serf of Prince Repnin. Studied under a P Antropov and P Rotari. 1760-62 studied at Academy of Arts and taught there 1762-65. From 1767 lived and worked in Moscow. Adopted by Russian court and nobility.

ROSLIN Alexander
b.1718 (Sweden), d.1793 (Paris). Portrait painter. Worked in Paris from about 1747. Academician, 1753. Returned to Sweden 1772. Summoned to work in Russia by Catherine II. Later returned to France.

RUDOLF David
Born Copenhagen. Jeweller. Master of the Guild of Foreign Jewellers from 1779. Appointed to head guild, 1793.

SCHARFF Johann Gottlieb
b. Moscow. Master goldsmith and jeweller. Studied in Moscow. Moved to St Petersburg, 1767. Master of Guild of Foreign Jewellers and is recorded until 1808.

SCHMIDT Georg Friedrich
b.1712 (Berlin), d.1775 (Berlin). Engraver, graphic artist and pastelist. Studied in Germany and Paris. Member of French Academy from 1742, court engraver to Frederick II, 1742. Worked in Russia, 1757-62. Head of engraving at Academy of Sciences from 1758 and taught at Academy of Arts. Executed many portraits.

SHIBANOV Mikhail
Dates unknown. Portrait and genre painter. Serf of Prince Potemkin, working in the second half of 18th century.

SHUBIN Fedot Ivanovich
b.1740 (Archangel Province), d.1805 (St Petersburg). Sculptor. Studied at Academy of Arts, 1761-66, pupil of N F Gillet. Academy scholarship in Paris, 1767-70. Academician, 1744, professor, 1794.

SHUKIN Stepan Semeonovich
b.1762 (Moscow), d.1828 (St Petersburg). Painter of icons, miniatures and portraits, teacher. Raised in a Moscow children's home. Studied under D G Levitskii at Academy of Arts and in Paris. Succeeded Levitskii as portraiture instructor, 1788. Academician, 1797. Councillor of the Academy, 1802.

SIMONE Antoine
Dates unknown. Master of molding, casting and gold work. Taught at Academy of Arts, 1769-70. Helped E M Falconet in making the 'Bronze Horseman' monument to Peter the Great.

SKORODUMOV Gavriil Ivanovich
b.1755 (St Petersburg), d.1792 (St Petersburg). Painter, engraver, graphic artist, miniaturist. Studied engraving at the Academy of Arts under A.Radigues. Academy scholarship to study in London, 1773-77. Worked in London and Paris. Court engraver in St Petersburg. Worked privately and on commission in Academy. Keeper of engravings at the Hermitage. Mainly engraved allegorical and historical compositions.

SMIRNOVSKII Ivan
Dates unknown. Belorussian portrait painter working at the end of the 18th Century and early 19th century.

SUCHANOV Andrian
Dates unknown. Craftsman working and teaching in second half of 18th century.

THEREMIN François Claude
Born in Prussia, son of pastor of French church in Berlin. Studied jewelry business in Berlin, Paris and London. Acquired passion for enamel work in Paris. Established jewelry factory in St Petersburg with brother Jordan where younger brother Pierre Etienne also worked. Members of the Guild of Foreign Jewellers.

TOCQUÉ Louis
b.1696 (Paris), d.1772 (Paris). Son of architectural painter. Pupil of Hyacinthe Rigaud. Summoned to Russia by Empress Elizabeth, 1757. Stayed for two years and painted Empress' portrait, 1758. Worked for Danish court.

TYRANOV Alexei Vasil'evich
b.1808, d.1859. Painter of portraits and interiors. Studied under A G Venetsianov and at Academy of Arts. Gold Medal of Society for the Encouragement of the Arts, 1830. Academician 1839.

UTKIN Nikolai Ivanovich
b.1780 (Tver), d.1863 (St Petersburg). Engraver, painter, miniaturist. Studied at Academy of Arts 1785-1800 under A Radigues and I Klauber, and on Academy scholarship in Paris 1803-07. Academician, 1814. Headed Academy's engraving class,1817-50. Keeper of engravings at the Hermitage from 1817. Keeper of prints at Academy from 1843. Member of Stockholm, Antwerp and Dresden Academies. Mainly engraved portraits and book illustrations.

VASIL'EV, Iakov Vasilevich
b. 1730 (St Petersburg), d. 1760 (St Petersburg). Engraver. From 1740 studied in drawing and engraving classes at Academy of Sciences under E Grimmel and I A Sokolov, and from 1759 at Academy of Arts under G F Schmidt. Well-known for views of St Petersburg, fireworks displays and book illustrations.

VAN DER SCHLEY Jacob
b.1715 (Amsterdam), d.1779 (Amsterdam). Engraver, graphic artist. Worked in St Petersburg, 1768-75.

VERETENNIKOV Matvei Iakovlevich
Serf to Count Saltykov and furniture maker to Catherine II, Paul I and his wife Maria Feodorovna.

WAECHTER Johann Georg
b.1726 (Heidelberg), d.1800 (St Petersburg). Medal-maker. Worked in Russia from early 1760s. Executed more than 40 medals to commemorate important events during reigns of Empresses Elizabeth and Catherine II.

WALKER James
b.1748 (London), d.1808 (London). Arrived in St Petersburg 1784 and became engraver to Catherine II. From 1794 Academician. Returned to England 1802. Worked mainly on portraits.

ZHDANOV Andrei Osipovich
b.1755, d.1811 (St Petersburg). Icon and portrait painter. Studied at Academy of Arts from 1791. Worked largely on mythological subjects.

BIBLIOGRAPHY

BACKSBACKA, L, St Petersburges Juwelware.
Guldoch silvekmedek 1714-1814 (Helsingfors,
Finland, 1951)

BENUA, A N, The Gallery of the Imperial
Treasures of the Imperial Hermitage/The Art
Treasures of Russia; 1902 N. 12 p.305-349

BERNOULLI, The Notes of Bernoulli, 1777/
Russian Archives; 1902 - Book One - 1902 -
p.5-30

BERNIAKOVICH, Z A, Russian Artistic Silver
17th - the early 20th century in the collection
of the State Hermitage (Leningrad, 1977)

BRIKNER, A, History of Catherine II, VI - 5
(St Petersburg, 1885)

BURKE, A Genealogical and Heraldic
Dictionary of the Peerage and Baronetage of the
British Empire (London, 1873)

CATALOGUE de la Section des Russica. Vols
1-2 (St Petersburg,1873)

CATHERINE II, Notes of Catherine II
(London, 1859)

CHENEVIERE, A, Russian Furniture: The
Golden Age 1780-1840 (London, 1988)

COLLECTION of Russian Medals
(St Petersburg, 1840)

COMBINED Catalog of Russian Civil Printing
of the 18th Century. Vols 1-5 (Moscow, 1963)

COMBINED Catalog of Books in Foreign
Languages Published in Russia in 18th Century,
Vols 1-3 (Leningrad, 1985)

Le CORBEILLER, C, European and American
Snuff-Boxes: 1730-1830 (London, 1966)

CORBERON, From the Notes of Corberon
1775-80/Russian archives; 1911 - Book Two -
1.5. - p.27-104. 6 - p.161-204

DASHKOVA, E P, Notes 1743-1810
(Leningrad, 1985)

DEMMENI, M G, Book of Decrees on the
Coin and Medal Business in Russia. Vols I II
(St Petersburg, 1887)

DESCRIPTION of Publications printed in
Cyrillic - Compilers G A Bykova, M M
Gurevich (Moscow, Leningrad 1958)

FELKERSAM, A E, Alphabetical Index of St
Petersburg Silver and Gilding Works,
Craftsmen, Jewellers, Etchers and Others,
1714-1814 (St Petersburg, 1907)

FYODOROV-DAVYDOV, A A, Russian
Landscape 18th to Early 20th Centuries
(Moscow, 1953)

GRIBOVSKII, A M, Notes about the Empress
Catherine the Great by the Colonel Attached
to Her Majesty as a State Secretary
(Moscow, 1864)

HAZELTON, A W, Russian Imperial Orders
(New York, 1932)

HISTORICAL Exhibition of Objects of Art.
Catalog (St Petersburg, 1904)

IVANOV, D D, Explanatory Guide to the Art
Collections of St Petersburg
(St Petersburg, 1904)

IVERSEN, Yu B, Medals In Honor of the
Russian State and Private Persons. VI - 2 (St
Petersburg, 1880, 1885, 1896)

KHRAPOVITSKII, A V, Memorable Notes of
A V Khrapovitskii, State Secretary of the
Empress Catherine II (Moscow, 1862)

KOMELOVA, G, The Series with Etchings of
the Vicinity of Petersburg at the Beginning of
the l9th Century. On the History of the
Etching and Landscape School of the Academy
of Arts/Culture and Art of Russia l9th Century
(Leningrad, 1985) p.19-30

KORSHUNOVA, T T, Russian Tapestry.
(Petersburg Tapestry Factory, 1975)

KORSHUNOVA, T T, Costume in Russia,
18th to early 20th century. From the collection
of the State Hermitage (Leningrad, 1979)

KOSTYUK, O G, J P Ador and his Works
in the Hermitage/West European Art 18th
Century (Leningrad, 1987) p.155-166

KUZNETSOV, A A, Orders and Medals of
Russia (Moscow, 1985)

KUZNETSOVA, L K, On the Question of
Evolution of the Artistic Form and System of
the Decoration of Snuff-Boxes in Petersburg
during the Second Half of the 18th Century/
Problems in the Development of Russian Art -
I.XIII - 1980 - p.40-62

KUZNETSOVA, L K, The Work of Petersburg
Jeweller François Bouddé: Decorative/Applied
Art of Russia and Western Europe at the End
of 18th-19th Centuries. Collection of Scientific
Works of the State Hermitage (Leningrad,
l986) p.39-44

LANCERE, A K, Russian Porcelain. The Art
of the First Russian Porcelain Works
(Leningrad, 1968)

LIVEN, G E, Guide to the Study of
Peter the Great and the Gallery of Treasures
(St Petersburg, 1901)

MALCHENKO, M D, Artistic Work of the
Tula Craftsmen 18th Century. Works of the
State Hermitage (Leningrad, 1974) Vol.15
p.161-70

MAKAROV, V K, Colored Stone in the
Collection of the Hermitage (Leningrad, 1938)

MOISEIENKO, E, Russian Embroidery 17th -
Early 20th Century. From the collection of the
State Hermitage (Leningrad, 1978)

MONUMENTS of the Russian Artistic Culture
10th - early 20th Centuries. Album/authors/
compilers: Z A Berniakovich, N B Kaliazina, G
N Komelova and others. Introductory article by
G N Komelova (Moscow, 1979)

PETERSBURG in the Works of Paterssen.
Compilers G N Komelova, G A Printseva, I G
Kotelnikova. Album (Moscow, 1978)

PORTRAIT Miniature in Russia, 18th to early 20th centuries. From the Collection of the State Hermitage - Authors of the introductory articles: G N Komelova, G A Printseva (Leningrad, 1986)

PRINTSEVA, G A, Nikolai Ivanovich Utkin. 1780-1863 (LENINGRAD, 1983)

ROVINSKII, D A, Detailed Dictionary of the Russian Etchers 16th to 19th Centuries. Vols 1-2 (St Petersburg, 1895)

RULIER, K K, History and Anecdotes of the Revolution in Russia in 1762/18th Century Russia through the Eyes of Foreigners (Leningrad, 1989) p.262-312

RUSSIAN Enamel: 12th to Early 20th Century. From the Collection of the State Hermitage. Authors of the introductory article and compilers of the album: N N Kalyazina, G N Komelova, N D Kostochkina, O Kostyuk, K A Orlova (Leningrad, 1987)

RUSSIAN Portraits 18th Century. Vols 1-5 (St Petersburg; 1905-08)

RUSSIAN Biographical Dictionary. Vols 1-25 (St Petersburg 1896-1911)

SEGUR, L D, Notes of Count Ségur on his Visit to Russia in the Reign of Catherine II (St Petersburg, 1865)

SMIRNOV, V P, Descriptions of Russian Medals (St Petersburg, 1908), Collection of Russian Medals (St Petersburg, 1840)

SOKOLOVA, T M, Essays on the History of the Artistic Furniture 15th to 19th Centuries (Leningrad, 1967)

SOKOLOVA, T M, and ORLOVA, K A, Russian Furniture in the State Hermitage. (Leningrad, 1973)

SPASSKY, I O, Foreign and Russian Orders up to 1917. (Leningrad, 1963)

SNOWMAN, A, 18th Century Gold Boxes of Europe (London, 1966)

SOTHEBY PARKE BERNET, Fine Gold Boxes and Portrait Miniatures. Auction 22-24/11/ 1987 (London, 1978)

TEVYASHOV, E N, Description of a Few Etchings (St Petersburg, 1903)

VISKOVATOV, A V (compiler), Historical Description of the Clothes and Armaments of the Russian Troops in 19 parts. Part III (St Petersburg, 1899) Part VI (St Petersburg, 1900)

VRANGEL, N N, Sketches on the History of the Miniature in Russia, Sratige Godi, 1909. Oktyabr - p.509-574.

WERLICH, R, Orders and Decorations of all Nations. Ancient and Modern, Civil and Military (Washington, 1965)

ZAMYSLOVSKY, E S & PETROV, I I, Historical Essay on Russian Orders and Books of the Main Order Statuses (St Petersburg, 1891)

ZVYAGINTSEV, V V, Banners and Standards of the Russian Army XVI - 1914 and Marine Flags (Paris, 1964)

KEY
V - Volume
P - Part
I - Issue
Ptrg - Petrograd

FURTHER READING

ALEXANDER, JOHN T, Catherine the Great, Life and Legend (New York and Oxford, 1988)

DUKES, P, Catherine the Great and the Russian Nobility (Cambridge, 1967)

KOCHAN, MIRIAM, Life in Russia under Catherine the Great (London, 1981)

LONGWORTH, P, The Three Empresses: Catherine I, Anne and Elizabeth of Russia (London, 1972)

MADARIAGA, Isabel de, Russia in the Age of Catherine the Great (London, 1981 and Yale, 1982)

MAROGER, D (ed.), The Memoirs of Catherine the Great (London, 1955)

MASSIE, S, Land of the Firebird (New York, 1982)

MASSIE, S, Pavlovsk: Life of a Palace (New York and London 1990)

RANSEL, D, The Politics of Catherinian Russia (New Haven, Conn and London, 1975)

TROYAT, H, Catherine the Great (Berkley, 1984)

TROYAT, H, Peter the Great: A Biography (New York, 1987)

STATE HERMITAGE MUSEUM INVENTORY NUMBERS

FRONT COVER *ERG 570*
FRONTISPIECE *ERG 2021*

ST PETERSBURG IN THE MID-EIGHTEENTH CENTURY

1. *ERG 560*
2. *ERG 1857*
3. *ERG 1856*
4. *ERG 20012*
5. *ERG 22095*
6. *ERG 275*
7. *ERG 2646*
8. *ERT 20019/29257*
9. *ERT 15504*
10. *ERT 30182*
11. *ERT 16182*
12. *ERMB 34*
13. *ERO 4601*
14. *ERO 4702*
15. *ERO 4721*
16. *ERO 4054*
17. *ERO 4556*
18. *ERO 4742*
19. *ERO 7765*

THE YOUNG COURT

1. *ERT 12700*
2. *ERT 11038/12702/10698*
3. *ERT 15563/15565*
4. *ERT 16113*
5. *ERG 563*
6. *ERG 562*
7. *ERG 2474*
8. *ERG 1407*
9. *ERF 8282* (Cream bowl with lid and handles)
 ERF 8284 (Patchbox with lid)
 ERF 8280 (Teapot)
 ERF 8294 (Spoon)
 ERF 8281 (Sweetmeat dish)
 ERF 8291 (Shaped sideplate)

THE RUSSIAN ORTHODOX CHURCH

1. *ERO 8912*
2. *ERO 8189*
3. *ERO 8918*
4. *ERT 17478*
5. *ERT 7859/7829*
6. *ERT 7858*
7. *ERT 7853*
8. *ERG 2431*
9. *ERO 7188*
10. *ERO 7193*

11. *ERI 69 a-d*
12. *ERG 2448*
13. *ERM 5364*
14. *ERM 5356*
15. *ERO 5712*
16. *ERO 5607*
17. *ERO 5706*
18. *ERD 2426*
19. *ERD 2427/2428*
20. *ERG 2639*
21. *ERG 2241*

EMPRESS CATHERINE II

1. *8035*
2. *8033*
3. *570*
4. *DRM 1169*
5. *8013*
6. *ERG 2333*
7. *ERG 3472*
8. *ERG 16653*
9. *ERG 16654*
10. *8014*
11. *139831*
12. *8330*
13. *ERT 11002/11003*
14. *ERT 11013/11023*
15. *ERT 16191*
16. *DRM 2725*
17. *DRM 2954*
18. *ERG 3472*
19. *ERG 6802*
20. *ERG 1879*
21. *ERG 118*
22. *ERG 94*
23. *ERG 738*
24. *ERG 1064*
25. *ERG 1923*
26. *ERG 27654*
27. *ERG 1890*
28. *ERG 2013*
29. *ERG 1733*
30. *ERG 588*
31. *ERG 599*
32. *ERS 111*
33. *ERG 14925*
34. *ERG 617*
35. *ERK 685*
36. *ERO 656*
37. *ERO 5109/5101/5102*
38. *ERG 15988/15989/15990*
39. *ERMB 109*
40. *ERMB 306*
41. *ERG 16719*
42. *686*

THE CULTURAL HERITAGE

1. *96573*
2. *72929*
3. *111054*
4. *97451*
5. *136327*
6. *264378*
7. *ERG 26989/26996*
8. *DRM 1298*
9. *ERD 2445*
10. *ERM 5246*
11. *E 3010*
12. *ERG 29344*
13. *ERG 20048*
14. *ERG 13118*
15. *ERG 133*
16. *ERG 1899*
17. *ERG 2623*
18. *ERSk 71*
19. *ERG 1902*
20. *ERG 2219*
21. *ERG 2614*
22. *ERG 12558*
23. *ERG 144*
24. *ERSk 5*
25. *ERG 30516*
26. *ERG 31491*
27. *ERG 17306*
28. *ERG 5727*
29. *RG 31874*
30. *ERG 16644*
31. *ERK 830*
32. *ERM 5218*
33. *ERM 246/247*
34. *ERF 479/480*
35. *ERM 37*
36. *ERMB 1350*
37. *ERMB 544*
38. *ERMB 70,950*
39. *ERMB 70,950*
40. *ERM 1448*
41. *ERT 16192*
42. *ERT 616184*
43. *ERG 1872*
44. *472*
45. *ERO 5116*
46. *ERO 2439*
47. *ERO 5095*
48. *ERO 5058*
49. *ERO 4759*
50. *ERKM 952*
51. *ERKM 960*
52. *ERKM 500*
53. *ERF 6810/a,b,v* (tureen)
 ERF 6834 (dinner plate)
 ERF 6821 (soup plate)
 ERF 343 (glass holder)
54. *GC 694* (tray and 2 cups with covers)
 GC 54 (dinner plate)
 GC 644 (bottle holder)
 GC 691 (covered dish)
 GC 603 (glass holder)
55. *ERK M-935*
56. *ERF 488*
57. *ERM 2347*
58. *ERM 2330*
59. *ERM 2395*
60. *ERM 2147/2148*
61. *7497*
62. *ERM 4580, 4593, 4586, 4594, 4598, 4609, 4604* (chessmen)
 ERM 4578 (box)
63. *ERM 7701*
64. *ERM 7593*
65. *ERG 13379*
66. *ERT 16010/12717*
67. *ERT 12710*
68. *ERT 13037/14973 /7189/ 11615*
69. *ERT 15570*
70. *ERT 10137*
71. *ERT 10569*
72. *ERT 10395*
73. *ERT 19533*
74. *RT 6571*
75. *RT 8703*
76. *RT 8761*

THE TREASURY

1. *E 2743*
2. *E 9144*
3. *E 13103*
4. *E 4262/4264/4613/4259*
5. *4745*
6/7. *2006/2007*
8. *E 2169*
9. *E 4274*
10. *E 5147*
11. *E 4025*
12. *E 4204*
13. *E 4495*
14. *E 4485*
15. *E 4462*
16. *E 4142*
17. *E 10820*
18. *E 4491*
19. *E 4459*
20. *E 4483*
21. *E 4065*
22. *E 3051*
23/24. *E 3008/3009*
25. *E 4307*
26. *E 4282*
27. *E 289*
28. *E 4795*
29. *E 6654*

THE RUSSIAN EMPIRE

1. *8093/8096*
2. *ERG 2702*
3. *ERF 791*
4. *ERF 406*
5. *ERF 795*
6. *ERF 407*
7. *ERF 176*
8. *ERF 178*
9. *ERK 710*
10. *76418/76419*
11. *115052/96165*
12. *ERG 10883*
13. *ERTkh 1618*
14. *DRM 3064*
15. *RM 1658*
16. *DRM 2710*
17. *ERG 11107/ERG 11113*
18. *ERG 16230*
19. *ERG 16766*
20. *ERT 16053/16054*
21. *DRM 8964*
22. *DRM 9013*
23. *ERG 31737*
24. *ERG 21066*
25. *ERG 16755*
26. *NSk 151*
27. *ERG 1727*
28. *Z0 7036*
29. *139831*
30. *ERO 8375*
31/32. *ZO 972*
33. *ZO 1365*
34. *ZN 601*
35. *ZN 574*
36. *ZN 145*
37. *IO 1384*
38. *R-707*
39. *IO-1392*
40. *R-710*
41. *ERF 301/306* (2 soup plates)
 ERF 300/302 (2 dinner plates)
 ERF 317 (leaf dish)
 ERF 4506 (small leaf dish)
 ERF 7388/7389 (2 knives)
 ERF 7378/7381 (2 forks)
 ERF 319/320 (2 cups with lids)
 ERF 6798 (biscuit basket)
 ERF 314/316 (2 salt cellars)
 ERF 4507 (oval dish)
42. *ERF 629* (dish with handles)
 ERF 644 (covered tureen)
 ERF 566 (dinner plate)
 ERF 664 (salt cellar)
43. *UT 1605*